The Art of
BOTANICAL ILLUSTRATION

THE CLASSIC ILLUSTRATORS AND THEIR ACHIEVEMENTS
FROM 1550 TO 1900

I have gathered a posie
of other men's flowers
and nothing but the thread that
binds them is my own

MONTAIGNE

The Art of
BOTANICAL ILLUSTRATION

THE CLASSIC ILLUSTRATORS AND THEIR ACHIEVEMENTS
FROM 1550 TO 1900

Lys de Bray

Grange
BOOKS

A QUANTUM BOOK

Published by Grange Books
An imprint of Grange Books plc
The Grange
Grange Yard
London SE1 3AG

ISBN 1-84013-071-7

QUMBTI

This book was produced by
Quantum Books Ltd
6 Blundell Street
London N7 9BH

Art Director: Ian Hunt
Designer: James Lawrence
Artwork: Danny McBride
Editorial Director: Jeremy Harwood
Picture Manager: Joanna Wiese
Picture Researcher: Josephine Wiggs
Senior Editor: Sally MacEachern
Editorial: Clare Pumfrey, Paula Borthwick.

Typeset by
Central Southern Typesetters, Eastbourne
Manufactured in Hong Kong by
Regent Publishing Services Ltd
Printed by
Lee Fung Asco Printers Ltd, China

Contents

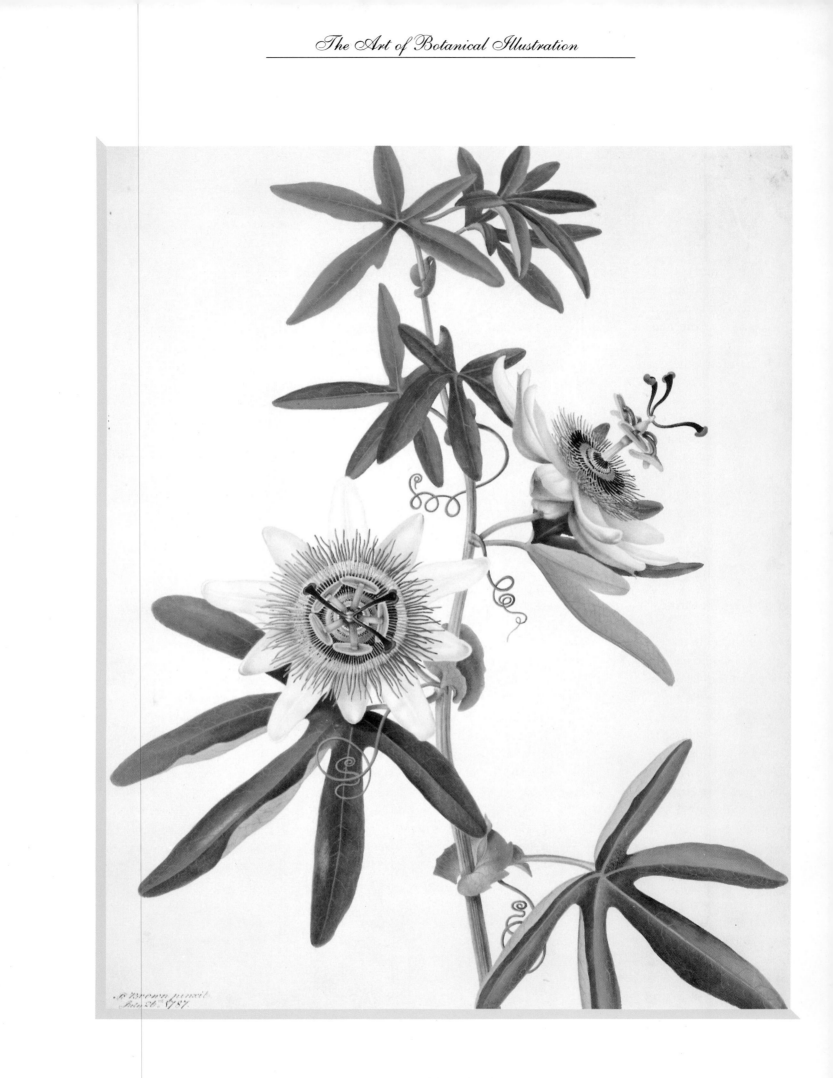

PASSION FLOWER
Peter Brown
26 July 1787

Introduction

IT IS THE PICTURES that tell the story in this book, dating as they do from over 2000 years ago to the present day. The accompanying text relates some 'framework' history but in the main it tells of the artists and their work. In most cases there is a mass of well-documented material but in other instances very little is known of the artists themselves and all that is left are the souls of the flowers that they painted.

The first plant-drawings made for herbal recognition, are interesting mainly because of their actual survival, though they are not works of great merit and sometimes they do not even fulfil the recognition-requirement; but since they were often the only pictorial representation available they are important, if only as chronological milestones. These led on quite quickly to unexpected examples of early artistic virtuosity, as in the case of Ligozzi, whose beautiful work is out of his century in its excellence.

The Dutch and Flemish painters played an important part in the history of botanical art, even though their (flamboyantly) accurate works cannot be called truly botanical. The paintings were chronologically and historically important because these now-famous flower-pieces often included the newest discoveries, brought back by the earliest collectors and reared in the great gardens of Northern Europe. These paintings influenced many later artists, including Redouté.

Gardening plays a very strong part (if behind the scenes) in such a book as this because wealthy patrons often collected vast numbers of plants, many of which have since been lost to us; in addition, these patrons often commissioned artists to make drawings ('drawings' is the traditional name for an actual drawing *or* a painting in water colour, body-colour or gouache) of their plant collections – as in the case of George Clifford at the Hartekamp in Holland. These collections have come down to us in the form of florilegiums, very characteristic of their epoch.

The compilers of herbals, early 'seed catalogues' and the vast folios of pseudo-botanical works, such as Thurber's *Temple of Flora* are equally fascinating because of their historical place in the progress of standards; there had been nothing like them before – or since – and their production sometimes meant financial ruin to their progenitors, though much technical knowledge was acquired to be used and improved on at a later time.

The industry and fortitude of some of the artists, such as Sowerby, Fitch, the Bauer brothers, Redouté and others like them was phenomenal, and they have left behind a unique and precious legacy which varies in interest from technical competence to work of great beauty.

It is an inescapable fact that the daylight by which they were originally painted would itself be their ruination if they were exposed to it for long periods of time. Therefore these treasures of a past age are kept for their safety and our pleasure in the darkness of boxes and portfolios in museums and libraries, only seldom being exhibited and then in carefully controlled conditions and never for long. A book such as this is a wonderful opportunity to tell the artists' stories by means of their work, and to print some pictures for the first time.

It has been a fascinating and spiritually rewarding task to find and see these paintings in the original and to write the text that links them together.

Lys de Bray
Wimborne, Dorset
England.

LADY'S BEDSTRAW – *Galium verum*,
CRANESBILL – *Erodium malacoides* and
SOFT CRANESBILL – *Geranium molle*
DIOSCORIDES – *De Materia Medica* (Codex
Neapolitanus) 7th century, 172 folios, f58r.

Incunabula and Iconography

—————— *1500BC–1660AD* ——————

ONE OF THE EARLIEST GROUPS of plant representations can be seen on the walls of the Temple of Thutmose III at Karnak in Egypt, where there is a group of plants carved in bas-relief. These show 'all the plants that grow' and was done for Thutmose III on his return from a victorious campaign in Syria. There are 275 plants shown, some recognizable and some not, but the inscription with them states that 'these plants exist in very truth'. This work, carried out in 1500BC, may be considered to be one of the first collections of herbal drawings. Later, flowers and plants were occasionally used as inspiration for design – palm trees, the lotus, lilies, crocus and roses – but for some reason plant forms were not considered important enough to be used as anything other than subjects for decorated household furniture and pottery.

The ancient Greeks contributed to botanical records, too. The Greek philosopher and botanist Theophrastus (370–288BC) wrote his *Enquiry into Plants* and, though no actual copy of this has survived the intervening millennia, an unillustrated manuscript of the notes for it has; this was translated by Sir Arthur Hart in 1916.

In the prolific writings of the Roman Pliny the Elder (Gaius Plinius Secundus AD23–79) we find that, fortunately, he was intensely curious about the marvellous world around him and was equally industrious about writing down his thoughts, opinions and discoveries. Pliny mentions the existence of illustrated herbals, that is, books containing descriptions of plants used for medicinal purposes, in the first century BC, and speaks of Cratevas (Krateuas) a physician who lived c50AD who was known to have made or had made, paintings of 'every hearbe in their colours'[1]. Nothing has survived of these, but Pliny later produced his own *Natural History*, which was a vast treatise consisting of all the known facts on the natural sciences. This was really a compilation (in Latin) of writings by Greek authorities, and a considerable portion of the work was devoted to botanical subjects of all kinds.

The first real herbal was written by Dioscorides (Pedianos Dioskurides cAD40–c90). This was written in Greek but is known by its Latin title of *De Materia Medica*. Dioscorides classified his plants according to his own system, at the same time criticizing those of his predecessors. He was clearly familiar with his material, which indicates that the plants were already well-known and in common use by physicians (a fact that medical tracts of the time serve to confirm).

An early copy of this great work, called the *Codex Vindobonensis*, still exists and can be seen in the Österreichische Nationalbibliothek, Vienna. The illustrations were copied and re-copied for centuries, in some cases as late as the 1900s. This work was produced in AD472 for Juliana Anicia, daughter of Flavius Anicius Olybrius, Emperor of the West. Fortunately, and almost unbelievably, it survived for 1,000 years, finally surfacing as a treasured possession of one Haman, the Jewish physician to Suleiman the Magnificent. This was c1554, and it was at this time that the Hapsburg ambassador, a Viennese called Ogier Ghiselin de Busbecq, came upon this great literary treasure while on an embassage from the Emperor Ferdinand I. Being keenly interested in new plants, and having not inconsiderable means of his own, he tried to buy the book, commenting at the time that it was not in a good condition. However, the asking price was too high even for him and so he left Constantinople without it, possibly consoling himself over the disappointment by buying tulip bulbs or at least some seeds. Whatever the exact truth, it is known that Konrad (Conrad) Gesner (1516–65) saw a red tulip in flower in the garden of a Councillor Herwart some five years after the return of Busbecq, c1559, and by 1562 the first cargo of tulip bulbs had been sent from Constantinople to a merchant at Antwerp.

During the Dark Ages and the Middle Ages in Europe much knowledge was preserved, often in translation, by the Islamic scholars of Asia Minor; and monasteries such as Monte Cassino in Central Italy, then called Magna Graecia, were also safe havens for such precious folios. The monks made translations from Arabic and Greek, which accounts for the different codices presently in existence. Sometimes blank spaces were left for the illustrations, which for various reasons were added – or not – at a later date.

Some time in the year AD400 a collection of herbal remedies was gathered together by Apuleius Platonicus, sometimes called Apuleius Barbarus, or Pseudo-Apuleius, to distinguish him from the amazingly versatile author of *The Golden Ass* who lived some 250 years earlier. Nothing seems to be known of the later-born Apuleius Platonicus, but his work was copied, plagiarized and pirated for centuries, and in about the 10th century it was translated into the vernacular Anglo-Saxon. A later codex, Cotton Vitellius CIII, dates from the 11th century.

1. *Natural History: a quotation from Philemon Holland's translation in 1601*

BRAMBLE – *Rubus fruticosus*
DIOSCORIDES – *De Materia Medica*
(Codex Vindobonensis) Constantinople, c.512,
491 folios, f83r

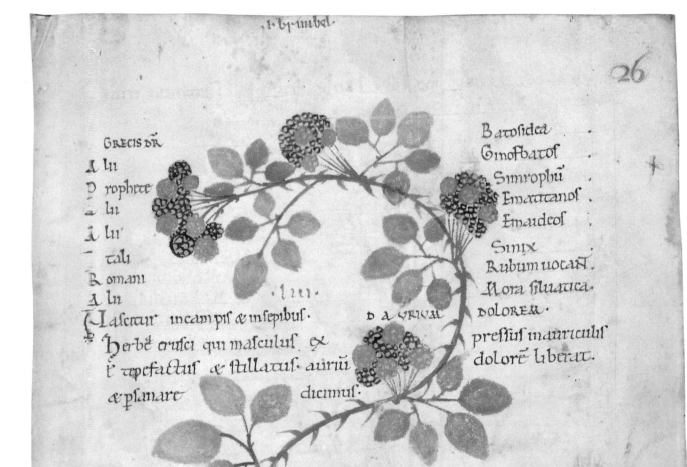

26

GRECIS DR

A lu

P rophete

A lu

i lu

tali

R omani

A lu

Nascitur incampis & insepibus.

Herbe erusci qui masculus. &
e tepefactus & stillatus aurium

& psanare dicimus.

Baurosidea
Cinosbatos
Sinrophu
Emarranos
Emaideos

Sinix
Rubum uotan.
Nora siluatica
DOLOREM.
pressus mauriculis
dolore liberat.

Herba erusci qui mas .uiiij. & mirte qui mas
ide .uiiij. mali granati sicci cortices teres
decoquan inse. & catesmas impigue. & cum
refrigid auert fomentabis tibi sessu .hoc
ptriduu faciens miri fice stringet. & sanat.
 D PROF LV VI VM mulieris. Herbas rusci
qui mas teneras ter septenas decoquis maqua usq; ad

teas & triduo ieiuno potu dab. ita. ut cotidie rino

ues potione. D CARDIACOS. Herba erusci folia pse tta
imponuntur & mamille sinistre dolore tollit. AD VSVS
GIHGEBARV ET DOLORV VITIA. Herbe erusci caules teneros
inumo decoquis & ipsu uinu more contenebis sume facit. A D
VVE REMEDIV. herbe erusci folia aresiant inumbri ea nere
in cluario facto. resilit inpresente nero. AD VVLHERA RE CEHTIA.
Herbe erusci flos aut maros sine collecti ones apiculo sanat. AD Cholo
mata. Herba rubu inumo decocta ad urias coq: uino souebis cdo
lomata & omnia uitia sedat. Mom SERPEHTIS SI PEDE OH.

BRAMBLE – *Rubus fruticosus*
APULEIUS PLATONICUS– *Herbarium*
Bury St Edmunds, England, *c*.1120,
108 folios, f26r

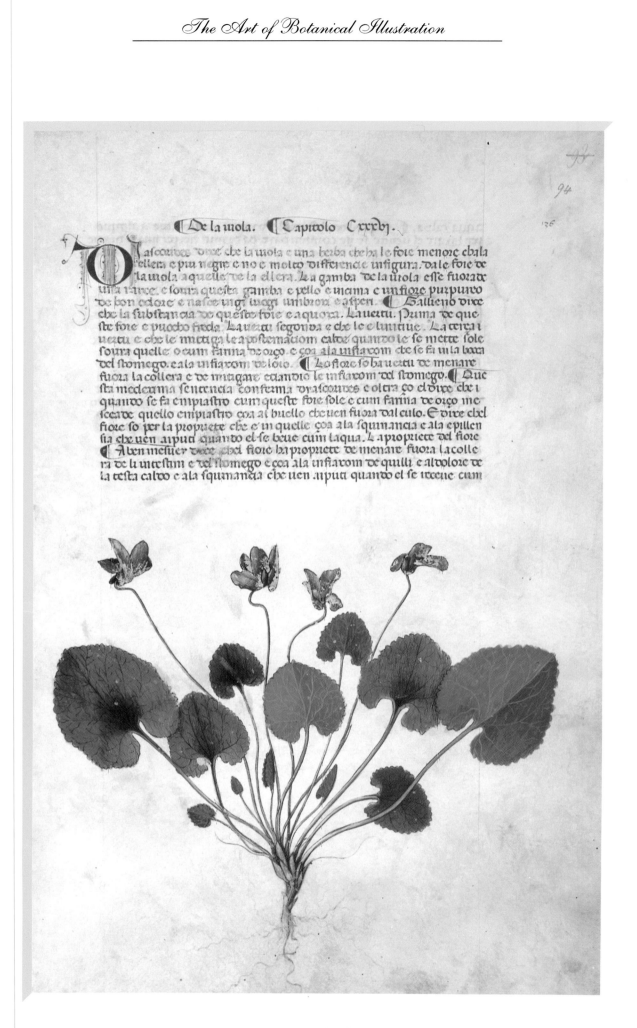

VIOLET – *Viola odorata*
SERAPION THE YOUNGER – *Herbolario volgare,*
Padua 1390–1400, 289 folios, f94r

HENBANE? – *Hyoscyamus niger*
APULEIUS PLATONICUS
Herbarium and other medical texts
England, c.1050, (written in Anglo-Saxon)
140 folios, f23v

PURPLE AND MILITARY ORCHIDS
Orchis mascula and Orchis militaris
Hans Weiditz

NARCISSUS
Otto Brunfels – *Herbarium Vivae Eicones*, 1530
(Hans Weiditz)

THE DEVELOPMENT OF DRAWING STYLE

The earlier drawings in Dioscorides' *De Materia Medica* were naturalistic, as were those of Apuleius, though these were not as good. During the 12th century a new Romanesque style of drawing emerged, which can be attributed to the influence of Byzantine art with its stylization and use of gilding. Though this made for delightful illustrations, the results were almost useless for purposes of recognition. The accompanying descriptive text was not much help either to the gatherer of simples, especially if the plants were very similar.

The herbals of this period were illustrated in this formal way until the end of the 14th century when the illustrators began to observe nature as it really was. They still copied from older sources, but were beginning to compare their references with what was actually growing in their monastic herb gardens. A good example of this welcome and necessary return to naturalism can be found in the work of the Arab physician Serapion the Younger who produced a treatise on medical botany (cAD800). The text was translated into Italian in the 14th century, and the unknown artist produced new and beautiful work of refreshing naturalism. The paintings were at first thought to have been added in the next century but some were copied by a later artist whose work was authenticated as being c1419. This herbal was produced by an Italian physician called Benedetto Rinio who employed Andrea Amadeo to paint his figures. Amadeo

Centũ capita. angľ. affodille.

herbe aspodili succo cum oleo amig
dalino perungas. omnē dolorem
qui fuit in corpore mirifice sanat.
Ad jecoris. uel epatis dolorems.
herbe aspodili radiculas decoques
cum aqua mulsata. potata uero:
jecoris uel epatis dolorem mirifice tol
lit. Hom ista herbe: Urilapatiuos. l. Lapaciũ
Acutũ.

Itali uocant eam. Lapatium acutũ.
Romani: Rumice. Alij: Idiam.
Alij: Rumiz cantaricam. Egypty:

Semem dicunt. Nascitur inter segetes
uel ubiqz. Prima cura eius si qua durici
herbã es in corpore nascitur.
Lapatium acutũ cum aruingia ue
teri. j pane domestico capies. j inde ma
larata facies. quasi malagma. j impo
nes. perfectissime sanat. Hom istius
herbe. Centauria maior. h
hunis genera sunt duo.
has autem centaurias
duas chnocentaurõs di
citur inuenisse. jnde ex
nomine ipsius centau
ri nomen eis iposure.
Jpse uero: de lus herbis
herbis mediciñã instru
it. primusqz egrota
tibus tradidit:

anglice
centauri

Quidam uocant eam. ocharonion.
Alij: plecroniam. unici: Abussú
sim. Alij: limnireos. r ophete: &
meracleon Alij: Cyronias dicunt.
Alij: apogirissam Alij: Polidñ.
Alij: emeuros. Egypty: Anciamã.

Gallitrichum, Immolum (houseleek)
Sempervivum tectorum
APULEIUS PLATONICUS – *Herbarium*
England, c.1200

Chervil (*Chaerophyllum bulbosum*), water mint
(*Mentha aquatica*), Alexanders (*Smyrnium
olusatrum*), lily (*Lilium candidum*), spurge
(*Euphorbia* sp)
APULEIUS PLATONICUS – *Herbarium*
Canterbury c.1070–1100

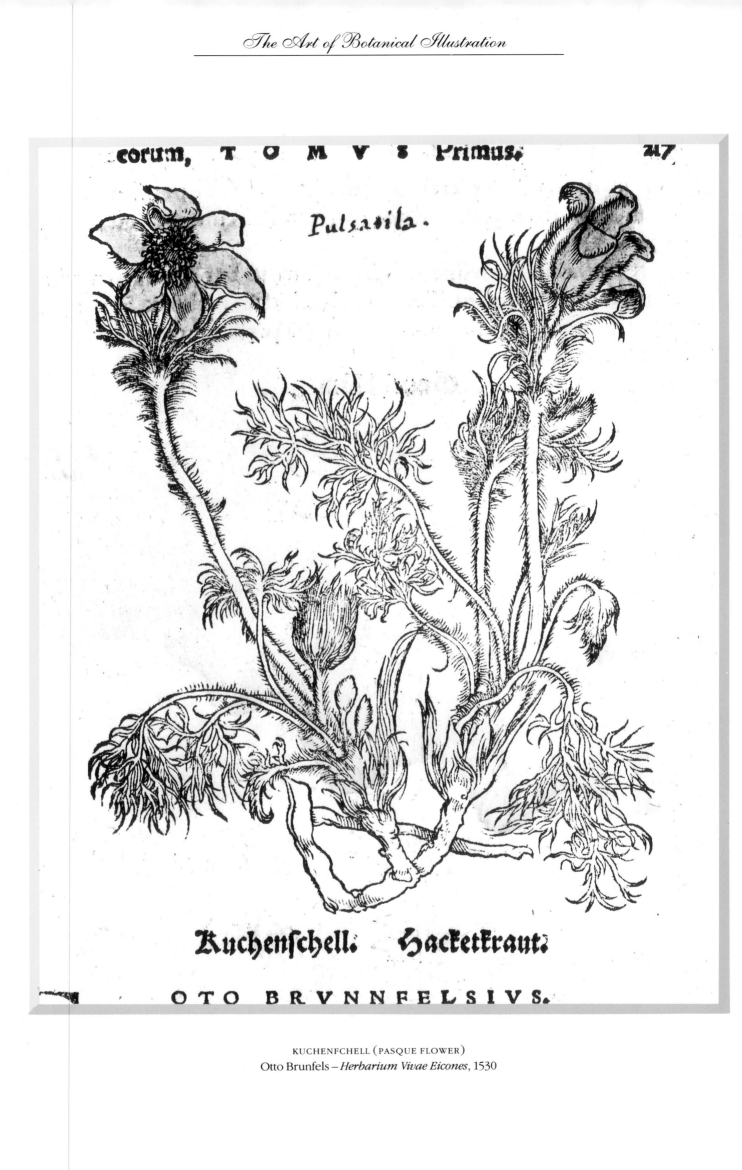

KUCHENFCHELL (PASQUE FLOWER)
Otto Brunfels – *Herbarium Vivae Eicones*, 1530

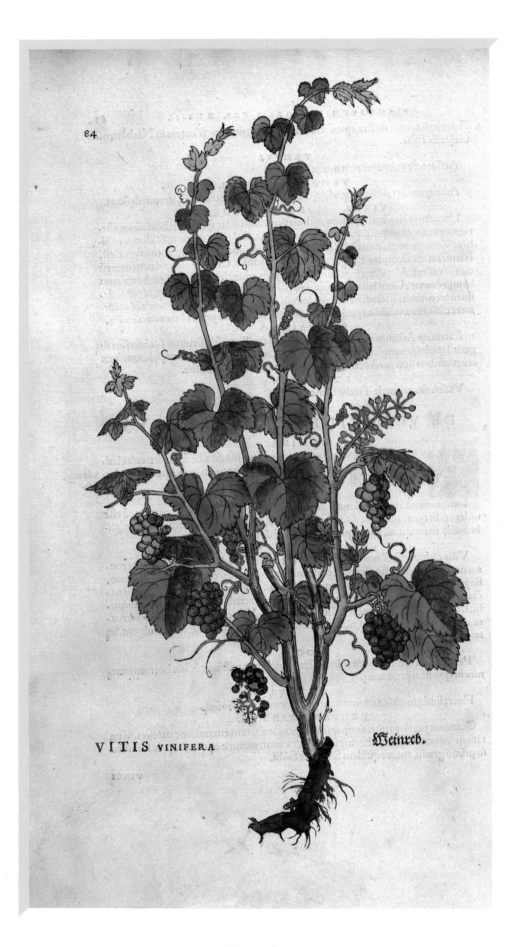

Vitis vinifera
(hand-coloured contemporary engraving)
Leonhart Fuchs – *de Historia Stirpium* (1542)

did this with clarity, observation and realism. This work, the *Liber de Simplicibus*, is in the Biblioteca Nazionale Marciana, Venice.

Certainly, it was Hans Weiditz (or Johannes Guidictius) who produced the first really beautiful plant drawings for Otto Brunfels' *Herbarium Vivae Eicones (Living portraits of plants)* in 1530. Hitherto, herbal drawings had been copied and re-copied mainly from Dioscorides and Apuleius – sometimes the drawings were even upside down. Inevitably the results were debased, even invented, and in many cases unrecognizable. The plant nomenclature of those times was, to say the least, colourful. It consisted of Latin, Greek, latinized Greek, Arabic, latinized Arabic, French, latinized French, German, latinized German, anglicized Latin, anglicized French and many common names, the same name often doing duty for several quite different plants. It was chaotic. The herbalists used exceedingly long but descriptive names in order to make each of their plants easily recognizable. After all, that was what the herbals, those first pharmacopoeias, were for.

With the arrival of Hans Weiditz, a pin-prick of light began to be seen in this appellative murk. To begin with, we know his name because Brunfels, unlike most of the herbal compilers, gave him due credit for his paintings as follows:

> *Nunc Johannes pictor Guidictius ille*
> *Clarus Apellaeo non minus ingenio*
> *Reddedit ad fabras aeri sic arte figuras*
> *Ut non nemo Herbas dixerit esse meras!*

Freely translated[2] this reads: 'Moreover that renowned painter Johann Weiditz, a rival in skill to Apelles, has provided illustrations of such artistry for the engravers that some have said they are real plants!'

Weiditz's drawings are like a breath of fresh air. The woodcut of the pasque-flower must be familiar to many. It is an exceedingly difficult plant to draw satisfactorily, but Weiditz has captured both its essential silkiness and its characteristic habit. Fortunately for us, Weiditz did not always draw what he had been told to, which were the classically-named herbs of antiquity. Other plants merely had vernacular names, which Brunfels called *herbae nudae*, probably meaning to place them separately in his book. But Weiditz seems to have had a mind of his own, and drew what he wanted, sometimes in addition to his list, but possibly sometimes instead of the required material. As is always the case, the printer was waiting impatiently for the completed work, and, since any drawing was better than no drawing at all, many plants, including the pasque-flower, were included in the final work in this way. Sometimes Brunfels apologized to his readers for the unintended inclusions of these 'common' plants with their lack of pedigree, but his readers of today will always be grateful for Weiditz's spirited independence and obvious love of flowers.

In 1542 Leonhart Fuchs published his *De Historia Stirpium*. This was illustrated by Albrecht Meyer who, in the new tradition, drew the plants in their seasons. Heinrich Füllmaurer, another artist, re-drew Meyer's drawings on to the wood-blocks and, finally, Veit Rudolf Speckle made the woodcuts themselves. The published folio is large and imposing and the illustrations were hand-coloured by children, women or students. Such volumes were always very beautiful and, consequently, very expensive. As in the case of the arum it was customary, for reasons of economy, to show the same plant flowering and fruiting simultaneously. All gardeners will know that the wild arum flowers in spring, then tidily disappears for the summer, until autumn when stems of knobbly green changing to red berries appear to brighten hedgerows and woods.

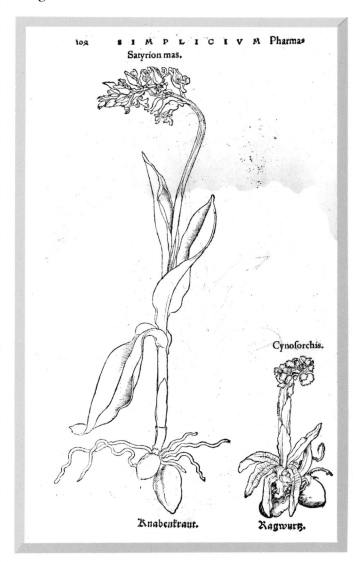

SATYRION MAS KNABENTRAUT
Otto Brunfels – *Herbarium Vivae Eicones*, 1530
(Hans Weiditz)

2. I am indebted to Mr Desmond Meikle at Kew for this.

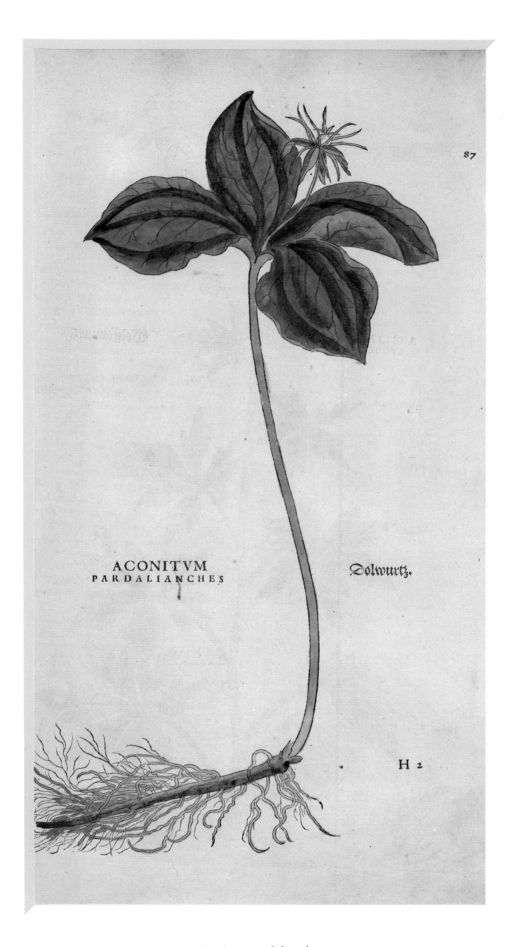

Aconitum pardalianches
(HERB PARIS)
(hand-coloured contemporary engraving)
Leonhart Fuchs – *de Historia Stirpium* (1542)

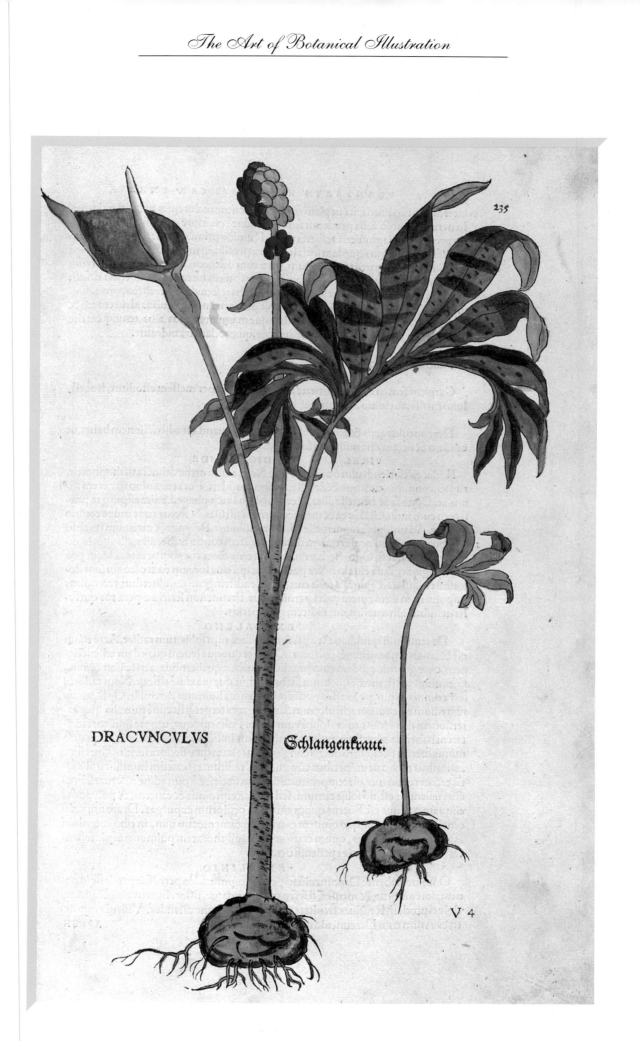

Dracunculus – ARUM, SHOWING FLOWER AND
FRUIT AT THE SAME TIME
(hand-coloured contemporary engraving)
Leonhart Fuchs – *de Historia Stirpium* (1542)

Another herbal, the *Commentarii in sex Libros Pedacii Dioscorides* was produced in 1544 by Pierandrea Mattioli (or Matthiolus) who was first physician to the Archduke Ferdinand and then to his brother the Emperor Maximilian II. The illustrations consist of shaded woodcuts, some of which were borrowed from previous work, such as Brunfels's *Herbarium*. However, the book was well produced and the early editions sold over 30,000 copies — figures that would please any author and publisher today. Later editions, in Latin, Italian, German and Czech, had new and better drawings by Georgio Liberale and Wolfgang Meyerpeck. The illustrations were not drawn to be coloured, but the owners of the volume sometimes painted them. There are inaccuracies in the drawings, some of which were done from dried plants which had been soaked in warm water. On one occasion, one of the artists lost the specimens and drew his figures from memory; since Mattioli kept no master-collection as a reference this desperate expedient was not noticed at the time.

It is difficult to reconcile the reasonable quality of these drawings with the excellence of the work of Giacomo or Jacopo Ligozzi. Ligozzi's work can be compared to that of Georg Ehret or the brothers Bauer some two centuries later. The plate of the mandrake (*Mandragora officinalis*) is an excellent example, with its botanical accuracy, realistic colouration and general vitality. This is all the more curious when one remembers that crude, anthropomorphic representations were still appearing in most herbals. The mandrake was a legendary plant since before the time of Christ, always associated with fecundity and fear. The story of Rachel and Leah in the Bible (see Genesis XXX v. 14–17) typifies the belief in its power to aid conception. It was said that the mandrake screamed horribly as it was drawn from the soil, and the sound of this scream presaged certain death to any who heard it. If only to stay alive the mandrake-diggers used a black dog to haul out the root, stopping up their own ears. Apparently, the mandrake's protesting screams had no effect on the dog.

But to return to Ligozzi; he became court painter to the Grand Duke of Tuscany and was later made Superintendent of the Uffizi Gallery, Florence, where many of his best paintings may still be seen. Ligozzi painted some of the introductions from The New World, such as marvel of Peru (*Mirabilis jalapa*), morning glory (*Ipomoea quamoclit*) and (*Agave americana*). He was particularly good at painting foliage in all stages of growth and even decay; and it is positively restful to gaze at side and back views of leaves as they really are, instead of having the plant or flower presented with everything facing forward.

In Flanders in the latter part of the 16th century three botanists lived and worked in apparent amity. They were Rembert Dodoens (Dodonaeus), Charles de l'Ecluse

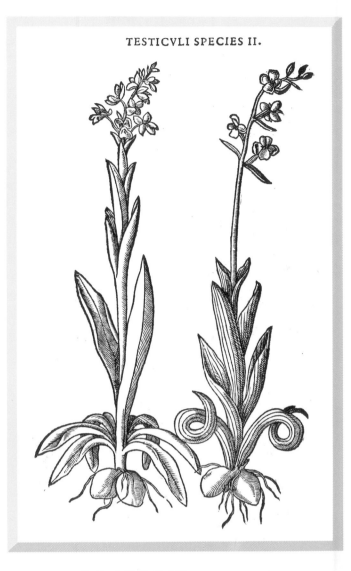

TESTICVLI SPECIES II.

Spetie de Testic II et III – WILD ORCHID,
REGARDED AS AN APHRODISIAC.
Pierandrea Mattioli
Commentarii in sex Libros Pedacii Dioscorides (1544)

(Carolus Clusius) and Matthias de l'Obel (de Lobel; Lobelius). All three men used the facilities of the famous publishing house of Plantin[3] at Antwerp, who employed as their principal artist Pierre van der Borcht. There is strong evidence that his greatest period of activity was between the years 1565 and 1573. Representations of European plants were made, together with many of the new introductions that had medicinal value. There were a great number of drawings and paintings housed in the Deutsche Stäatsbibliothek in Berlin before the Second World War, but it is not known exactly where these treasures are now. This large collection was important because it was used as a common 'pool' for the illustra-

3. The Plantin Press was started in Antwerp in c1549 by Christophe Plantin, a bookbinder who became interested in typography. His establishment became famous for its excellence and by 1575 he was employing 73 workmen. In 1589 he died, but the business was carried on by his son-in-law John Moretus, though its exceptionally high standards of work gradually declined. In 1876 the town of Antwerp was able to buy the building complete with all the old presses and opened it as the Musée Plantin in the following year.

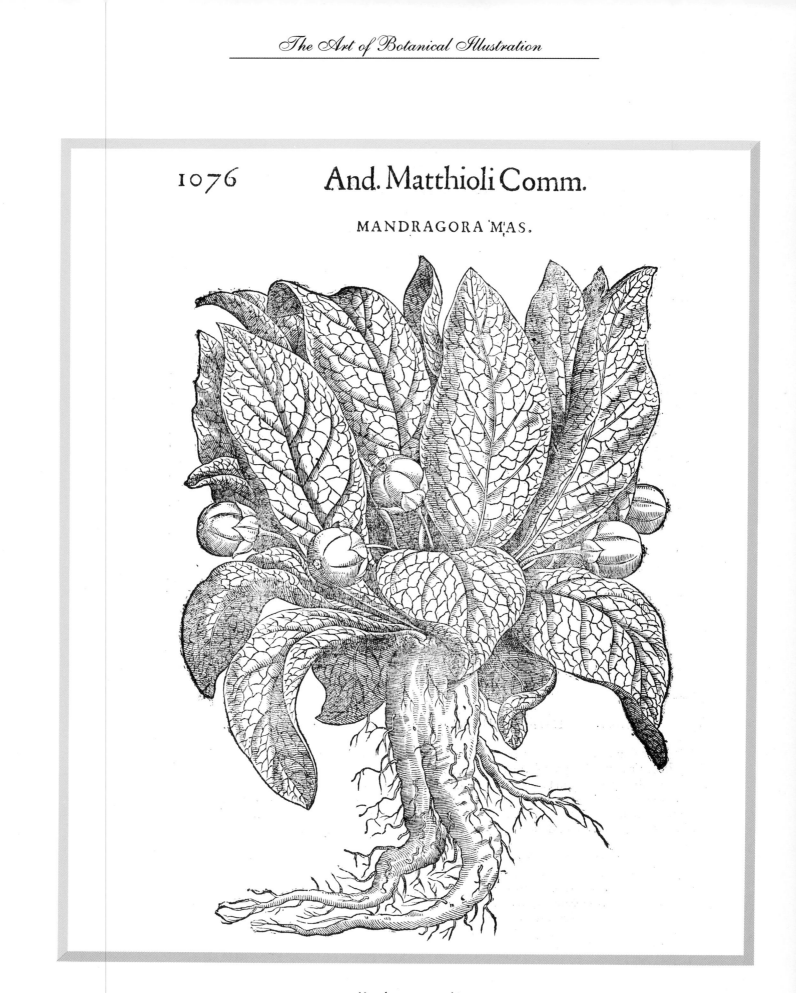

1076 And. Matthioli Comm.

MANDRAGORA MAS.

Mandragora maschio
Pierandrea Mattioli
Commentarii in sex Libros Pedacii Dioscorides
(1544)

MANDRAKE – *Mandragora autumnalis*
Jacopo (Giacomo) Ligozzi, c.1480

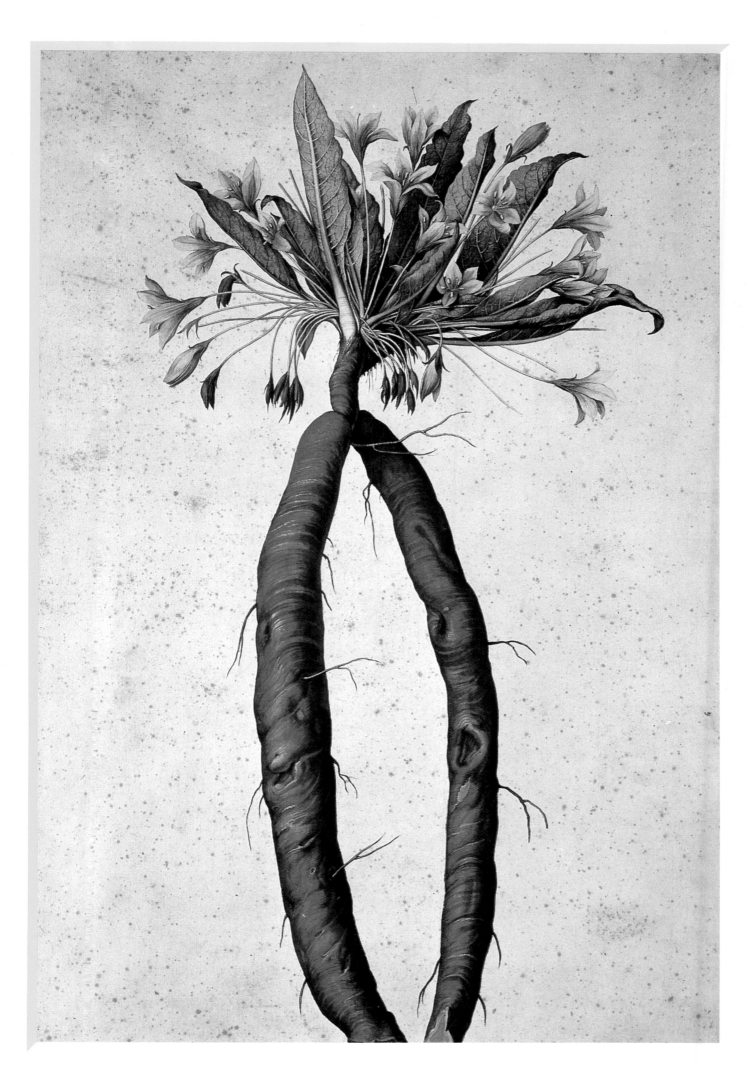

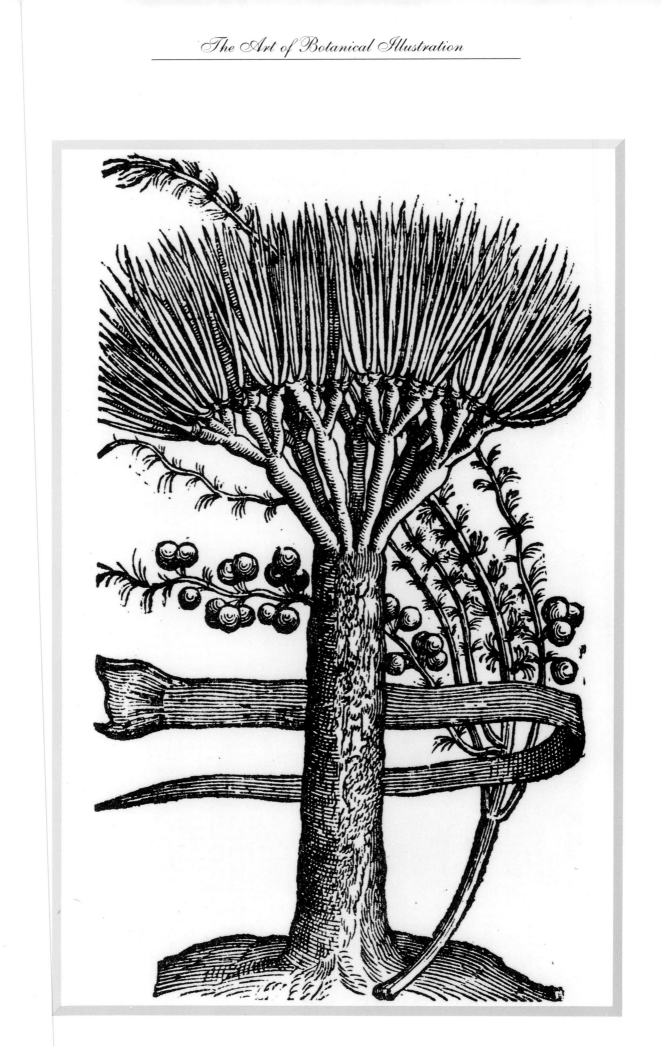

DRAGON TREE
Pierre van der Borcht
Van der Borcht collection

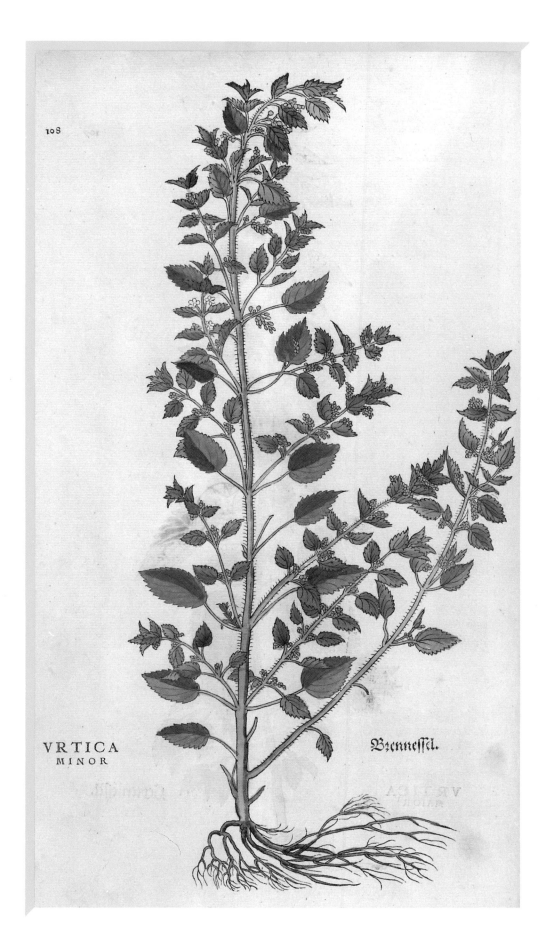

108

VRTICA
MINOR

Brennessel.

Urtica Minor 108
Leonhart Fuchs
de Historia Stirpium (1542)

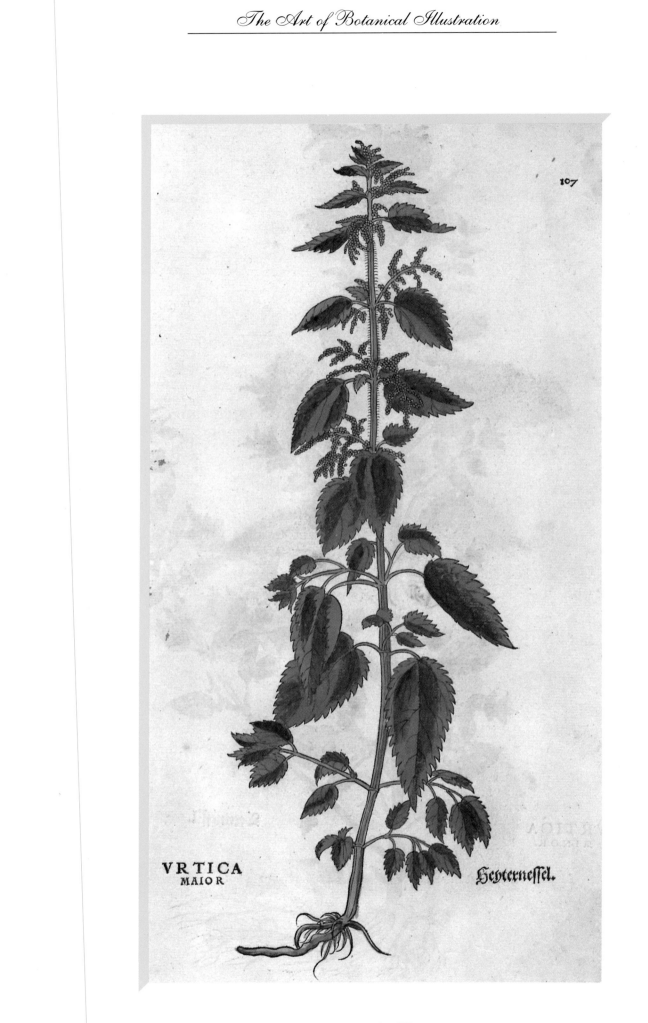

Urtica Major 107
Leonhart Fuchs
de Historia Stirpium (1542)

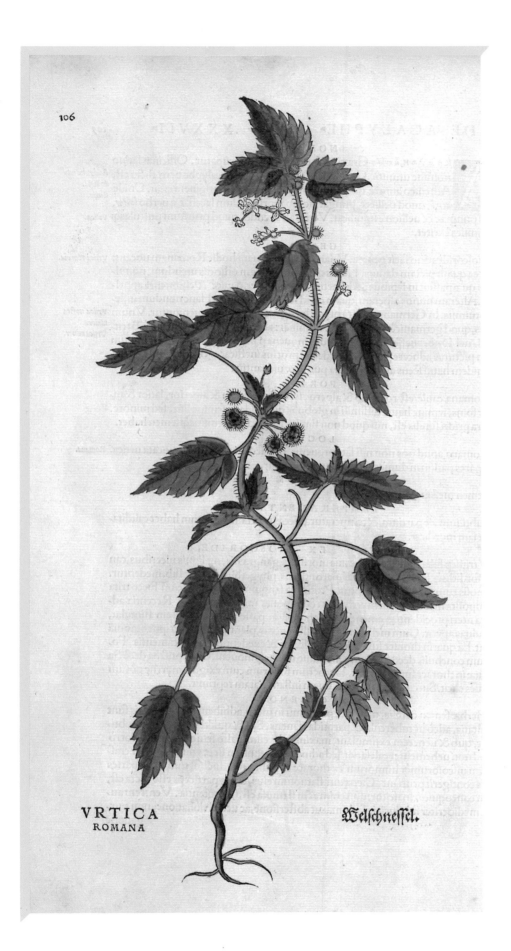

Urtica Romana (106)
Leonhart Fuchs
de Historia Stirpium (1542)

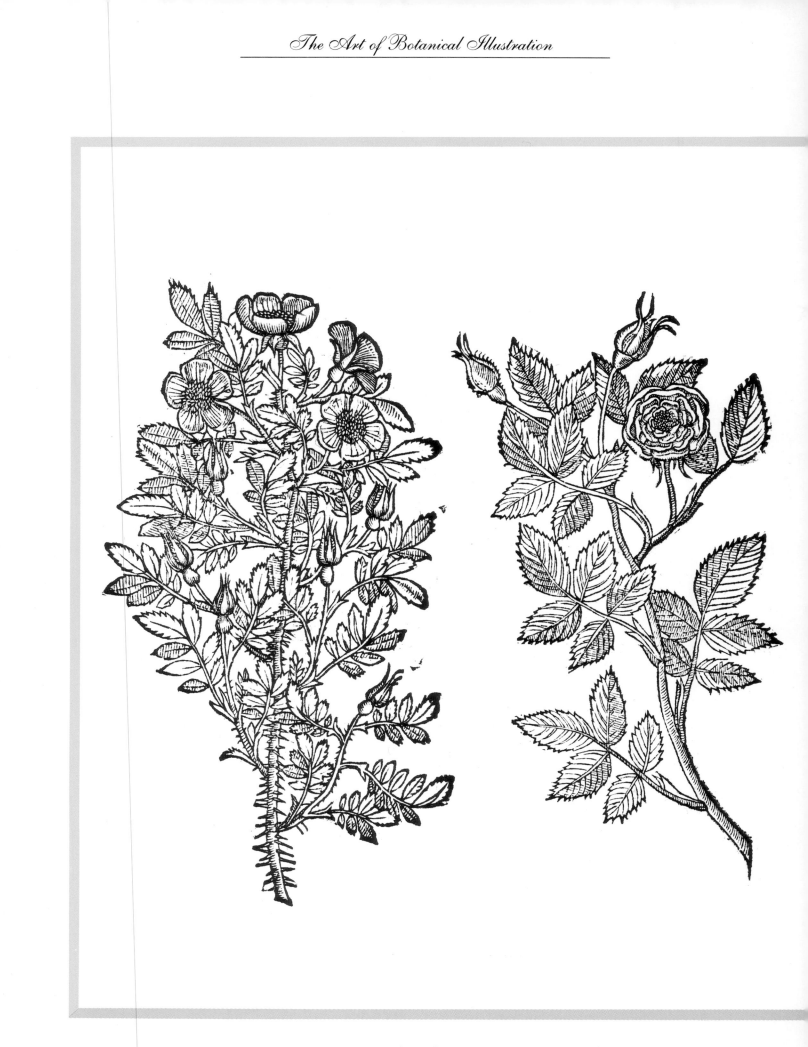

Rosa campestris odorato flore, Rosa campestris
cum fuo fructo
Clusius (Charles de l'Ecluse)
Rariorum Plantarum Historia (1601)

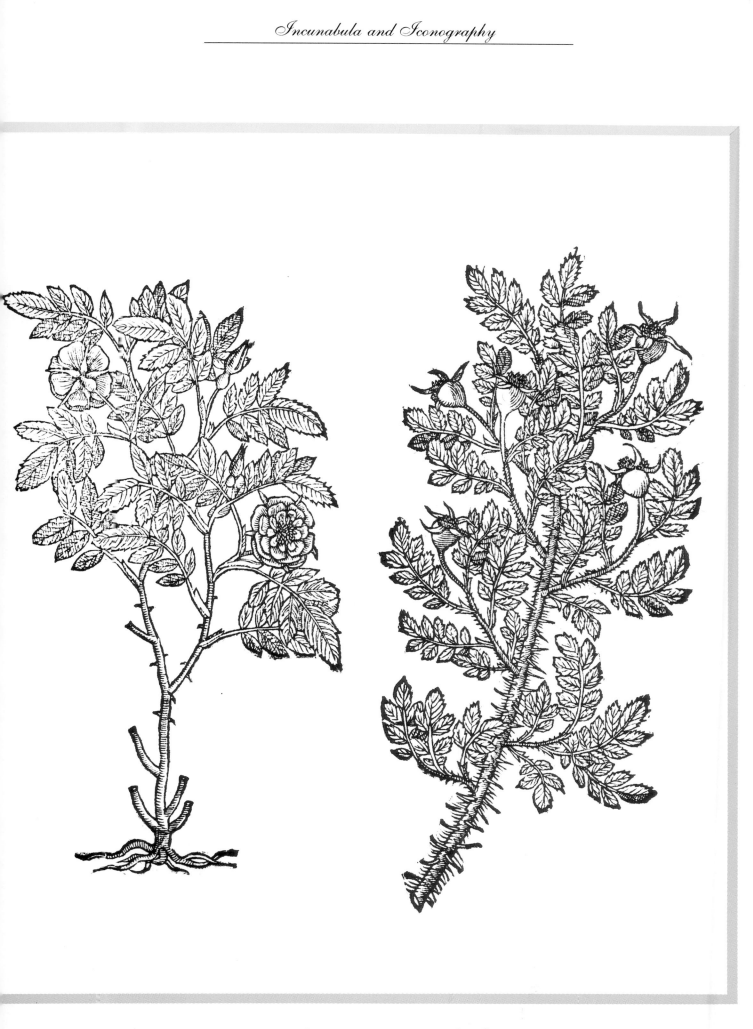

Rosa fine spinis, Rosa Cinamomea pleno flore
Clusius (Charles de l'Ecluse)
Rariorum Plantarum Historia (1601)

1 *Calendula multiflora maxima.*
The greatest double Marigold.

2 *Calendula maior polyanthos.*
The greater double Marigold.

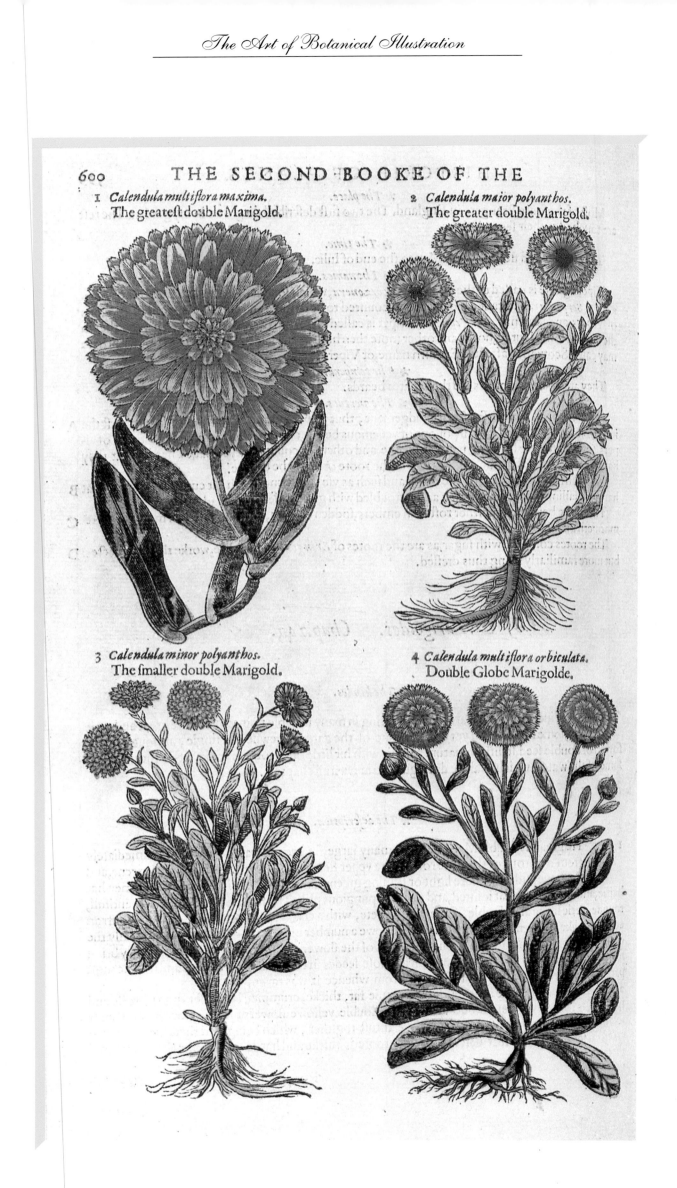

3 *Calendula minor polyanthos.*
The smaller double Marigold.

4 *Calendula multiflora orbiculata.*
Double Globe Marigolde.

tions for many herbals at that time and later, often, alas, becoming debased through indiscriminate copying by less scrupulous publishers.

Rembert Dodoens produced several herbals but is chiefly remembered for his *Stirpium Historae Pemptades Sex*, published in 1583.

Charles de l'Ecluse was a brilliant man, speaking no less than eight languages. He was not a strong man but despite this he travelled to Spain and Portugal, discovering and describing some 200 new species of plants. On his return in 1576 he published *Rariorum aliquot Stirpium per Hispanias observatarum Historia*. In 1583, after a trip to Austria and Hungary, he published *Rariorum aliquot Stirpium per Pannonium, Austriam et Vicinas Historia*, and ultimately, in 1501, he combined both works in the *Rariorum Plantarum Historia*. His descriptions of plants and the accompanying illustrations were of considerable help to botanists at a later date, in spite of the limited methods of classification existing at that time; in addition, he was a keen gardener, cultivating many of the new introductions from the Middle East, and was responsible for the introduction of the potato into the Low Countries. He was friendly with Ogier Ghiselin de Busbecq and was, therefore, among the first to grow the tulip, as well as lilac (*Syringa* spp.) and horse-chestnut (*Aesculus* spp.), also introduced by Busbecq.

Matthias de l'Obel spent some of his working life in England. In 1570–71 he produced (with a friend and fellow student called Pierre Pena) the *Stirpium Adversaria Nova* which was dedicated to Queen Elizabeth I. He was almost immediately given the care of Lord Zouche's own physic garden at Hackney. The Plantin Press produced other works edited by l'Obel. The plants in his 'picture book' *Plantarum seu Stirpium Icones* were arranged according to his own system of classification, based on the physical appearance of a plant's foliage. L'Obel was made physician to William the Silent (Prince of Orange and Count of Nassau); after this King's assassination in 1584 he went to live in Antwerp, but spent his last years in England where in 1607 he was given the appointment of 'Botanicus Regius' to King James I.

In 1551 William Turner published the *New Herball*. This was, as usual, a compendium of existing knowledge, while the illustrations were lifted bodily from Fuchs. In 1578 Henry Lyte produced *A Nievve Herball* which was

MARIGOLDS – *Calendula officinalis*
Gerard, *Herball*, p.600

a translation of Clusius's translation of Dodoens's *Stirpium Historae Pemptades Sex*, with illustrations from the house of Plantin. This sets the scene, so to speak, for John Gerard who produced his famous herbal in 1597. It is the best-known herbal of them all, though not the earliest British herbal. The story behind its production is most interesting.

John Gerard was, most certainly, a keen, observant and enthusiastic gardener and collector of plants and he was very interested in the wild flora of England. After early travel through the Baltic and into Russia – perhaps as a ship's surgeon because he had been apprenticed to the Barber-Surgeons when he was 17 years old – he was made the superintendent of Lord Burghley's gardens in both town and country, while he still maintained his own garden at Holborn. In 1596 he published his invaluable list of his garden's contents, the *Catalogus*, which enables us to learn what plants he had at the time. Many were gifts or exchanges from fellow gardeners overseas and so they would not have been generally available. Some were positively tropical in their origin, and perished quickly, despite his every care. However, this comparatively peaceful existence was not to last.

A publisher called John Norton had noted the success of Lyte's *Nievve Herball*, and had commissioned a Dr Priest to make a translation of Dodoens's *Pemptades*. Before this work could be finished however, Dr Priest died, leaving Norton with an unfinished project. Norton presumably asked Gerard to complete the task, but it will never be known whether Gerard took over extended notes or an almost-completed manuscript, without more than a casual acknowledgement to Dr Priest. It is one thing to be a good gardener, a collector of plants and an easy, competent, not to say colourful and humorous, writer, but quite another to produce a definitive reference book, such as Dr Priest's herbal was intended to be. Gerard's Latin was not good enough, in fact, it was poor, as Gerard himself admits, and when Norton produced some 1,800 wood-blocks from which the illustrations were to be made, Gerard was unable to match them all up with the existing text. Somewhat piteously he says, 'Faults I confess I have escaped, some by the printers oversight, some through defects in my self to performe so great a work, and some by meanes of the greatnesse of the labour'.

The book was published as it was, with all its faults.

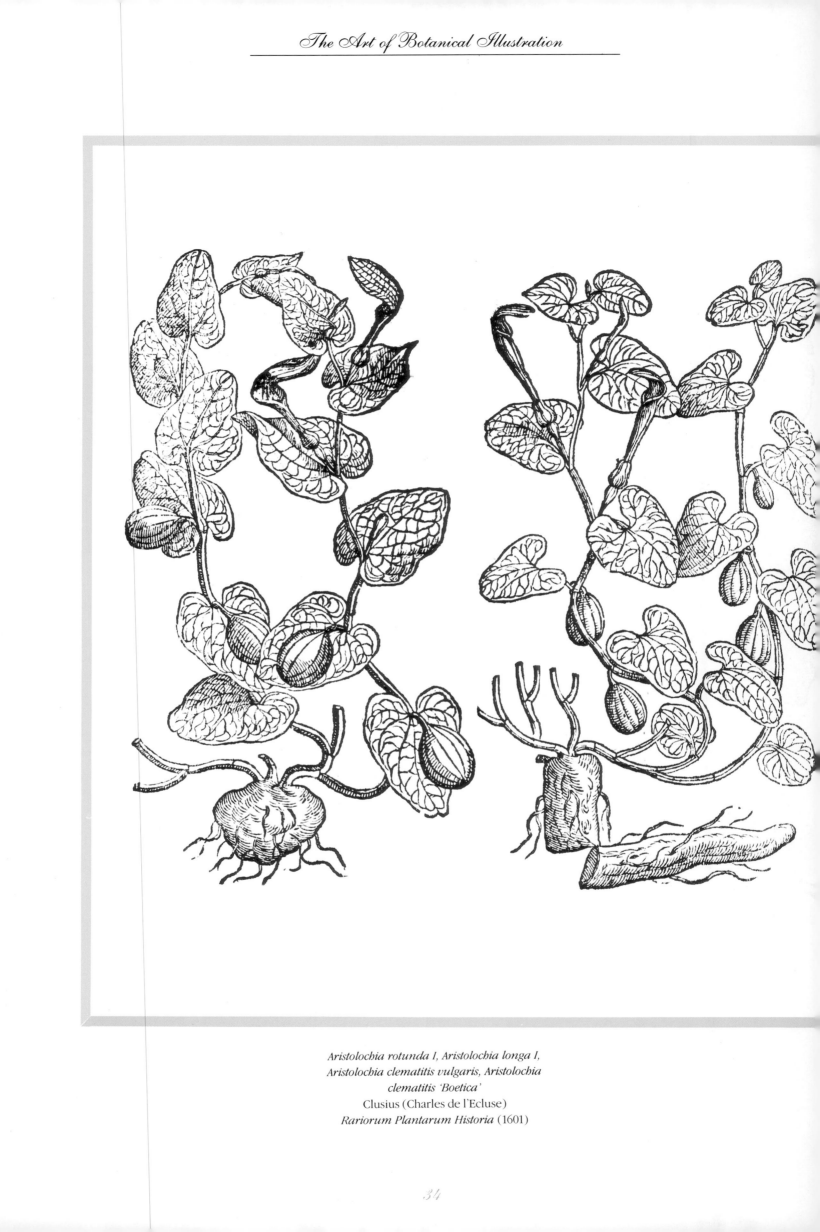

Aristolochia rotunda I, Aristolochia longa I,
Aristolochia clematitis vulgaris, Aristolochia
clematitis 'Boetica'
Clusius (Charles de l'Ecluse)
Rariorum Plantarum Historia (1601)

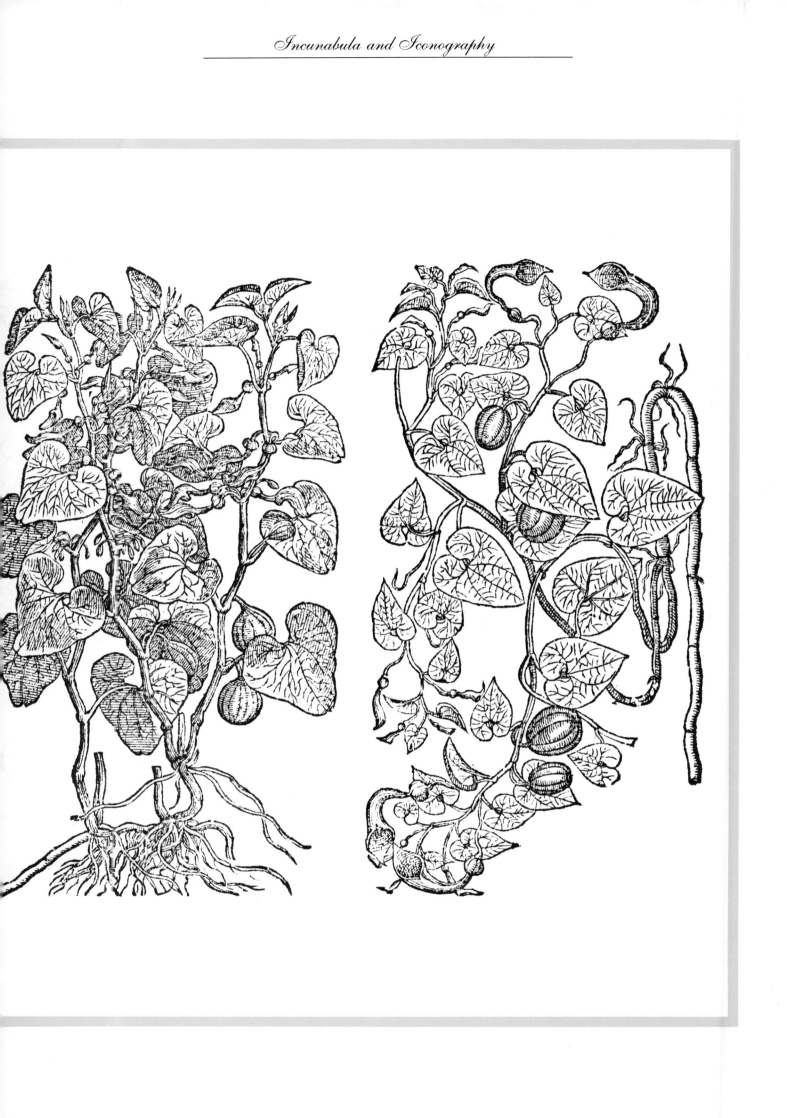

After Gerard's death Norton's firm (Norton himself having died) decided to amend and enlarge the Herbal. They asked Thomas Johnson, an apothecary, to re-write, amend, add to and generally improve upon the original, and, as with all publishers, they were in just as much of a hurry. The updated version was almost twice as large; the illustrations were taken from that useful and overworked Plantin pool of reference. The revised Herbal, called 'Johnson's Gerard' to distinguish it from the previous edition, was an infinitely superior work.

During the compilation and publication of these and many other herbals, the real botanists among the authors were, of course, impossibly hampered by the problem of nomenclature. This problem was becoming more and more acute as the world's horizons began to recede before the many expeditions of the 16th-, 17th- and 18th-century explorers. Clumsy Latin descriptions were the best that could be managed. The work of the artists was of the utmost importance in portraying the new plant introductions.

During the preparation time of 'Johnson's Gerard', John Parkinson was working on his mighty tome *Paradisi in Sole Paradisus Terrestris* which took 10 years to produce. The title is a pun on his name – 'Park-in-sun's Park on Earth'. Not very much is known of his early life other than the fact that he was an apothecary, later appointed Apothecary to James I and afterwards 'Botanicus Regius Primarius' to Charles I. His *Paradisus* was among the first of the florilegiums, or flower-books. He described it as 'a Feminine worke of Flowers' and dedicated it to Queen Henrietta Maria. His later book the *Theatrum Botanicum: the Theater of Plantes, or An Universall and Compleate Herball* was, as he described it, a 'Manlike Worke of Herbes and Plants', and it was appropriately dedicated to Charles I.

Parkinson always included a wide range of plants in his books, from such newly introduced subjects as the banana and the yucca to indigenous wild flowers like the Welsh poppy (*Mecanopsis cambrica*), the scarce, though he does give its location, lady's slipper orchid (*Cypripedium calceolus*) and the strawberry tree (*Arbutus unedo*) which had only recently been discovered in Ireland where today it still grows wild. The illustrations were copies of the Plantin wood-blocks – all except those pictures which depicted the newest plants. This was the last of the vast, heavy herbals and because flowers had been included for their beauty's sake alone, these great works were no longer to be regarded as herbals.

Auriculas
Alexander Marshall

TRAVELLERS AND EXPLORERS

Much has been said about the herbalists and the artists themselves, but some mention should be made of the explorers of the times. Trade was the prime incentive to travel initially. It was for this reason that Christopher Columbus set out with his tiny vessels to seek a new route to the riches of the East, discovering America (or the West Indian portion of that continent) in 1492. New plants and seeds would have been part of the rich cargoes that subsequent voyagers carried. Because Turkish rule dominated the Eastern end of the Mediterranean, the Levant, it became necessary to find a new and different route to the East. This was discovered by Vasco da Gama in 1499. Again, this must have been like opening the door to an Aladdin's cave of botanical treasure.

The Tradescants, father and son, were great travellers and gardeners. Early in the 17th century, John Tradescant the elder became gardener to the Earl of Salisbury at Hatfield House. It must have been an interesting and exciting position, for he was sent to France and Holland to visit plant nurseries and famous gardeners of the time. Tradescant created an astonishing garden full of the new and exotic plants, shrubs and fruit trees and many of the plants were painted by Alexander Marshall. Eventually, Tradescant left Hatfield and became gardener to Sir Dudley Digges, who took him to Russia on an embassage. Naturally, the journey was used for the collection of new plants. Any excuse for travel and danger seemed to suit Tradescant who even volunteered for an expedition which involved combating Algerian pirates. He naturally brought back more plants, this time from North Africa. The Tradescants were veritable magpies, collecting all kinds of curiosities in the course of their travels. Their collection eventually formed the nucleus of the Ashmolean Museum's collection at Oxford.

John Tradescant's next employer was Charles I, who gave him a free hand in setting up the gardens of Oatlands in Surrey, destroyed subsequently by Oliver Cromwell. While he was serving these masters he extended his own garden at Lambeth, with a specific emphasis on American plants. By 1634 he had 100 different species. Tradescant's son, John, made several voyages to America where he visited Virginia and acquired some land. While in America his father died, but John Tradescant the younger continued his endeavours and in 1656 he published his *Museum Tradescanteanum* which was a list of the museum contents and an extended and updated list of the plants then growing in the Lambeth garden. This is both a fascinating and very useful volume.

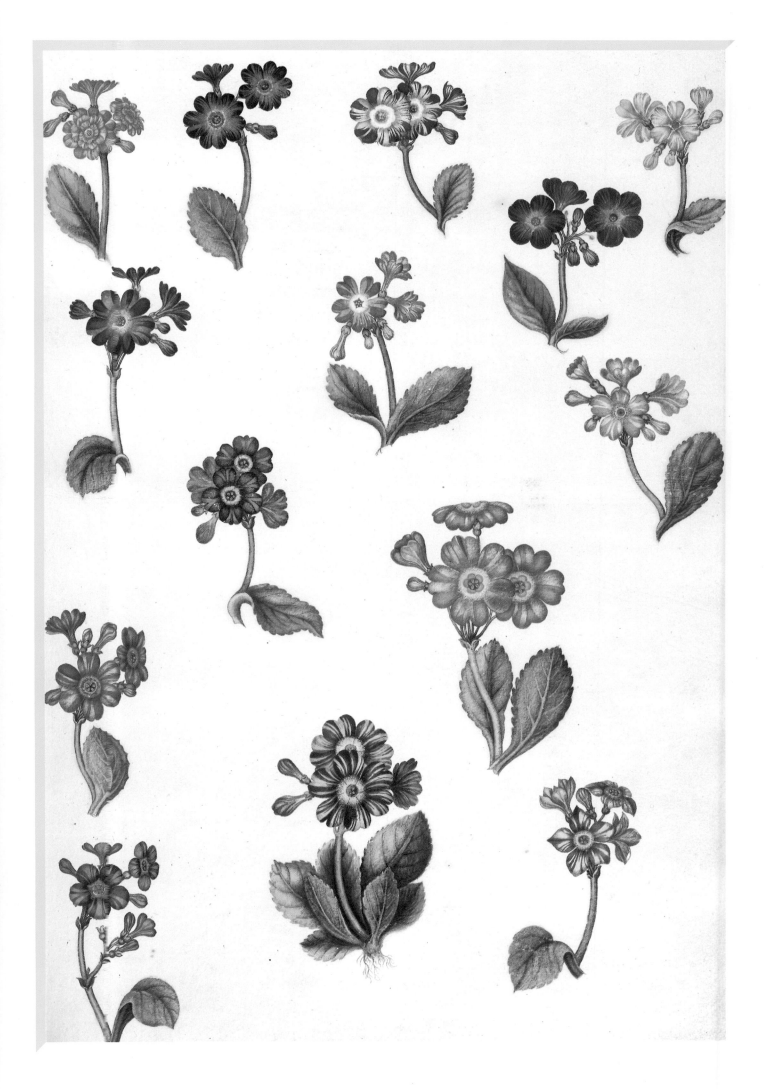

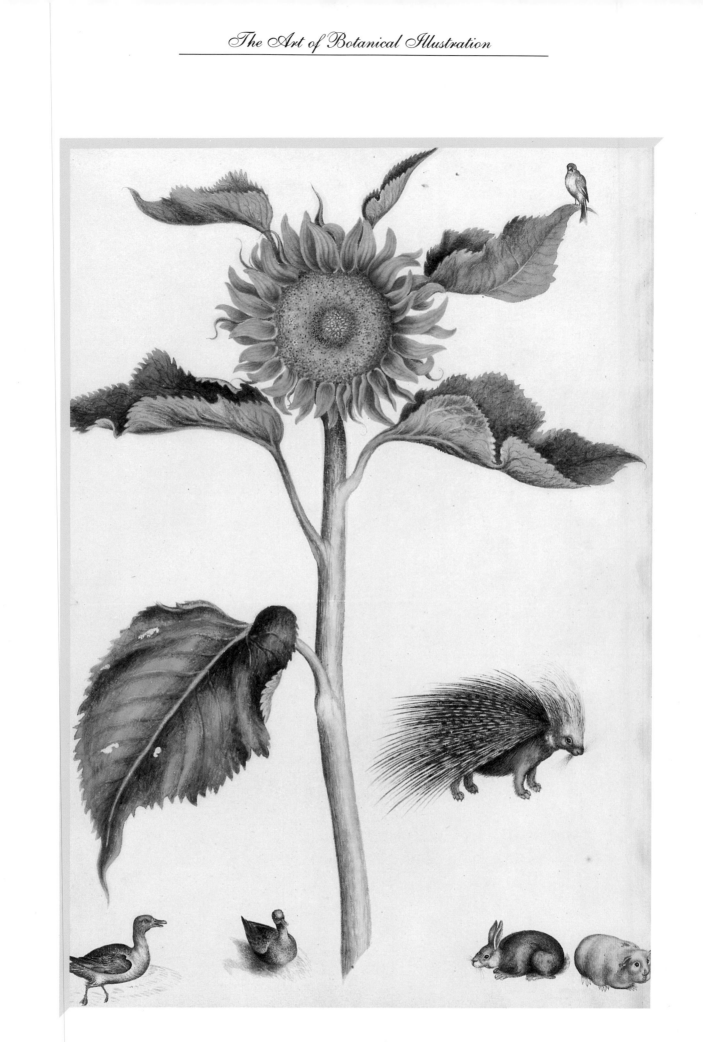

SUNFLOWER – *Helianthus annuus*
Alexander Marshall

THE ROYAL SOCIETY

In 1660 a group of scholars met at Gresham College, near the Guildhall of the City of London. They resolved to form a group to promote the new 'Physico-Mathematicall Learning' and their purpose was set down in a Founding Memorandum. King Charles II was informed of the group's intentions and expressed his interest; in 1662 the group of scholars was given a Royal Charter and the Society was officially formed, calling itself 'The Royal Society of London for Improving Natural Knowledge', more generally known as the Royal Society. It has exerted great influence on the development of science and learning and, in many ways, is now regarded as Britain's national academy of sciences.

The founder members numbered such distinguished intellectual leaders as Christopher Wren, Robert Boyle, William Harvey, William Gilbert and Francis Bacon, to name but a few. The Society's motto *Nullius in verba* loosely translated as 'The word of no man' expresses the determination of early Fellows to verify all statements by an appeal to facts. The Society held weekly meetings to discuss experimental science; they wished to disseminate the results of their own experiments and scientific knowledge generally. Henry Oldenburg, one of the first secretaries, initiated the *Philosophical Transactions* which featured the Society's correspondence with foreign scientists. This correspondence has continued to the present day, that is, over 327 years, and the letters form a fascinating part of the Society's archives.

In 1671 a young man called Isaac Newton was admitted to the Society; in 1703 he became its President, remaining in that office until 1727. This was a period when the Society was becoming established as the world's leading scientific organization, ushering in the new scientific age. The Society assisted in the planning, preparation and funding of Captain Cook's epic voyage of circumnavigation. Aboard the famous vessel *Endeavour* there was a small team of scientists, cartographers, artists and the botanist Joseph Banks who later became one of the Society's most active and influential Presidents, from 1778 to 1820.

In its early days, people with but an amateur interest in science were elected to the Fellowship of the Royal Society. This changed, however. From 1847 the Statutes were altered to ensure that the Society's members were men of significant scientific attainment. The annual election of Fellows was limited to 15 persons distinguished for their personal contribution to science. These changes were intended to refine the membership to those who were truly representative of science in their own fields. This policy has continued ever since, and election to the Society is regarded as a considerable honour.

The Royal Society is not a government institution but an independent body, free to give objective opinions and advice on scientific affairs. The members, elected after a searching evaluation of their own work in science or technology, pay an annual subscription, make the Society's rules, elect their own Officers and Council and contribute their own time and expertise voluntarily for the benefit of the Society. For many, this means a substantial amount of time and effort devoted to the cause of science for which they receive no financial reward. The pool of expert scientific advice on call to the Society is unequalled in any other national corporation.

The number of annually-elected and Commonwealth British Fellows has been increased to 40, with the addition of six foreign members. The Society's Patron is Her Majesty Queen Elizabeth II, with some other members of the Royal Family as elected Fellows. The Society adjusts to changing circumstances on the advice of its Council and a wide range of committees.

Each year the Society awards medals and prize lectureships for outstanding achievements in science and technology. In addition, the Society supports from its private and public funds over 160 research appointments in all disciplines and at all levels. Among its many publications the Society still publishes the *Philosophical Transactions* and the *Proceedings* which are issued in two series: A (mathematical and physical sciences) and B (biological sciences).[4]

4. I am indebted to the Royal Society for their assistance in the preparation of this extract.

The Dutch and Flemish Schools

—————1550–1850—————

HOLLAND AND FLANDERS[5] were centres of botanical learning, trade and exchange during the late 16th and early 17th centuries, because the Dutch were vigorously developing trade with Turkey and the Far East; this led to the formation of the Dutch East India Company in 1602. Antwerp became the most important North European city after the harbour at Bruges silted up, enjoying easy access – via the river Scheldt – to the Baltic and the North Sea. The economic situation was good because a bourse, which was an exchange where merchants could meet (one of seven), had been set up to handle the growing volume of business which in 1560 was centred on Antwerp. As a result, money was available to encourage the artistic emergence of the characteristic Dutch flower-piece. The soil of the area was rich and fertile, and though the summers were warmer then, the North European climate was not much better than it is now; gardening would not have been difficult and must, indeed, have been exciting. This is why the Dutch and Flemish flower-painters flourished at that time – the subjects that formed their great masterpieces were, almost literally, on their doorsteps, as was the money to pay for them. The paintings were bought almost as a matter of course by rich and poor alike.

Purists may say that the flower-painters should have no place in a book about botanical art, especially as some of the flower-pieces were seasonally incompatible – tulips and hyacinths flourishing among autumn-ripe ears of corn and brambles. However, the artists were quick to depict the new plant discoveries and their work was usually signed and dated, so for these reasons the arrangements are very interesting. Their methods were eminently practical: they painted a tulip or a rose or a peony or a ranunculus as a reference work, and copied and re-copied the paintings. They changed the colour and aspect of the flowers, and we see them again and again, upside down, back to front, or in a different shade or tone.

Sadly, it is the single paintings of the tulips, the roses, the peonies and the ranunculuses that we would like to see now, but they would have been regarded as working sketches and thrown away in due course. This technique is clear in the work of Jan Brueghel the Elder (1568–1625) in particular.

Another reason for regarding these ebullient examples of flower-painting as decorative art and not true botanical painting is that they were almost always executed in oils. The trained botanical artist used watercolours as his preferred medium on paper (or body and watercolour on vellum for special commissions).[6] There are three reasons for this – speed, support and storage. Watercolours can be executed very swiftly and colour sketches can be made in a few minutes on location, as it were, according to the skill of the painter. In contrast, oil-paintings need time in which to dry before they can be safely moved, though temporary 'spacers' can be placed at the corners to prevent wet canvases from touching and smudging.

The 'support' is the surface on which the painting, more generally called the drawing, is made. Paper or vellum is thin and can be easily bound into a book or stored in quantity in portfolios, boxes or drawers. Canvas, the best and most traditional support for oil-paintings, has to be stretched over a frame, which, though comparatively light, is bulky and cumbersome in quantity.

Skilled artists can work in both mediums. With watercolours one works from light colours to dark, with no margin for any error, whereas in oil painting one works from dark colours to light and errors can be easily painted over. The botanical paintings of the great masters are almost always painted in watercolour on an unpainted, unshaded white background. This may seem unnatural but this method utilizes the white paper as 'light' and is often left unpainted where highlights occur on petals and shiny foliage. Watercolour also gives the illusion of transparency, luminosity and delicacy, characteristic of many flowers. Painters in oil produce wonderfully handsome works but they very seldom use this medium for

5. *The county, state or district of Flanders was the largest part of the southern Netherlands. Holland gradually became the largest province or state of the northern Netherlands and eventually gave its name to the whole country.*

6. *Marianne North's work is a possible exception (See chapter 8).*

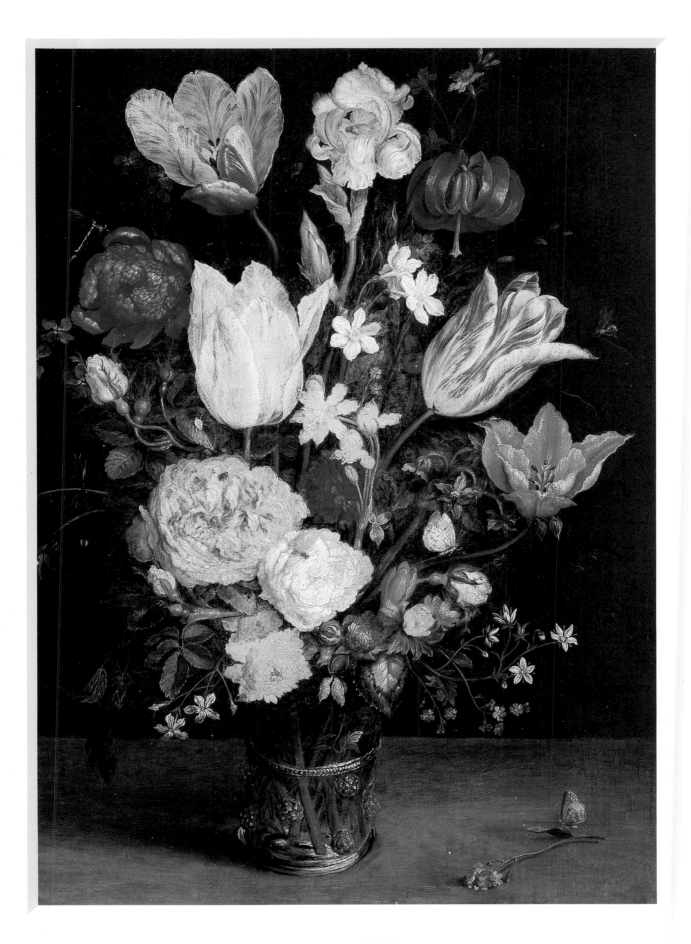

A VASE OF FLOWERS
(oil on panel – painted about 1615–20)
Jan Brueghel the elder

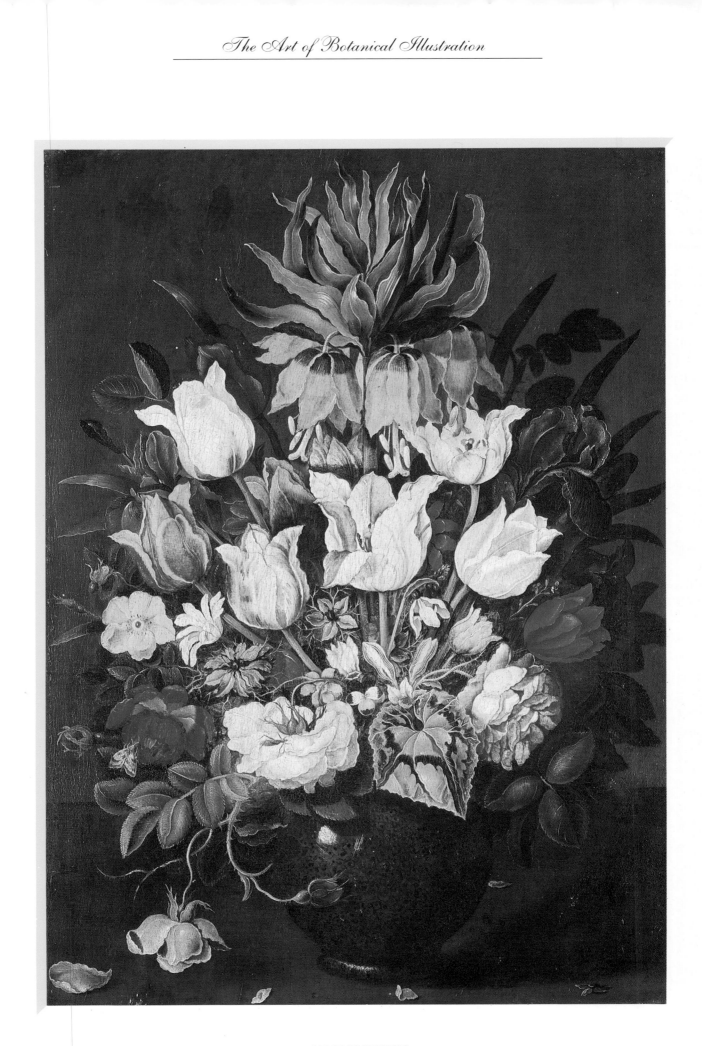

A VASE OF FLOWERS
(oil on panel)
Osias Beert the elder
'On a table in a tiger-ware vase, an arrangement
of tulips, iris, crown imperial lily, roses, love-in-
the-mist, crocus, pansy, jonquil, grape-hyacinth,
snowdrop, forget-me-not and cyclamen.'

botanical illustration, even though a more natural green-to-dark background is so easily achieved. Sections of plants, enlargements of parts and habit sketches[7] would look laboured if executed in oils or on a dark or coloured ground; however, watercolour drawings are neat and informative, with nothing to distract the eye.

'Body-colour' is the term used for watercolours that are mixed with white, giving them greater opacity. Gouache is the term used for pigments that are bound with glue; white is added to the lighter colours and so artists can paint out mistakes and cover background or darker detail very quickly instead of painting carefully up to an outline without any change in tone. The word 'gouache' was not used much before 1882 when these pigments consisted of ground colours mixed with gum and honey. However, the Ancient Egyptians used a form of gouache, as did medieval artists, especially in ecclesiastical work.

In 16th- and 17th-century Netherlands the phenomenon of Tulipomania occurred. Tulips can be seen in almost all the flower pieces of that era. Many of these are what, today we would call 'Rembrandt' tulips, with variegated petals of two or more colours. The variegation, usually called a colour-break, took several forms: 'flamed' tulips were a light shade with a flame-like patterning of a darker or very dark colour running from the base of each petal to the tip; 'feathered' tulips had feather-shaped markings of a dark colour on a light ground; 'bizarres' were a bolder and more definite form of the flame-design. These colour-breaks were caused by a virus transmitted by the aphis, though this was not known at the time. Plain or self-coloured tulips were known as 'breeders', and their progeny would break into the most amazingly coloured or marked flowers. If offsets (small bulbs) grew from these parent bulbs, most of them would be like the parent. They had the advantage of coming into flower more quickly than tulip seedlings which take about seven years.

The freakishly beautiful blooms excited the passionate interest of the Dutch, and bulbs began to change hands at ridiculous prices. Gambling was rife and fortunes were quickly made and lost even more quickly. One of the most famous tulips was *Semper Augustus*, a red and white flower with blue-based petals, and in 1623 a bulb was sold for thousands of florins. Everybody speculated on the bulbs, and these changed hands at inflating prices even while they were still in the ground. It was not always the beauty of the flower which occasioned the highest prices but was, as the name for it indicates, *Tulpenwoede* (tulip-madness). The government brought in legislation to limit the price of any one bulb to 6,000

Dutch florins; this was in about 1637 at the peak of the frenzy. So if a bulb of *Semper Augustus* was sold for 5,500 Dutch florins it would be worth approximately 50 times as much today. Then the bubble burst and the Dutch regained their sanity.

FLOWER-PIECES AND FLORILEGIUMS

There were many great flower-painters during this period. Osias Beert the Elder (1580–1624) though not the earliest exponent of this art form is one of the best of his time. He included some of the 'new' flowers in his paintings – tulips, crown imperial, grape-hyacinth and cyclamen, which must have been refreshing when one considers those overworked Plantin woodcuts that had for centuries formed the basis of herbal illustration. Beert's fritillary is paler than those we grow today, although the colour in the painting may have faded with the passage of time. Certainly, these paintings had a different purpose. The herbal was produced as an instruction manual, whereas the flower-piece was purely a commercially ornamental piece of decoration. Both have their place in the history of art.

Willem van Aelst (1627–83) was another flower-painter. Like almost all such artists he had pupils. One of them was the great Rachel Ruysch (1664–1750). It was most unusual for a woman to earn a living from her own work during this period, and to earn it from painting was even more unusual.

Rachel Ruysch became one of the most well-known and important of the Dutch flower-painters, working in The Hague from 1701 to 1708; from 1708 to 1716 she worked in Düsseldorf as the court painter to the Elector Palatine. She specialized in rich bouquets and still lifes. Her thistle painting is probably not characteristic of her work: I feel that she painted the thistle because she found it an interesting plant, and it forms a pleasantly severe contrast to the ebullient arrangements of the earlier Dutch and Flemish artists. She may well have painted it for herself, as so many busy artists promise themselves they will. Such paintings are always better than commissioned work because they have more of the artist's soul in them. The thistle must have been grown as an ornamental plant rather than as a 'weed', the word that described it in later centuries, until that great gardener, Vita Sackville-West, rescued it from the roadside to grow in her wonderful garden at Sissinghurst. Flower-arrangers were quick to see the architectural qualities of this plant, which, though as spiny and spiteful as most of its kindred, is certainly worth growing in groups wherever space permits.

Balthasar van der Ast (1593/4–1657) was contemporary with Osias Beert and would surely have seen the work of Jan Brueghel the Elder. Van der Ast specialized in still lifes, preferring fruit and flowers as his subjects. He is thought to have been born in Middelburg, and was

7. This is a diagrammatic drawing of a plant as it grows in its natural habitat. For example, a palm tree drawn with a pyramid and a camel, which would also indicate scale.

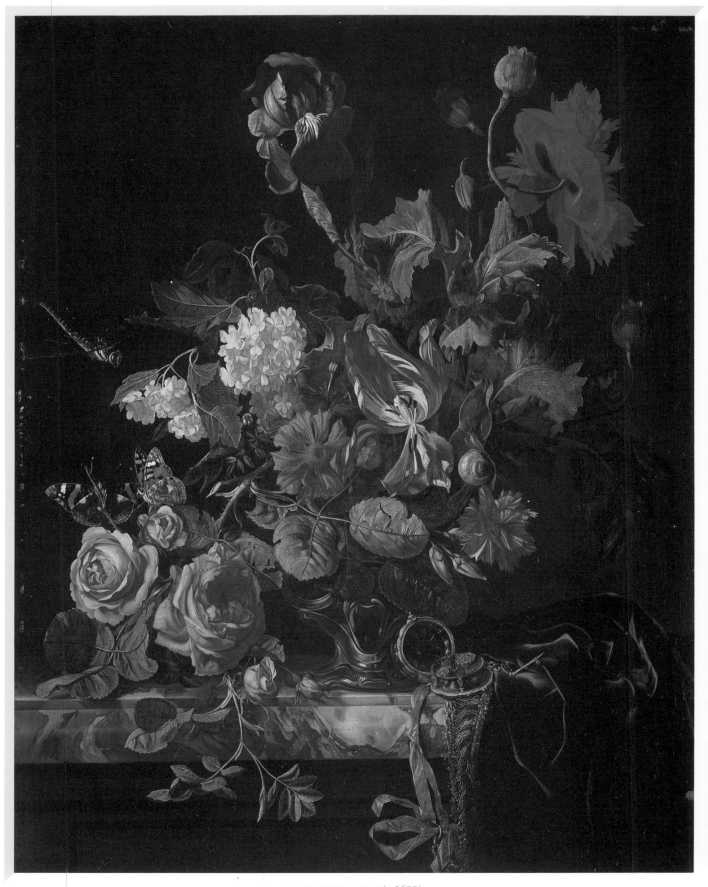

A VASE OF FLOWERS (c.1688)
(oil on canvas) Willem van Aelst

'In a silver vase, standing on a marble sill draped with gold-fringed black velvet, an arrangement of roses, tulips, poppies, iris, carnations, marigolds and guelder-roses, with butterflies and other insects; in the foreground a crystal and gilt-cased watch with a blue key-ribbon.' This is another characteristic example of Van Aelst's work, closely resembling the picture dated 1663 at the Hague. The silver vase and the topmost poppy appear again in a picture dated 1671.

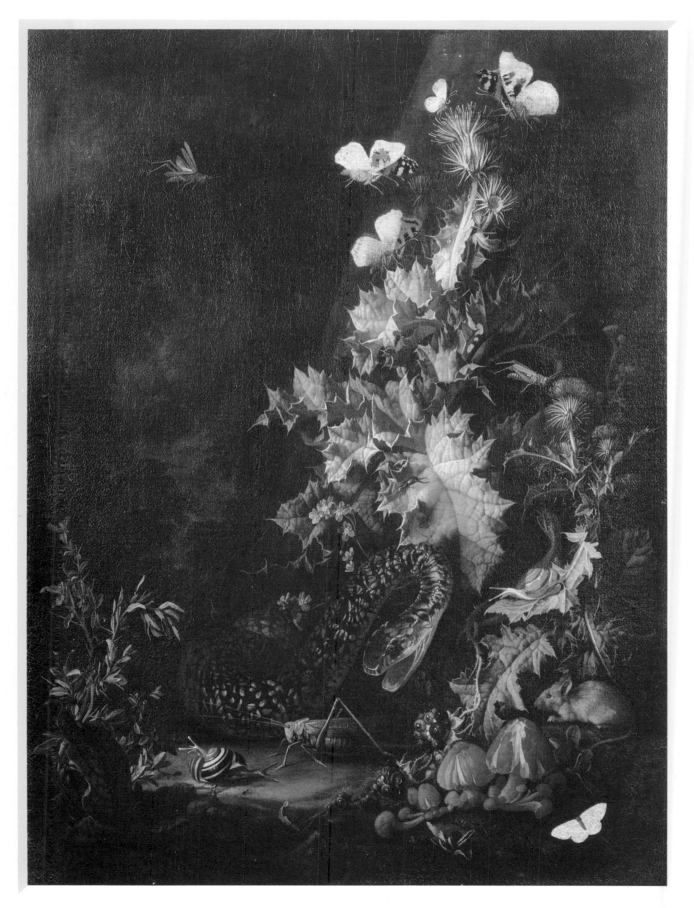

STILL-LIFE WITH A SNAKE
(oil on canvas – probably an early work of
about 1685–90)
Rachel Ruysch
'Against a dark landscape background featuring
thistles, with butterflies, moths and insects, a
grass-snake about to strike at a grasshopper, a
clump of toadstools, a field-mouse and a snail.'

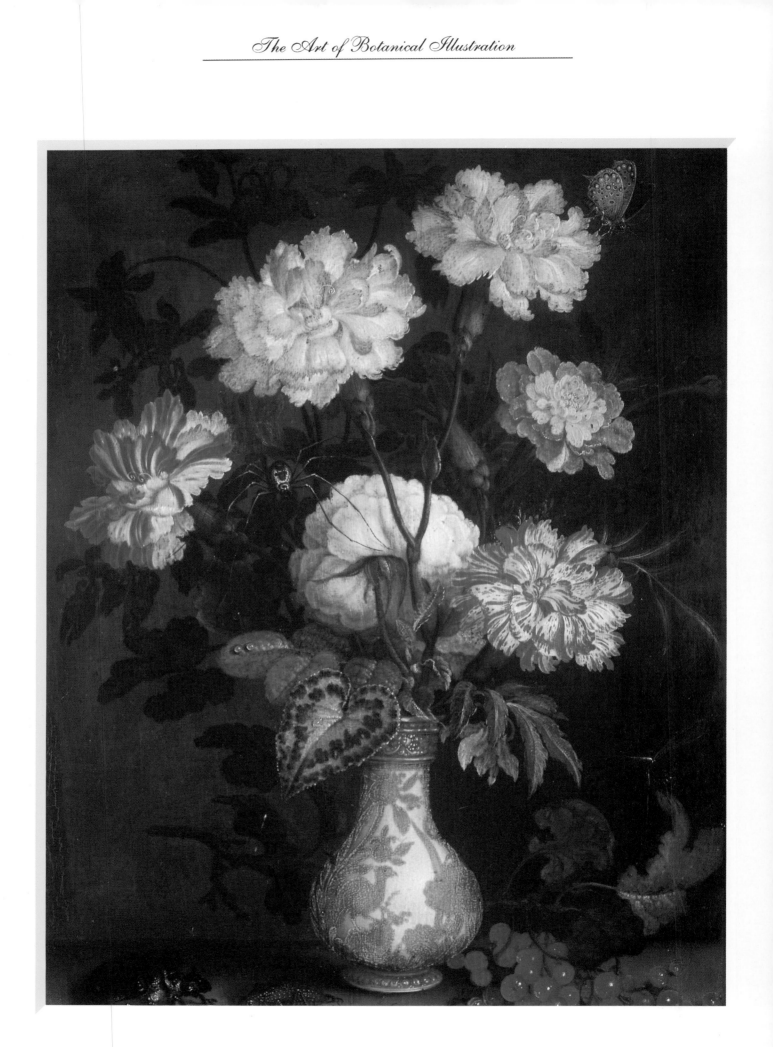

A VASE OF FLOWERS
(oil on panel)
Balthasar van der Ast

most active at Utrecht and Delft. Like many of the Dutch flower-painters, he was influenced by the work of Ambrosius Bosschaert (1573–1621), his brother-in-law, who lived in Middelburg from 1593 to 1613, and thereafter in Utrecht. Bosschaert liked to paint on copper which gave his work an extra quality of delicacy and perfection. Examples of Bosschaert's work can be seen in Amsterdam, Copenhagen, the Hague and the Ashmolean Museum, Oxford.

Such magnificent pictures were painted to be hung on walls but collections of flower-paintings in books, known as florilegiums, were being published for the first time in this period. These collections would often be quite random depending on the whim of the patron commissioning the work. One of the first and most famous, though not necessarily the best, of the florilegiums was published in Germany in 1612 by the Dutchman Emmanuel Sweert. It has no text other than a catalogue of the 'illustrated plants' in Latin, German, French and English. Few botanical books of the time contained wholly original work – Alexander Marshall in England being an exception – and Sweert's florilegium was a fine

example of such artistic piracy. It contained plates copied from another just-published florilegium which, in its turn, had all too-similar illustrations to those in Pierre Vallet's *Le Jardin du très Chrestien Henry IV, Roi de France et de Navarre, dédié à la Reyne*, published in 1608. Vallet's book was primarily intended as a pattern-book for embroidery. There is, however, no stiffness and artificiality in the illustrations, rather, the flowers are painted with such botanical accuracy that an embroideress would have had to have been skilled indeed to transfer the blossoms into the formalities of design.

Another beautiful florilegium was the *Hortus Floridus* by Crispin de Passe (*c*1574–1637) published in 1614 in four languages. This is a charming book full of spring flowers such as tulips, narcissi, hyacinths, fritillaries, primulas and irises. Interestingly, it also shows contemporary Dutch garden design. Florilegiums were to become very popular in Europe among those who were able to afford to commission them. Later chapters include some beautiful examples of which Redouté's *Les Roses* and *Les Liliacées* are among the best examples of this specialized work.

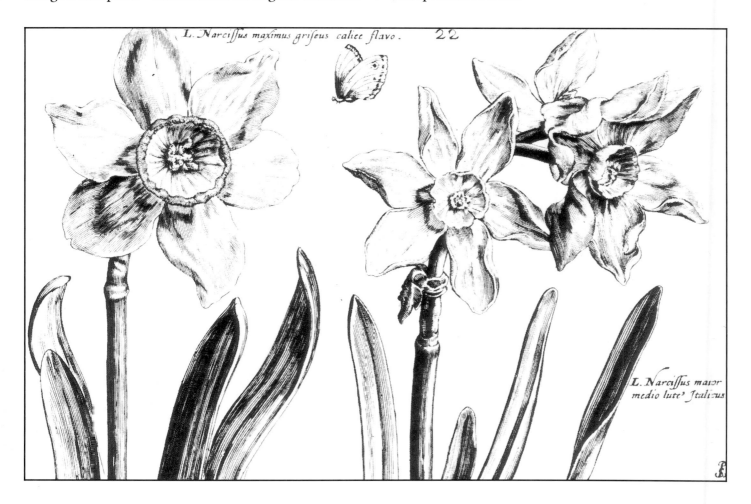

NARCISSI (hybrids)
(engraving)
Crispin de Passe
Hortus Floridus 1614

The tradition of flower-painting was firmly established in Holland, where Maria Sibylla Merian (1647–1717) finally settled and led a most unusual life. Her father, a Swiss man called Matthaus Merian, married the daughter of the painter Johann Theodor de Bry, thereby inheriting a printing and engraving business in Frankfurt, where Maria was born.

Her father died when she was very young, and her mother married the famous Dutch flower-painter Jacob Marrell. Maria showed an early talent for painting, insects in particular, and was encouraged by her parents.

Jacob Marrell had pupils, as did most artists of stature, one of whom was Johann Graff from Nuremberg. Maria became Graff's pupil and then his wife in 1668. She could paint in oils or watercolours, and produced many still lifes featuring flowers, fruit and birds, but she is most famous for her excellent studies of insects. She produced the first of three volumes called *Der Raupen wunderbare Verwandlung und sonderbare Blumennahrung* (*The Wonderful Transformation of Caterpillars*) which was illustrated with her own engravings, coloured by her eldest daughter Dorothea. The illustrations showed various insects in different stages of metamorphoses on the plants with which they are associated. The other two volumes followed in 1683 and 1717. Her daughter Dorothea did the drawings for the third and last volume, perhaps because her mother was by then failing in health.

Maria's relationship with her husband was not good and she left him in 1685 to enter a Dutch Labadist[8] convent in Freisland, accompanied by her mother and two daughters. However, while she was there she saw a collection of South American insects which fired her with the desire to see them in their native habitat. She left the convent and, financed by the Dutch government, she travelled to Surinam (now known as the French, Dutch and British Guianas) where for two years she collected and painted the native lepidoptera and flora.

Returning to Europe, she went to Hamburg and presented the museum with some of her drawings. Then she began work on a book about the insects of South America. She returned to South America with her daughter Johanna in order to collect and study more specimens. On her return, she settled in Amsterdam where she finished her most excellent *Metamorphosis*

Insectorum Surinamensium (published in 1705) and where she died in 1717.

Her books were very advanced for the period and became foundation works in zoology and botany, later used in the Swedish naturalist Linnaeus's classification of natural species.

Herman Hen(g)stenburg (1667–1726) was a pastry-cook who decided that painting would be a much more interesting profession to pursue. He studied under the flower-painter Johannes Bronkhorst who, coincidentally, had also been a pastrycook and turned to painting flowers and insects on vellum. Hengstenburg was equally famous for his paintings of landscapes, birds and game.

Jan van Huysum (1682–1749) has a distinctly recognizable style which is softer, lighter and more delicate than some of his contemporaries. He really liked the flowers that he painted, and took pleasure in the preparatory sketches of his 'arrangements'. During the summer months he used to visit Haarlem to study the flowers being grown there, and his paintings reflected this interest. The central item in his compositions is often an urn of some kind, filled with an ever-changing variety of flowers or fruit. He was very secretive about his techniques and refused to allow visitors into his studio while he was working, lest they discovered and copied his methods. He had only one pupil, a Margareta Havermann, and from this one can assume that he did well enough from the patronage of the nobility.

Aert Schouman (1710–92) was born at Dordrecht where in his youth he was a pupil of Adrian van der Burg for eight years. He moved between Dordrecht and The Hague where he eventually died. Schouman was very versatile, painting portraits, small history pictures and landscapes with animals; he also did glass-engraving, produced wallpaper designs and was skilled enough at engraving to make his own mezzotints. He died in The Hague in 1792. He was best known for his ornithological studies rather than for his botanical work, but the latter are so pleasing, with the plants in their pale, scenic settings that do not distract the eye. The painting of the amaranthus, with its 'tail' lying negligently over the stonework is very true in its detail.

The Dietzschs were an industrious and talented family who lived in Nuremberg. All of them were artistic and Barbara Regina Dietzsch (1706–83) was particularly famous for her paintings of flowers, insects and birds. Her father, Johann Israel Dietzsch, her brother Johann Christoph, her sister Margareta and she were employed at the court of Nuremberg.

The family was friendly with the famous physician

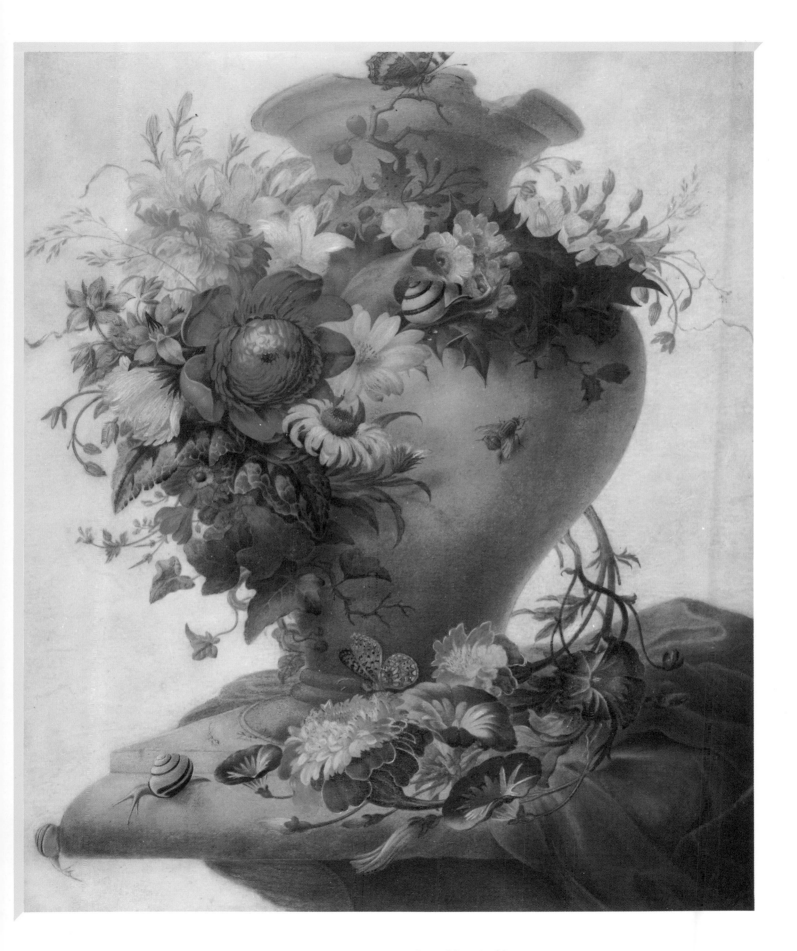

VASE OF FLOWERS – *Ipomoea*, 'French' marigolds
(*Tagetes*), ivy leaves, borage, butterflies, snails,
grasses, *Campanula*
Herman Herstenburg (Hen-g-stenburg)

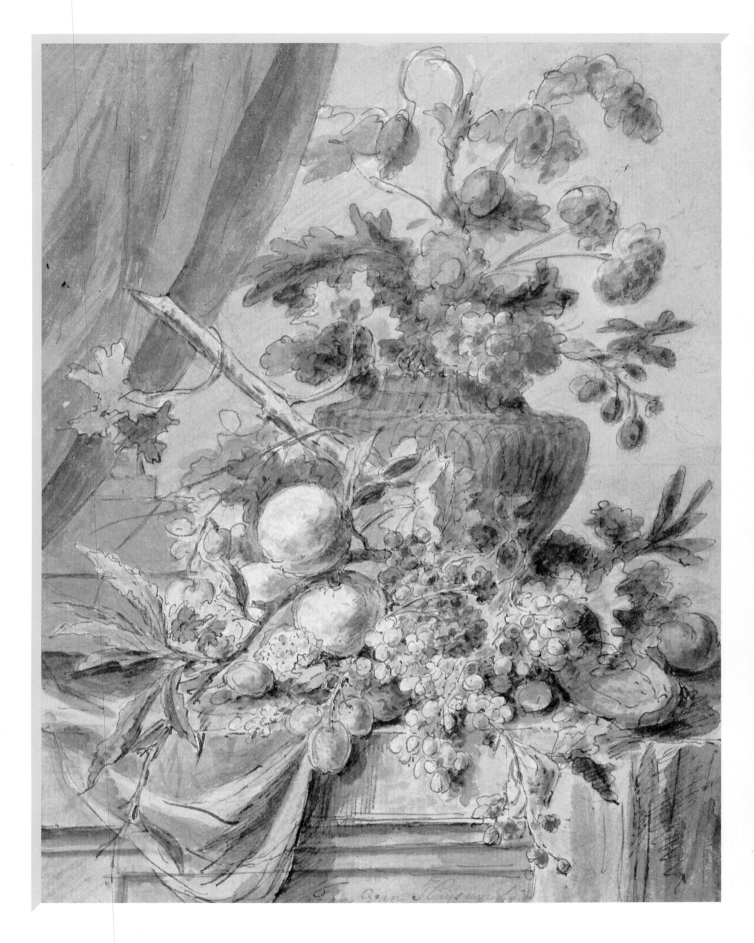

WATERCOLOUR SKETCH
Jan van Huysum

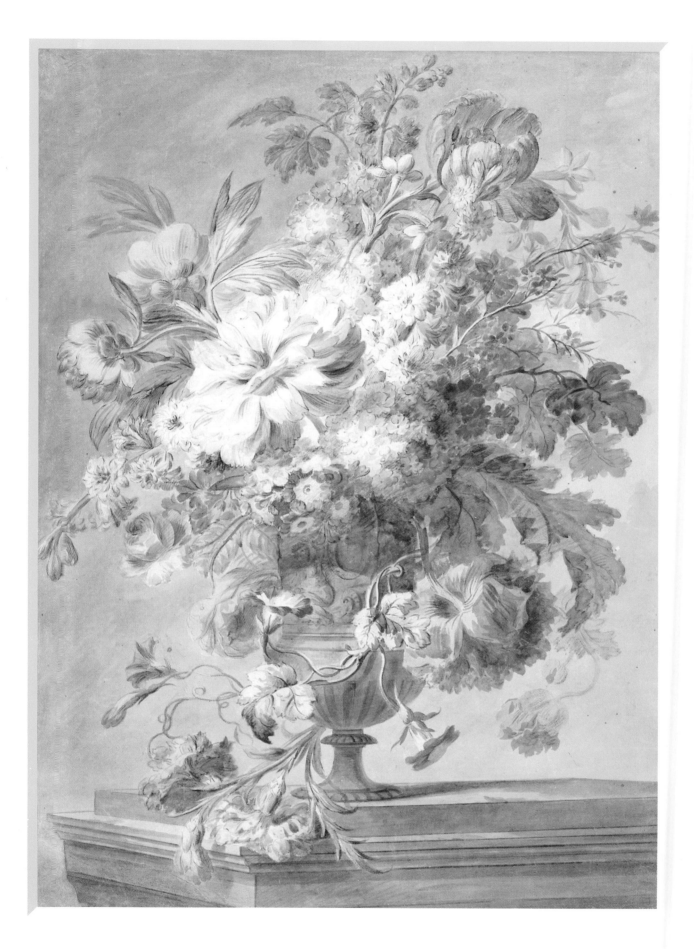

A VASE OF FLOWERS ON A PLINTH

Jan van Huysum

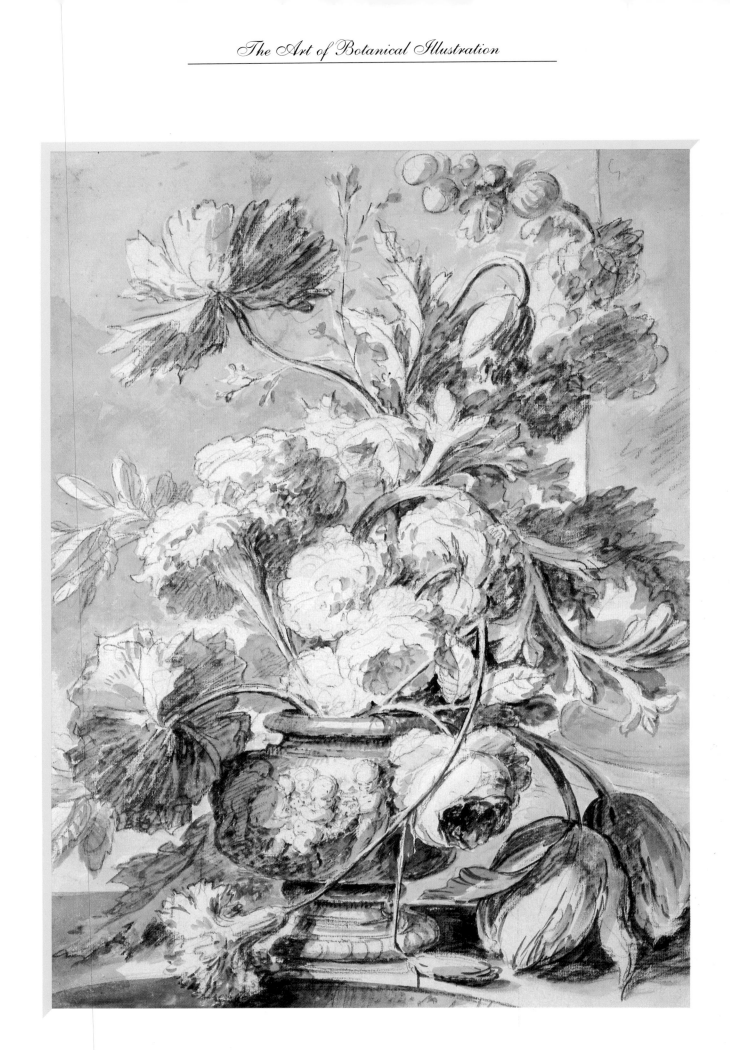

STUDY OF A VASE OF FLOWERS
(brush and grey washes over black chalk)
Jan van Huysum

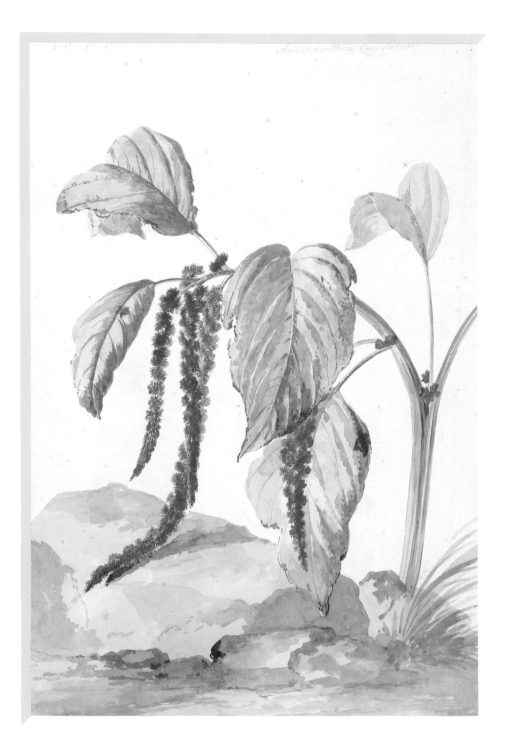

Amaranthus caudatus
Aert Schouman

Christoph Jakob Trew. Dr Trew's influence on the botanical world was considerable. He seemed to act as a catalyst between botanists, gardeners, explorers, scientists, artists and the nobility, and he is particularly well-known because of his long association with Linnaeus. Barbara Dietzsch was almost as famous for her insect paintings as Maria Merian, though she lacked that intrepid lady's adventurous spirit and enquiring mind. The presence of the Dietzsch family and Dr Trew in Nuremberg began to make the town something of a centre for botanical artists. The trademark of the Dietzschs was their use of a black background, which, though wholly artificial, had tremendous impact.

Johann Christoph Dietzsch (1710–69) painted landscapes as well as he did flowers, and, like his sister Barbara's work, those flowers are alive with insect life. The work of Margareta Barbara Dietzsch (1716–95), Barbara's sister, shows a family likeness and it is interesting to see that Margareta painted a Scotch thistle which is very reminiscent of Rachel Ruysch's painting a century earlier, although Margareta substituted a lizard for the serpent.

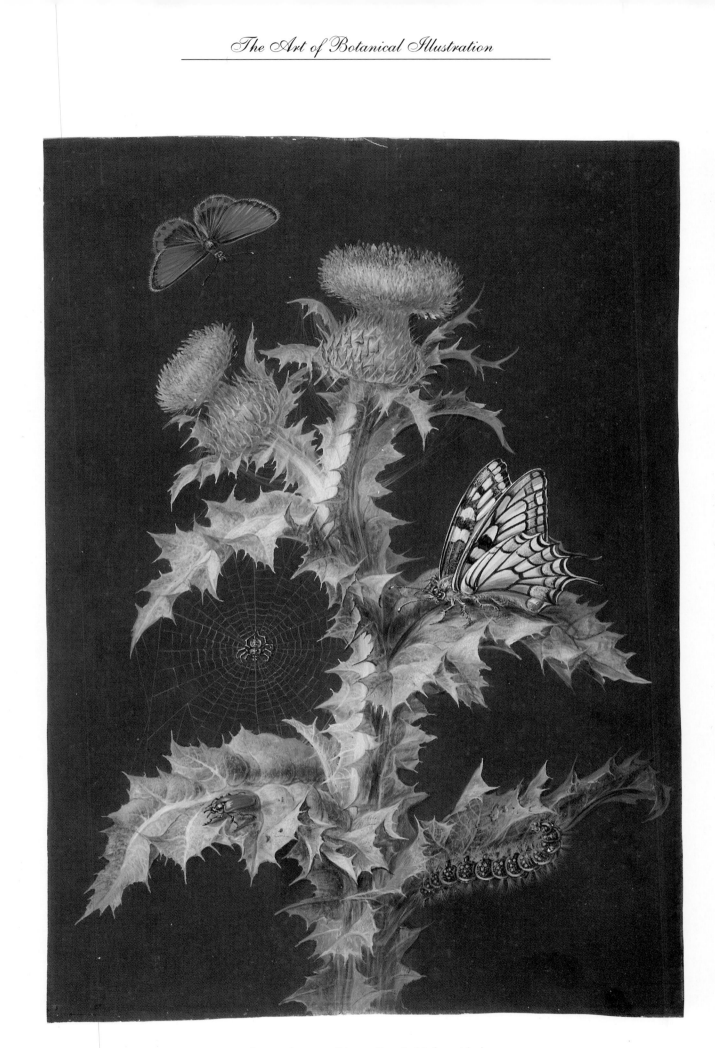

Onopordon acanthium – Scotch thistle, spider's
web, butterfly, moth, caterpillar and beetle
(bodycolour and gum arabic on prepared black
ground, on vellum)
Johann Christoph Dietzsch

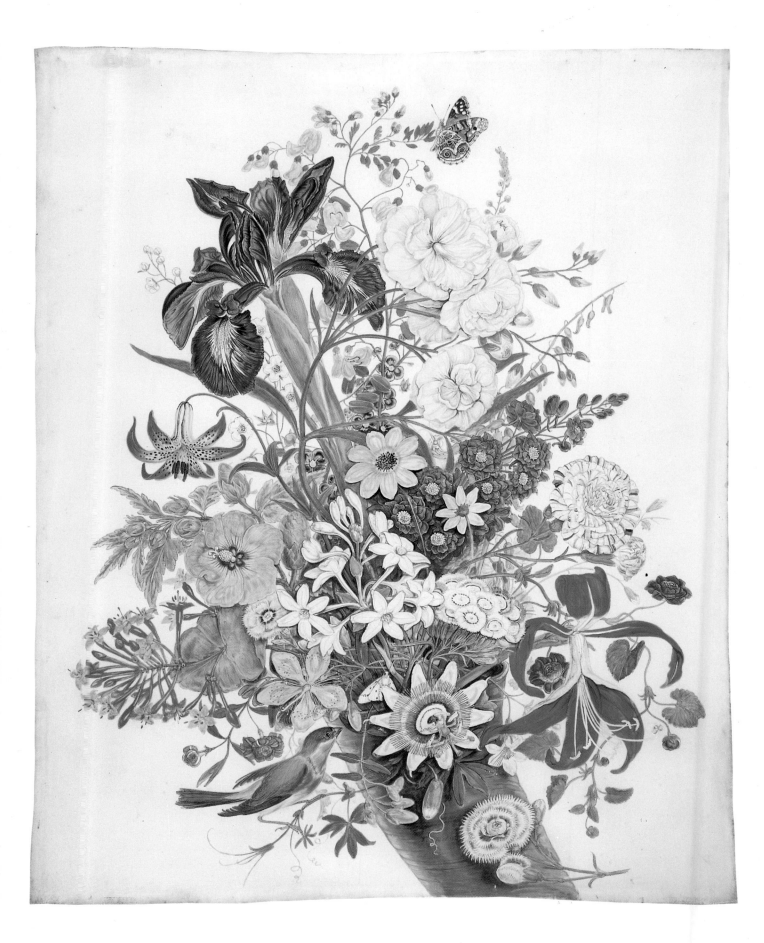

MIXED FLOWERS IN A CORNUCOPIA
(watercolour and bodycolour on vellum)
Thomas Robins the elder

Thomas Robins (1716–70) and his son, Thomas (1748–1806), lived in Bath. Thomas Robins the Elder was a topographical draftsman, while his son was known for his flower-paintings. Their work was so similar in style and execution that it has always been difficult to tell them apart. The confusion between father and son is further increased as they seldom dated their work. However, it is clear from Thomas Robins the Elder's work the *Cornucopia* that he was influenced by the Dutch flower-pieces. This and the accompanying four drawings are interesting for several reasons. Firstly, they are painted in watercolour and body-colour instead of oil, which was almost mandatory at that time for this kind of painting; secondly, the *Cornucopia* shows many of the newer flowers which by then were being introduced to English gardens or hothouses – the passion flower, sprekelia, hibiscus, *Colutea*, verbascum, tuberose and *Gasteria*, for example; and finally, the four smaller drawings are clearly taken from a florilegium and show Robins' re-use of them.

Nikolaus von Jacquin (1727–1817) was born at Leiden in Holland. He had a cosmopolitan education, and went to Vienna in 1752 to finish his medical studies. While there he helped to organize a botanical expedition to the West Indies to bring back specimens for the Emperor Francis I. The Empress Maria Theresa was exceedingly interested in natural history, particularly plants. Von Jacquin was given the post of Director

of the University Gardens (The Schönbrunn Gardens) in Vienna, begun in 1753. These gardens later became an exotic show-place, with huge heated glasshouses filled with tropical plants and free-flying birds.

In 1763 von Jacquin took another post as Professor of Chemistry near Dresden, but the powerful lure of the vegetable kingdom took him back to Vienna five years later, where he was subsequently appointed Professor of Botany and Chemistry and Director of the University Botanic Gardens. Thus all his interests and knowledge were brought together in one position. He held this post until his retirement in 1797, and during this time produced several splendidly illustrated volumes. Von Jacquin travelled extensively in order to produce such detailed florilegiums. Consequently, he had to commission other artists – notably the Bauer brothers – to draw as he had so little time himself.

Among the many magnificent volumes von Jacquin produced were the *Hortus Botanicus Vindobonensis*, which had 300 engravings and was published between 1720 and 1776; *The Icones Plantarum Rariorum* had 648 engravings and was published between 1781 and 1793; *The Plantarum Rariorum Horti Caesarei Schoen-*

brunnensis was published with 500 engravings between 1797 and 1804, and his book *Selectarum Stirpium Americanarum Historia* (1763) illustrated with von Jacquin's own drawings, was an account of his visits to the West Indies and Central America. Many of the plates in the books are unsigned, and it is not known exactly where these new plants were collected.

Floras were also beginning to appear. These were collections of botanical drawings of species of plants that grew in one specific area. They had more scientific beginnings. They are fascinating for three reasons; firstly, because they show what grew wild; secondly, they show when these species were growing because the artists usually named and dated their work. This marked the stages of botanical classification which by this time must have become even more of a headache. Finally, the drawings were more exact and usually showed roots, corms, bulbs, fruits and sections.

There were many examples of European floras, for example, *The Florae Austriacae Icones* that was produced by Nikolaus von Jacquin between 1773 and 1778. This featured 500 plates of the flowers of Austria. *The Flora Danica* is justly famous both for its comprehensiveness and for giving its name to a dinner-service. It was conceived in 1761 but was not completed for a further 100 years. It contained 3,060 engravings, and the text was written by Georg Christian von Oeder. The drawings were made by many different artists. It was one of the earliest and most comprehensive of the floras.

Gérard, Gerardus or Gerrit van Spaëndonck (1746–1822) had a long, influential and distinguished career as a botanical artist, and his name is often associated with that of his most famous pupil, Pierre Joseph Redouté. Van Spaëndonck was born in Holland and studied painting in Antwerp. In his early years he was considerably influenced by Van Huysum, but Van Spaëndonck developed a personal style that has greater clarity. He left Holland in 1770 and became a porcelain designer and miniaturist at the Sèvres factory near Paris. After about four years he moved to Versailles, where his abilities as a miniaturist and teacher of painting made him popular at the Court. In 1774 he was appointed Painter in Miniature to the King and taught painting, particularly flower-painting, at the Jardin des Plantes where he succeeded Madeleine Basseport as *Professeur de peinture de fleurs*. He continued the work on the famous *Vélins du Roi* and in 1781 he was elected a member of the Académie Royale (the French equivalent to the Royal Society). In 1793 he was appointed Administrator and Professor of Iconography in the Musée Nationale d'Histoire Naturelle. The

Part of a letter from Nikolaus von Jacquin to
Jonas Dryander, October 1792.

Solanum macrocarpum
G. van Spaëndonck

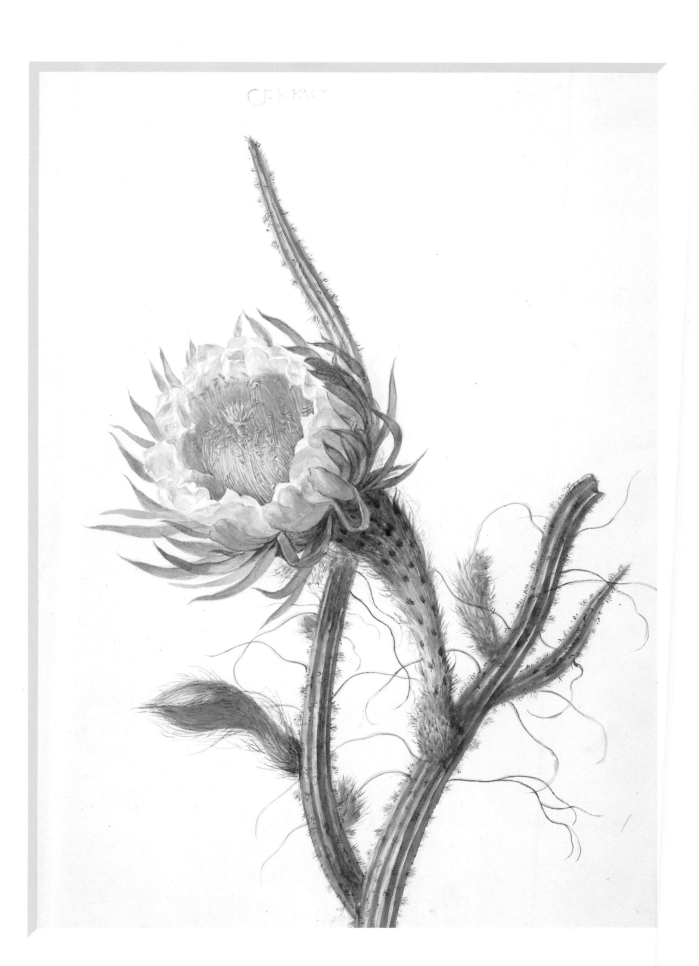

Cereus
Henrietta Geertruida Knip

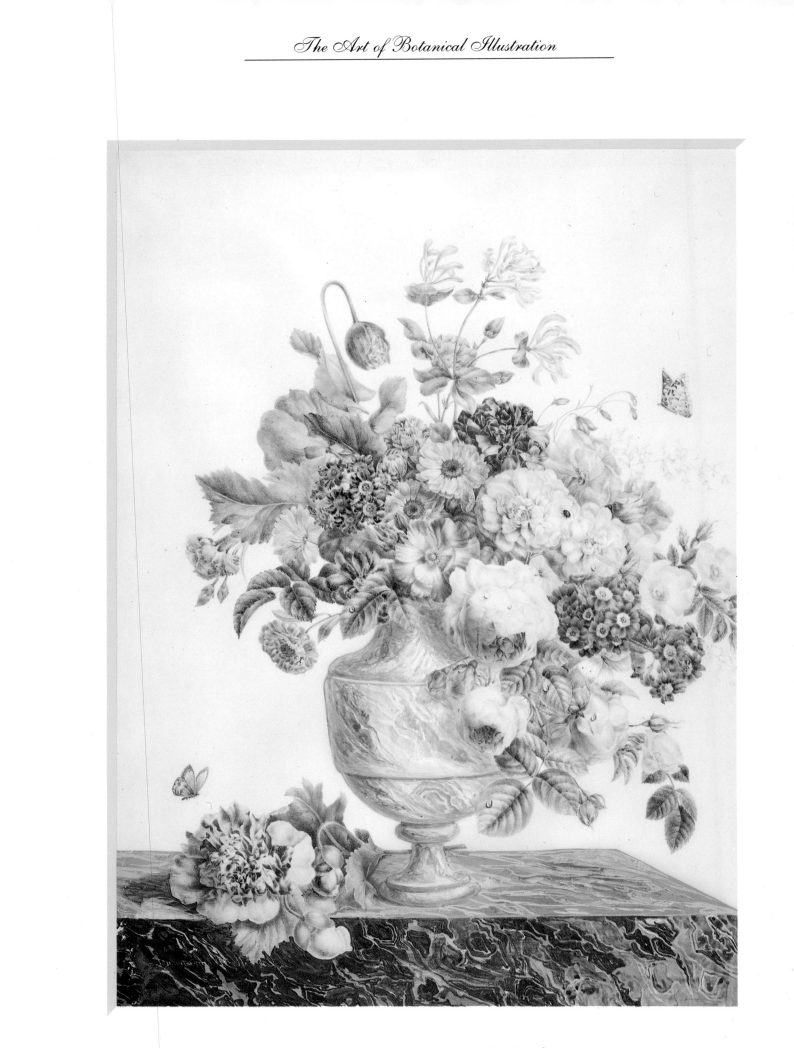

BLUE POPPY, ROSES, HONEYSUCKLE, *Campanula,*
Auricula, CARNATIONS, ON VELLUM
Corneille van Spaëndonck

turbulence of the French Revolution (which lasted from 1789 to 1799 seems to have left him unscathed, though his painting classes must surely have changed in character owing to the absence of his aristocratic pupils.

In 1800 Van Spaëndonck produced an album of engravings called *Fleurs dessinées d'après Nature*. This was his only published work. It consisted of 24 flower-paintings in watercolour which were stipple-engraved by P. F. Le Grand. Wilfred Blunt says that these are the finest engravings ever made. Previous to this, Van Spaëndonck had been experimenting with watercolour for the famous *Vélins*. His earlier work in the years 1780 to 1782, was in gouache but later paintings, dated 1784, are in watercolour and equal to Redouté's best work. Van Spaëndonck encouraged Redouté, as indeed he did all his pupils and his name should never be forgotten as a master of his art.

Corneille (Cornelis) van Spaëndonck (1756–1840) followed his illustrious elder brother to the Jardin des Plantes via the Sèvres porcelain factory, and in 1789 he was elected to the Académie Royale. Not much is known of him, but his work was equal to, or even better than,

that of many of the Dutch and Flemish artists. Had he not had so illustrious an elder brother we might have known more of him; the same could be said of Redouté's younger brother.

Henrietta Geertruida Knip (1783–1842) was born in the same town of Tilburg, in Holland, as the Van Spaëndoncks. Her father, Nicolaas-Frederick Knip, was a still-life and landscape painter, who eventually became totally blind. Her two brothers and she were taught by their father initially. The brothers turned to landscape painting while Henrietta concentrated on flowers. Henrietta went to Paris and became one of Gerard van Spaëndonck's pupils. Later she was taught by Jan Frans van Dael. Her work clearly shows Van Spaëndonck's influence. The painting of the Cereus always poses the problem of the exact time of day it was painted, since this flower is supposed to open its petals at, or about, midnight.

Augustin Pyramus de Candolle (1778–1841) was a Swiss botanist who implemented his own system of plant classification and published it in *Théorie Elementaire de la Botanique* (1813). In 1808 he produced an incomplete French flora called *Icones Plantarum Galliae Rariorum.*

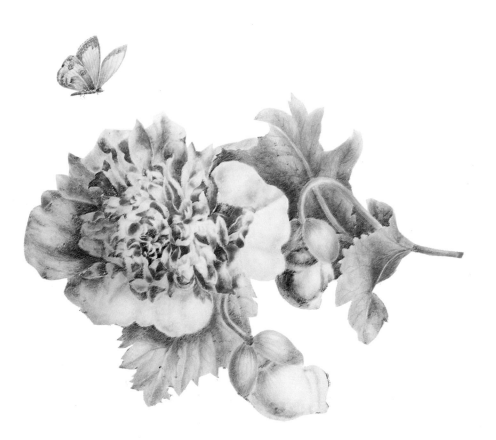

Linnaeus and Other Eighteenth-Century Artists

THE SOCIETY OF GARDENERS was founded in 1724 in England to protect the interests of nurserymen. Once a month the various gardeners and florists[9] met in a coffee-house in Chelsea to name and discuss the introduction of new plants. Among the members were the gardeners and botanists Philip Miller and Robert Furber. The society decided to publish a work called *The Catalogus Plantarum* which was to be divided into four parts – plants, trees, shrubs and fruit. In the event, one volume only was completed. Though the plates are not outstanding, they are of botanical interest because they show new introductions and give their names at that time. The title page reads: 'Catalogus – 1730. A catalogue of trees and shrubs, both Exotick and domeftick, that are Hardy enough to bear the cold or our Climate in the open Air, and are propagated for Sale in the gardens near London.' The plates were engraved by Jacobus van Huysum (c1687–1740) who settled in England for the later part of his life. By all accounts he indulged in drunken and dissolute behaviour which resulted in his being dismissed from Horace Walpole's employment.

The Catalogus Plantarum in its entirety had been planned as a reference catalogue. So, too, was Robert Furber's *Twelve Months of Flowers*, which must surely be the best seed catalogue ever produced. Furber was almost honest in his selection of blooms. As in all gardens, each flower spans three months – the end of one, the main flowering month and a short part of the next, to die in – augmented by carnations which in those days were gloriously scented, unlike today's sterile flower-shop blooms. The illustrations are, in effect, flower-pieces and it is sad to consider just how many of these immensely valuable volumes have been cut up to make matching sets for dining-room decorations.

Mark Catesby (c1682–?), an English botanist from Suffolk, provided 24 of the flowers illustrated. When he came into a legacy, he decided to visit his married sister who had settled in Virginia in America. While he was there he sent back seeds and dried plant specimens. On his return to England in 1719 he was pleased to learn

that his work was sufficiently appreciated for him to be recognized as a serious collector; a group of subscribers contributed enough money for him to return to America, this time to the much warmer southern regions of Carolina and Georgia and the islands of the Bahamas. He sent back regularly collections of seeds and plants during a period lasting about six years.

Catesby is best known for his work *The Natural History of Carolina, Georgia, Florida and the Bahama Islands* (1730–47). He was taught engraving by a Mr Joseph Goupy because he wished to illustrate the work himself and also because he was no longer wealthy enough to have the illustrations engraved for him. In 1763 Catesby produced a second work that was primarily a gardening manual. It was called *Hortus Britanno-Americanus,* or, *A Curious Collection of Trees and Shrubs. The produce of the British Colonies in North America: adapted to the soil and climate of England.*

THE RISE OF LINNAEUS

Now it is time to turn to the man who, in his lifetime, managed to convert the chaos of mixed nomenclature and personal classification into one harmonious whole. His name was Carl (Carol) Linné or Linnaeus who was born in Sweden in 1707. His father was a pastor in southern Sweden, who later had three daughters and another son. Linnaeus grew up in a happy country environment with a father who was intensely interested in flowers and gardening. He was taught from infancy to remember plant names, and this early discipline benefited him for the rest of his life. He was always playing truant from school during the summer months so that he could go out to the countryside to look at the flowers. Despite this behaviour, he managed to reach the top class at school, and was introduced to Dr Johan Rothman, the state doctor for that area and a senior schoolmaster at the nearby Gymnasium, or High School, where Linnaeus was later to study. Linnaeus was not very interested in the set subjects considered suitable for him – it was assumed that he would enter the church – and either could not or did not want to work hard enough to pass the necessary examinations. This was a shock to his father, but the situation was saved by Dr Rothman's recognition of the boy's possible career in

9. *A term much in use describing a person who grew flowers professionally, not the proprietor of a flower shop which is its modern meaning.*

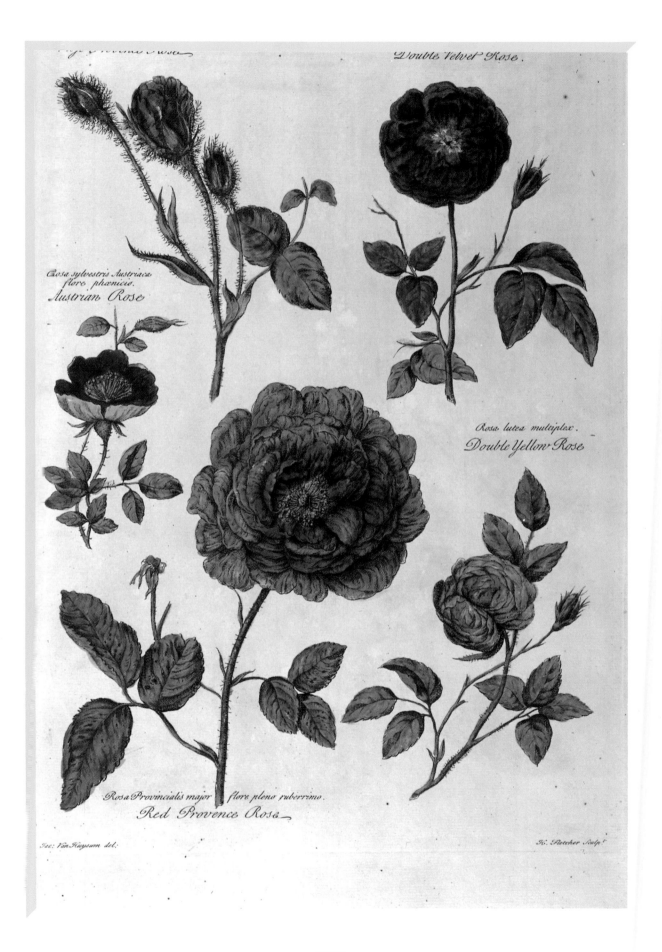

ROSES

The Society of Gardeners – *Catalogus*
Plantarum (1730)

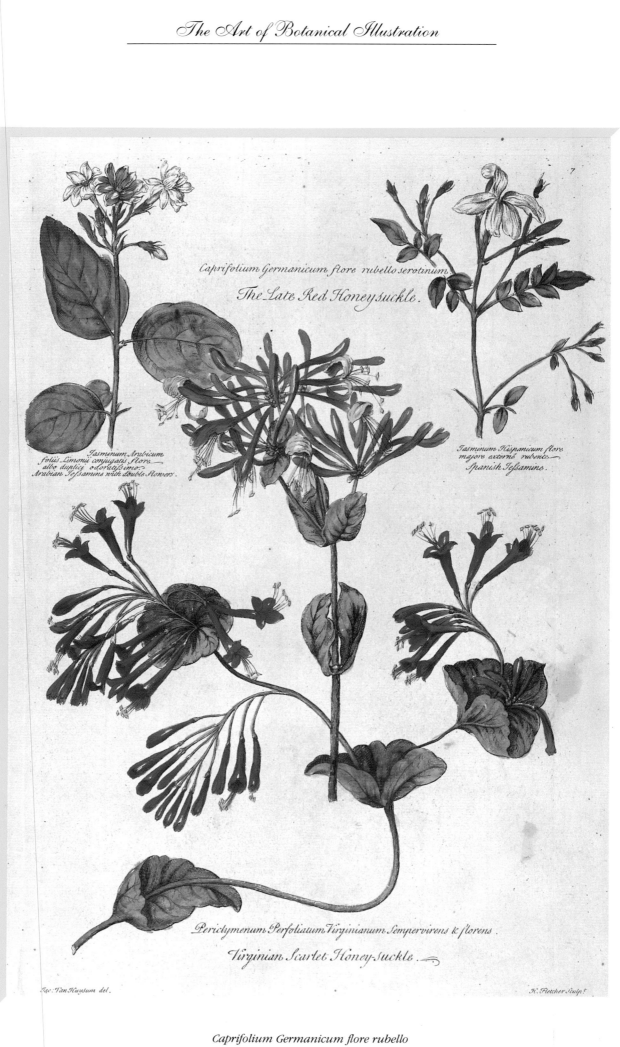

Caprifolium Germanicum flore rubello
seratinum
The Society of Gardeners – *Catalogus*
Plantarum (1730)

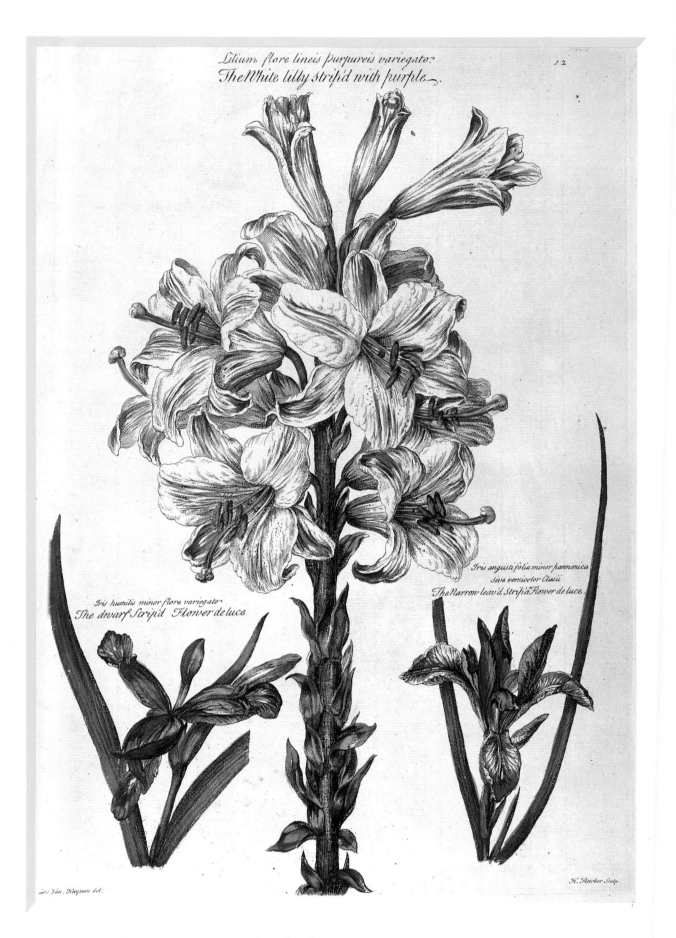

Lilium flore lineis purpureis variegato – THE
WHITE LILY STRIPED WITH PURPLE
The Society of Gardeners – *Catalogus
Plantarum* (1730)

medicine, and he offered to give the lad a thorough grounding in botany and physiology for his last year at school.

In due course, Linnaeus entered the University of Lund, where he stayed with Dr Kilean Stobaeus, an eminent doctor and a keen student of natural history. Dr Stobaeus had a fine library and a substantial collection of shells, minerals, stuffed birds and pressed plants. In 1728 Linnaeus transferred himself to the University of Uppsala where the facilities were slightly better, though not exactly good. Linnaeus was extremely poor, but was fortunate enough to win a small scholarship, which enabled him to visit Stockholm. Here he met a young man called Peter Artedi with whom he was to form a deep and lifelong friendship. The two young men studied and discussed all aspects of natural history and it was during this period of his life that Linnaeus realized that it was the sexual parts of a plant that a botanist should look at to determine what genus or family the plant belongs to.

Linnaeus had been using Joseph Pitton de Tournefort's (1656–1708) classification system, in which plants were arranged according to the number and structure of their petals. Linnaeus was also influenced by the British naturalist John Ray (1628–1705).

While he was in Uppsala, Linnaeus met Dr Olaf Celsius, a keen botanist. Linnaeus and Dr Celsius got on well and, subsequently, the poverty-stricken Linnaeus became a lodger in the doctor's household. Linnaeus was awarded a Royal Scholarship, in June, 1729, probably on Celsius's recommendation. He presented his thesis, which was an excellent though charmingly simplistic paper on the reproductive organs of plants. This was not entirely new – Camerarius[10] had produced similar ideas in 1694 – but Linnaeus's work was more public and controversial, earning him disapproval from many. However, he was asked to hold botanical demonstrations, in the Botanic Garden at Uppsala, which were crowded with interested students. In June, 1730, Linnaeus was asked to act as tutor to Olaf Rudbeck's three younger sons (Rudbeck had 24 children by three wives) and a special grant, later doubled, was awarded to him.

Linnaeus continued to work on his own system of plant classification, doubting more and more the practicality of Tournefort's system. He began to arrange plants according to his own ideas, dividing them into classes or families according to the number and disposition of the stamens and pistils. He applied the binominal (two-word) naming system to plants: the first word applied to a whole group of plants, and the second name identified each plant individually. Linnaeus named 7,700 plants in total. His great work the *Species Plantarum,* published

in 1754, represents the beginning of a clear systematic method of botanical naming. Linnaeus spent the rest of his life observing, teaching, travelling, writing his own books and in correspondence with all the notable botanists of the day.

In 1735 Linnaeus was offered the post of tutor to the young Claes Sohlberg. One of the conditions of the post was to accompany the boy to Holland because at this time the Dutch people had a higher standard of education, a thriving economy, erudite scholars, wealthy patrons of the arts, amazing gardens stocked with rare plants from overseas and excellent printers. Linnaeus was promised a salary, but this was never paid. However, as he had made careful plans in expectation of the visit to Holland he decided to go through with the commitment, putting his trust in God to take care of all the essentials since the elder Sohlberg had never paid him his promised wages.

When the two young men arrived in Amsterdam they visited the Botanic Garden there. As a result of this, Linnaeus met Johannes Burman, a noted botanist, Professor of Botany and Director of the Hortus Botanic Gardens. However, they did not take to each other at all. In addition, while he was in Holland, Linnaeus wanted to meet Dr Herman Boerhaave, who lived in Leyden. Boerhaave was also a man of international renown as a teacher of medicine, a chemist and a botanist. He would not receive the young man at first, and Linnaeus, disappointed, resolved to meet him at another time.

One of his reasons for wishing to visit Holland was because of the excellent standard of Dutch printing. Linnaeus had brought his manuscripts with him and hoped to find a means of publishing some of them. He was fortunate in meeting the botanically-minded Dr Johan Gronovius the Younger, who took to the young man and gave him much practical help and encouragement. In the first instance, Gronovius decided to assist Linnaeus by funding the publication of the *Systema Natura;* and in this he was helped by a young Scottish doctor called Isaac Lawson. The work was thus published privately but, subsequently, enlarged and amended editions began to appear. At last Linnaeus had a foot on the bottom rung of the ladder, but limited financial resources were almost exhausted and he knew that he would soon have to return to Sweden.

Gronovius and Boerhaave were friends and so Gronovius introduced Linnaeus to Boerhaave. Again, Linnaeus failed to make a good impression. Boerhaave considered him to be forward and conceited, but he recognized that here was a young man of considerable promise. Boerhaave obviously made an effort to dispel his first impressions and began a friendship which was to last for the rest of his life.

Due to his lack of money at this time, Linnaeus talked of returning to Sweden almost immediately. Boerhaave tried to persuade him to stay by offering him an expedi-

10. *Rudolph Jakob Camerarius (1665–1721) German botanist and physician, chiefly known for his work on reproductive organs of plants* De Sexu Plantarum Epistola, *(1694).*

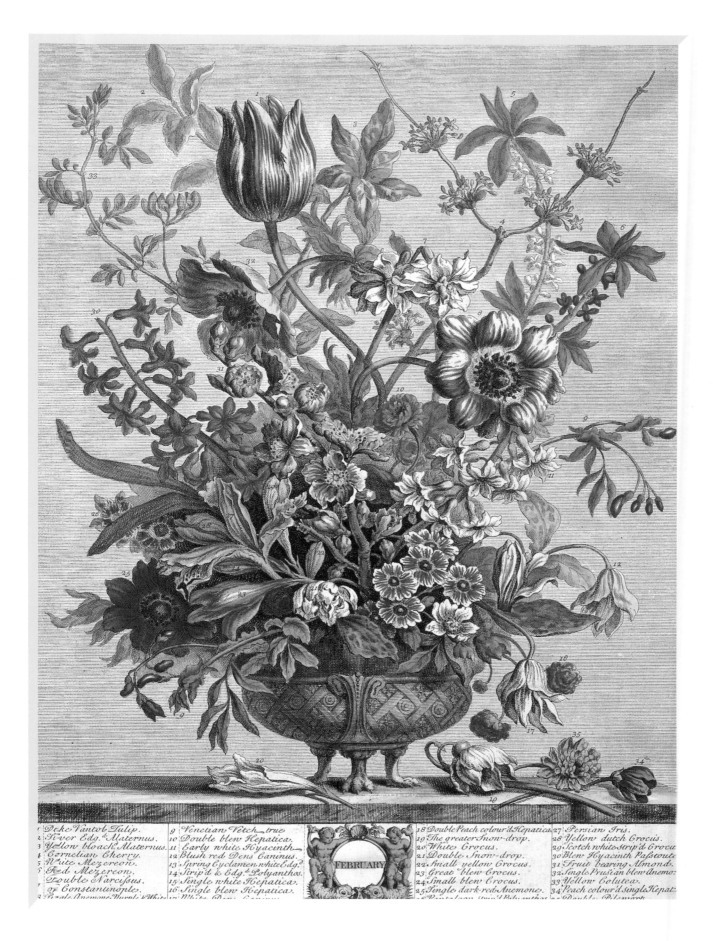

FEBRUARY
(hand-coloured engraving)
Robert Furber's *Twelve Months of Flowers*
(1730)

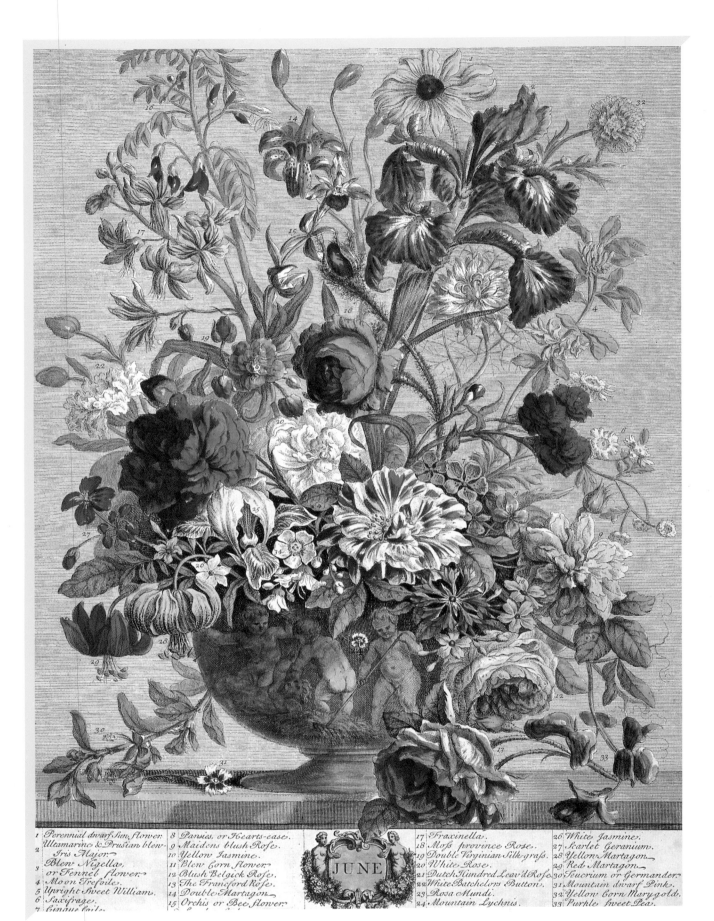

1 Perennial dwarf Sun flower.	8 Pansies, or Hearts-ease.	17 Fraxinella.	26 White Jasmine.
2 Ultamarine & Prusian blew Iris Major.	9 Maidens blush Rose.	18 Moss province Rose.	27 Scarlet Geranium.
3 Blew Nigella, or Fennel flower.	10 Yellow Jasmine.	19 Double Virginian Silk-grass.	28 Yellow Martagon.
4 Moon Trefoile.	11 Blew Corn flower.	20 White Rose.	29 Red Martagon.
5 Upright Sweet William.	12 Blush Belgick Rose.	21 Dutch Hundred Leav'd Rose.	30 Teucrium or Germander.
6 Saxifrage.	13 The Franeford Rose.	22 White Batchelors Button.	31 Mountain dwarf Pink.
7 Cinque foil.	14 Double Martagon.	23 Rosa Mundi.	32 Yellow Corn Mary gold.
	15 Orchis or Bee flower.	24 Mountain Lychnis.	33 Purhle Sweet Pea.

JUNE

JUNE
(hand-coloured engraving)
Robert Furber's *Twelve Months of Flowers*
(1730)

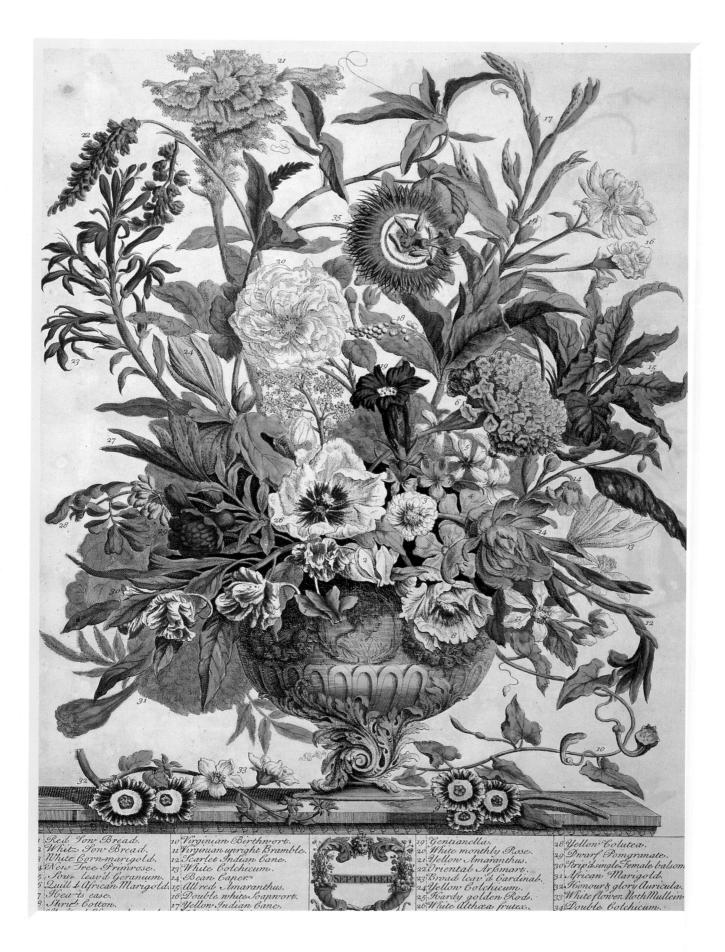

SEPTEMBER
(hand-coloured engraving)
Robert Furber's *Twelve Months of Flowers*
(1730)

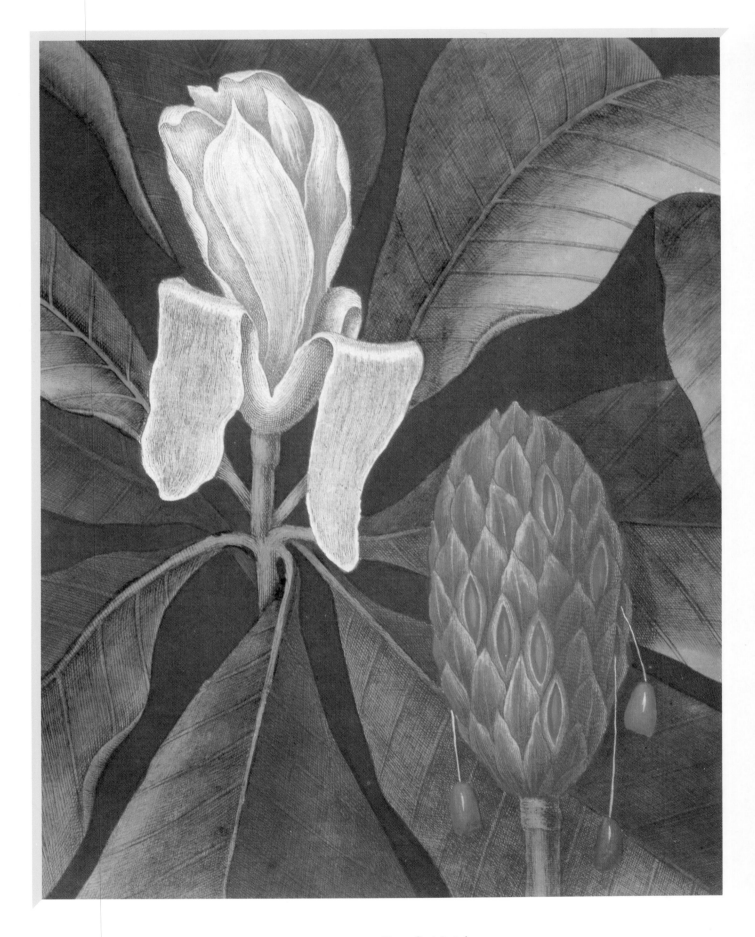

UMBRELLA TREE – *Magnolia tripetala*
(hand-coloured engraving)
Mark Catesby
The Natural History of Carolina, Georgia,
Florida and the Bahama Islands, 1730–47

tion, financed by the state, to South Africa and then to America to collect plants for Holland, followed by a professorship in Leiden on his return. Strongly tempted though he probably was, Linnaeus refused, saying that he disliked extremes of temperature. Boerhaave suggested that as he was returning to Sweden by way of Amsterdam, he should make another attempt to meet and get to know Johannes Burman; assisted by a helpful letter from Boerhaave, Linnaeus tried again and this time the two men got on better. Burman developed a respect for Linnaeus's botanical knowledge, so much so that he suggested that Linnaeus should help him with the preparation of his work, *Thesaurus Zeylandica,* in return for bed, board and a comfortable workroom. Linnaeus's young companion, Sohlberg, had been sent some money from home for his tutor and this unexpected good fortune enabled Linnaeus to plan to stay with Burman for the winter, working on his own books *Fundamenta Botanica* and *Bibliotheca Botanica* as well as on Burman's work.

It was at about this time that Linnaeus met the immensely rich George Clifford, whose family had come to Amsterdam from England in the mid-1600s. Clifford was a banker and a director of the Dutch East India Company, and his wealth made it possible for him to turn the estate of Hartekamp into a horticulturalist's paradise. The gardens must have rivalled almost anything that exists today. In addition, as Clifford was a wealthy individual, there were none of the limitations on spending and upkeep that would have been imposed by an organization or government department. There were fishponds, fountains, mounds, mazes, statues, stonework, topiary and a large menagerie containing tigers, wild dogs, deer from India, peccaries from South America, goats of different kinds and monkeys, with heated aviaries full of tropical birds. But it was the hothouses or 'Houses of Adonis' that were exceptional for the period. They were arranged so that in the first there were plants from southern Europe; in the second there were plants from tropical Asia; in the third there were plants from Africa and in the fourth there was a range of plants from the different temperature zones of the Americas. In addition, there was an excellent museum. It was Burman who introduced the eager Linnaeus to these gardens.

Clifford was fascinated by Linnaeus's ability to classify plants that were unknown to him simply by looking at the parts of the flowers. Linnaeus thought that the Hartekamp gardens must be the most wonderful place on earth and hoped that Clifford would ask him to take charge of the great garden and all its vegetable treasures. This came about but it is not known exactly how. It is known that Clifford was a hypochondriac and that Boerhaave was his physician. Gronovius was a friend of Clifford's, and so it appears that it was arranged between them for Linnaeus to act as resident doctor to Clifford and to superintend the gardens.

Linnaeus was delighted with this new situation, but there was a problem. Linnaeus had pledged his word to Burman to stay with him and help him with his books during the winter months. How could Linnaeus get out of this difficult position, when it was Burman whom he had to thank for the introduction? Burman was not at all happy at the prospect of his new assistant's desertion. It was while they were all walking round the Hartekamp library that a solution to the problem occurred. Burman noticed a new book on Clifford's shelves — Sir Hans Sloane's *Natural History of Jamaica* — and immediately wanted a copy of his own. Clifford seized his opportunity. He offered to give the book to Burman if he would set Linnaeus free from his obligations. Burman agreed, and shortly afterwards, in the autumn of 1735, Linnaeus moved to the Hartekamp, where his duties consisted of classifying and ordering the herbarium specimens, supervizing the care of the hothouses and keeping a regular check on his new patron's health. He was paid the princely wage of 1,000 florins a year, he had free board and lodging, he could select what books he liked for the library and whatever plants the gardens and hothouses lacked. He stayed in this paradise for two years, during which time he made many new friends who shared his interests. One of them arrived soon after he had taken up his duties — a young painter Georg Dionysius Ehret.

Linnaeus's fascinating story is chronicled in Wilfred Blunt's *The Compleat Naturalist.* This is the best and most erudite account of the great man's life and work. The world's greatest naturalist died in his house at Hammarby in 1778, respected and mourned by all.

OTHER GREAT 18TH-CENTURY ARTISTS

Elizabeth Blackwell was a renowned botanical artist of the 18th century. She published a book called *A Curious Herbal* (1737–39). Her husband Alexander was a doctor who had become a printer. He was successful in a small way, until rival printers combined together to shut him down because he had never served an apprenticeship. This was a financial disaster and Dr Blackwell was condemned to a debtor's prison. There he might have spent the rest of his life, had his wife not come to his aid.

Elizabeth discovered from Sir Hans Sloane that a new herbal of medicinal plants was needed, and so she moved to a lodging near the Chelsea Physic Garden and went into the garden every day to paint the specimens. From her drawings she made the engravings for the book while Dr Blackwell worked on the text in his prison cell. History does not tell us anything of Elizabeth's background and training, but she was obviously cast in the same mould as other determined and notable English plantswomen. The book came out and was sufficiently successful to pay off the doctor's debts, and two years after publication he was a free man once more. However, Dr Blackwell does not seem to have had a stable character. The next we hear of him is as an agent to the Duke of Chandos, for whom he produced a work called *A new method of improving Cold, Wet, and Clayey Grounds*. A little later on he is heard of in Sweden, where he was engaged in some form of farming; in addition, he was peddling spurious medicines. Subsequently, he became involved with bad companions in a plot to interfere with the Royal succession. The plot was uncovered and Dr Blackwell was arrested and charged with treason. At his trial he was found guilty and was condemned to be tortured and then broken on the wheel. This sentence was, mercifully, altered to a speedier death by decapitation. Of Elizabeth Blackwell nothing more is known, but the story is so strange that it deserves an airing while her paintings are more than competent.

Mary Moser (1744–1819) was the daughter of a Swiss goldsmith and portraitist who had settled in England. Her father had taught drawing to King George III, and so his daughter grew up in elegant surroundings. Mary Moser was a founder member of the Royal Academy. Her early work was mostly flower-paintings but later she turned to historical subjects. She married a Captain Hugh Lloyd in 1797 and continued to paint, but thereafter signed her work 'Mary Lloyd'. She stopped painting after 1802 because her sight was failing.

Sydney Parkinson (c1745–71) had a brief but exciting and arduous life. He worked as a woollen-draper, but he had considerable skill in draughtsmanship. He met Joseph Banks who introduced him at Kew where he worked on plant drawings. At this time, c1768, Captain James Cook was planning his first famous voyage in which he circum-

FIG – *Ficus carica,*
Elizabeth Blackwell, *A Curious Herbal*, vol. 1,
125.

navigated the world. The ship *Endeavour* carried 94 people, including Joseph Banks, Daniel Carlsson Solander, a Swedish naturalist and a pupil of Linnaeus, and Sydney Parkinson. Their route took them via Madeira, Rio de Janeiro, Tierra del Fuego, where two black servants died of exposure, and the Society Islands, where the landscape artist Alexander Buchan died of epilepsy in Tahiti.

The voyage continued to New Zealand, Australia and Java, where both Herman Sporing and Sydney Parkinson contracted dysentery; Sporing and Parkinson, who was only 26 years old, died at sea on the voyage home. The *Endeavour* continued by way of the Cape of Good Hope and St Helena, arriving back in England by July 1771. During the expedition some 30,000 plant specimens had been collected and dried for preservation. Parkinson had produced 21 volumes of natural history drawings, 18 of which were specifically botanical. During the earlier parts of the voyage to Madeira, Brazil and Tierra del Fuego, Parkinson was able to complete the paintings himself, working from the specimens collected by Solander and Banks. Solander and Banks wrote in a letter to

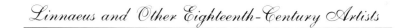

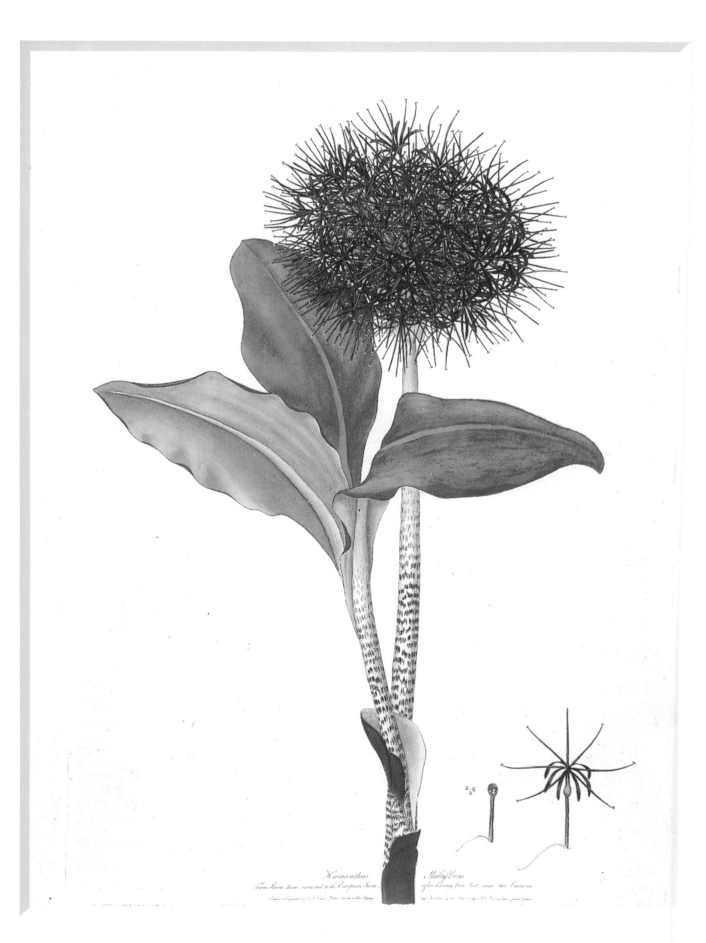

Scadoxus multiflorus
(handcoloured engraving)
Frederick Nodder

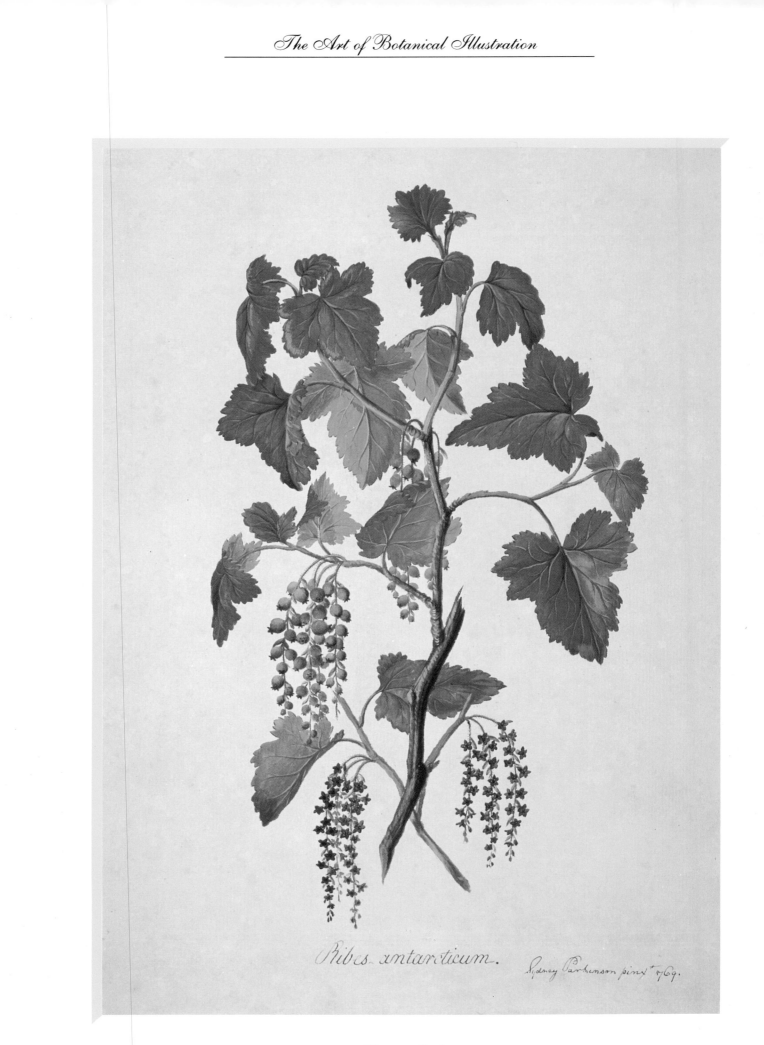

Ribes antarticum. Sydney Parkinson pinx.t 1769.

Ribes magellanicum
Sydney Parkinson, Tierra del Fuego (probably
finished by John Frederick Miller)

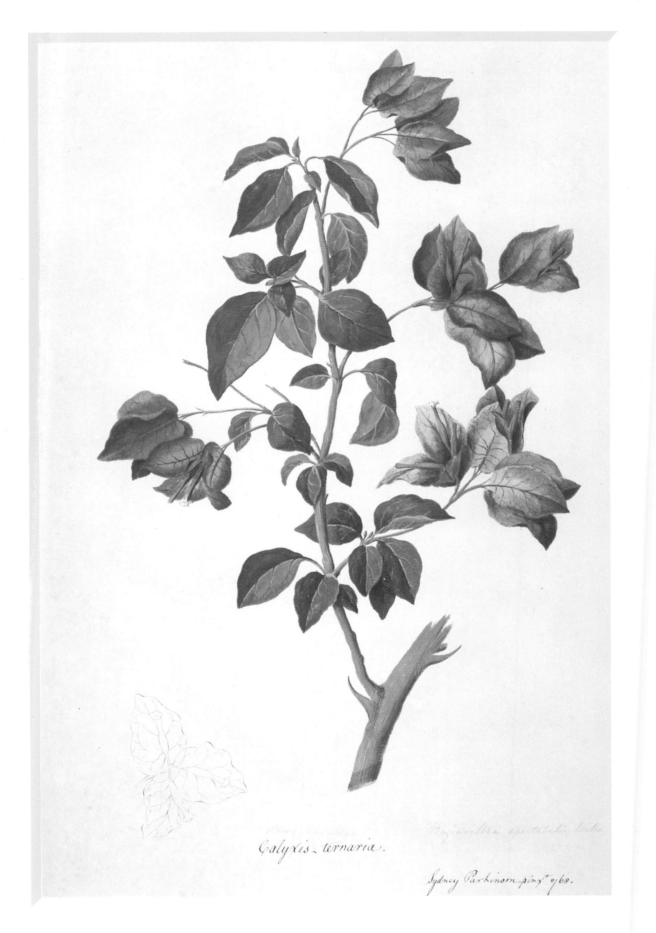

Calyxis ternaria.

Sydney Parkinson pinx[t] 1768.

Bougainvillea spectabilis
Sydney Parkinson, Brazil (probably finished by
John Frederick Miller)

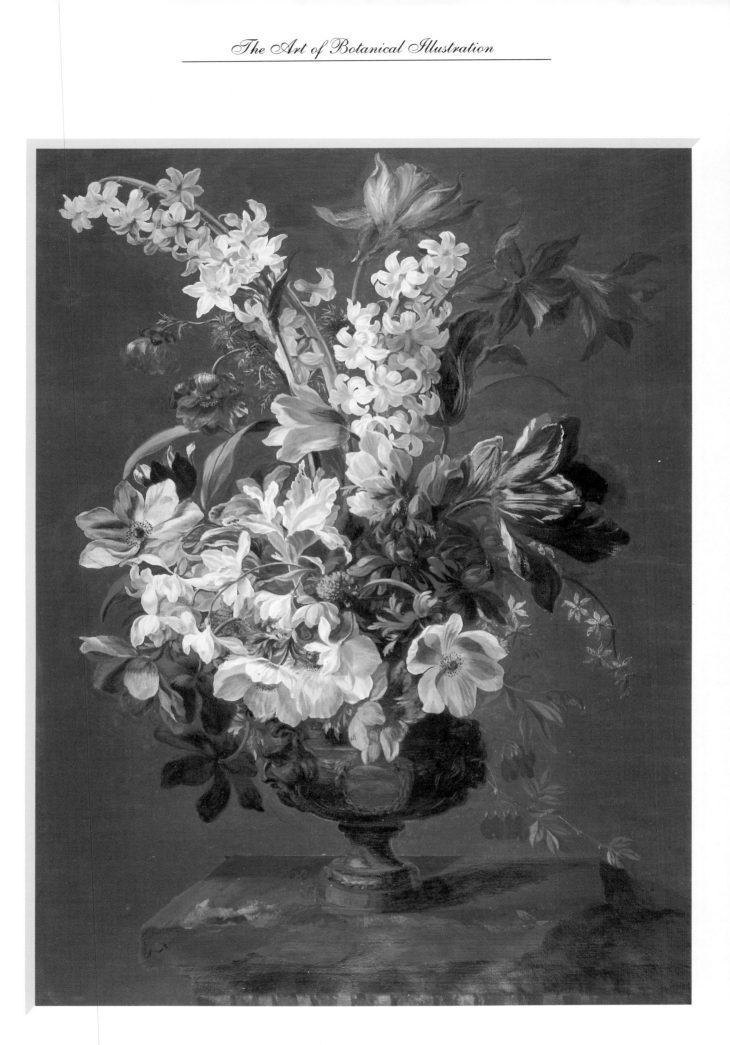

MIXED FLOWERS IN AN URN, ORNAMENTED WITH THE
ASTROLOGICAL SYMBOL FOR PISCES (watercolour
and bodycolour with gum arabic on paper)
Mary Moser

THE PONTIC RHODODENDRON (1802)
*The Sexual System of Linnaeus and the Temple
of Flora* (1799–1807)
Dr Robert John Thornton

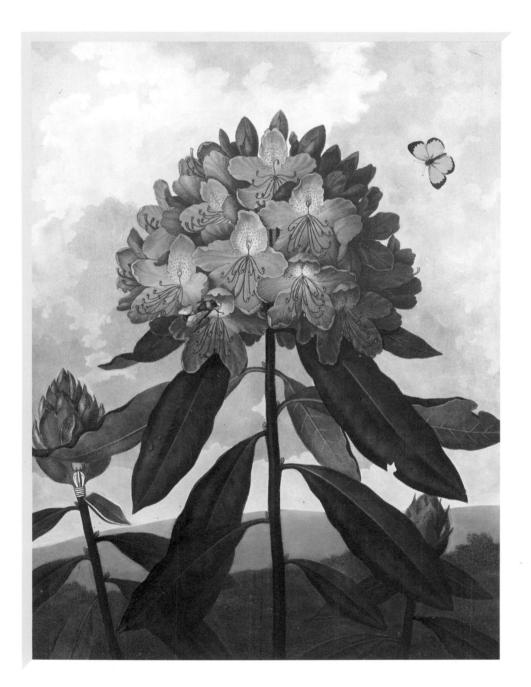

the plant hunter Claes Alstroemer '... We sat till dark at the great table with the draughtsman opposite and showed him in what way to make his drawings, ourselves made rapid descriptions of all the details... while the specimen was fresh.'[11] Later on, during the period when the expedition visited the Society Islands, New Zealand, Australia and Java, there were far too many new plant specimens so Parkinson was only able to make outline drawings. In due course, this mass of uncompleted work was finished by John Frederick Miller, his brother James and Frederick Polydore Nodder, botanic painter to Queen Charlotte.

Dr Robert John Thornton (c1768–1837) is best remembered for the huge folio known as Thornton's *Temple of Flora*. This formed part of a larger work called *New Illustration of the Sexual System of Linnaeus*.

This was issued in parts, as was generally the custom, and the first part was available in 1799. But it is the third section (published separately) that became so well-known. It consisted of 28 sumptuous flower portraits, set against appropriate backgrounds. Dr Thornton provided the text which is as flowery as the volume itself. There has never been anything quite like it since, and complete copies are very valuable. The flowers are chosen apparently at random − tulips, as one would expect, roses (painted by Thornton himself), auriculas, lilies, the famous 'night-blowing Cereus', the dreadful dragon arum, passion flowers, cyclamen, 'the maggot-bearing stapelia', 'the Pontic rhododendron' and the American cowslip are some of those featured. Thornton gives an 'Explanation of the Picturesque plates'[12] and some irresistible extracts are set out as follows: 'Each

11. *Rauschenberg, 1964.*

12. *The number of plates varied depending on the edition.*

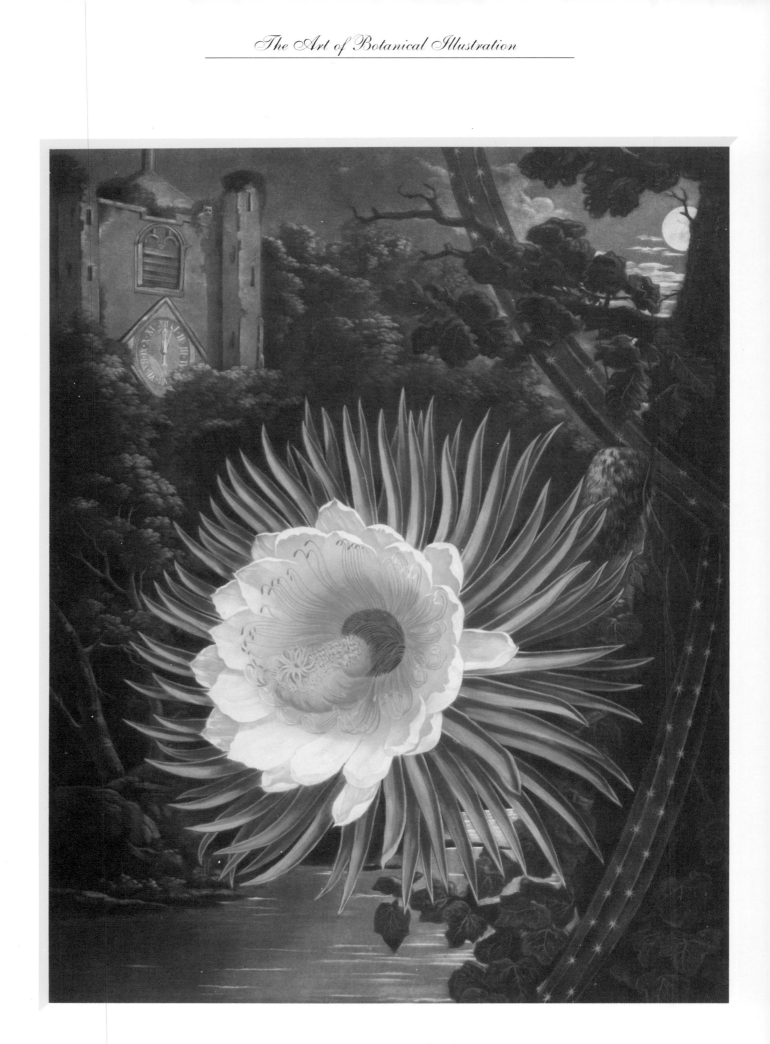

THE NIGHT-BLOWING CEREUS (1800) – *Cactus grandiflorus*
The Sexual System of Linnaeus and The Temple of Flora (1799–1807)
Dr Robert John Thornton

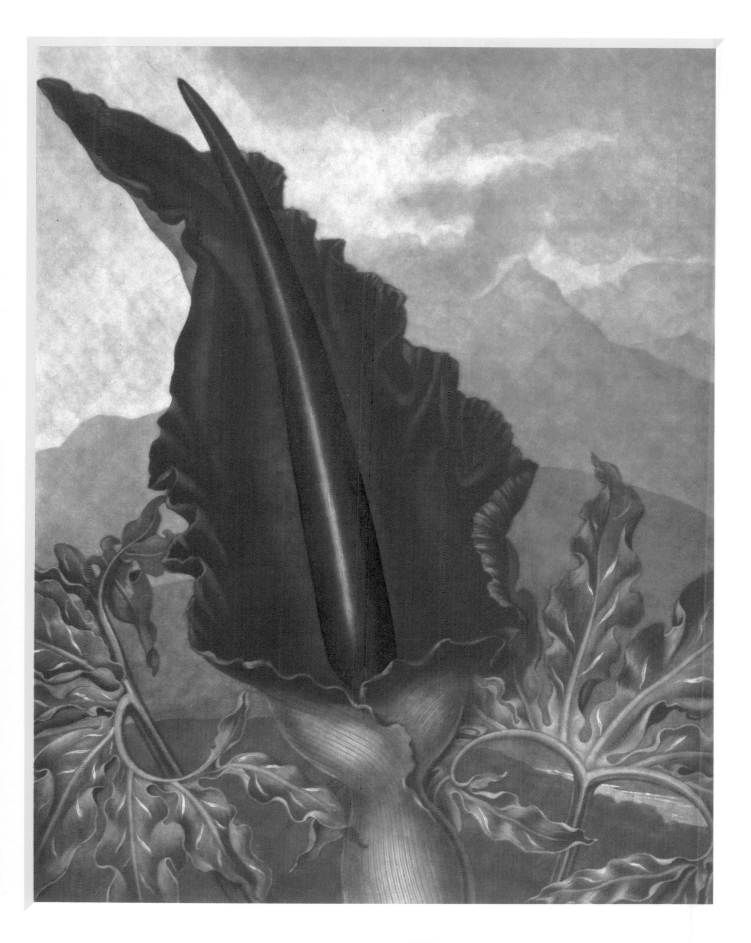

THE DRAGON ARUM (1801)
*The Sexual System of Linnaeus and the Temple
of Flora* (1799–1807)
Dr Robert John Thornton

THE AMERICAN COWSLIP (1801) – *Meadia*
The Sexual System of Linnaeus and *The Temple
of Flora* (1799–1807)
Dr Robert John Thornton

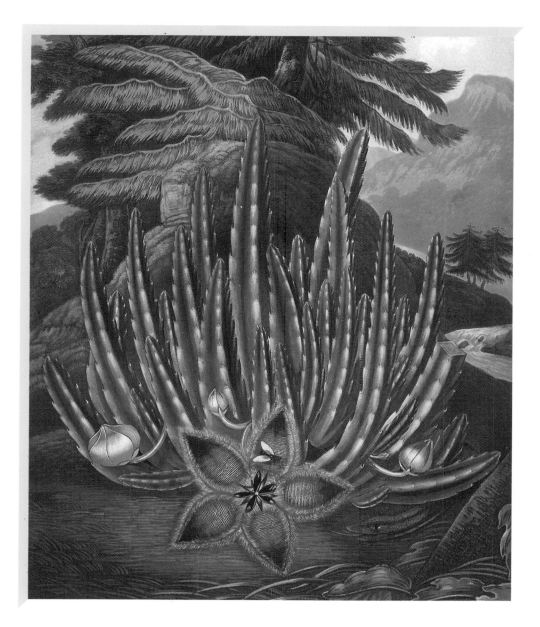

THE MAGGOT-BEARING STAPELIA (1801)
(hand-coloured engraving)
*The Sexual System of Linnaeus and the Temple
of Flora* (1799–1807)
Dr Robert John Thornton

scenery is appropriated to the subject. Thus in *the night-blowing Cereus* you have the moon playing on the dimpled water, and the turret-clock points to XII, the hour at night when this flower is in its full expanse,' and, 'In the DODECATHEON or *American* Cowslip *(Dodecatheon meadia)* a sea view is given, and a vessel bearing a flag of that country'. 'In the *white* lily, where a dark background was obliged to be introduced to relieve the flower, there is a break, presenting to the view a temple, the only kind of architecture that can be admitted in a garden.' 'The TULIPS and HYACINTHS are placed in Holland, where these flowers are particularly cultivated, embellishing a level country.' 'In the *Maggot-bearing* STAPELIA you will find represented a green African snake, and a blow-fly in the act of depositing her eggs in the flower, with the maggots produced from this cause.' 'The clouds are disturbed and everything looks wild and sombre about the *Dragon* ARUM, a plant equally poisonous as foetid. This extremely foetid poisonous plant will not admit of sober description. Let us therefore personify it. SHE comes peeping from her purple crest with mischief fraught: from her green covert projects a horrid spear of darkest jet, which she brandishes aloft: issuing from her nostrils flies a noisome vapour infecting the ambient air: her hundred arms are interspersed with white, as in the garments of the Inquisition: and on her swollen trunk are observed the speckles of a mighty dragon: her sex is strangely mingled with the opposite! Confusion dire! All framed for horror; or kind to warn the traveller that her *fruits* are *poison-berries, grateful* to the *sight* but *fatal* to the *taste,* such is the plan of PROVIDENCE, and such HER wise resolves.'

The Indian Reed (or Canna) yields this particularly lugubrious (unsigned) poem attributed to George Shaw.

Where Sacred Ganges proudly rolls
O'er Indian plains his winding way,
By rubied rocks and arching shades
Impervious to the glare of day,

Bright Canna, veiled in Tyrien robe
Views her lov'd lord with duteous eye;
Together both united bloom
And both together fade and die.

Thus, where Benares' lofty towers
Frown on her Ganges' subject wave,
Some faithful widow'd bride repairs
Resolv'd the raging fire to brave.

True to her plight'd virgin vow
She seeks the altar's radiant blaze
Her ardent prayers to Bramah pause,
And calm approaching death surveys

With India's gorgeous gems adorn'd
And all her flowers, which loveliest blow:
'Begin' she cries 'the solemn rites
And bid the fires around me glow.

A cheerful victim at that shrine
Where nuptial truth can conquer pain,
Around my brows rich garlands twine,
With roses strew the hallow'd plain.

Near yon deep grove the pyre ascends,
Where, pale in death, Calindus lies;
Soon shall these arms no more withheld,
Embrace him in his kindred skies.

Friends of my youth, your plaints forbear
Nor with a tear these rites profane;
E're long, the sun, that now declines,
Shall see me midst the sainted train.

Mother, my last embrace receive;
Take sisters, take, this parting kiss:
A glorious martyr decks your race
And leaves you for the realms of bliss.

Hark! From the clouds his voice I hear;
Celestial visions round me fly!
I see the radiant shape appear,
His image beckons from the sky.

Haste, Holy Brahmins! Light the blaze
That bears me to my parted love:
I fly, his seraph form to meet,
And join him in the realms above.'

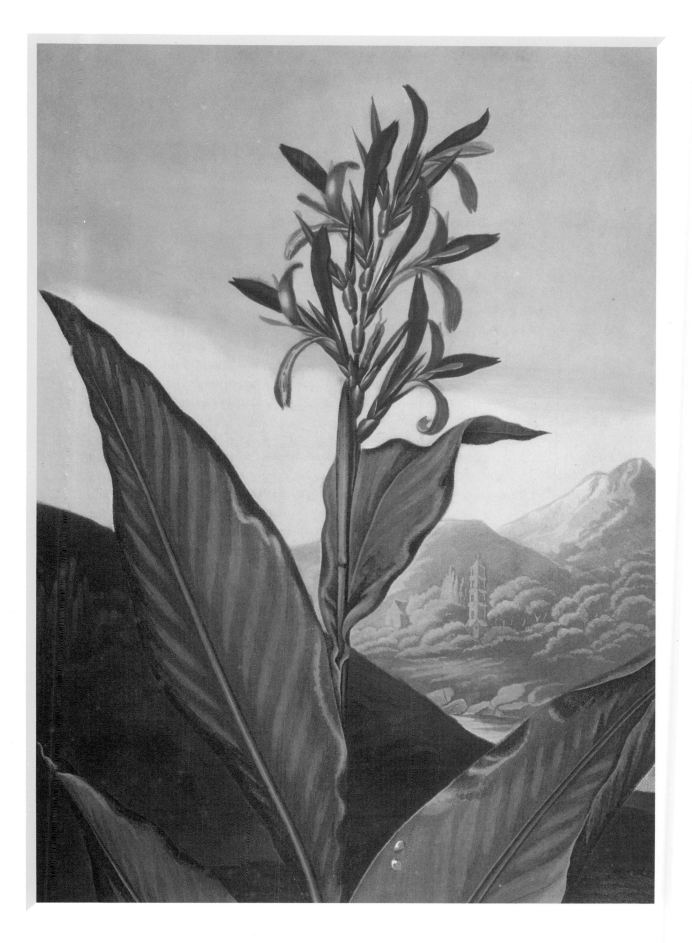

INDIAN REED (1804) – *Canna indica*
*The Sexual System of Linnaeus and the Temple
of Flora* (1799–1807)
Dr Robert John Thornton

THE SNOWDROP (1804)
(handcoloured engraving)
*The Sexual System of Linnaeus and the Temple
of Flora*
Dr Robert John Thornton

'After the mournful sacrifice, the ashes of the faithful widow are collected and deposited in an urn, placed in the family sepulchre; and it is both . . . an affecting and interesting sight to see the Hindoos proceeding in groups, carrying flowers in their hands, which they spread over the tomb of the deceased, at the same time they chaunt solemn songs in honour of the dead.'

The illustrations for the *Temple of Flora* are very handsome; they were drawn by a team of artists which included Peter Henderson, Philip Reinagle, Abraham 'Moonlight' Pether (famous for his night scenes), Sydenham Edwards, and, of course, Thornton. The large engravings are a mixture of mezzotint by Ward, Earlom and Dunkarton, and aquatints by Stedler and Sutherland. Sometimes the plates are a combination of both processes, and they were also basically engraved in colour and afterwards finished by hand. The whole exercise cost an astronomical amount and Thornton found himself in serious financial problems. He blamed the French Revolution for his difficulties:

APOLOGY TO MY SUBSCRIBERS

'It was my original idea, had the times been propitious, to have greatly enlarged this part of the work, and presented the world with seventy PICTURESQUE BOTANICAL COLOURED PLATES, in which case another distribution of them would have been made, and *every class* illustrated by SELECT EXAMPLES of the *most interesting flowers*, accurately *described*, and immortalized by *poetry*; but during the progress of this *expensive* work, with the exception of a few months respite, infuriate *war* has constantly and violently raged, which, like a devouring conflagration, destroys everything before it; commerce, agriculture and *The Arts*, all the sources of public prosperity, and private happiness, are by it dried up and annihilated. The once *moderately rich* very justly now complain they are exhausted through *taxes* laid on them to pay armed men to diffuse *rapine, fire*, and *murder*, over *civilized* EUROPE. *One Monarch* dares, in the face of *that religion* which teaches *no difference among men*, to wage *universal* war only from motives of a cursed *ambition*! All kinds of crimes are now every hour accomplishing on the sanguined theatre of cruel War! The earth is inundated with human blood! The man of sensibility, his heart overwhelmed with grief, and shame, beholds such *atrocious scenes* with *horror*! There is no counterpart in NATURE to compare with *such Men*. Tygers do not even gorge themselves with the blood of Tygers!

In 1811, in order to attempt to salvage something from the impending disaster he was allowed to hold a lottery, in which the first prizes were the original paintings for the book, while the other prizes were copies of the volume, sets of unbound plates, and copies of his other books. But by this time the day of the great florilegium was past, and the lottery was not as successful as had been hoped. Thornton died in 1837, leaving his widow and family in great poverty. It is now assumed that many more sets of the plates were struck at the time of the lottery than were publicly accounted for, as, occasionally, sets or single illustrations with various watermark dates appear at sales or auctions.

THE PERSIAN CYCLAMEN (1804)
(handcoloured engraving)
The Sexual System of Linnaeus and the Temple of Flora
Dr Robert John Thornton

Pre-Renaissance to Post-Revolution
1450–1850

IN RENAISSANCE EUROPE the arrival of new and exotic plants from the Far East and the Americas created considerable interest, among physicians in particular, and among gardeners. A new breed of gardener developed, a keen collector of beautiful or rare plants. The noble and wealthy patrons of the arts at this time could afford to commission sets or collections of botanical drawings which were bound into sumptuous folios. Many of these have, fortunately, survived the vicissitudes of time.

In addition to or instead of their 'physick' gardens, vineyards, orchards, nutteries and vegetable plots, the wealthy were beginning to have their estates laid out in fashionable style. 15th-century Renaissance gardens had formal parterres (arrangements of flower-beds) which were a development from embroidery design and were best seen from above. They were often bright with marigolds from America; peonies from Southern Europe, the Middle East, India and China; carnations from southern France; gladioli from the Mediterranean area and South Africa; crown imperials from the Middle East; lilies of all kinds from various parts of Europe, Greece, the Middle and Far East; amaranthus and dahlias from tropical America and many more. Taller plants like the hollyhock from China and the giant annual sunflower from America would also have been included in larger designs of this formal kind of gardening. Both of these plants would have needed some leafy form of concealment for their lower stems at flowering time.

Nasturtiums, asters (Michaelmas daisies), tobacco plants, evening primrose and the striking, scarlet-flowered, crimson-leaved *Lobelia cardinalis* were making their first appearance on the garden scene, and though not all these flowers were suitable in height, shape or character, all would have been experimented with because of their novelty. Gardeners may appear to act slowly or with deliberation but they *never* miss a chance to acquire new plants. Botanic gardens such as those at Pisa (1543) and Padua (1545) were laid out to accommodate the new plants which were being studied. The subjects were drawn in a more scientific manner than formerly, and were extremely beautiful.

The work of Leonardo da Vinci (1452–1519) stands

supreme in the exciting period of Italian history known as the Renaissance. His drawings, 500 years later, still sing with his vitality and life-force. The small collection of his flower-drawings, in chalk, charcoal or crayon, that have come down to us are perfect examples of line, rhythm, balance, vitality and exactness. What he saw he drew, and as with all great artists, drawing and seeing are analogous. But his study of the madonna lily shows that when he saw that nature's arrangements were inharmonious, he tidied her up. Leonardo made many botanical studies but these have not survived. The Spanish historian Oviedo[15] regretted that Leonardo could not be persuaded to accompany him on his many voyages to America, and Mexico in particular, to draw the newest plant discoveries. But Leonardo was at the height of his creative powers and must have been working on one or more of his great masterpieces at this time. Oviedo wrote *La General y Naturel Historia de las Indias,* though this was not produced until 1526, seven years after Leonardo's death.

In the borders of devotional books of that period were to be seen charming representations of flowers, painted in the trompe l'oeil manner. The strong shading beneath the stems and leaves makes the blooms seem as if just laid down on a coloured or gilded ground. They are accompanied by a friendly assortment of butterflies, moths, caterpillars, grasshoppers, ladybirds, dragonflies and even a snake or two in this artificial Eden. One of the best known examples of this work is *Les Heures d'Anne de Bretagne,* the *Book of Hours of Anne of Brittany,* painted by Jean Bourdichon between 1500 and 1508. These are more exactly botanical than some earlier works or the very beautiful Grimani Breviary which is in St Mark's Library in Venice. In this fat volume, the flower stems are sometimes kept in place, as if on fabric, with realistically painted sharp gold pins.

It was through Albrecht Dürer (1471–1528) that the ideas from Renaissance Italy reached northern Europe. He is famed for his engravings and woodcuts but he also painted in watercolour – though not often. He instructed

15. *Gonzalo Fernández de Oviedo y Valdez (1478–1557)*

MADONNA LILY – *Lilium candidum*
Leonardo da Vinci, *c.*1479

DAS GROSSE RASENSTÜK
(The Large Piece of Turf)
(watercolour on paper)
Albrecht Dürer, *c.*1503

MARSH MARIGOLD – *Calltha palustris,*
and WOOD ANEMONE – *Anemone nemorosa*
(ink and black chalk)
Leonardo da Vinci, c.1505

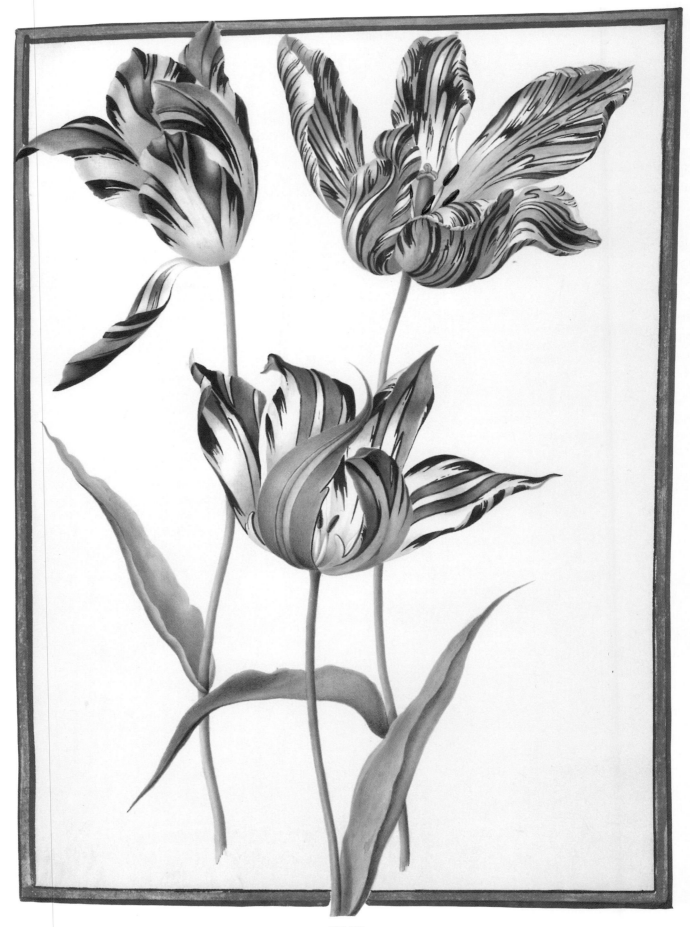

TULIPS
(watercolour and bodycolour on prepared
vellum)
Nicholas Robert

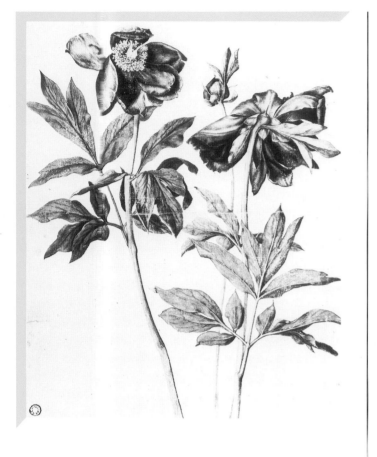

PEONIES
Albrecht Dürer, *c.*1503

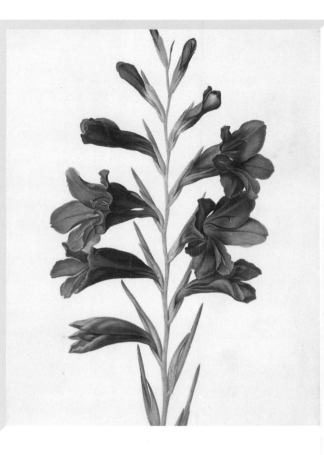

GLADIOLI
(watercolour and bodycolour on prepared
vellum)
Nicholas Robert

artists to 'study nature diligently. Be guided by nature and do not depart from it, thinking you can do better yourself. You will be misguided, for truly art is hidden in nature and he who can draw it out possesses it.' Dürer was the first to do just this and one of his most famous paintings is *Das Grosse Rasenstük* – a large piece of turf. This is a very detailed painting of brown soil from which grow grasses, a flowerless plantain, daisy-leaves, salad burnet and a dandelion with a closed bloom.

PRINTING AND ENGRAVING

New methods of reproducing drawings brought them within the reach of more people. This caused the demand for reasonably inexpensive printing to escalate. For the first herbals the original drawings and paintings were executed on paper or vellum and bound in with whatever text there was so as to make a book, often called a folio. This word has had several meanings down the centuries and is still much used by publishers today. These very precious books were only to be found in the libraries of monasteries, royalty or the aristocracy. The monks would make (almost) perfect copies of the volumes as gifts or exchanges with other religious houses, or the monastery might be requested to make a copy of a special treasure to mark a significant historical occasion. It was at this

stage that any existing errors were perpetuated or even magnified because the brother who was working on the calligraphy might know little of herbs. The translations were done by monks who had knowledge of other tongues but perhaps less of plants or medicine, and this is where loose drawings were occasionally copied upside down or added to.

The woodcut process was used from *c*1418 onwards for whole pages of text, and for the illustrations. The cuts were made with a knife in wood *plankwise*. Wood engravings were cut using a burin[16] or other sharp engraving tool on the end-grain making very fine lines. However, wood engraving does not really occur much before the mid-18th century. Gutenburg had invented the first printing press in Europe in about 1455. The illustrated herbal books emanating from these first presses had pictures of two types. The first was drawn without shading so that the plant's colouration could be carefully filled in later. The first few copies might be painted by the artist as a guide. The remainder of the run was either painted in by children or left uncoloured for the purchaser to fill in if he so wished. The other kind of illustration was

16. *A burin is a sharp engraving tool generally used for
engraving copper.*

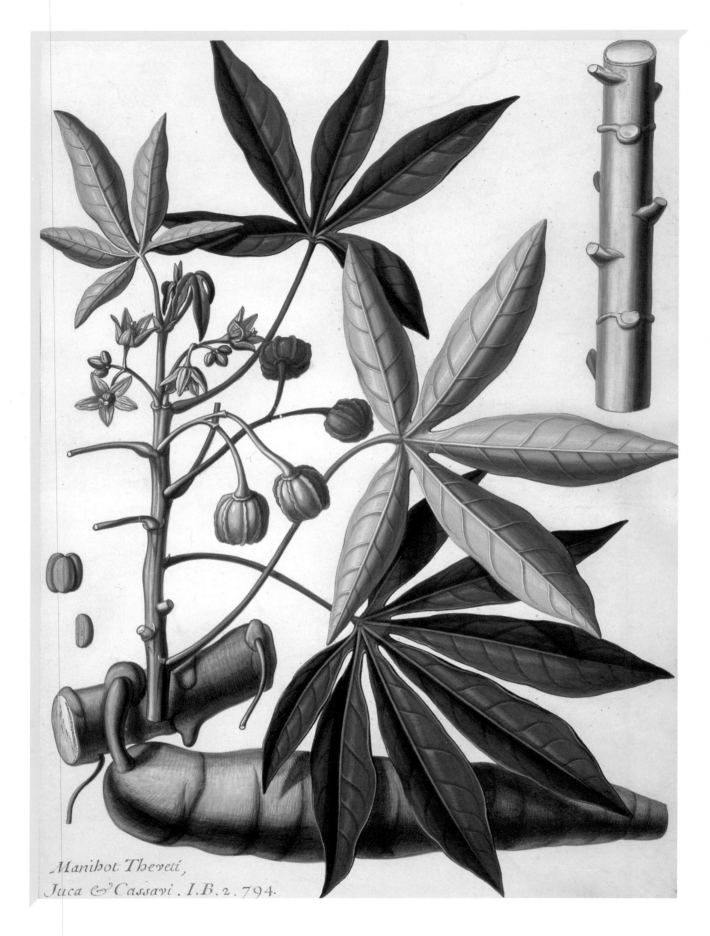

Manibot Theveti,
Juca & Cassavi. I.B. 2. 794.

Manibot theveti
Claude Aubriet

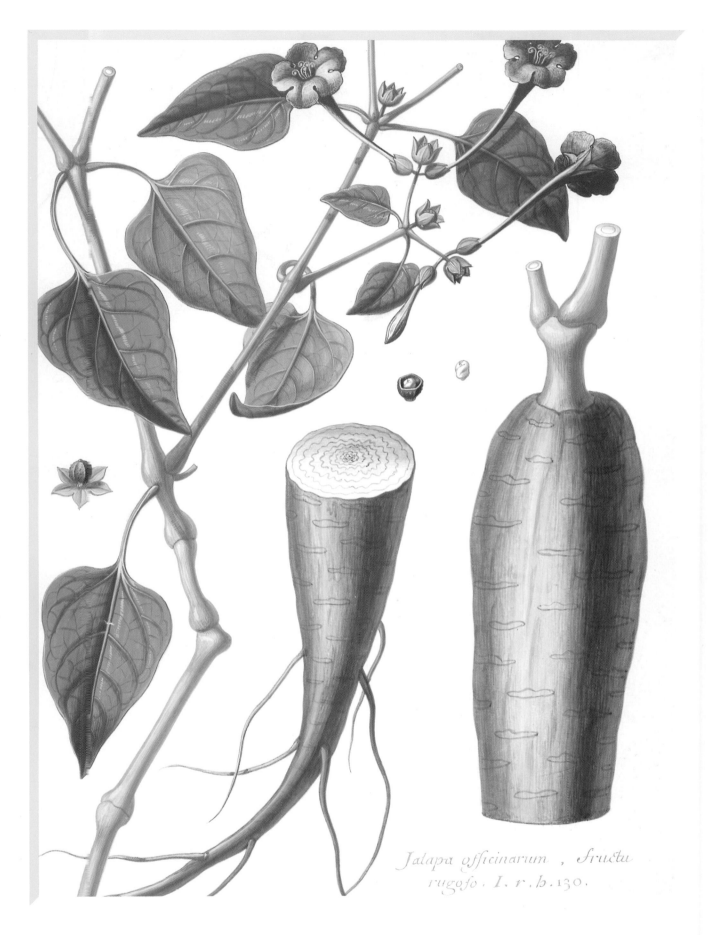

Jalapa officinarum , fructu
rugofo . I . r . h . 130 .

Jalapa officinarum rugato
Claude Aubriet

Colocynthis fructu rotundo minor
Claude Aubriet
(overleaf)

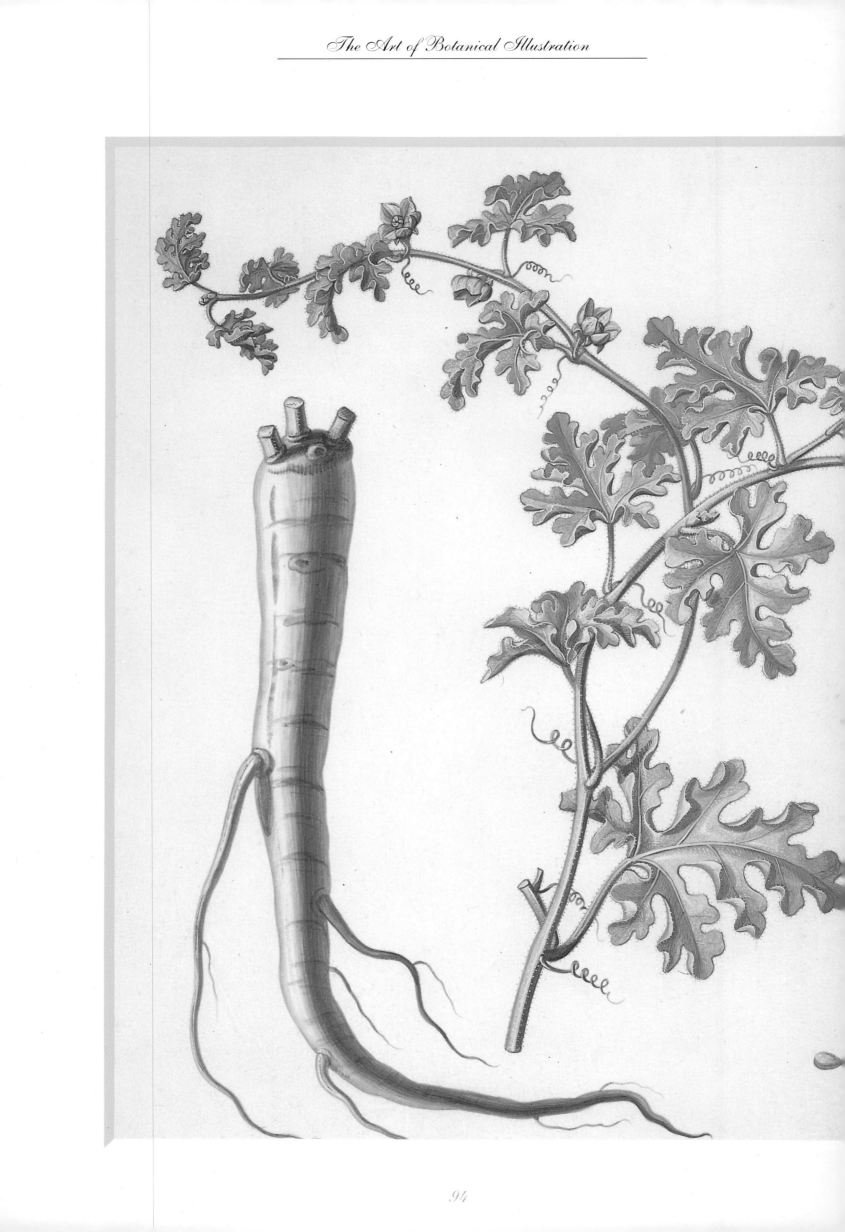

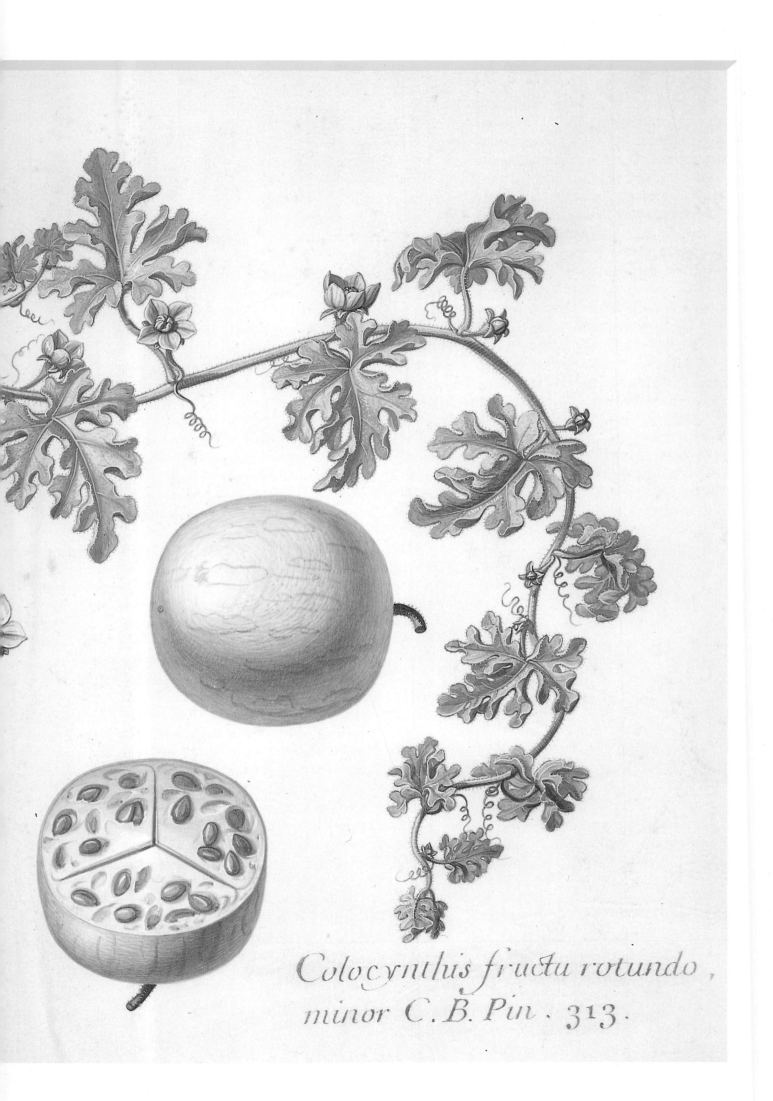

*Colocynthis fructu rotundo ,
minor C. B. Pin . 313 .*

drawn with appropriate shading and was not intended to be coloured.

Line-engraving was first developed in Italy in the 15th century, and good examples may be seen in the work of Dürer. The burin was used with a pushing movement to draw the design on to a soft metal plate, usually copper. The burin leaves a firm, strong track in the copper and considerable skill is needed to make a good picture, because the most natural way to draw is to push *or pull* the tool, as the drawing requires.

Etching involves the use of the same kind of thin copper or zinc plate which has been covered with a layer of acid-resistant wax called a 'ground'. The design is drawn or scratched through to the ground, but not so as to damage the plate, which is put into a bath of diluted acid. The acid 'bites', that is, it eats away areas unprotected by the wax ground. Then the ground is removed with a solvent, printer's ink is rubbed into the design-lines and a print is made by passing the plate covered with a sheet of paper through a roller press.

Using this method, the finished print is, of course, reversed. If a similar print to the drawing is required, an outline of a tracing of the drawing has to be made and imprinted on the ground. The rest of the detail of the drawing is added in reverse, using a mirror. The first print is then coloured in if required, depending on the presence or absence of shading. Some artists did their own etching, thus preserving their own true line. Most had to rely on other competent artists to transfer their work to the plate, which would in turn be given to the engraver to make a final print. It was during this process that the quality was retained or lost, and comparisons through the various stages of older work are very interesting and sometimes very depressing. An incompetent engraver could, and very often did, take the life out of good drawings.

FRENCH FLOWER-PAINTERS AND ILLUSTRATORS

Jacques Le Moyne des Morgues (c1533–c88) was born in Dieppe, a centre for cartography in the 16th century. In 1564 an expedition to Florida was planned and Le Moyne went along as the official artist. On their arrival, despite the troubled situation, things went reasonably well, and Le Moyne was able to map the rivers and attend to his other duties. However, this peaceful situation was not to last and the Indians ceased trading their food with the French exploratory party, who may have been in a state of siege within their newly-built Fort Caroline. They were close to starvation – some of their party had died already – when a British privateer arrived, captained by John Hawkins. Ever practical, Hawkins sold the French a ship and provisions.

Later the same year the Spanish attacked Fort Caroline and captured it, killing all but Le Moyne, Lardonnière and 14 of his party, who escaped. A French ship was sent to rescue them but this was shipwrecked nearby and the officers, captain and crew were all killed. Le Moyne and his terrified party managed to launch their own ship and set sail for home, reaching the port of Bristol in the autumn of 1565, little more than a year later. Le Moyne returned to France, but had to flee at the time of the successive massacres of the Huguenots (French protestants) who were being persecuted for their religious beliefs. He returned to England and for a time worked for Sir Walter Raleigh; Le Moyne died in Blackfriars, London, in 1588.

Little was saved from Le Moyne's American voyage. His later work included drawings of garden flowers of the period. He also produced an attractive book of embroidery designs, *La Clef des Champs,* which was dedicated to Lady Mary Sidney, mother of Sir Philip Sidney.

Marie de Médicis was a patroness of the natural sciences and had considerable influence in court circles, particularly after Henry IV's assassination in 1610, when she became Regent of France. She appointed Pierre Vallet (c1575–c1635) botanical painter to the French court. He produced a florilegium in 1608 called *Le Jardin du très Chrestien Henry IV, Roi de France et de Navarre, dédié à la Reyne.* The featured garden was at the Louvre, planned and managed by the famous French gardener Jean Robin, who grew the new, exotic plants from Guinea (West Africa) and others from Spain and southern Europe. There is no text but the drawings of the plants are surprisingly accurate, considering the volume was designed as a pattern-book for embroidery.

Court favourites come and go, and Pierre Vallet's successor was the talented Daniel Rabel (1579–1637). Rabel was a landscape artist, a portraitist and a designer for the ballet, in addition to being an excellent flower-painter. In 1622 he produced a florilegium called the *Theatrum Florae;* some of the original drawings have survived and these are preserved in an album which is kept in the Bibliothèque Nationale (formerly the Bibliothèque du Roi) in Paris. These form a small part of a large and wonderful collection of drawings and paintings which are now kept – very suitably – at the Jardin des Plantes (formerly the Jardin du Roi, founded in 1635).

Nicolas Robert (1614–85) became famous almost instantly for his delicate and beautiful work on the *Guirlande de Julie,* an album of flower-paintings with quite a tale to it. In Paris, during the reign of Louis XIII, there were many salons which were glittering centres of wit, beauty, taste and culture. One of these was the Hôtel of Madame de Rambouillet, mother of the beautiful Julie

'HORNED POPPY'
Joseph Pierre Buc'hoz
'Collection Précieuse et Enliminée des fleurs
les plus belles et les plus curieuses, qui se
cultivent tant dans les jardins de la Chine que
dans ceux de l'Europe.'

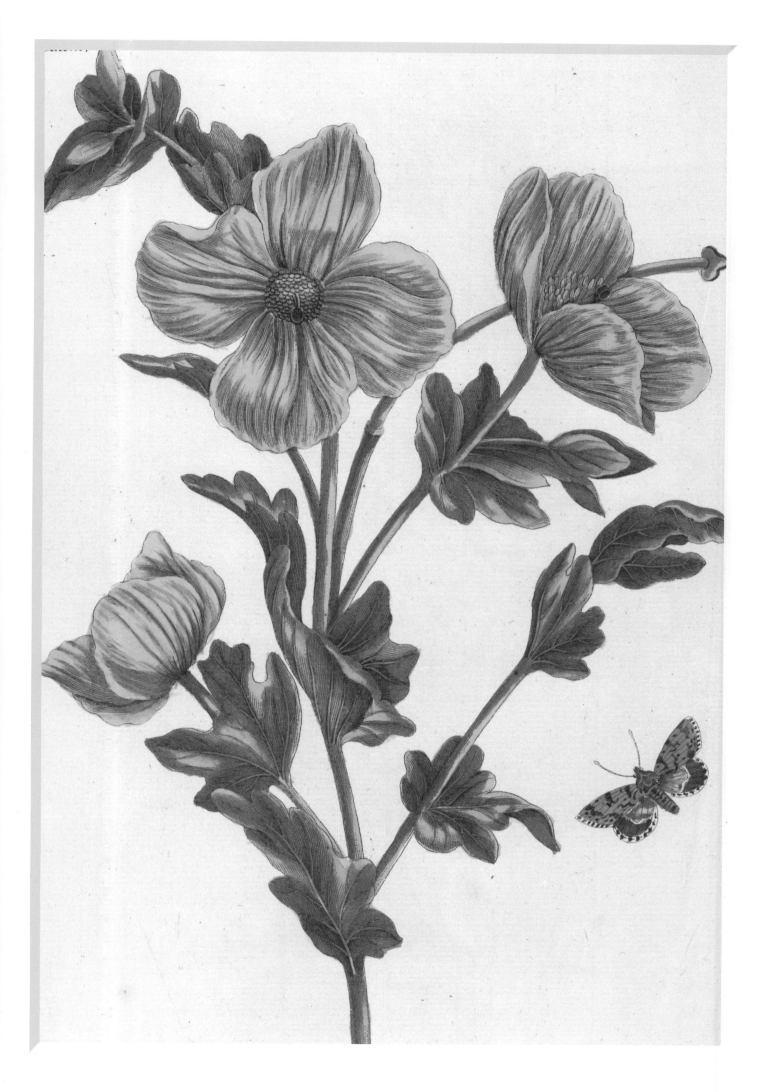

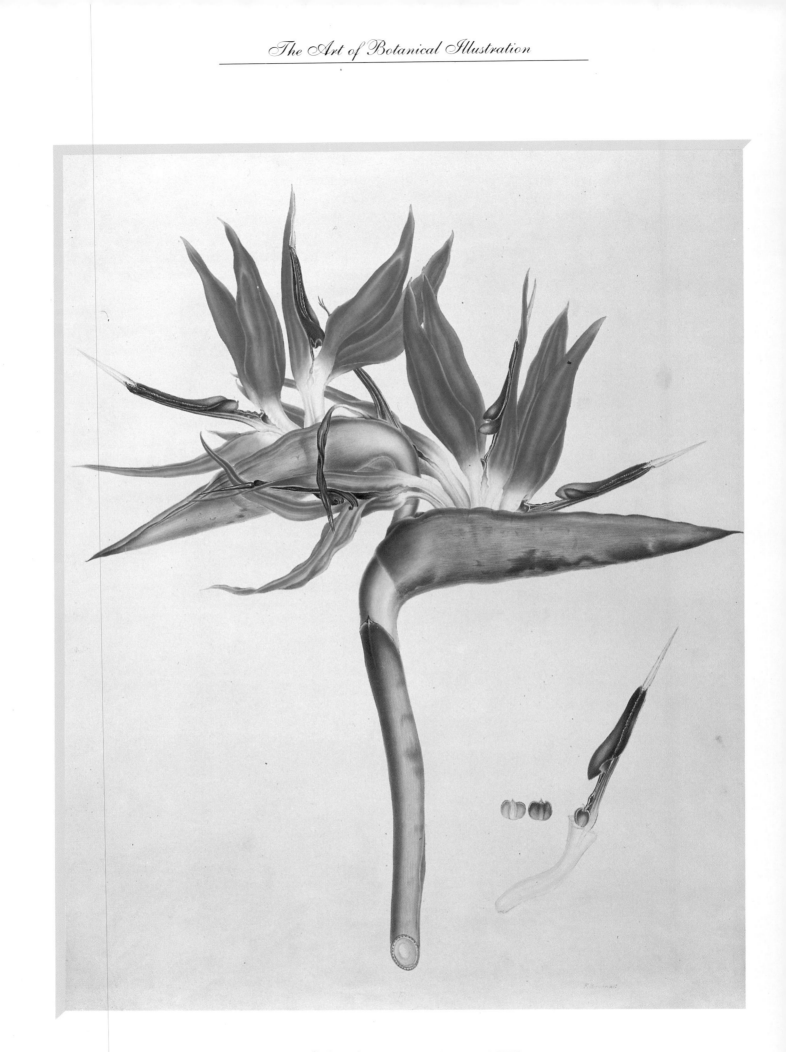

Strelitzia reginae – BIRD OF PARADISE FLOWER
Francis Bauer

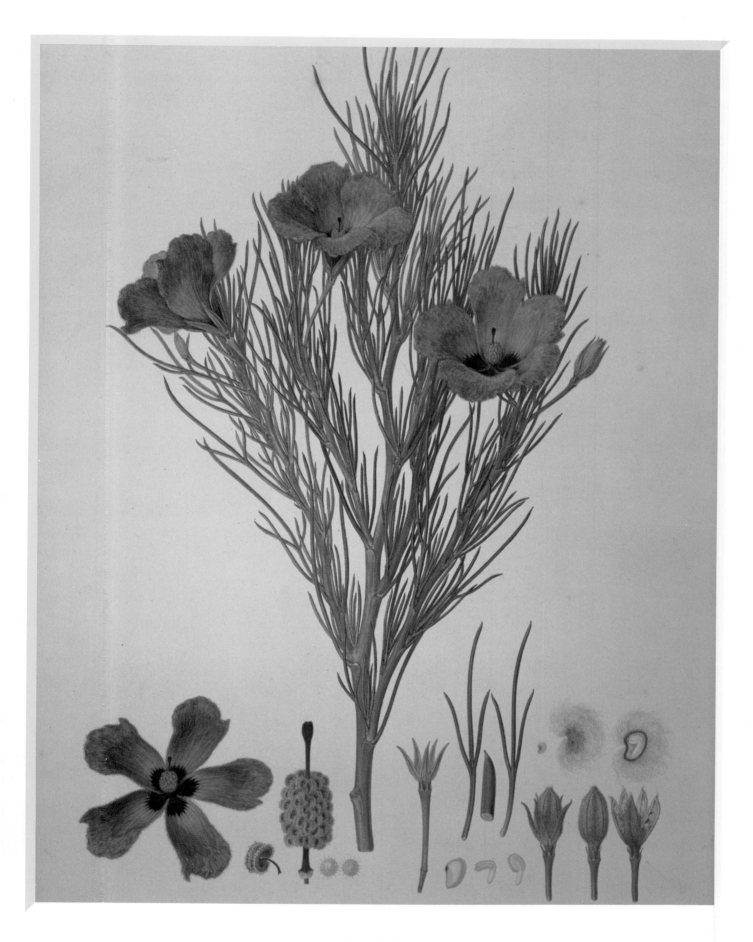

Hibiscus filifolius
(watercolour)
Ferdinand Bauer

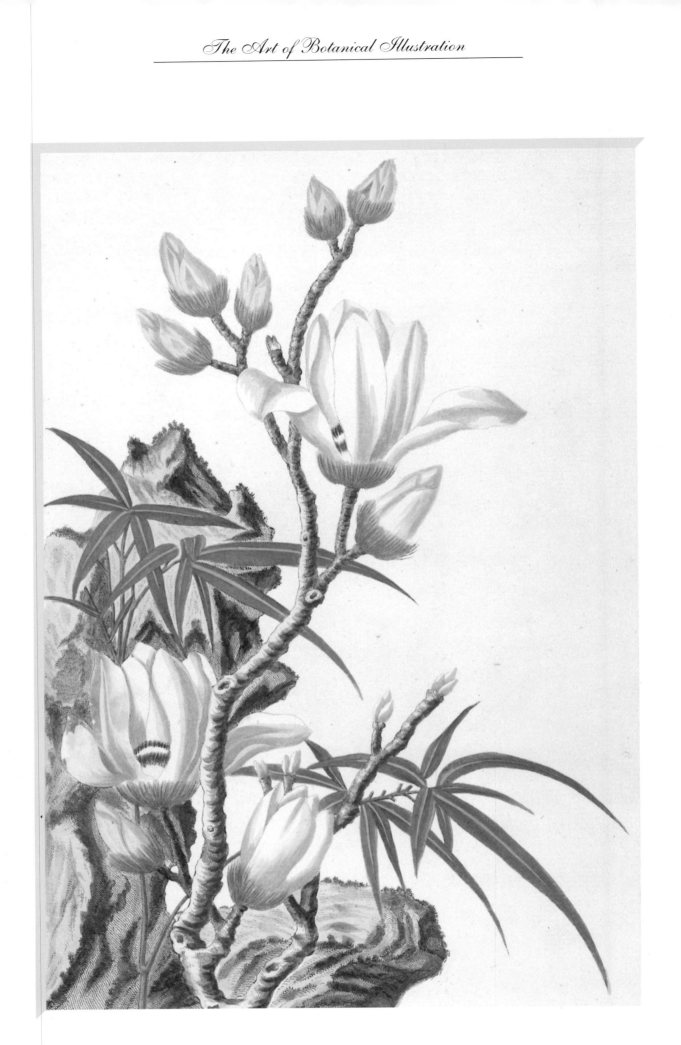

'A MAGNOLIA'
Joseph Pierre Buc'hoz
'Collection Précieuse et Enliminée des fleurs
les plus belles et les plus curieuses, qui se
cultivent tant dans les jardins de la Chine que
dans ceux de l'Europe.'

d'Angennes, adored by all and besieged by many suitors. As the years passed Julie rejected her suitors one by one, until eventually she realized that there was a distinct possibility that she might never marry. Fortunately, the baron de Sainte-Maure, later the duc de Montausier came to pay court to beautiful Julie. She accepted his proposal, but made certain conditions. Firstly, she asked him to become a Catholic, as she was; secondly, she told him that he had to wait until she named the wedding day.

The baron commissioned an album of flower-paintings by Robert, with calligraphy by Jarny, as a birthday gift for her. This was the *Guirlande de Julie* which contained madrigals and poems by the greatest exponents of the times. In 1641 baron de Sainte-Maure went to war and was taken prisoner, languishing in captivity for four years. But in 1645 he was released and came back to claim his bride, now 38 years old. He was three years younger than her. The marriage took place at last, so the story did have a happy ending. The *Guirlande* still exists in France, where it is in a private collection.

Robert became famous and was asked to paint the plants in the garden of Gaston d'Orleans, Louis XIII's younger brother, at Blois. The paintings formed part of the Royal collection, known as the *Vélins (les Vélins du Roi)*. Robert became court painter in 1664, 'peintre ordinaire de Sa Majesté pour la miniature' and continued to add to the *Vélins* at a rate of about 20 a year. At this time the gardens at Blois were managed by the Scottish botanist, Robert Morison, who probably interested Robert in scientific botanical illustration. When the *Académie Royale des Sciences* was founded it was decided by the members to produce a History of Plants, the *Mémoires pour Servir à l'Histoire des Plantes,* with Robert as the main illustrator. This volume (with 39 plates by Robert) was published in 1675 as a precursor to a huge project – the *Recuil des Plantes* – that was delayed for years. Robert died before the work was completed, though most of the illustrations were his.

The extra plates and the text were ready by 1692, but by then France had been at war for three years and this was not the time for the publication of such an extravagantly beautiful work. Eventually, however, it was published, in three volumes, almost exactly 100 years after the idea had first been conceived. Few copies were made and so it never went on sale to the public. It was at that time the finest publication of botanical work in the world, and it constituted an important record of the plants currently in cultivation.

Nicolas Robert's successor was Jean Joubert, a very competent artist but not capable of the extraordinarily high quality work of Robert before him and Aubriet who followed him.

Claude Aubriet (1665–1742) was born in Châlons-sur-Marne, but came to Paris to work. He was discovered by Jean Joubert who recognized his promise and encouraged

his work on the *Vélins*. While doing so he met the greatest botanist of the day, Joseph Pitton de Tournefort who was at that time Professor of Botany at the Jardin du Roi. It was here that Tournefort had begun his own system of plant classification. He was delighted to meet Aubriet who did the fine engravings for Tournefort's *Elements de Botanique,* published in 1694, later to be translated into the Latin *Institutiones Rei Herbariae* in 1700. This work took plant classification several stages forward. Aubriet's drawings were done under Tournefort's direction, and it was thanks to his mentor at this time that all his later botanical work was to the same high standard.

Tournefort took Aubriet with him to the Levant some six years later, and wrote this famous sentence which is as true now as then. 'It frets a man,' said Tournefort in his account 'to see fine Objects, and not to be able to take Draughts of them; for without this help of *Drawing* 'tis impossible any account thereof should be perfectly intelligible.' They visited Crete, 32 different islands in the Aegean, Constantinople and the shores of the Black Sea. During this time Aubriet sketched, drew and painted indefatigably, making on-the-spot records of immense botanical value. The drawings were sent home and when the travellers reached Constantinople they found a critical letter from the superintendent of the Jardin du Roi. It appeared that he was not satisfied with the quality and colouration of the work, saying that it was 'slight' and the greens were wrong. This is the same situation in which Sidney Parkinson found himself. When he was faced with dozens of new plant-specimens, he had to draw as much as he could as quickly as possible and make colour notes where time permitted. This is just one of the difficulties of working in the field.

Two years after they had set sail they returned safely to France, where Aubriet's technical skills began to be appreciated. In due course, he succeeded Joubert at the Jardin du Roi, and worked up his sketches of the Levantine plants into finished paintings, most of them hitherto unknown. His name is commemorated in the exuberant spring-flowering 'Aubrieta' – usually mispronounced 'Aw–bree–sha'. Like most artists Aubriet took pupils, and one of them, Madeleine Basseporte, was to succeed him after his retirement as *Peintre du Roi, de son Cabinet et du Jardin du Roi.*

During his later years Aubriet enjoyed his work and made the drawings for Vaillant's *Botanicon Parisiense* (1727). He took up another interest, entomology, and began drawings for a great work on insect metamorphosis which he never completed. Towards the end of his life his style became more decorative but it was always saved from being conventionally beautiful by the early influence of Tournefort's scientific training. Aubriet retired in 1735, passing on his title to Madeleine Basseporte (1701–80) who began her artistic career as a portraitist. She soon

turned to flowers as her main subject of interest, and was fortunate to be at the Jardin du Roi with the botanist Bernard de Jussieu who instructed her in her botanical work for some years. This gave her early work scientific credibility. She was popular at the French court, where the King, Louis XV, would watch her working; while there she taught the art of flower painting to the Royal children. She became quite a successful figure at the court, and was consulted on interior decor by Madame de Pompadour. It is nice to be able to record that her status at court did not make her conceited, and her pleasant nature is proved by the fact that she gave free lessons to several poor but talented girls. Madeleine Basseporte was never a great painter, merely a competent one, who worked all her life. On one of her late paintings she wrote in a trembling hand, 'âgée de 80 ans'.

ARTISTS OF THE LATE 18TH CENTURY

Joseph Pierre Buc'hoz (1731–1807) was born at Metz, where he studied law and, later, medicine, obtaining a post as Physician in Ordinary to Stanislaus, King of Poland. He was also exceedingly interested in the production of floras, florilegiums, and compendiums on a diversity of subjects such as botany, minerology, medicine, agriculture and ornithology. He was no artist himself, nor was he a conscientious author in his own right, plundering illustrations and text from many sources to make up his elaborately advertised works which nobody bought. His wife died and, partly because of the Revolution in 1789, he faced financial ruin. He was saved from disaster by the benevolence of one of his deceased wife's wealthier friends, who helped him sort out his affairs, and then married him. One of his best compilations was the *Collection Précieuse et Enluminée* which featured the work of oriental artists.

The Bauer brothers were a phenomenon which has left the world a wonderful legacy of studies, sketches and finished pieces regarded as some of the finest botanical drawings. Ferdinand, the eldest (1756–1826) was born in Feldsburg, as was his brother, Francis (Franz) (1758–1840). Their father, Lucas Bauer, was court painter to the Prince of Liechtenstein, and he died when his sons were very young. Both the Bauer brothers showed an early talent for flower painting. This was encouraged by the abbot of Feldsburg, Father Boccius, who was interested in botany and who commissioned Ferdinand to paint a large number of flower studies. This work took both the brothers to nearby Vienna, where they met Nikolaus von Jacquin, then Professor of Botany at the University. Von Jacquin liked their work and engaged them to paint some of the new treasures in the Schönbrunn. The work of the two brothers was so very similar that in some cases they must have worked together. In paintings of similar plants it is difficult to tell the work apart when looking at the foliage because their palettes

and style were so similar, but when it comes to the flowers, a difference of approach and technique can be seen.

At about this time, John Sibthorp, the Sherardian Professor at Oxford, came to Vienna to see the famous *Codex Vindobonensis*. He had planned an expedition to the Levant and with the encouragement of Von Jacquin and Father Boccius, he decided to take Ferdinand Bauer with him. Subsequently, it was always the adventurous Ferdinand who travelled and Francis who stayed at home. Sibthorp and Ferdinand Bauer left Vienna in 1786. They travelled to Crete, and then through the Aegean to Smyrna (now Izmir), Constantinople, a long inland trip to Belgrade and then back to Cyprus and Greece. During the sea voyages and land expeditions Ferdinand made many botanical sketches and studies, and both of them collected plant specimens which were dried as they went. In 1788 they returned safely to Oxford where there was much work to do in sorting and classifying the specimens. Ferdinand began to work up his sketches to the finished drawings that were later to form the famous *Flora Graeca* (1806–40).

At this time Francis Bauer and the younger Von Jacquin came to visit England. Here Francis met Sir Joseph Banks (1743–1820), President of the Royal Society, a notable name in the annals of English botany. He was wealthy and charming, and assisted the advancement of scientific understanding wherever possible by personally subsidizing artists, botanists and exploratory journeys. King George III appointed him horticultural expert at Kew which meant that he was in all but name its director and arbiter. Banks had for some time recognized the need for a permanent artist there, and having met Francis Bauer he realized that here at last was his man. After consulting with the King, a suitable post was created for Francis at Kew; his salary was funded by Banks himself, both during his lifetime and afterwards. Here Francis stayed quite happily for the following 50 years, painting the new discoveries in the tranquillity of the great and wonderful gardens. It would not have been work for him, indeed, it would have been a vocation. The world is the richer for the cornucopic outpouring of paintings that resulted from the meeting of Joseph Banks and Francis Bauer in about 1790.

John Sibthorp returned to the Levant in 1794–5, but Ferdinand was too busy working on the first batch of drawings to accompany him. Regrettably, Sibthorp contracted tuberculosis during the trip from which he died in 1796. The *Flora Graeca* was to be his best memorial. It was published in sections at a total cost of £30,000, but, fortunately the expense had been anticipated by Sibthorp and funds had been set aside to meet the enormous and uncommercial production costs. Sowerby was so skilled an engraver that he could produce the plates from unfinished drawings. This makes for even more

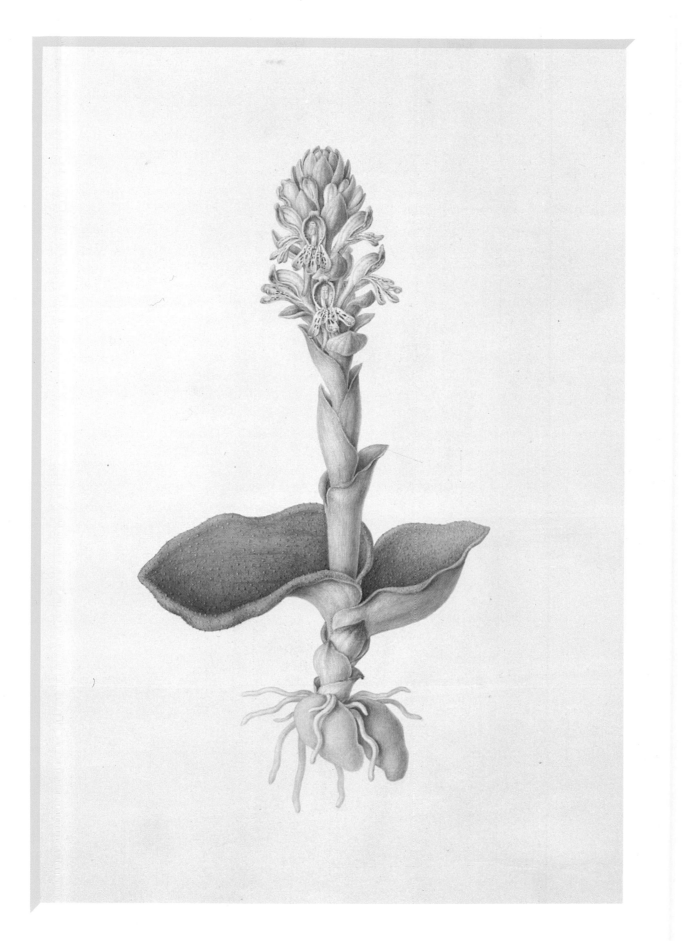

Satyrium erectum
Francis Bauer

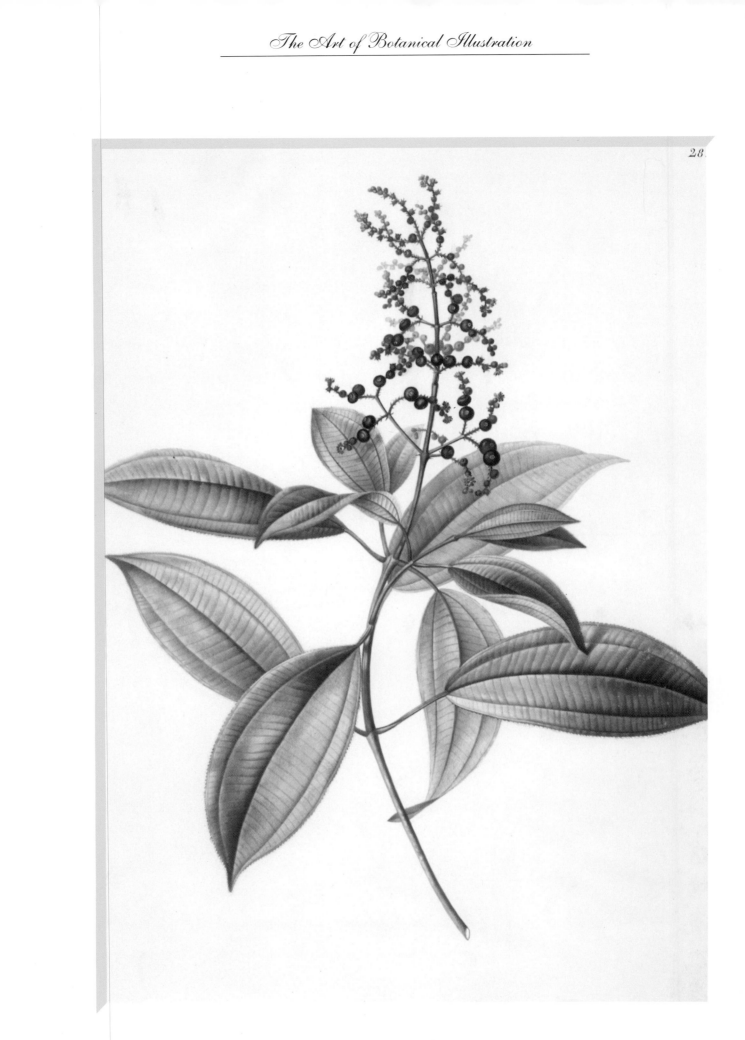

Melastoma ciliata
Pierre Jean Francois Turpin
(Monographies des Melastoma dessins par
P.J.F. Turpin et P.A. Poiteau gravure par
bouquet)

interest because it forces the reader to imagine the original expedition and the later effort that went into the sorting and classification of all the new specimens. This was botany in the raw.

Ferdinand Bauer was to have another chance to exercise his desire to travel. Captain Matthew Flinders, the explorer, navigator, and man of science was preparing an expedition to visit Australia or *Terra Australis* as it was still called. He asked Ferdinand to come in an official capacity and paid him a salary, with a food allowance for himself and his servant. This expedition numbered among its party the landscape artist William Westall and the Scottish botanist Robert Brown. The group set off in the autumn of 1801 in the *Investigator* and the expedition proved to be as exciting and rewarding as was expected.

The account of the sea voyages and the exploratory journeys in the coastal areas of Australia and the subsequent shipwreck, changes of vessel and the imprisonment of Flinders in Mauritius can be read in Flinder's own account, *A voyage to Terra Australis.* The book contains maps, topographical drawings and some of Bauer's paintings.

Some five years later Ferdinand Bauer returned to England with a vast collection of drawings and specimens. After his return, he began work on the *Illustrationes Florae Novae Hollandiae* (New Holland was another name for Australia). But this proposed flora was obviously going to be expensive and Ferdinand found that, owing to the financial and political climate of the times there was not the money nor even the interest available to support the venture. Ferdinand regarded the proposed work as a failure and decided to return to Europe. He settled in a small house near Schönbrunn, although he made one trip to England to see his brother and Sir Joseph Banks. He completed, for his own satisfaction, fortunately, drawings of the Australian plant discoveries. Because of the influence of Robert Brown, Bauer's work on the Australian trip is scientifically better than his earlier work on the *Flora Graeca,* good though this was. Ferdinand died in Schönbrunn in 1826.

Francis Bauer was living at Kew, where he had established himself as botanical artist supreme. He often used a microscope to draw, even better, the detailed dissections for which he is so famous. He did many beautiful plant portraits of all the new discoveries, encouraged by the patronage of George III and Queen Charlotte. The Queen and Princess Elizabeth took painting lessons from him but these did not continue for very long. Perhaps Francis had little patience with gracious dilettantism and less ability to hide his opinions. He died in 1840 and was buried in Kew churchyard.

Pancrace Bessa (1772–1835) was born in Paris, where his obvious talent displayed itself early. Paris was the right place to be at this time, just as the Netherlands had been two centuries earlier. Bessa is thought to have studied under Van Spaëndonck, as had Redouté, Prevost, Poiteau, Chazal and Madame Vincent. At a later date, he was also one of Redouté's few male pupils. Bessa became proficient at stipple engraving, a process that seems to have remained essentially French for some reason. He exhibited at the Paris Salon from 1806 onwards, and was patronized by the duchesse de Berry, who also received painting lessons from him. Charles X purchased Bessa's illustrations to the *Herbier Général de l'Amateur* (1816–37) in 1826 and presented them to the duchesse.

There was considerable rivalry between Bessa and the young Redouté, but when Van Spaëndonck died in 1823, they jointly assumed the position of painters on the Vélins at the Musée d'Histoire Naturelle. Bessa is famous for his fruit pieces, but seems to have dissipated his energies and undoubted capabilities on smaller and unrewarding work. He deserves to be better known, but was outshone by the determination and energy of the younger Redouté.

Pierre-Jean-François Turpin (1775–1826/1840?) was the son of a poor workman. He showed artistic promise very early on and learned the basis of drawing at school in Vire where he was born. But a living had to be earned so when he was 14 years old he enlisted, joining the batallion du Calvados. Later he was sent to San Domingo, where he met the botanist Pierre-Antoine Poiteau. The two young men became friends for life, botanizing and drawing the plants of the area. Some time later Turpin went to New York, where in 1801 he met the naturalist and explorer Von Humboldt. Turpin remained in America for a year and then returned to France with Von Humboldt, where Poiteau afterwards joined them. Poiteau was still painting and he and Turpin began to work together collaborating on Duhamel du Monceau's *Traité des Arbres Fruitiers* (1808–35), and Von Humboldt and Aimé Bonpland's *Monographies des Melastomacées* (1816–23). Later, in 1819–20, Turpin produced *Leçons de Flore.* He had the constant presence and stimulation of Redouté whose phenomenal success would have been a barometric indication of the climate of interest in flower-painting. Other eminent botanical writers, such as C. S. Kunth, were preparing their works and needed scientific illustrators; and *Nova Genera et Species Plantarum* with text by Humboldt, Bonpland and Kunth (1815–25) and *Mimosées* (1819) were illustrated solely by Turpin.

The artists of that period achieved a quality of botanical illustration never before equalled. Fortunately, almost all their work can be seen if one has sufficient determination. Paintings of this quality have to be kept shut away in the darkness of boxes and portfolios because daylight fades them and damages their use as an accurate colour reference. It is for these reasons that it may be difficult to get access to them. However, students and researchers may apply in writing to the various museums and libraries, who will usually do their best to help.

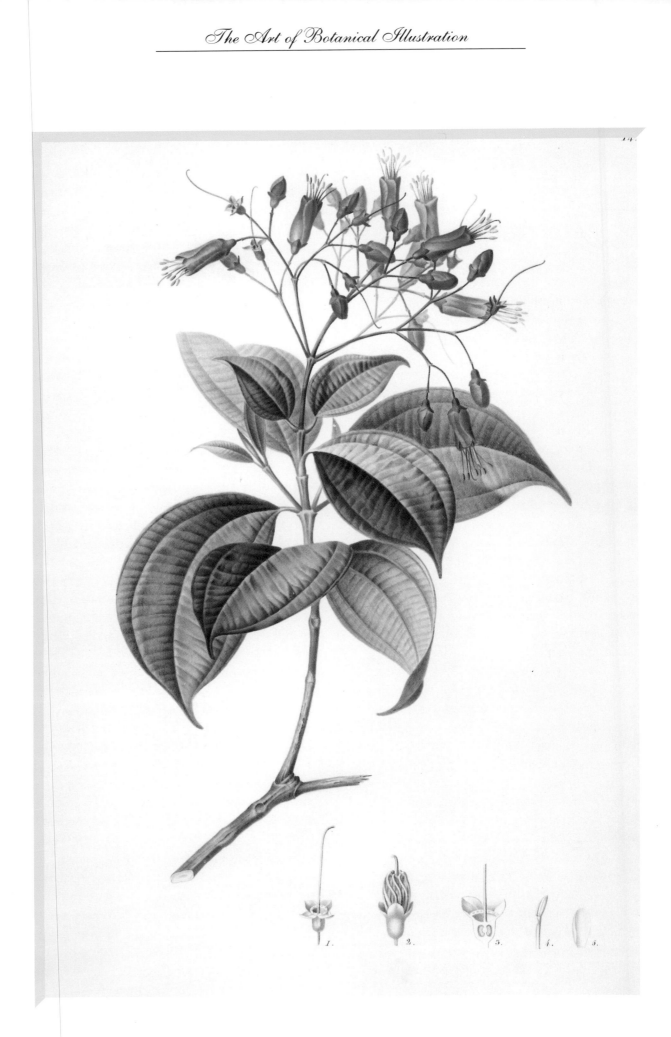

Melastoma coccinea
Pierre Jean François Turpin

Georg Dionysius Ehret
1708–70

IT IS FORTUNATE FOR POSTERITY THAT, at the age of 50, Ehret wrote a brief autobiography. He and his brother Christoph were born in Heidelberg, the sons of Ferdinand Christian Ehret, a smallholder who for pleasure portrayed the vegetables and plants that he sold. As the young Georg grew up, his father taught him what he knew of drawing. The boy showed great interest and promise, but as was often the case, painting was not considered suitable employment.

Ehret's first job was as gardener's apprentice to his uncle at Bessingen. Here he spent 'three years of slavery' only improved by the kindness of his cousin who found him flowers to paint and allowed him to use his room in which to to paint in peace and quiet during his brief periods of spare time. Ehret's father died and his mother remarried. Her new husband, also a gardener, was Anton Godfried Kesselbach who was in charge of two gardens belonging to the Elector Palatine in Heidelberg. Kesselbach seems to have been a kindly man. He was a Catholic but made no objection to his new wife and children's Protestantism. He gave Christoph and Georg the care of one of the gardens, possibly the Renaissance garden of Heidelberg Castle. By this time the garden had fallen into a ruinous state.

After a year the young men decided to move on to fresh pastures and left Heidelberg. Also about that time, the Margrave Karl III Wilhelm of Baden-Durlach was trying a new experiment. After a distinguished career in the Imperial army he wished to settle down to enjoy a peaceful existence separated from his family home near the town of Durlach. However, so popular a man was he that his former citizens followed him to his retreat, a hunting lodge, and it became necessary to build a new town for them nearby. He did this and called it Karlsruhe. The Margrave designed the whole thing. It had a neat street-grid, churches, schools, administration buildings and even a synagogue. Since, in those days, a Margrave had absolute power over the destinies of others, he allowed religious freedom, a tax-free period and there were no customs duties at the gates to this paradise. The Margrave was also a gardener, and so he laid out formal pleasure grounds to surround his new palace, with radiating driveways and paths in the French style. The gardens

were sumptuous: there were parterres, made from different coloured sands and gravels, with coal to provide the dark elements of the designs. There were orangeries, glasshouses, waterworks, stonework, statues, topiary, aviaries, menageries, pavilions and small dwellings for the gardeners. All the buildings were made of wood to harmonize with their surroundings.

Fortunately, even with all this grandeur on which to feast the eye, the Margrave became interested in scientific botany. He had another house in Haarlem and there he met the leaders of Dutch horticulture, visiting their gardens and broadening both his own circle of acquaintances and his plant collection. The Margrave was a rich man and was able to indulge his hobby of plant collecting on a vast scale; but it was said that he often went out to do some gardening dressed in similar clothes to his workmen. He was also a far-sighted man, maintaining his woods and forests and initiating a practical agricultural policy. Under his wise and beneficent rule the surrounding country began to recover from the ravages of the recent wars.

In 1727 August Wilhelm Seivert, a painter of plants, was engaged to portray the Margrave's vast collection. Ehret had hoped to learn some aspects of watercolour techniques from Seivert, but was not allowed time from his gardening duties, though he was permitted to grind colours for the artist. Being in Seivert's company reawakened his own interest in painting and so he began to paint again. He produced studies of tulips and hyacinths which he gave to the Margrave. His employer immediately took a keen interest in this young man who displayed such talent and wished to encourage him. However, great jealousy boiled up among the other gardeners at the apparently preferential treatment of one of their number. The behaviour of the other gardeners became so unendurable that Ehret decided to leave. He had entered the Margrave's service as a journeyman-gardener and so he was free to go at any time; however, he had to have an audience with the Margrave beforehand. The Margrave was annoyed at the behaviour of the other servants towards Ehret but realized that the situation was insupportable. He angrily remarked that none of the other gardeners liked the plants so well.

So the Ehret brothers left the service of the Margrave and began to make their way to Vienna. They travelled by way of Regensburg where they stopped to see a famous gardener to whom they had been given an introduction. The gardener welcomed them and introduced Georg to an apothecary called Johan Wilhelm Weinmann and to a banker called Loeschenkohl, both of whom were interested in plants and plant-paintings. Weinmann showed Ehret his own collection, and Ehret knew he could do better, and said so. When Weinmann saw some of Ehret's work he commissioned him to paint 1,000 'figures of plants for 50 thaler a year'. Ehret was delighted to cease the hard labour of gardening and get on with the work.

No time-scale seems to have been mentioned, but by the end of the first year Ehret had completed 500 plant portraits and asked for some payment on account. To complete 500 paintings in one year shows real application – about one-and-a-half every day, allowing for some being small and easy and others being large or more complex. Weinmann paid him 20 thaler for the work completed, reminding Ehret that he had free accommodation and food during the time that he had been working there. Weinmann caused so many difficulties and made so many complaints that Ehret, aggrieved at this apparent meanness, decided to leave. Weinmann was preparing to publish his *Phytanthoza iconographica,* and after Ehret had left him he continued with the project, paying much more for subsequent illustrations than he had paid Ehret. When the book came out, in parts from 1737–45, it was something of a hotch-potch of untrained artists' work. Ehret's work, though presumably copied, has no attribution. The book was certainly imposing, but has been criticized for featuring imaginary plants. The two men parted, somewhat at odds, and Ehret went to work for the banker Loeschenkohl who had a large garden with many rare plants. These he wished to have painted, and he also wanted an edition of the *Hortus Indicus Malabaricus* coloured in. There were 12 parts to this huge compendium, and one wonders how on earth the engravings of the strange new flowers could be coloured, from descriptions only, with any degree of accuracy, since they would have been quite unknown to Ehret.

DR CHRISTOPH JAKOB TREW

During this early period of his life – he was about 23 years old – he worked hard at improving his own botanical knowlege. In 1731 Ehret met and formed an acquaintainship with a young man of his own age called Johann Ambrosius Beurer, a young cousin of Christoph Jakob Trew (who was to become one of the most influential people in Ehret's life). Beurer had come to Regensburg as an apprentice apothecary, and corresponded regularly with Trew, his favourite relative. In his letters he wrote about particular plants and sent some of Ehret's drawings of these in the hope of helping his new friend. Soon an arrangement was made between Dr Trew and Ehret; Dr Trew began sending Ehret good quality drawing paper to suit his own requirements. He continued to do this for several years. During the previous months Ehret had been quietly producing his own work which was to be titled *Herbarium Vivum Pictum.* He had made 600 drawings which he sent to Dr Trew, who was able to sell them to a friend in the medical profession. This collection of paintings was later re-titled, *Deliciae Botanicae.*

Trew became Ehret's permanent patron, but his preference was always for rare or exotic plants rather than the 'vulgar' flora of field and hedgerow. This presented a problem for Ehret as such plants did not grow in field or hedgerow, but only in the gardens, and glasshouses, of rich collectors. In Regensburg there were few rich collectors. Loeschenkohl was one of them and a Herr Ortluff was the other. So Ehret used to go to their gardens when their owners were away from home, since he had quarrelled with them both. Ehret asked Dr Trew not to show his work to too many people so that word should not get back to Loeschenkohl and Ortluff, who, because of the individual rarity of the plants, would be sure to recognize them. Ehret continued to paint rare plants for Trew whenever he was able and this arrangement lasted for the rest of his life. Beurer remained a good friend to Ehret, recognizing with admiration his great artistic gift. He corresponded regularly with Dr Trew, and often spoke of Ehret. In one letter he was eulogizing about his friend's general excellence in gardening, garden design, botany, engraving, the painting of humble or 'exotic' flowers, and ends this description of his friend's character with a telling summation 'he has only one fault, he is flighty'.

Ehret had, as yet, not met Trew. Beurer was acting as an excellent intermediary, but Ehret felt that the time had come for him to make the journey to Nuremberg. So in 1733 he travelled by coach to make this most important first contact.

Dr Jakob Trew was a highly respected physician who was to become well-known throughout Europe for his erudition, his medical skills, his botanical knowledge and his wide circle of eminent acquaintances, among whom was Linnaeus. Dr Trew corresponded regularly with such well-known names as John Hill, Sibthorp and Sir Hans Sloane in Latin, since he did not speak English. Trew kept all their replies and these letters formed a vast and fascinating collection which were eventually bequeathed to the University of Altdorf and later came into the safe-keeping of the University of Erlangen.

Dr Trew liked to correspond with gardeners, and among them was the botanist Peter Collinson, who had a famous garden at Mill Hill in Middlesex, England. Collinson was a good correspondent (his letters can be seen at Erlangen). They are full of naturalistic news that must have been of mutual interest, and Collinson regularly sent boxes of bulbs, seeds and plants, and was meticulous

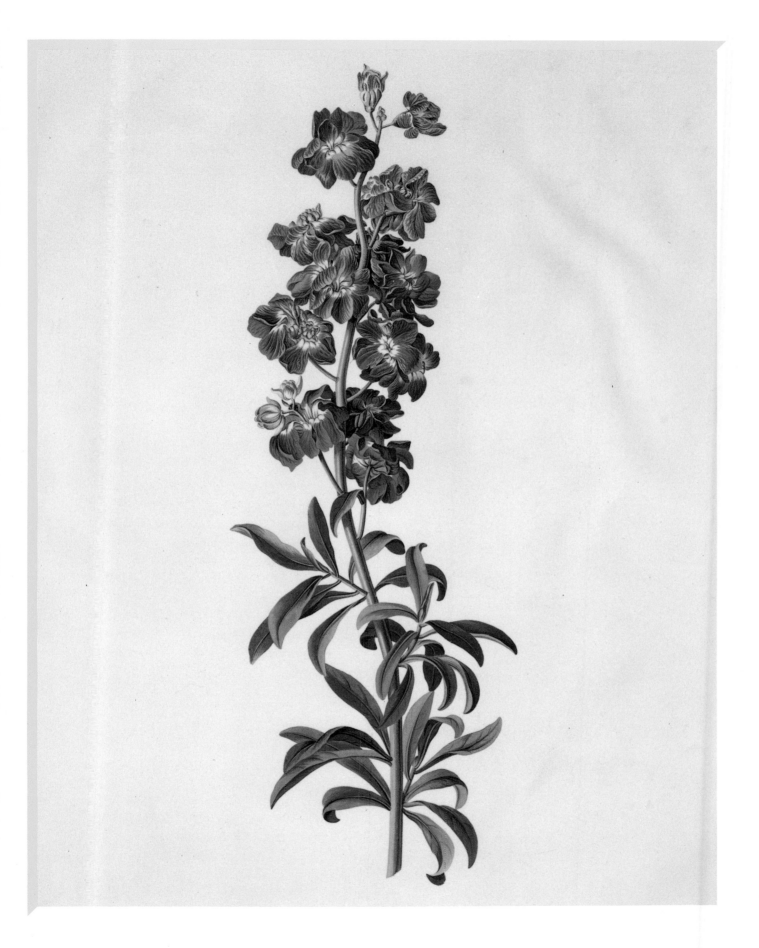

STOCK
(watercolour and bodycolour on vellum)
Georg Dionysius Ehret 1746

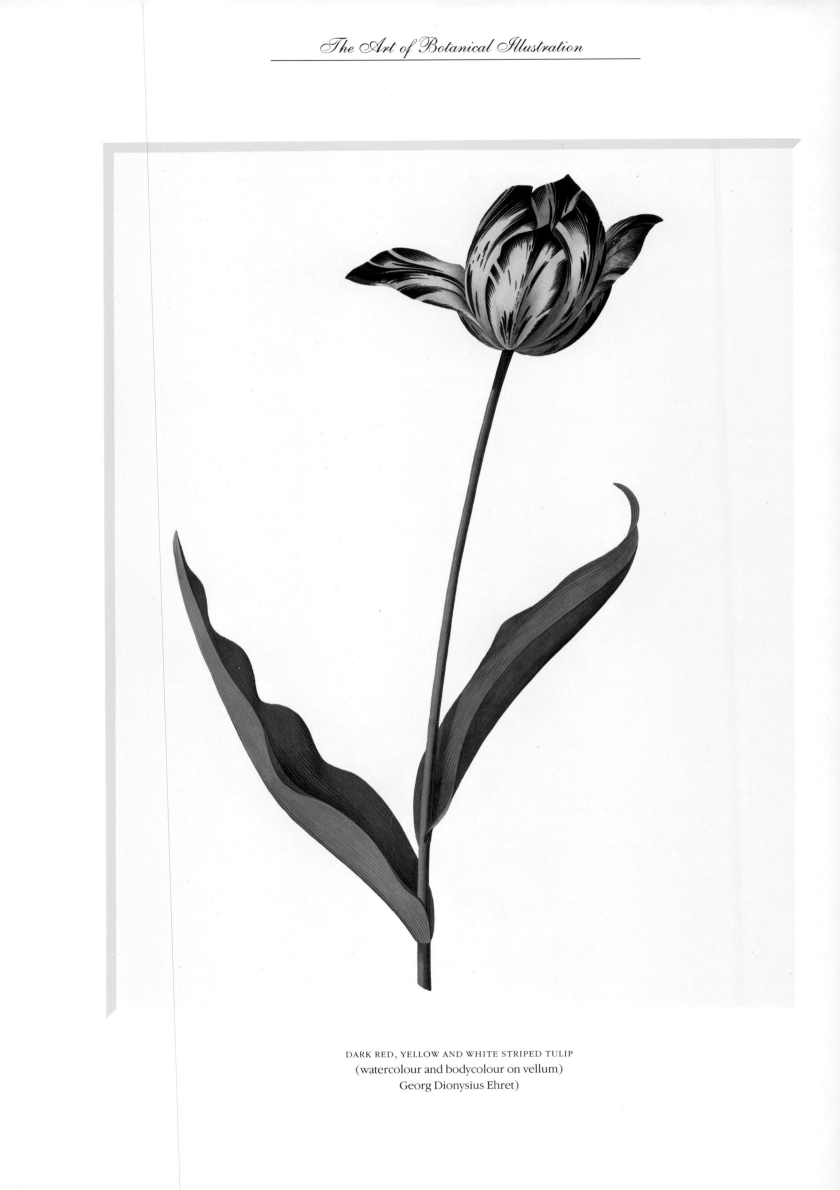

DARK RED, YELLOW AND WHITE STRIPED TULIP
(watercolour and bodycolour on vellum)
Georg Dionysius Ehret)

about advising his recipient as to shipping dates. Books and drawings also went to and fro, often with carping critiques: an example of this is Elizabeth Blackwell's *Curious Herbal* which was amended and re-published by Trew from a German translation. Collinson thought that both were a waste of time and said so.

After meeting Trew, Ehret was determined more than ever to study and paint plants from a scientific point of view. The world of botanists was beginning to recognize the importance of identification by means of floral parts, even though most of the botanists were approaching this goal of knowledge by different routes. Trew gave Ehret a short lecture on this very important aspect of his work. Ehret must have left Regensburg with much to think about; and when he returned to the pedestrian task of colouring in the engravings of the *Hortus Indicus Malabaricus* for Loeschenkohl, he realized that this task would take him about five years. Having just returned from the stimulating presence of Dr Trew, Ehret felt that it was time once more to move on, and with some recriminations from the disappointed Loeschenkohl, he left Regensburg.

From Regensburg Ehret went to Basle to see the botanic garden there, and found employment laying out a new garden for Samuel Burckhardt. During this period in history 'small' wars were occurring all over Europe like the after-flickers of a forest fire. While Ehret was actually gardening again in Basle, such a war threatened the Principality of the Margrave Karl III of Baden-Durlach. The Margrave sought refuge temporarily in Basle where Samuel Burckhardt went to call upon him as the two were old acquaintances. Samuel Burckhardt told him about his new garden and his new gardener. The Margrave was delighted to have news of his former protégé and offered him a position at Karlsruhe. Ehret refused this as graciously as he could and was given a letter to ensure his safe travel and valuable letters of introduction from both men. One of these letters was to Bernhard de Jussieu in Paris and the other was to George Clifford in Holland. These were to be of great help to Ehret. By divers means, often paying for his board and lodging with paintings in the time-honoured way, Ehret decided to see something of the world. He took a berth on a boat going south down the river Rhône. He visited Montpellier, Lyons, and that city of black granite, Clermont (Ferrand). From there he walked to Paris. Eventually he arrived at the Jardin des Plantes and Bernard de Jussieu[13] who made him welcome, partly because of the letter of introduction and partly because he could instantly see that this travel-weary young man had an unusual talent. De Jussieu gave Ehret a room in the garden-house at the Jardin des Plantes, where he stayed for the winter, painting many of the 'exotick' plants which abounded there. He was able to send drawings to Trew again and began to paint on 'pergament' or vellum. In his memoirs, Ehret tells us that he started to make several copies of his good work when he did it. In this way everybody can have daffodils in December – and I quote from Gerta Calmann, 'He also painted the Lilio Narcissus' for the Marquis de Gouvernet, 'who could not get enough copies for his friends.' Each painting would sell at the same price. But each painting was done by the man himself, and *that* is what should be remembered.

This is the first time that Ehret had come into contact with vellum. He may have seen the famous Vélins, the Royal collection of flower-painting on vellum, and decided to try out this 'new' technique. Mastering it would have taken but a short time for someone of his natural skills and thereafter he produced a great deal of work on this appropriately satisfying animate support. He also began to paint in body-colour at this time.

After a while, Ehret realized that there seemed to be no real prospects for him in Paris and that he should go to Holland. In this he was dissuaded by De Jussieu who told him that England would be better for him because there were many gardens there. De Jussieu assisted him in every possible way with 12 letters of introduction to notabilities and he also obtained a letter to gain safe passage signed by the King. After several adventures along the way, Ehret arrived safely in England in 1735. He began to deliver all his letters – all but one, and that, possibly, was the most important. This was addressed to the secretary of the Royal Society and Ehret must have forgotten all about it, because it was found in his effects after his death. However, other new contacts proved to be helpful in promoting his work and finding him patrons, and once established he began to send drawings of 'exotick' plants to Trew again.

But the first flush of interest in his work seemed to die down after about a year, and Ehret again resolved to try his luck in Holland. He still had the Margrave's letter, and in 1736 he packed up his things and boarded a ship for Holland, and stayed at Leiden after he arrived. While he was in Leiden he heard that Linnaeus was staying at the Hartekamp with George Clifford, so he prepared himself carefully before making a visit. He took some good drawings of new plants with him, together with the Margrave's letter of introduction. At the Hartekamp he met Clifford and handed him the letter. Clifford was most impressed when he saw his drawings, and offered

13. *Bernard de Jussieu (1699–1777) was the* demonstrateur *or teacher of botany at the Jardin des Plantes (or the Jardin Royal des Plantes). He trained the gardeners there as botanists, and made this small area in Paris into a true botanical garden. He had a medical grounding but his whole interest lay in botany. He had spent much time working out a method of plant classification which differed from that of Tournefort, but, being an unassertive man he did not publish it. Indeed, though well-known and well respected, he published little, though one of his students collected his lectures.*

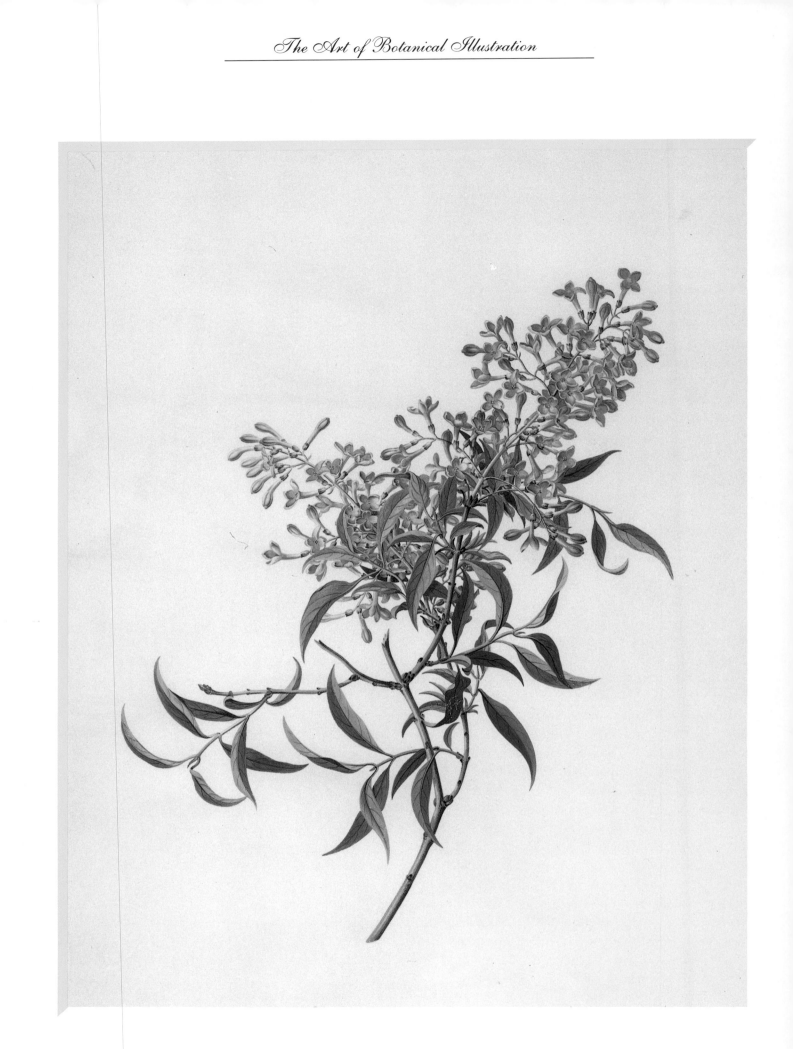

PERSIAN JASMINE
(watercolour and bodycolour on vellum)
Georg Dionysius Ehret

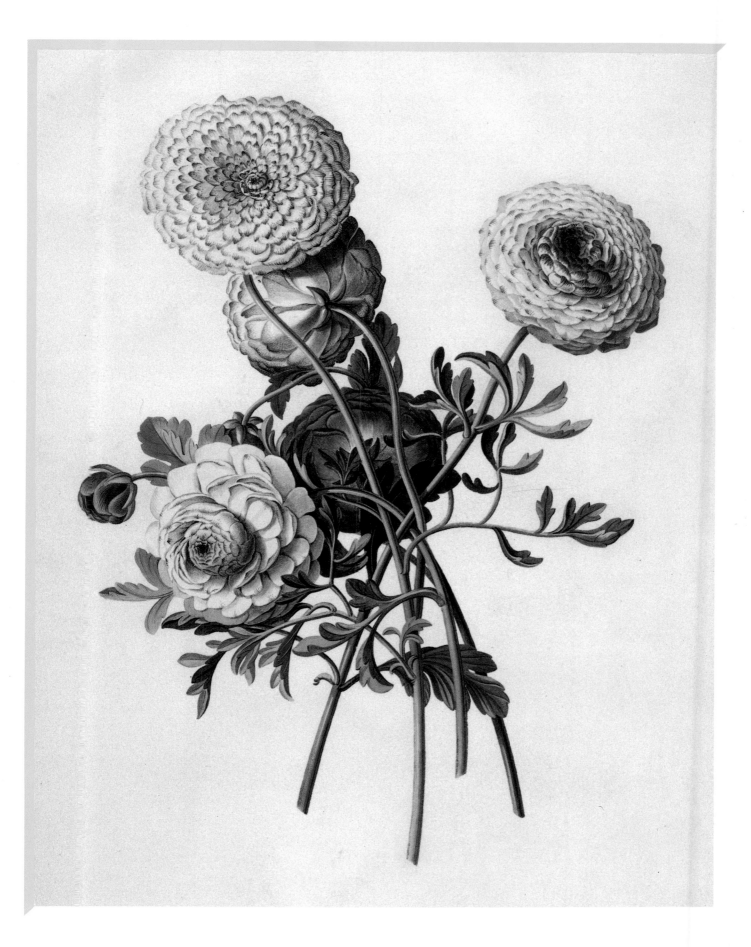

RANUNCULUS
(watercolour and bodycolour on vellum)
Georg Dionysius Ehret

to buy them on the spot. Linnaeus was present at the meeting but does not seem to have commented on the quality of Ehret's drawings.

Clifford suggested to Ehret that he stay for a few weeks at the Hartekamp. Ehret learned later that Clifford was planning a book about the garden to be entitled *Hortus Cliffortianus*, which would need illustrating. Ehret stayed at the Hartekamp for about a month drawing and painting the plants and his work appeared later in the *Hortus Cliffortianus*. During his stay he made friends with Linnaeus, who explained his system of plant classification. Ehret worked quickly while at the Hartekamp, producing 20 finished drawings for the *Hortus*, which had 34 plates when published. It is interesting to discover that Ehret said at first that he did not wish to include the detailed drawings of a plants' pistils and stamens as he thought that they would spoil the appearance of the finished page. However, under Linnaeus's guidance he did the necessary drawings of the dissections. He became so interested in these that he is said to have often included inessential drawings in his work. Ehret was very sensitive about this aspect of his drawing and accounts of his early work with Linnaeus vary considerably. Ehret made a drawing, *The Tabella*, of Linnaeus's sexual system of plant classification and published this after he left the Hartekamp; he acknowledged Linnaeus plainly and clearly at the top of *The Tabella*, which featured the various groups of stamens; *The Tabella* sold well, and the original drawing still exists in the care of the Natural History Museum. Linnaeus later included *The Tabella*, without acknowledgement, in his *General Plantarum*.

The *Hortus Cliffortianus* is important because it was the first printed work of the Linnaean system of plant classification. This, though artificial, helped very considerably in reducing the chaos of botanical nomenclature to some sort of manageable order, and it remains in use, though it has been re-interpreted in the light of the Darwinian theory published in the *Origin of Species* in 1859.

Though there appears to have been a conflict of both opinion and wills between two men of character, Linnaeus and Ehret became friends and remained so for the rest of their lives. They corresponded irregularly and exchanged gifts of seeds and plants; Ehret also sent Linnaeus copies of his various publications as they appeared.

EHRET'S ENGLISH PATRONS

After his work for Clifford had been completed, Ehret began to get restless again; he had a living to make, and there seemed to be no more wealthy patrons at that time. So he packed up his things once more and in 1736 he returned to England and never left again. He moved about the country according to his commissions and the requirements of his patrons. His first address was at the Chelsea Physic Garden where he painted some plants

for Philip Miller, the first curator. Philip Miller was at that time producing his *Gardener's Dictionary* which ran to many editions. Though the work has about 300 plates, only 16 are by Ehret and these are in later editions, notably that of 1760.

Miller was the principal horticulturalist in England at that time and gave Ehret many useful introductions. Later on, however, their friendship deteriorated, but as has been seen, Ehret did not always get on well with people. In 1736 Linnaeus came to London at Clifford's request to visit Miller at the Chelsea Physic Garden, where he hoped to acquire some rare plants for the Hartekamp. Miller, at this time, did not accept Linnaeus's new plant system and was not very helpful at first, though he must have relented because Linnaeus went back to Holland with a good selection of 'new' plant treasures, including some even newer dried specimens from America, which were for the museum's herbarium.

Miller's wife had a sister called Susanna Kennet who became Ehret's wife in 1738. Three children were born, but only one (George Philip Ehret) survived. The lad was apprenticed to an apothecary and surgeon and seems to have settled down well but he showed no sign of inheriting his father's great talent.

Ehret was in contact with many eminent botanists, among them John Martyn (1699–1768) Professor of Botany at Cambridge and a Fellow of the Royal Society. Martyn had recently published *Historia Plantarum Rariorum*. Some of the subscribers to this work were well-known names in the botanical world, and among them were Hans Sloane, William Sherard, Herman Boerhaave Stephen Hales, Philip Miller, Lord Petre and Peter Collinson. The drawings for this were executed by Jan van Huysum's brother Jacob, who had moved to England. There is a folio in the Royal Society, acquired in 1737, which contains work by Ehret and Van Huysum. It would appear that the two artists painted their subjects – aloes – from exactly the same position, and the work can be compared. This is very unusual and one wonders about the reason for this apparent duplication. If a choice has to be made, the drawings by Ehret are infinitely superior.

England's scientifically-minded botanists, often good gardeners themselves, were beginning to accept Ehret and he was almost always in constant employment. John Fothergill (1712–80) had a garden of some 30 acres in Essex. He employed 15 gardeners and was an avid collector of new plants. However, when he had received some especially rare seed from abroad, he did not entrust it to his own gardeners, but gave it to another accomplished gardener he knew who was particularly skilled at propagation. Fothergill often commissioned paintings and Ehret did many drawings for him.

Most of these wealthy or titled patrons had a 'cabinet', a loose term used to describe their collections of just about everything in the world of natural history. Some

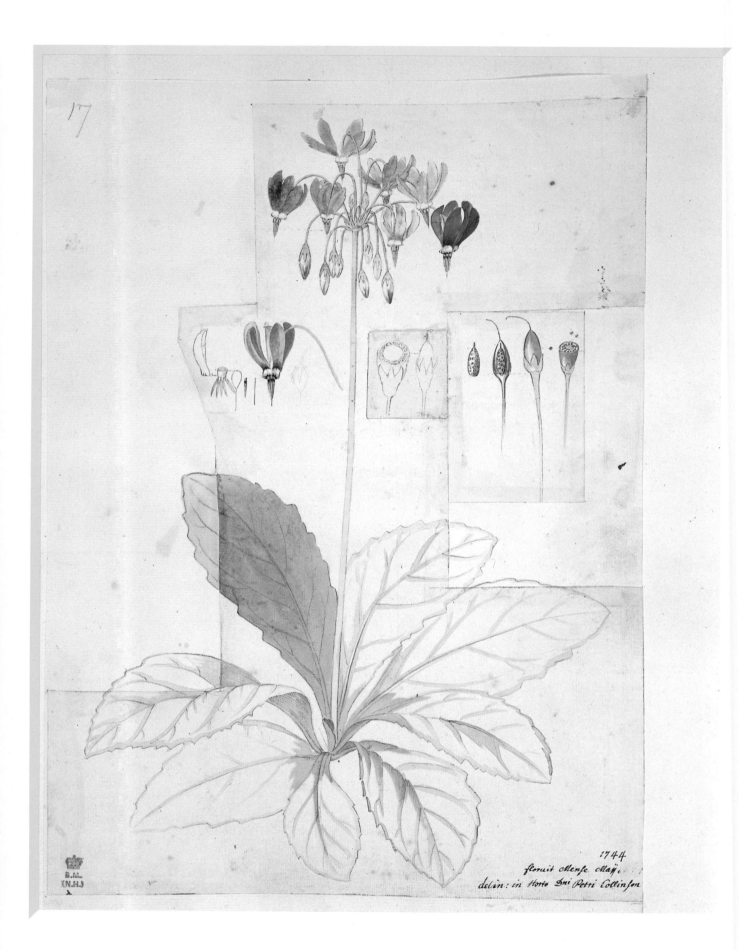

Dodecatheon meadia
(sketch)
Georg Dionysius Ehret (1744)
(L. Trew set 'B' 17)

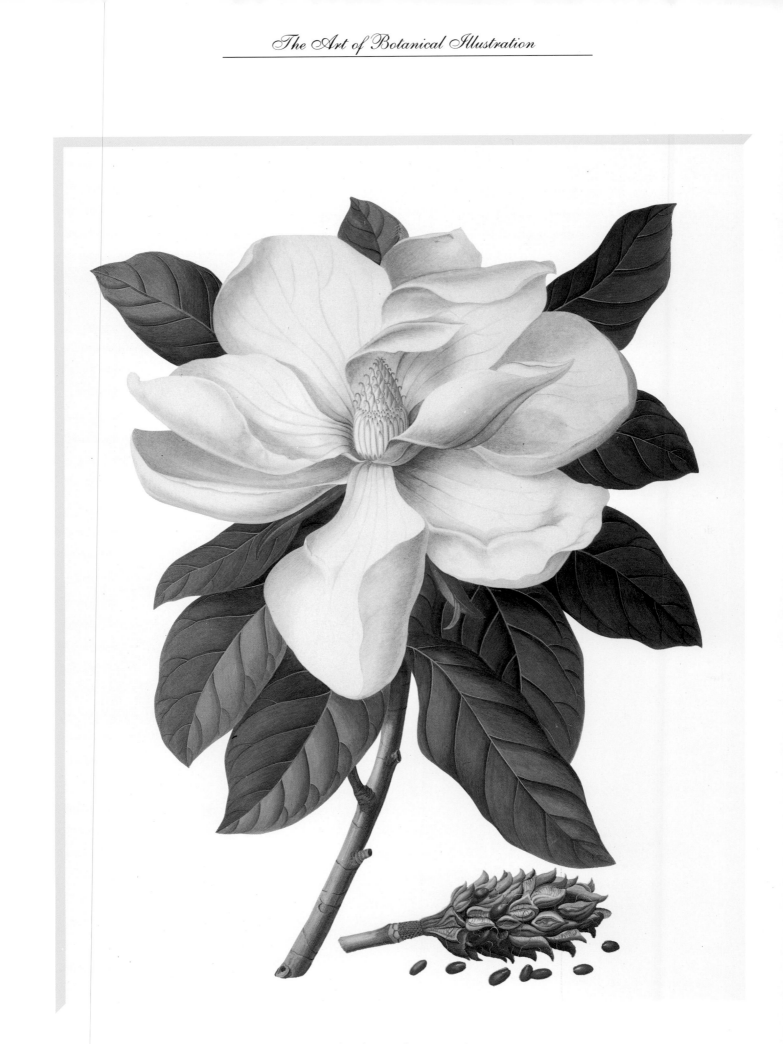

Magnolia altissima lauro-cerassi — LAURET-
LEAVED TULIP TREE
(watercolour and bodycolour on vellum)
Georg Dionysius Ehret 1743

of these 'cabinets' formed the nucleus of museum collections (as the Tradescant collection formed the nucleus of the Ashmolean Museum collection). Fothergill was one such collector and when he died in 1780, the sale of the contents of his museum took 11 days. The drawings, including those by Ehret, were sold to the Empress Catherine II of Russia.

Dr Richard Mead (1673–1754) was another of Ehret's better patrons. Though aged 70, he was still keenly interested in botany (the *Dodecatheon meadia* is named for him) and commissioned Ehret to do 200 drawings for him. Ehret seems to have been able to produce his high quality work at a prodigious rate, which is indicative of his sureness of touch and clarity of observation. Dr Mead introduced Ehret to many influential people in order to help his career.

Other patrons included Taylor White (1701–72), who was a wealthy lawyer. He commissioned and collected paintings of natural history subjects, and at his death there were 987 works in his possession, 500 of which were thought to be by Ehret. Another patron was Robert More (1703–89) a Fellow of the Royal Society, an enthusiastic traveller, a scientist, a politician and a patron of the arts. When More died, his drawings were sold and Joseph Banks bought the 65 drawings by Ehret.

When Ehret was older, and his phenomenal eyesight was beginning to fail him, he became friendly with Ralph Willett (1720–95) a Fellow of the Royal Society who lived at Wimborne, in Dorset. Ralph Willett's wealth came from sugar plantations in Barbados, where his father had married an heiress. On his father's death Willett inherited the fortune and in 1751 bought an estate at Merly (now Merley) near Canford Magna, Wimborne, in Dorset, where he designed a handsome residence. Ehret went to stay with him each summer and they went for long walks. During these visits Ehret experimented with landscape painting, but these, alas, were not good and are best forgotten. At Willett's death the plant drawings were sold; there were 230 finished drawings on vellum, 70 on paper, 500 unfinished works and also some sketchbooks. In local history accounts he is not remembered for his close association with Ehret, and is only commemorated by a public house and a country road, both named after him.

It is clear that Ehret seems to have found a sufficient number of patrons to commission and pay for his work, almost on a regular basis. He was exceedingly busy with teaching and with these commissions in the middle of the 18th century and must have worked almost continuously. Most of these commissions were of the flower-

portrait type, but gradually Ehret was being recognized as a scientific botanical artist. Ehret's work appears in several botanical books published at that time. Mark Catesby's *Natural History of Carolina* (1731–43) contains three drawings; Richard Pocock's *Description of the East* contains 11 drawings which were engraved by Ehret. Griffith Hughes produced *The Natural History of Barbados* in 1750 with 12 plates (of vegetables) by Ehret in Volume 4. Ehret did not like this particular commission, and commented on it later with sarcasm.

In 1750 Ehret was offered the position of curator of the Oxford Botanic Garden under Professor Humphrey Sibthorp. This meant that he would have much less time for drawing, his studies and his teaching, and at first he accepted this because the post carried a regular wage, which is something that almost all artists can only dream about. Ehret presumed that if he fulfilled his gardening duties adequately, his time would be his own, and he could continue his various other activities, if, perhaps, to a lesser degree. But Sibthorp would not allow this. He demanded that Ehret should submit to his rules which the fiery-natured artist found irritating and tiresome. He wrote an infuriated letter to the Committee in charge of the (Physick) Garden, complaining about a number of petty aggravations which, taken together, made the post insupportable. The final straw for Ehret was the rule that 'the gardener' (Ehret) should not correspond with any other botanists without permission from Sibthorp, which was always witheld. So Ehret resigned.

His teaching brought in a good competence, and in addition he travelled all over England to give his lessons in flower-painting to the daughters of the aristocracy. Their seasonal flittings suited him because they were away in the country from June until autumn, or Christmas, and in town from January until June. Ehret was invited to stay at their various residences, where he would have enjoyed great comfort. Of all the great names of the nobility, that of the Duchess of Portland will be remembered as his particular and most steadfast patroness. He was often asked to stay at Bulstrode, her country seat, where the Duchess gardened, gathered items for the inevitable cabinet or museum[14] and took natural history very seriously indeed. She commissioned many drawings (about 150) for her collections, and was most concerned when Ehret began to complain of failing eyesight. However, he continued to teach, study, write and produce his excellent drawings but possibly at a slower rate.

14. *It must have been quite a collection, even for those times, because after her death in 1784, the sale of the 'Museum' curiosities took 39 days.*

In 1756 Patrick Browne produced *The Civil and Natural History of Jamaica* which must have been a prodigious task. Browne particularly wished Ehret to do the drawings as he proposed to use the new Linnaen system of classification, with which he knew Ehret was familiar. Such a work involved drawing from dried herbarium specimens, which needs a special kind of talent. Ehret did not like this kind of work and made excuses saying that it would cost Browne much more because of the difficulties involved. But Browne was a determined man and had a way with him. He took a collection of dried specimens and went to see Ehret; placing the collection in front of him, he suggested that Ehret choose 40 of the best. While Ehret was turning them over, Browne put down 40 guineas on the table as an advance. Ehret undertook the drawings but he did not do the engravings for the book. Browne later named a flowering shrub *Ehretia tinifolia* after him.

In 1766 Joseph Banks came back from his exploratory voyage to Labrador and Newfoundland, and gave Ehret the task of drawing his precious specimens. By now Ehret was so good at this difficult work that there appears to be no difference between the finished drawing of a fresh flower with the dew hardly dry upon it and a flattened, dehydrated, brownish-green herbarium subject.

Ehret was, by this time, contributing regularly to scientific journals both in England and Germany, and in 1757 he was elected a Fellow of the Royal Society. There was another honour to come, however; Dr Trew proposed him as a member of the Imperial German Academy of Naturalists – the Leopoldina – and in 1758 Ehret was accepted.

Ehret continued to teach, draw and engrave for the rest of his life, and it is fortunate that he came to England at a time when there was great interest in the Natural Sciences. Teaching his art – or attempting to, because there was never anyone else who could portray plants as he did – brought him in a comfortable living. It also took him to the houses – and the hothouses – of the wealthy who could afford to grow the 'exotick' plants and flowers that they found so fascinating. Ehret is thought to have painted more than 3,000 pieces of original work, but through his engraving he hoped to reach and interest a wider public. In the 1740s he began to gather together a collection of drawings of rare and new plants. The plants had to be rare or 'exotick' in order to satisfy the fashion for the unusual that was so prevalent. The work was titled *Plantae et Papiliones Rariores depictae et aeri incisae a Georgio Dionysio Ehret* and it was brought out from 1748–62. There was no real text, nor even any introduction, and, oddly enough, Ehret does not use the Linnaean method of classification, possibly because he was aiming the book at a more general market. In 1770, on 9 September, Georg Dionysius Ehret died. His accuracy and general excellence as a true botanical artist have never been equalled.

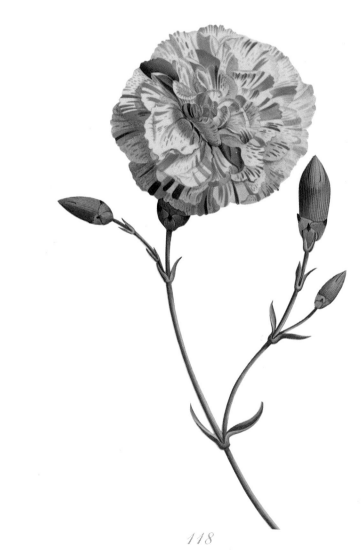

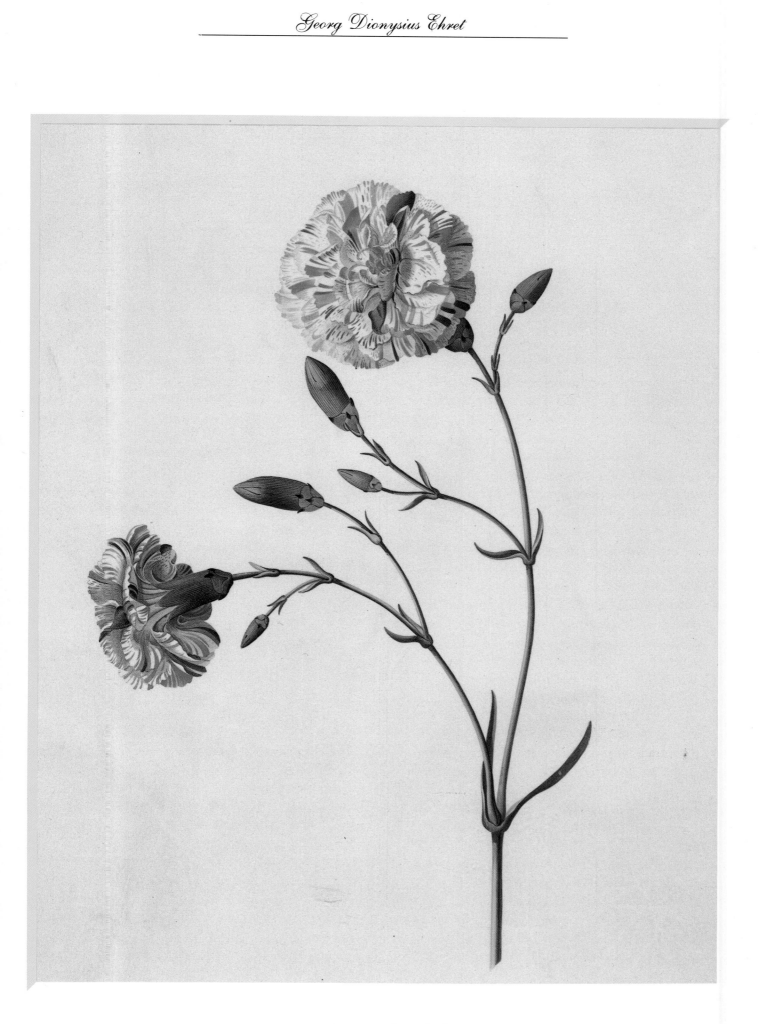

BIZARRE VIOLET (carnation)
(watercolour and bodycolour on vellum)
Georg Dionysius Ehret 1745

Redouté Josephine and Malmaison
——————1759–1840——————

As an illustrator, Pierre-Joseph Redouté's name must be the best-known in the world of plant portraiture. This is so for three reasons. Firstly, his work is excellent; secondly, he was at the height of his creativity at the best period of the engravers' art, thus making his work known and available to far more people than was previously possible; thirdly, he knew and produced what was wanted by the average Monsieur et Madame.

Antoine-Ferdinand, Pierre-Joseph and Henri Joseph Redouté were born at St Hubert in the Ardennes (then part of Luxembourg) where their father was an artist and an interior decorator. The family had been painters, specializing in different subjects, for three generations. Redouté's elder brother Antoine-Ferdinand continued his father's interior decorating business, but moved to Paris in 1776, where he did well; he was commissioned to work on what is now the Elysée Palace, the château of Malmaison and later the Palace of Compiègne. In addition he worked as a stage designer mainly at the Théatre Italien. The youthful Pierre-Joseph Redouté absorbed his father's teachings and left home to start on his own at the age of 13. Even in those times he was young to be starting out in such a trade or profession. He travelled about in Belgium and Holland earning a precarious living from interior decorating and the production of religious paintings. During his travels he saw the work of the Dutch and Flemish flower-painters which made a lasting impression on him.

In 1776 Redouté's father died. Redouté took a year's painting-lessons in Liège, and then in 1782 he joined his brother who was becoming successfully settled in Paris. Redouté helped him at his work of decorating the houses of the aristocracy and with the scene-painting at the theatre. While in Paris, Redouté discovered the Jardin du Roi and began to paint its flowers in his spare time. He sold some of his earlier work to an art-dealer named Cheveau who then had it engraved by Gilles-Antoine de Marteau. The engravings were seen by Gerard van Spaëndonck and also by the amateur botanist Charles-Louis L'Héritier de Brutelle, both of whom recognized Redouté's emerging talent. Redouté continued to paint flowers at the Jardin du Roi, and also attended the lectures of van Spaëndonck who took a personal interest in his progress. Van Spaëndonck was, at that time, using gouache and would have taught in this medium. A little later on, in 1784, he started to use pure watercolour. Redouté followed his example, and during his lifetime took this most difficult of techniques to a pinnacle of excellence.

While he was having lessons from Van Spaëndonck, Redouté learned the art of engraving from De Marteau, who turned out to be a compatriot from Liège. This and subsequent knowledge were to give Redouté the capability to produce his later work at a price that was affordable to many. His brother, Antoine-Ferdinand had at first thought that flower-painting was a waste of time, but he must have realized that there was a possibility that Pierre-Joseph might actually support himself in this way.

In the late 18th century, Paris was becoming a centre of science, culture and fashionable patronage. Redouté had the good fortune to have as teachers and friends at the Jardin du Roi eminent botanists such as R. L. Desfontaines (1750–1833), E. P. Ventenat (1757–1808) and Augustin Pyramus de Candolle (1778–1841). Under their guidance Redouté's natural talent began to expand in the same way as the ephemeral flowers that he portrayed, but through him their beauty lives forever. L'Héritier in particular seems to have taken to the young man, though he was not of a prepossessing appearance: in later life, at the height of his fame, J. F. Grille in *La Fleur des Pois* (1853) describes him as follows: 'A stocky figure with elephantine limbs; a head like a large, flat Dutch cheese; thick lips; a hollow voice; crooked fingers; a repellent appearance; and – beneath the surface – an extremely delicate sense of touch; exquisite taste; a deep feeling for art; great sensibility, nobility of character; and the application essential to the full development of genius: such was Redouté, painter of flowers, who counted all the prettiest women in Paris among his pupils.'[17]

CHARLES-LOUIS L'HERITIER
AND HIS PATRONAGE

L'Heritier taught Redouté how to make botanical drawings correctly and acted with great kindness, inviting him to

17. Quoted by Ch. Léger (1945).

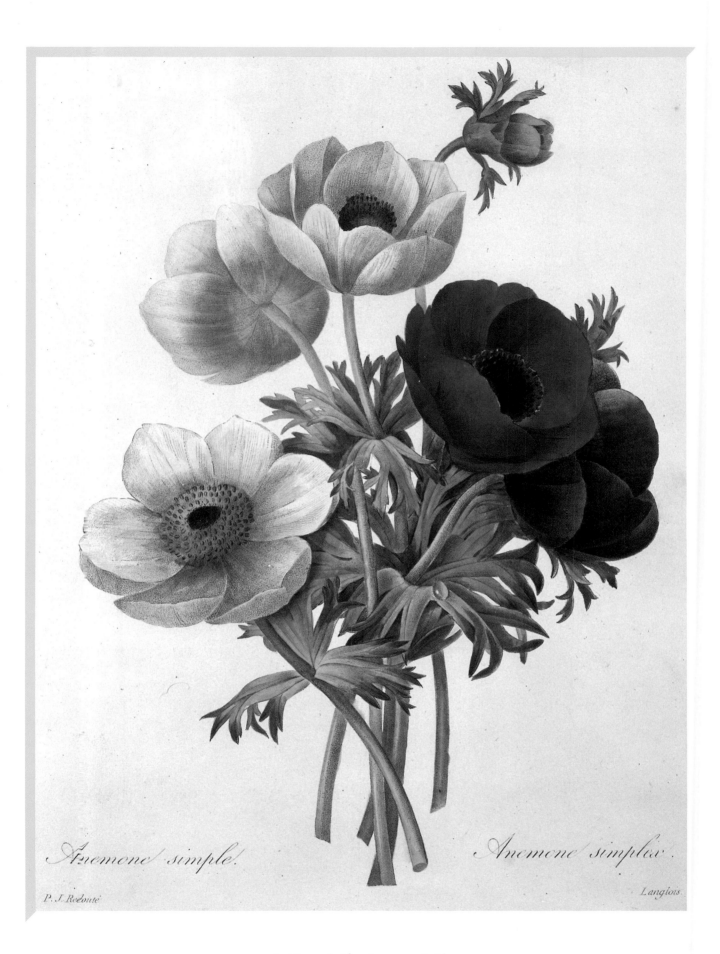

Anemone simple — Anemone simplex,
Anemone coronaria
Pierre-Joseph Redouté
Langlois sculpt.

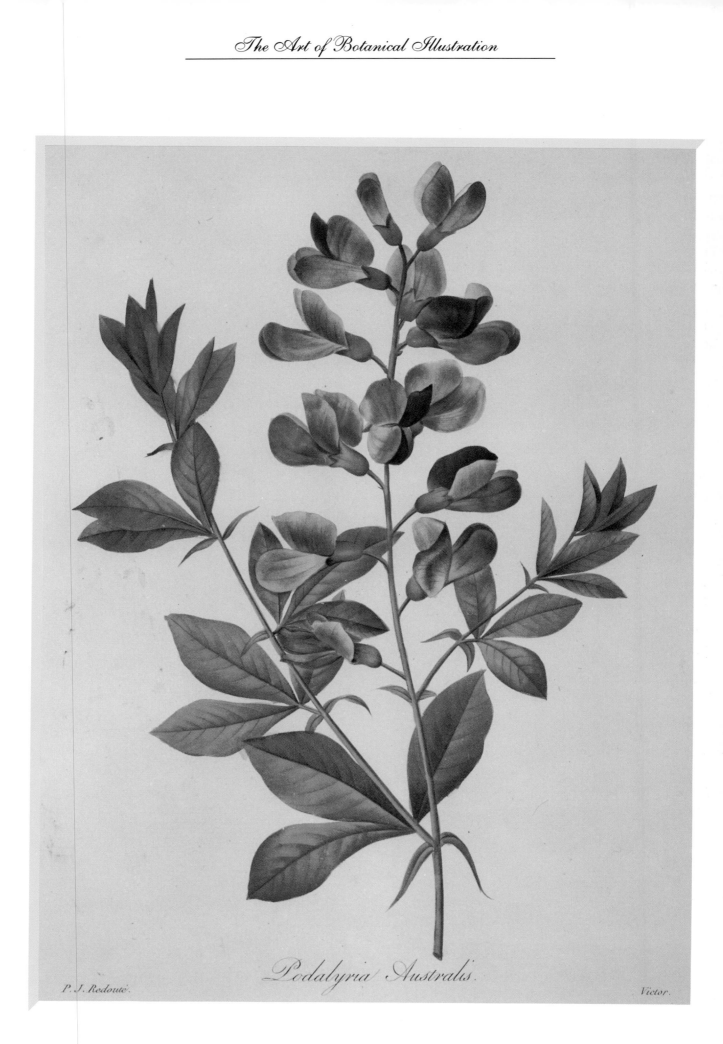

Podalyria australis – Baptisia australis
Pierre-Joseph Redouté
Victor sculpt.

his mansion and encouraging him to use his excellent library. The botanist was preparing his own work then, *Stirpes Novae aut Minus Cognitae,* which was published in 1784–5 and at the time it needed more illustrations. L'Héritier gave Redouté the task of producing over 50 of the drawings still needed, which he might not have been able to do had he not had such able botanical instruction and assistance.

At that time L'Héritier was a wealthy magistrate appointed to the *Cour des Aides* (a French Court dealing specifically with taxation). Pre-revolution standards of probity in French courts were lax and corrupt, but this particular court and L'Héritier had an unusually good reputation for the times – which may have helped to save his head later on during the Reign of Terror. He was an intelligent, conscientious aristocrat who had been appointed superintendent in charge of the water supply and woods in the Paris area. In those days, such posts were generally ill-served by their appointees who would generally never take the trouble to learn anything about their duties. But L'Héritier was an exception. Knowing that he was ignorant of forestry and the allied sciences, he studied these and related subjects with zeal and tenacity and in so doing he learned about the Linnean system of plant-classification.

L'Héritier went on peacefully with his many occupations for a while and then a curious adventure befel him. In 1785 a Spanish plant-hunting expedition to Chile and Peru returned to Europe after 10 years in South America. The expedition had been an example of greed, ignorance, theft, bureaucratic incompetence, stupidity, bad planning and international rivalry at its worst, and the account of it makes fascinating if cheerless reading.[18] The party had been led by a competent young botanist called Joseph Dombey, who was being paid by the French Government. However, the Spanish Government insisted on two pharmacists, Hipolito Ruiz Lopez and Antonio Pavon y Jiminez taking titular charge of the enterprise. Unbelievable hardships, disasters, illnesses and shipwreck overtook the party, and when eventually the sad remnants of 10 years effort, danger and privation reached Paris the Spanish Government demanded that the remaining boxes of specimens be given up to them. Since they were in the care of the exhausted Dombey they were, in fact, legally the property of the French Government which had previously agreed that L'Héritier should have the specimens to study prior to a publication about them. He was preparing the publication when he heard that the Spanish Ambassador was at the Paris court and was requesting that the collection of specimens be handed back to Spain immediately. Recognizing the imminent danger of an international wrangle in which the specimens were likely to come off worst, L'Héritier, with the help of Redouté and another botanist friend, P. A. M. Broussonet, gathered up the collection, packed it all up in one night, loaded it into a coach and galloped away with it to Boulogne where

L'Héritier boarded a ship for England and sought refuge at Sir Joseph Banks' house in Soho. A stirring tale indeed.

L'Héritier intended to stay only for a short in England, while the international dust settled, during which time he studied and named Dombey's new plants. However, life in England proved very congenial and he was dividing his time between the rare plants at Kew and his own more specific work. As a result, he remained in England for 15 months. The new Kew plants fascinated him so much that he decided to produce a book about them. For this he needed an illustrator, or illustrators. He had already discovered James Sowerby but felt a different style would make the book more interesting. Accordingly, he asked Redouté to come to England to illustrate the work, the *Sertum Anglicum,* which was intended as a gift of thanks to the English nation. Redouté could not resist the invitation (he probably wanted to see the Kew plants as well) and in 1787 crossed the Channel. In England he produced 22 illustrations for the book, Sowerby did 13, which came out in 1788. Never a man to waste time, he became friendly with Francesco Bartolozzi, a master engraver, who taught him the art of stipple engraving which was actually of French origin but was, at that time, being perfected in England. Redouté recognized that the process would suit his own work to perfection.

Stipple engraving consists of spaced-out lines of dots which produce more delicate gradation of tone than the use of etched lines alone.

When Redouté returned to Paris and the Jardin du Roi, Van Spaëndonck asked him to do some paintings for the famous collection of *Vélins.* This collection had been steadily added to for over 150 years. He painted the flowers in the Petit Trianon garden for Queen Marie-Antoinette and was awarded the honorary appointment of Draughtsman to the Cabinet. Though the Queen loved flowers, she did not care for painting generally. However, when she was later imprisoned she was given a flowering cactus and she asked that Redouté should capture its ephemeral beauty for her. But the threat of the Revolution was looming large and Redouté's appointment, like many things of that epoch, was not to last. By this time Redouté's young brother Henri-Joseph was also working at the Jardin du Roi, though his speciality seems to have been depicting zoological subjects.

Redouté began working on the illustrations for *Plantes Grasses* (succulents) whose shapes were a new departure for him. These succulent plants cannot be effectively kept as herbarium specimens, their three-dimensional solidity is completely lost in the drying process. Succulent plants of all kinds were, consequently, still rare and of great interest to the botanists. Accurate portrayals by an artist as skilled as Redouté, particularly in the use of perspective, were very valuable. Georg Ehret had also

18. The Quest for Plants *by Alice M. Coats.*

produced drawings of succulent plants, which, though better than those of his contemporaries were not always good because a lack of knowledge of perspective was Ehret's only weakness. One does not need it in flower painting because the depth of field is seldom great enough to need the employment of the traditional methods of imaginary horizons.

1789 saw the start of the French Revolution. L'Héritier was stripped of most of his wealth and imprisoned, only narrowly avoiding execution. When he was eventually released he was given a lowly post in the Ministry of Justice, but he naturally still retained his passionate interest in botany. He began work on a minor flora but was assassinated in 1800 as he was returning home through the streets of Paris.

The *Vélins* became national property and were transferred to the newly named Museum National d'Histoire Naturelle, as the Jardin du Roi had been renamed. Redouté seemed unaffected by all the turbulence about him and continued to paint, almost undisturbed. This is difficult to believe when about 40,000 people were publicly decapitated during that time of terror. For years before the Revolution he had been giving painting lessons, mainly to members of the aristocracy and their daughters. He continued giving these classes, though with different pupils, for the rest of his life.

THE EMPRESS JOSEPHINE

It is possible that Redouté met Joséphine when she was the vicomtesse Alexandre-François-Marie de Beauharnais. The vicomte was executed despite being a patriotic republican and his beautiful young wife was to have suffered the same fate, but for the timely execution of Robespierre by his peers. Joséphine was saved and her beauty attracted the desire of Paul Barras, the leading republican. She became his mistress until in 1795 she met Napoleon Bonaparte who as the world knows, fell in love with her instantly. A year later they were married, though in very humble style. Napoleon became the rising star of France, with his successful Italian campaign, his invasion of Egypt (Redouté's younger brother Henri-Joseph and a team of scientists followed the expedition up the Nile) and his election as First Consul of France in 1799. At that time Joséphine acquired the ruinous estate of Malmaison and began to restore the château. More importantly, she redesigned the gardens, building a vast glasshouse for her tropical plants and a menagerie for her animals. She began her other lifelong love-affair – with the roses. In the early days Joséphine had about 250 different species, which was a considerable number at that time.

Redouté worked on some drawings of the rare plants in the garden of Jacques-Martin Cels, who was a friend of L'Héritier. Other artists, including Redouté's brother Henri-Joseph, had contributed drawings, while the botanist Etienne-Pierre Ventenat (1752–1808) was responsible for the descriptions. The book, *Description des Plantes nouvelles et peu connues cultivées dans le Jardin de J. M Cels* came out in 10 parts between 1800 and 1802. Ventenat decided to go on a shopping trip to England to purchase books, which was no light undertaking in those days. On the homeward journey there was a sudden storm in which the ship sank; captain, crew and all the passengers, except Ventenat, were drowned. He was either very lucky or an exeptionally strong swimmer, or both. Supported by a piece of wreckage, he was eventually rescued near the coast of France. Ventenat had had a good grounding in botany from De Jussieu, and was therefore an excellent man to advise Joséphine, who had realized that she needed what might now be called technical advice in order to have her plants cared for properly. In any case, her plants would have been of even more interest to him. It is likely that Ventenat introduced Redouté to Joséphine and this was the start of their life-long association.

In 1804 Napoleon was elected Emperor of France, with Joséphine as Empress. Fortunately for the tradesmen of Paris and elsewhere, Joséphine was tastefully extravagant and she had the means to become a patron of the arts. Her example was emulated by all those around her which would have had an excellent effect on the French economy. Here, Redouté found his spiritual home. Now he began to produce his best work: *Jardin de la Malmaison* in two volumes (1803–5) with descriptive text by Ventenat; the famous *Les Liliacées* which came out in eight volumes and took him 14 years to produce (from 1802–16); *Description des Plantes rares cultivées à Malmaison* (1812–17) for which Bonpland supplied the text; and, the most famous of all, the three volumes of *Les Roses* (1817–24) with text by Claude-Antoine Thory (1759–1827).

For years, ever since the meeting with Bartolozzi in England, Redouté had been experimenting and refining his engraving techniques and had begun to produce his own exquisite colour prints. But printers dislike changes, even when it seems that new inventions make for better results. Redouté had been accused of stealing the method and had been taken to court, where he successfully vindicated himself by describing his own procedures. The case excited much interest because of Redouté's fame, but the court recognized that he was blameless and dismissed the action.

The Napoleonic wars in Europe rumbled on, and communications with other countries were difficult. Joséphine had been in the habit of obtaining rare plants from the famous nurseries of Lee and Kennedy at Hammersmith in London. It is a historical fact that John Kennedy continued to travel between France and England with plants for Malmaison; even if he were not aboard the various ships, the packages of plants arrived at their destination quite safely. But it must always have been dangerous and

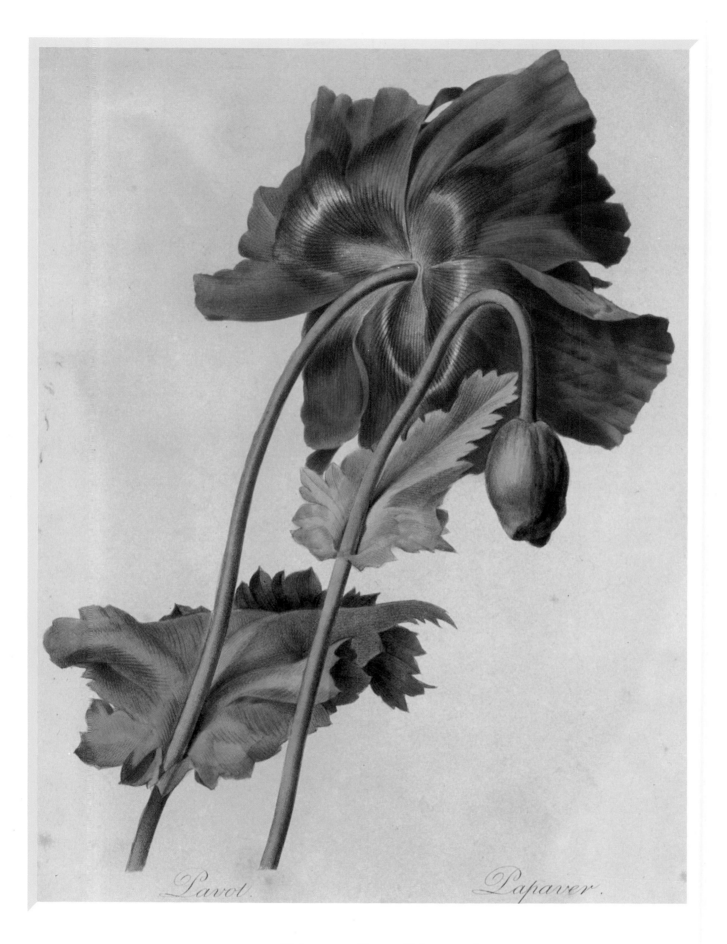

PAVOT (*Papaver somniferum* – Opium poppy)
Pierre-Joseph Redouté
Langlois sculpt.

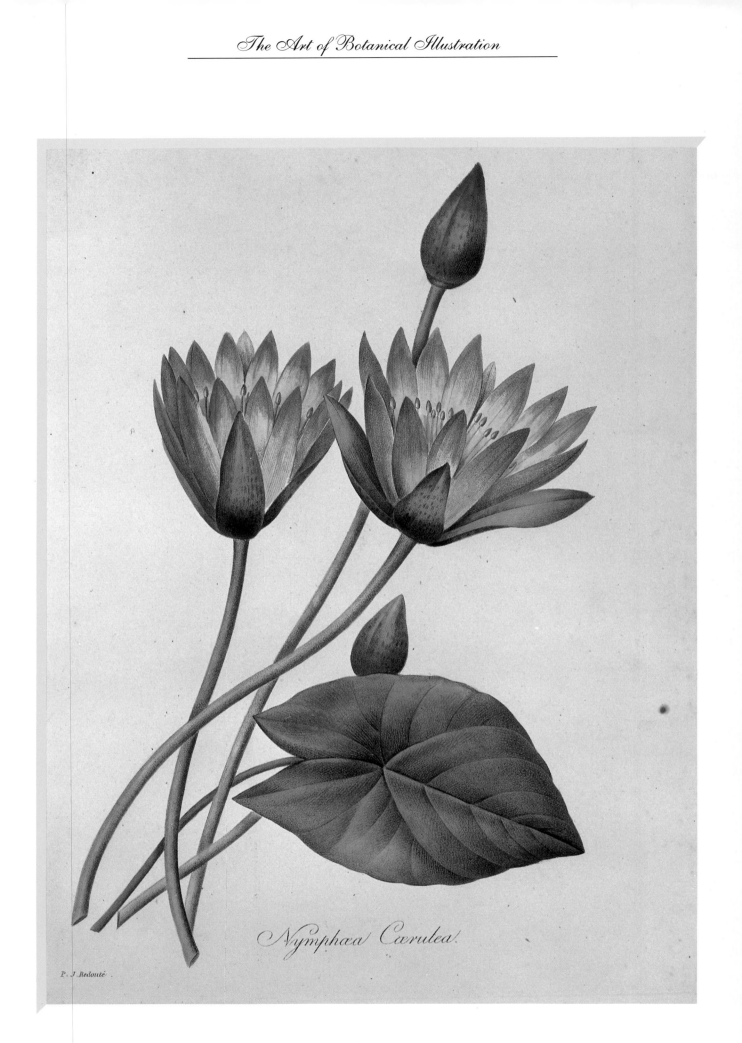

Nymphaea caerulea
Pierre-Joseph Redouté

as a mark of gratitude, Ventenat named a new Australian genus, *Kennedya* after this unusually brave and, one hopes, well-paid, nurseryman.

Joséphine was employing Redouté to paint her roses and this regular income gave the artist sufficient financial security to buy a country house at Fleury-sous-Meudon. It was delapidated and had a neglected, overgrown garden, but Redouté recognized its possibilities and in this he was a true gardener, never put off by past neglect or raw newness. Redouté began to grow his own roses, and as many other plants as space allowed. But, alas, this happy state of affairs was not to last. Joséphine had already had two sons by her first husband but Napoleon and she could not produce the child that the Emperor so badly wanted. With regrets and much sadness their marriage was annulled in 1809 and Napoleon married the 18-year-old daughter of the Austrian Emperor; in 1811 she dutifully produced the longed-for son and heir.

Joséphine 'retired' to Malmaison, but this was felt to be too close to Napoleon's new ménage. Consequently, the Emperor bought her the estate of Navarre, near Evreux, in the Seine Maritime and gave her a generous income with which to maintain it. Redouté's association with Joséphine continued as before, for a time, with Redouté beginning work on another book.

But now Emperor Napoleon's fortunes changed, culminating in his abdication in 1814. In the same year Joséphine died at Malmaison, thus bringing to an end her unstinting patronage of the arts and of Redouté in particular. At her death her debts were approximately 2½ million francs. For Redouté, times became difficult. He had formed expensive habits which were no longer affordable since Joséphine's death. He found himself in debt and had to concentrate his activities on producing what in today's terminology would be marketable commodities. He did the illustrations for *Choix des plus belles Fleurs et des plus belles Fruites* (1827–33) which was produced by Charles-Louis Panckoucke, who happened to have his home near Fleury. Formerly Redouté had published his own works but now he could no longer afford to do so. The book features a random choice of flowers and fruits painted purely for aesthetic appeal. Redouté was forced to borrow money to maintain his position.

Van Spaëndonck died in 1822 and the post at the former Jardin du Roi (now the Museum d'Histoire Naturelle) ceased with his death. Two new positions of *Maitres de Dessin* were created instead. Redouté occupied one, and the other was awarded to Bessa. Redouté taught painting to members of the new aristocracy and their daughters, and in 1825 he was made a Member of the Légion d'Honneur. Redouté was doing well, selling his paintings and his prints, but not well enough: the house and the apartment in Paris were a constant drain on his resources. However, a new patroness appeared, in the duchesse de Berry. But she was not to be a second Joséphine, even though her father-in-law Louis X bought her the original paintings for *Les Roses*. Charles X was removed from power and Louis-Philippe became King in his place. His Queen, Marie-Amélie (1782–1851), was interested in flower-painting and gave Redouté a salaried position of 'Peintre des Fleurs du Cabinet de la Reine'. He was now an old man in his 81st year, beset with financial worries of all kinds, but still able to paint. On 19 June 1840, while examining a lily which was to be part of a commissioned flower-piece that he was planning, he had a stroke. He died the following day. It is most fitting that his last coherent vision must have been that of one of his favourite flowers, and he died in the month of roses. A wreath of roses and lilies was placed on his coffin with the words:

O peintre aimé de Flore et du riant empire
Tu nous quittes le jour où le printemps expire
which, freely translated means:

O Artist loved by Flora and the gay Empire
You leave us the moment the days of Spring Expire.[19]

19. *I am indebted to Mlle Diana Cresswell, Paris, for this translation.*

Kew, Heart of the Botanical World
—————1760–1900—————

KEW GARDENS IS THE GREEN HEART of the botanical world, its veins of communication linking it with early medical knowledge, Royal history, exploration, scientific discovery, plant hunters and the culture of centuries of horticultural treasure hunting. Kew is about 300 acres of landscaped gardens, open spaces, water, rocks, trees, hardy shrubs, herbaceous plants and bulbs, great glasshouses replicating countries and other climates; and the Herbarium is the precious repository of centuries of scientific discovery and plant drawing.

But Kew started small – as does every plant. In 1721 or thereabouts, the estate of Kew was acquired by Lord Capel. The house, with its 'small' garden of about 11 acres was leased to the Prince of Wales, Frederick Louis (son of George II) who liked the peace and tranquillity of this country area. The Prince and Princess of Wales were interested in the cultivation of rare plants and in this pursuit they were joined by the Earl of Bute, whose own interest was almost an obsession. The Earl of Bute had a botanical library and herbarium, many hundreds of botanical paintings, and a huge heated glasshouse 300ft long. He was a knowledgeable gardener and botanist and, like many men of wealth and position, he grew and studied the exotic new plant discoveries. He financed the publication of several books, and his practical knowledge and enthusiasm for botany must have had an effect on the Prince and Princess of Wales.

The gardens at Kew were a continuing source of pleasure and interest to the Prince. After his unexpected death in 1751, the Princess of Wales and Lord Bute continued to occupy themselves with the gardens and it was said that perhaps the relationship was more than horticultural. In 1759 the Princess was making plans to build a hothouse at Kew; this was being designed by Dr Hales (after whom the genus *Halesia* was named). At that time the young William Aiton, a pupil of Philip Miller at the Chelsea Physic Garden, took over the care of the gardens, supervised by Lord Bute.

This century saw great territorial expansion and scientific discoveries which were fascinating to the wealthy and cultured classes. The Prince of Wales had commissioned William Kent to lay out the gardens as they existed at that time, though the interest in landscape gardening on a grand scale (with its simplicity of upkeep) must

have been difficult to integrate with an equal passion for 'exotick' plants that needed individual daily care. After the death of Queen Caroline, the Dowager Princess extended the gardens and commissioned the young Sir William Chambers to design some 'appropriate' architecture. This he did, bringing his newly-discovered interest in Chinoiserie into full play. The pagoda at Kew is the only example of this that remains; he also designed and built the Orangery. After the death of George II, his grandson 'farmer' George was crowned king. George III devoted much of his leisure time to the care and maintenance of the gardens. 'Kew Palace' was built by a Dutch merchant, Samuel Fortney, and was originally called 'Dutch House'; it is the only 'Royal' building left in the gardens at Kew.

When Lord Bute died, George III had the very man to replace him – Sir Joseph Banks. This was a period of great expansion in British history. Wealthy men such as Lord Bute had spent their private fortunes on the collection and dissemination of knowledge and Joseph Banks was to follow suit, with his personal backing of Captain Cook's memorable voyage. Banks left England as a keen botanist and returned as a botanical ambassador. His suggestions were later to lead to the setting up of one of Kew's functions, that of plant exchanges between countries and continents. Banks envisaged Kew as a world storehouse of information, knowledge and research and it was because of his farsighted vision that Kew was able to grow and flourish. Kew was sending out plant collectors who came back laden with seeds, bulbs and dried specimens, and the building that is now the Herbarium was privately purchased by Sir William Hooker to store them.

There was, however, to be a change of fortune at Kew. In 1820 King George III and Sir Joseph Banks both died, and George IV came to the throne. Kew went into a 20 year long eclipse, saved only, it seems, by William Townsend Aiton (son of William Aiton) who just managed to keep the spirit of Kew alive. In 1841 Aiton resigned, though his Scottish assistant remained. During this sad period with its lack of funding and interest, it must have been difficult indeed to reconcile the drab and depressed situation with the surging vitality and great artistic names of the past; Parkinson, the Bauer brothers, Ehret, Sowerby,

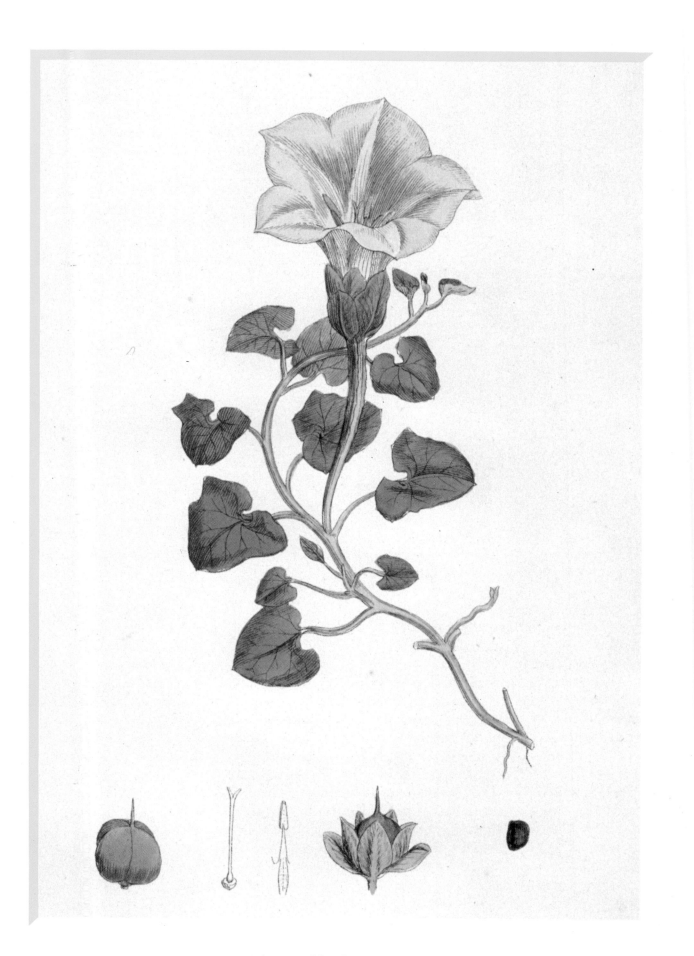

Calystegia soldanella – SEA BINDWEED
James Sowerby

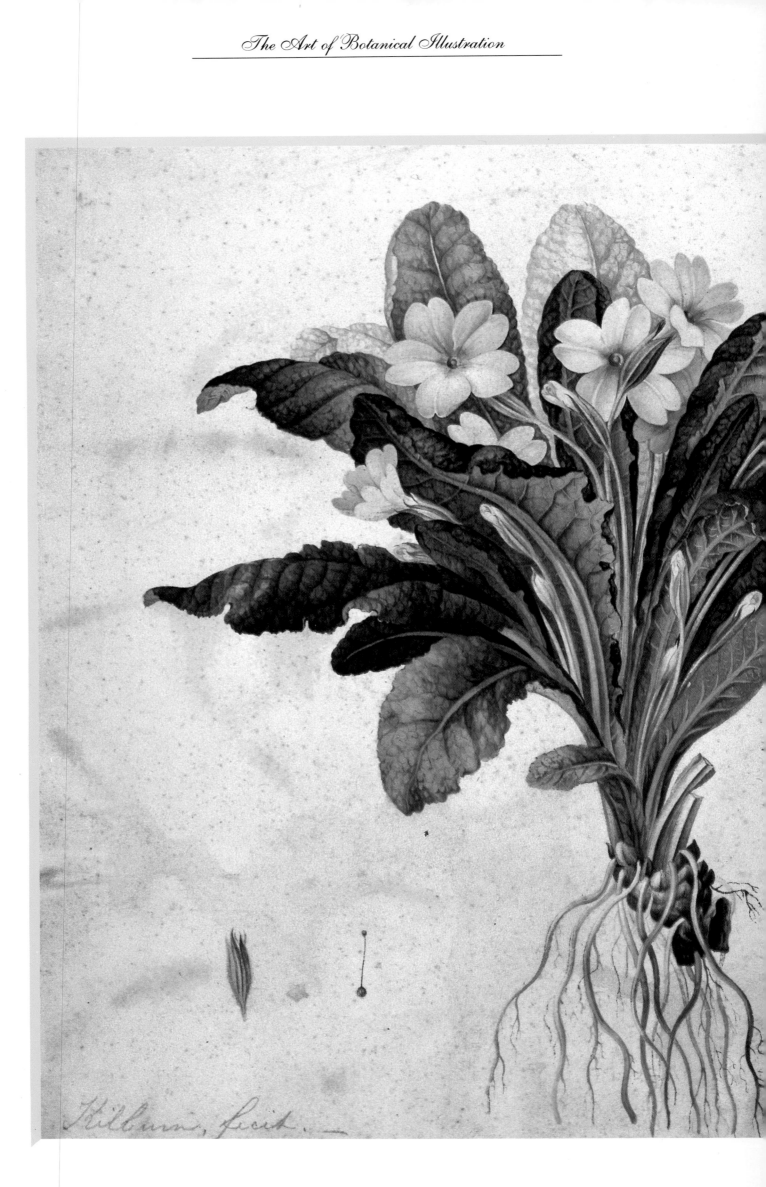

Kilburn, fecit.

Sydenham Edwards and many others. At least their precious work was safely stored in the Herbarium library. In 1840 Kew had been adopted as a national establishment, thereafter becoming known as 'The Royal Botanic Gardens, Kew' though its affairs were managed by the Government department of Woods and Forests. It was at about this time that the Royal Horticultural Society began to share in the rich harvest of plants and seeds that came to Kew from all parts of the world.

In 1841 the declining affairs of Kew were examined by a special Commission and Sir William Jackson Hooker was appointed as Director. It was to be a new era for Kew, orientated more towards scientific study, though the horticultural and scenic aspect of the gardens were not to be neglected. Kew was still small, only about 15 acres in total, but was about to grow dramatically. A total of 250 extra acres of land was acquired. This, then, to 1841 was the structure of the emergence of Kew, and it is time to retrace our steps, people the structure, and chronicle their work which still continues today. An example of such continuity is William Curtis's Magazine[20], launched in 1787. This famous periodical has been published with but few interruptions from that time until the present day, a life-span of 202, sometimes difficult, years.

CURTIS'S MAGAZINE AND ITS ILLUSTRATORS

William Curtis (1746–99) was born at Alton in Hampshire, England, where he was apprenticed to an apothecary. He left his country home for the brighter lights of London, where he set up in business as an apothecary and soon was able to take on a partner. The apothecary's shop did well enough so that in time he was able to sell his share of it. After that he spent his time collecting and studying plants, gaining more knowledge about them from books, cultivating his garden at Bermondsey and meeting friends with similar tastes. He was so thorough in his application to the subject that in 1772 he was appointed Praefectus Horti and Demonstrator to the Society of Apothecaries at Chelsea. He was a good lecturer and a good gardener, and sometimes arranged talks and demonstrations on botany and horticulture at his own garden.

His main interest, however, was in the indigenous flora of Britain, particularly those that grew in and about London. Curtis knew Lord Bute, and with his assistance, he began work on a mighty project, the *Flora Londinensis* which was to be a compilation of all the flowers that grew within 10 miles of London. The first part of this beautiful book appeared in 1777, dedicated to Lord Bute.

20. *Affectionately called the 'Bot Mag' by the staff of the Kew Herbarium.*

Primula vulgaris – PRIMROSE
William Kilburn

Curtis resigned his post at Chelsea in order to continue with this delightful but unprofitable task. After 10 years of hard work two handsome folios had been published but public response was poor. The books – 300 of the first edition – were sold to named subscribers. It seemed that the class of customer who was able to afford the books did not buy them because common wild flowers were featured. Lesser folk could not afford the books, even though the subjects might grow by their garden gates. Today the folios are almost priceless and it is a privilege to be allowed to turn their pages of hand-coloured engravings. An enlarged version including wild flowers from other parts of the British Isles was produced from 1817 onwards but it does not seem to be compatible with the book's title.

Curtis, though a private visionary, knew when enough was enough, and decided to pander to the public whose appetite for pictures of exotic plants seemed to be insatiable. And so on 1 February, 1787, the first edition of Curtis's *Botanical Magazine: or Flower Garden Displayed* was produced. It contained coloured engravings of the 'most Ornamental FOREIGN PLANTS, cultivated in the Open Ground, the Green-House, and Stove,' together with information regarding their culture. Curtis did not always select the most tropical of the exotics, he popped in a few of the prettier British wild flowers here and there, assuming (probably rightly) that the public would not know what any of them were anyway; though of course the botanists would. The first issue contained three engravings, and cost one shilling; subsequent issues usually had about the same number of engravings; if one was added, that particular issue was more expensive. The first illustrator was William Kilburn, followed by James Sowerby and Sydenham Edwards; these three produced most of the drawings for the first 28 years of the magazine's life.

William Kilburn (1745–1818) was the son of an Irish architect. The young Kilburn liked to draw and had learned the art of engraving at an early age. However, his father did not approve of his intentions to pursue a career as an artist. So, the young man found employment as an apprentice with a calico-printer, as it was the only work he could find that was close to painting. This employment did at least produce an attractive product, even if the designs were sometimes simplistic and repetitious.

After his father's death came release, and Kilburn went to London where he took lodgings near Curtis's garden at Bermondsey. Naturally the two met and Kilburn showed Curtis some of his own drawings. Curtis immediately asked him to work on the plates for the *Flora Londinensis* in both his capacities as artist and engraver. But Kilburn returned to his trade of calico-printing eventually, probably because Curtis was unable to pay him well, or even regularly. He did exceedingly well, as may be imagined, and in due course he was able to start up his own factory,

becoming both rich and influential. However, during his time with Curtis he produced many of the drawings for the *Flora Londinensis* and also for the *Botanical Magazine*. The latter would not have taxed him too much, since the average number of illustrations was about 45 a year and Sowerby and Edwards were also contributing their share.

James Sowerby (1757–1822) was born into an artistic family. He studied at the Royal Academy Schools and was afterwards apprenticed to Richard Wright the marine painter. As a competent general artist and engraver he was unsure about which subject he should choose to specialize in. For a while he taught art and painted portraits. He also met the botanist L'Héritier, who commissioned some botanical paintings from him. Sowerby became very interested in the work and began assisting Curtis in the production of his plates for the *Flora Londinensis* and the *Botanical Magazine*. In addition, he began work for Sir James Edward Smith's *Icones Pictae Plantarum Rariorum* (1790–3) and for William Aiton's *Hortus Kewensis* (1789). He was also planning and producing two of his own works – *An Easy Introduction to Drawing Flowers according to Nature*, which he brought out in 1789 to fulfil a need for a ladies' drawing book, and the *Flora Luxurians* (1789–91).

In addition to these many commitments he worked on the drawings for *English Botany*, which was published in 36 volumes with 2,500 drawings. It is exhausting to even contemplate this man's phenomenal output especially as he would have been doing some, if not all of his own engraving as well. The text for *English Botany* was supplied by Sir James Edward Smith, who wished to remain totally anonymous and so his name does not appear in the early editions. This major work took up so much of Sowerby's time that he ceased making drawings for the *Botanical Magazine*, and did not even see much of Curtis for some while. In 1797 he was engaged in another great work, the engravings for *Coloured Figures of English Fungi*; he also worked on the plates for Thornton's *Temple of Flora*. In 1806 he began work on the engravings for Sibthorp's *Flora Graeca*, with the help of his son, James de Carle Sowerby, and Ferdinand Bauer.

Drawing must have been as natural to Sowerby as breathing. It is interesting to find that in later life he studied fossils, minerals and zoology; by this time, in addition to producing the drawings, he wrote the text as well. In recognition of his contributions, a genus of Australian lilies, *Sowerbaea*, was named after him, also a whale, *Mesoplodon sowerbiensis*. Most of the Sowerby family were artistic; James Sowerby's three sons were James de Carle[21], who became a naturalist and artist; George Brettingham, who became a conchologist and also an artist; Charles Edward, who appears not to have picked up a pencil, but whose son John Edward was to follow in his illustrious grandfather's footsteps as a botan-

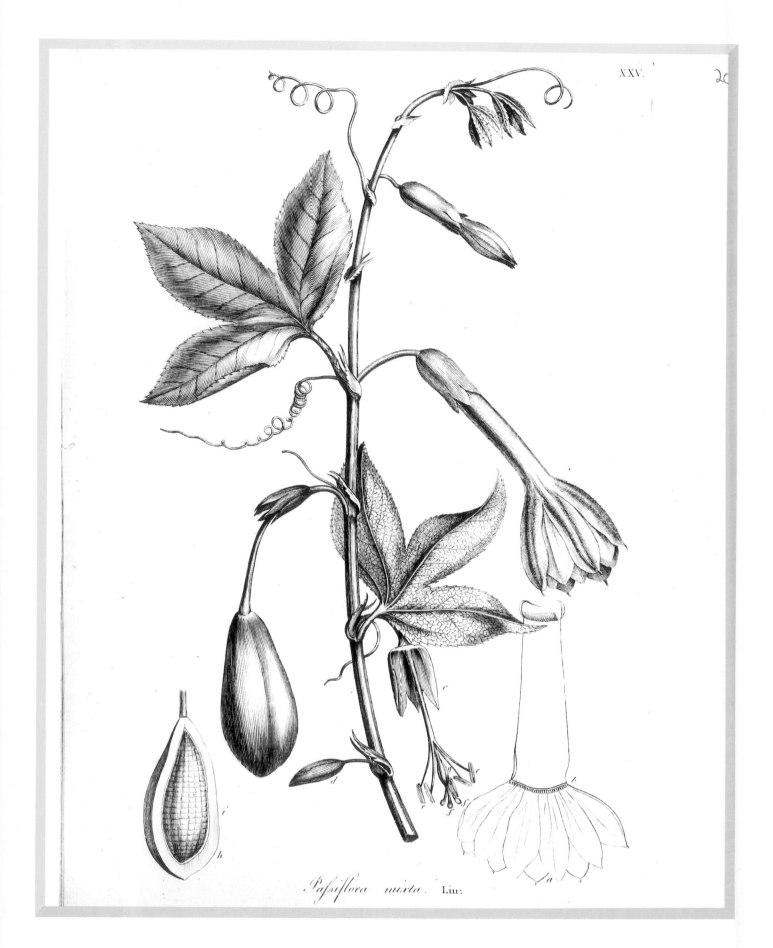

Passiflora mixta. Lin:

Passiflora mixta
James Sowerby
Plantarum icones in herbario Linnæano
Jacobo Eduardo Smith MD (MDCCLXXXIX)
Plate 25

Rubus rosaefolius
James Sowerby
Plantarum icones in herbario Linnæano
Jacobo Eduardo Smith MD (MDCCLXXXIX)
Plate 66

Helleborus ranunculinus
James Sowerby
Plantarum icones in herbario Linnæano
Jacobo Eduardo Smith MD (MDCCLXXXIX)
Plate 37

ical artist. George Brettingham had two sons, George Brettingham *secundus* and George Brettingham *tertius* both of whom painted shells. George Brettingham's other son, Henry, is not recorded as having any ability with pen or brush

Sydenham Teast Edwards (1769?–1819) was the son of a Welsh schoolmaster. The boy drew flowers for his own pleasure, and must have had access to a copy of the *Flora Londinensis,* for he copied some of the plates which was part of the normal learning process. William Curtis was shown some of his work and was impressed by the standard of the drawing. He asked young Edwards to come to London, where he was given some instruction and a position almost simultaneously. From then on, he was Curtis's constant companion on the many expeditions that were such a pleasure to them both. Curtis died in 1799, and the *Botanical Magazine* continued under the guidance of John Sims (1749–1831) until William Jackson Hooker (later Sir William Hooker, 1785–1865) took over the directorship in 1826.

During the first and uninterrupted period of the life of the *Botanical Magazine* most of the drawings were done by Edwards, and since attribution is given to the artists, it can be seen that out of a total number of 1,721 plates, Edwards produced approximately 1646 during the magazine's first 28 years. Edwards also worked on the continuing *Flora Londinensis* for Curtis, and *A Complete Dictionary of Practical Gardening* by McDonald (1807) which included some American plants. Some of these plates were re-used in the *New Botanic Garden* (1812) sometimes confused with Maund's lovely volumes *The Botanic Garden* (1825), and the *New Flora Britannica,* republished in the same year (1812) as *The New Botanic Garden.* In addition, Erasmus Darwin wrote and published a poem called *The Botanic Garden* in 1789, so this title, at this time, was not the best choice for Edwards. One wonders if he received any royalties — most probably not, alas; indeed, he might have been lucky just to receive due attribution.

In 1815 Edwards had a disagreement with the magazine and launched another magazine in competition. It was very similar, and was called the *Botanical Register.* Benjamin Maund produced the text and his engraver, E. D. Smith made the plates, so the magazine was of a high standard.

Clara Maria Pope (*c*1780–1838) born Clara Maria Leigh was originally a miniaturist, exhibiting at the Royal Academy for many years. Then she turned to nursery rhyme and fairy tale subjects. Her first marriage was to Francis Wheatley who painted the *Cries of London.* He often

used her as a model so we know what she looked like. Her second marriage was to the actor Alexander Pope. Attracted by the current interest in flower-painting, she began to do some studies of flowers and plants and found that these brought her much more recognition as a painter. With flowers, surprisingly, she went for the big, the bold (and the beautiful) and filled large folio-sized pages with powerful paintings of peonies, camellias and roses. She illustrated Curtis's *Monograph on the Genus Camellia* (1819) and did some of the plates for his *Beauties of Flora* (1805–20) which he produced in competition to Thornton's *Temple of Flora.* Though even larger in size than the latter, in this case big was not beautiful and the volume was never a success. It is exceedingly rare today, and for this reason valuable, rather than for the quality of its contents. Clara Maria Pope's peonies belonged to the Horticultural Society, and were subsequently sold at one of their sales on 5 May, 1856. The paintings are now in the care of the Natural History (British Museum).

Of Ralph Stennat (*fl*1800s) very little is known, other than the fact that he lived at Bath and was a most talented Natural History draughtsman exhibiting at the Royal Academy in 1803. The Natural History (British Museum) has an interesting collection of his work which is well worth seeing.

Robert Sweet (1782–1835) was a horticulturalist, a botanist and an ornithologist. Born at Cockington, near Torquay, he first worked as an under-gardener for his half-brother James Sweet who was employed by Richard Bright, near Bristol. Here he learned his trade, and then left after nine years to take care of the plants of John Julius Angerstein. Between 1810 and 1815 he went into partnership with a William Malcolm at his nursery at Stockwell; but the partnership may have been unsatisfactory, at any rate it was severed in 1815 and Sweet became a foreman at the Whitley, Brames and Milne nursery at Fulham. While he was working there he produced his first book, *Hortus Londinensis: A Catalogue of Plants Cultivated in the Neighbourhood of London.* The year after this he transferred himself to the nurseries of James Colvill, famous for their exotic plants and also for the large area of glasshouses in which these were kept.[22] Sweet continued to produce many books, and as was usual, they came out in parts and so he would often have been working on several at one time. *Geraniaceae* (in four parts) came out between 1820 and 1828 followed by a supplement. The famous *British Flower Garden* came out in 1822, and while working on these he had begun *The Botanical Cultivator, Cistineaea,* a book on

21. *James de Carle Sowerby was almost as industrious as his father, producing about 10,000 small drawings for J. C. Loudon's Encyclopaedia of Plants (1829). This is a monumental book of reference whose text was produced by the equally indefatigable Loudon.*

22. *The glasshouses and their heating were a source of great fascination to the press and the public, and it became the custom for the gentry to pay a daily visit to Colvill's during the flowering season to see the wonderful displays of new, rare plants*

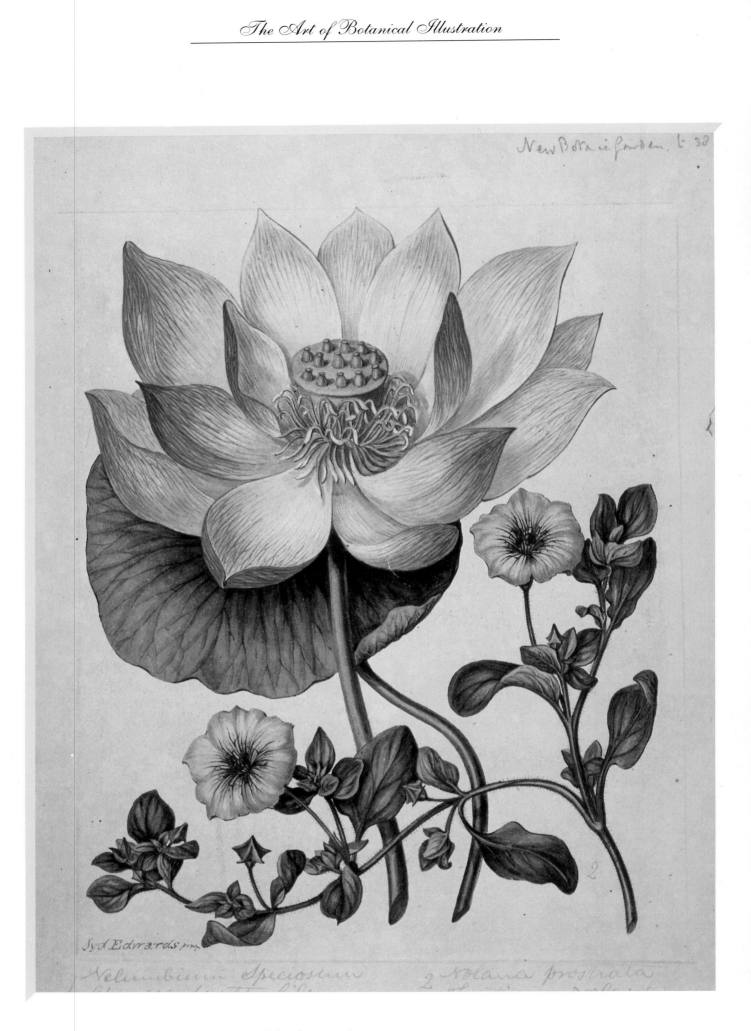

Nelumbium speciosum – CHINESE WATER LILY,
Solana prostrata – TRAILING SOLANA
Sydenham Teast Edwards – *New Botanic Garden*

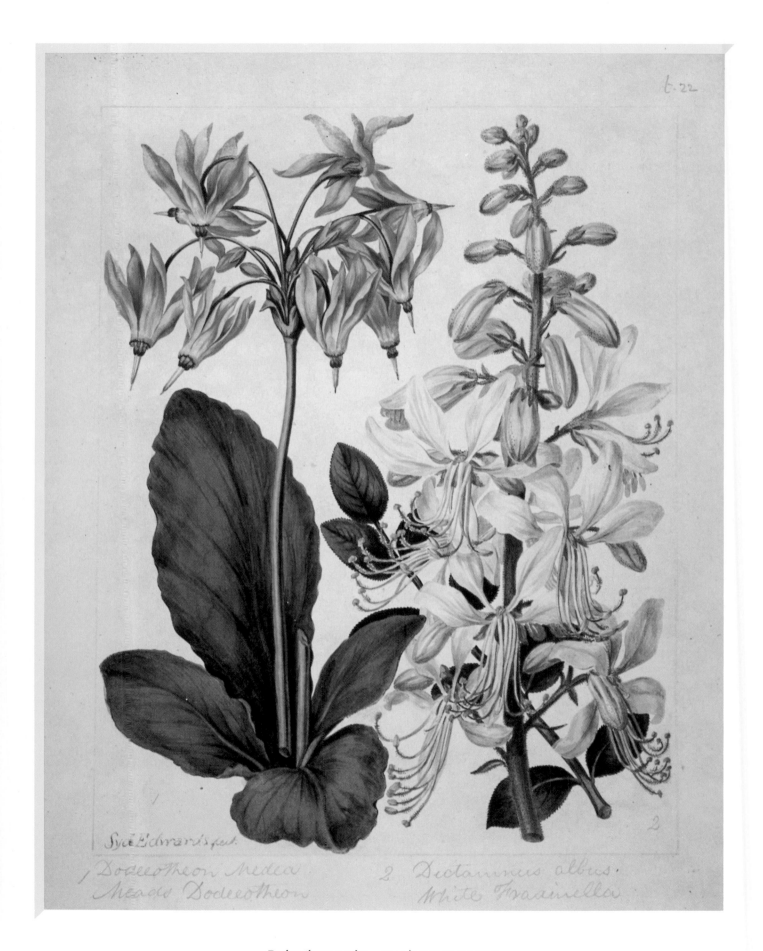

Dodecatheon medea – MEAD'S DODECATHEON,
Dictamnus albus – WHITE FRAXINELLA
Sydenham Teast Edwards

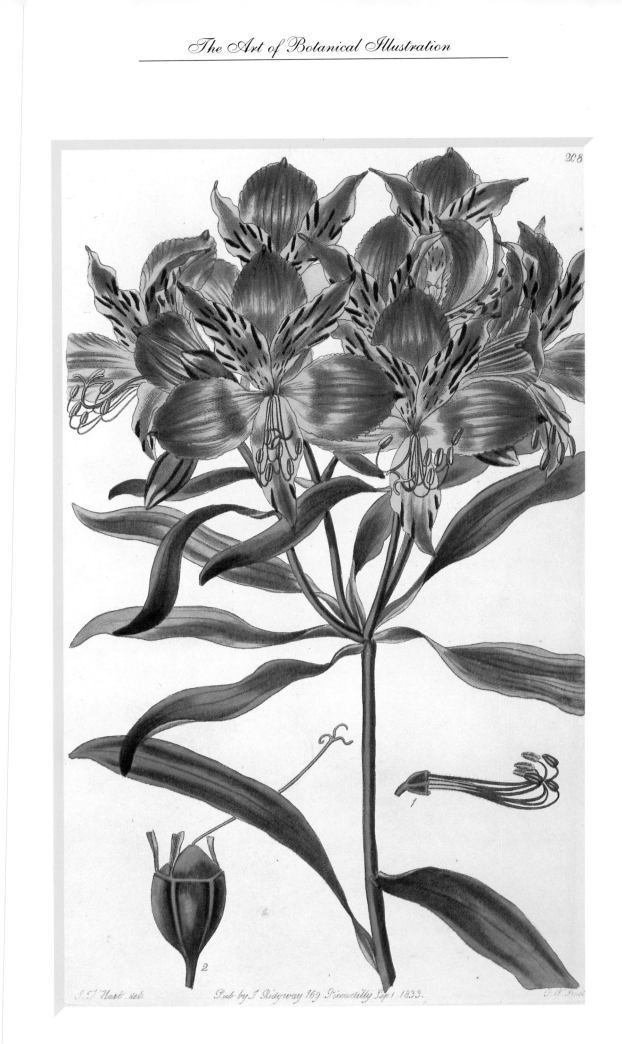

Alstroemeria aurantiaca
Robert Sweet, *British Flower Garden*, second
series vol. III 1835, pl. 205

Helleborus viridis – GREEN HELLEBORE,
Hypericum hircinum – FOETID ST JOHN'S WORT
Sydenham Teast Edwards – *New Botanic
Garden*

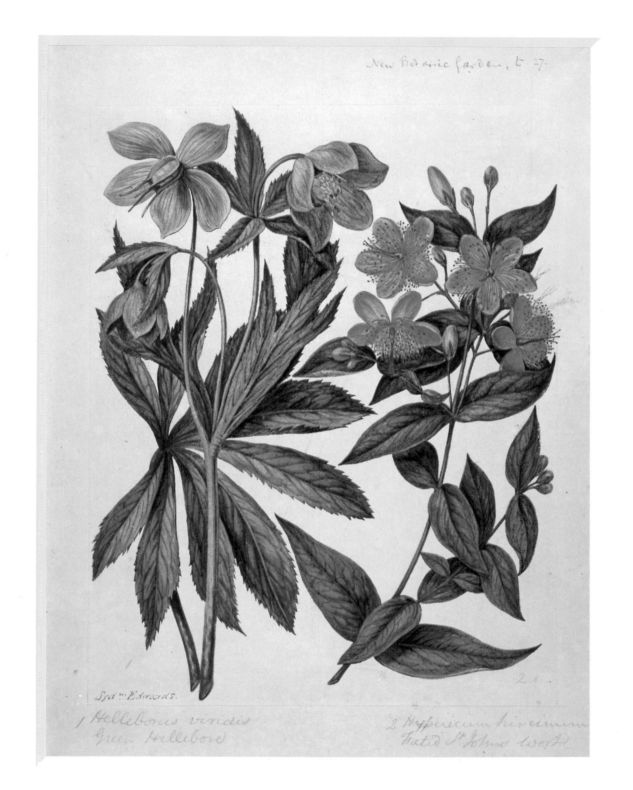

New Botanic Garden, t. 27.

Syd.m Edwards.

1 *Helleborus viridis*
Green Hellebore

2 *Hypericum hircinum*
Fætid St John's Wort

birds, *British Warblers,* the unillustrated *Hortus Britannicus,* the *Florist's Guide* and then *Flora Australasia.* All this would have taken nine days a week even if he had not had a full-time occupation at Colvill's, whose plant collections (and turnover) improved dramatically while Sweet was with them. In 1826 a complex and unplanned series of events occurred. Sweet was arrested for 'Feloniously receiving . . . seven plants, value £7, and seven pots, value 6d, the goods of our Lord the King' which had been taken from Kew. Stealing was still a hanging offence, particularly if the goods stolen belonged to the king, as all at Kew did. It is thought that Sweet was accused by Aiton (then Director of Kew) on this trumped-up charge because Sweet had criticized Aiton in one of

his books. There is much that is inconclusive in the account of the trial, but eventually Sweet was found 'Not Guilty'. The after effects of the trial left Sweet mentally unstable. He left his position at Colvill's to concentrate on another book which was never finished; his mental state deteriorated and he died, more or less insane, in 1835.

Walter Hood Fitch (1817–92) was an outstandingly prolific botanical artist, rivalling, if not exceeding, James Sowerby in his output. His style is unmistakable, particularly when seen in colour; it needs no signature for the student of botanical illustration, especially when he painted rhododendrons, which one feels he must have loved. Fitch was apprenticed to a Glasgow firm of calico-

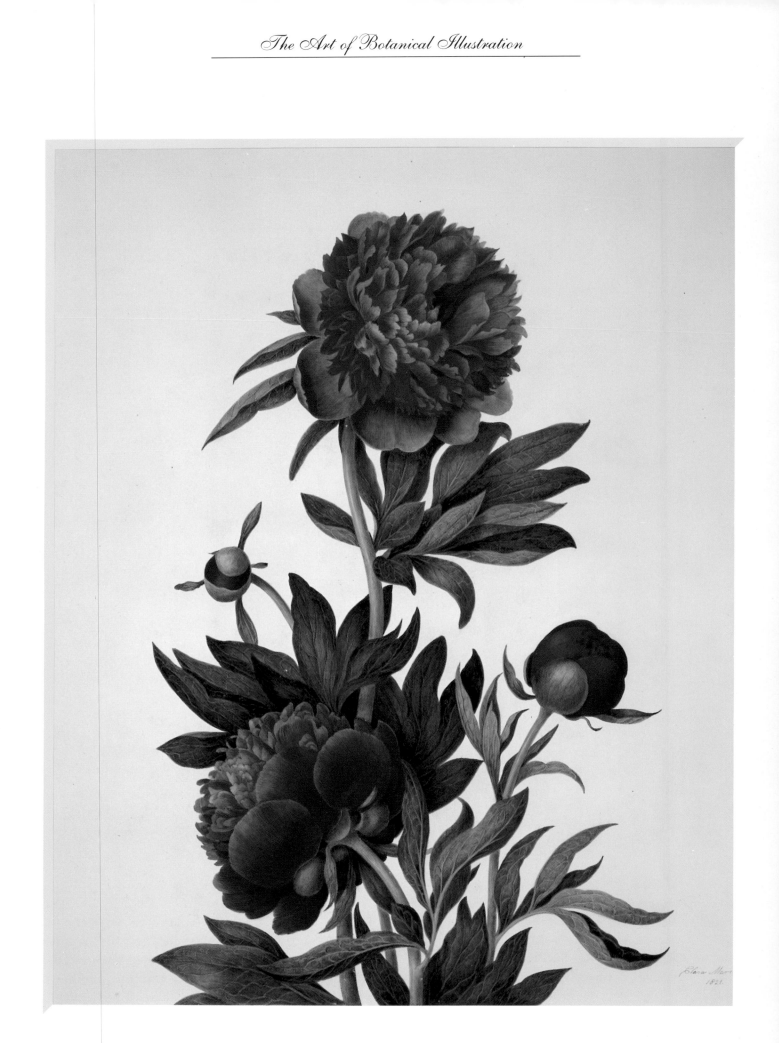

PEONIES (1821)
Clara Maria Pope

designers and became known to Sir William Hooker (1785–1865), then Regius Professor of Botany at the University of Glasgow. Fitch helped Sir William mount the dried plant specimens in the Herbarium in his spare time and his ability as an artist must have become apparent, as he began to draw the plates for the *Botanical Magazine* – his first illustration being dated 1834. Sir William bought out his apprenticeship so that he could employ Fitch full-time, and in 1841, when Sir William was appointed Director of Kew Gardens, he took Fitch to London. Fitch produced all the plates for the *Botanical Magazine* for about 40 years, and in addition he did the illustrations for a very great number of other publications. It is recorded that 9,960 drawings were published by him during his working life, and one can only marvel at the man's prodigious and apparently unflagging industry. In 1877 he had an argument with the director of the *Botanical Magazine* and ceased to provide any more drawings for it.

It is difficult to disassociate Fitch, the magazine, Kew and the Hookers, so closely are their stories interwoven. Sir William Hooker was a competent, though not brilliant botanical artist, and when Sydenham Edwards left the *Botanical Magazine* there were only a few other artists available to produce the plates. These, John Curtis (an entomologist, and no relation to William Curtis) and William Herbert, kept the magazine going, but in 1826 Sir William Hooker took the responsibility of the illustrations upon himself and continued to produce them for about ten years. In addition, he made drawings for the new edition of the *Flora Londinensis.* He had considerable knowledge and what the drawings may have lacked in actual beauty was more than made up for by their botanical accuracy.

By 1841 Kew had become a national institution, with Decimus Burton's great Palm House being commissioned in 1844 and finished in 1848. This is now a Kew logo. The public were allowed in every afternoon, and until 1980 the entrance fee was the best pennyworth in the British Isles. Sir William Hooker encouraged new patrons for Kew who funded plant-hunting expeditions. His son Joseph, having taken a medical degree at Edinburgh, went as naval surgeon and botanist in the *Erebus* on a geographic voyage to the Antarctic. There were two ships in the expedition, the other being the *Terror,* and they visited Madeira, Trinidad, St Helena, the Cape of Good Hope, the Antarctic and New Zealand. During the four-year voyage, Joseph Hooker sent letters and specimens back to his father, though he wisely kept the main collection of these with him aboard the *Erebus.* When the ships returned in 1843, Kew had been officially open to the nation for two years. Joseph Hooker took about four years to collate his specimens, and Fitch, by now the official Kew artist, would have been able to revivify these; the results can be seen in Joseph Hooker's three-part

Botany of the Antarctic Voyage of HMS *Erebus and Terror.* The first part was *Flora Antarctica* (1844–47), the second was *Florae Novae Zelandiae* (1853-5) in two quarto volumes, and the third part was *Florae Tasmaniae* (1855–60) which included mosses, lichens, ferns, fungi and algae. All the illustrations were done by Fitch, and almost all from dried specimens.

Joseph Hooker also visited the Himalayas to collect rhododendrons; at that time (1848–9) only about 32 species of rhododendron were known. In addition he saw and collected many other new plants, enduring appalling hardships during the journey. As he went he made comprehensive sketches, particularly of the rhododendrons which were in flower. These sketches were (with the botanical back-up of dried specimens[23]) re-drawn by Fitch to become the handsome plates of *The Rhododendrons of Sikkim – Himalaya* (1849–51). Fitch also re-drew botanically the drawings by Indian artists for Hooker's *Illustrations of Himalayan Plants* (1855).

Fitch made use of the new lithographic printing process, usually drawing directly on to the stone. Once the drawing was made or traced directly on to the stone, a special kind of porous limestone, with a special grease pencil, the design was 'fixed' and then the surface was damped with water. After this, a roller loaded with greasy ink would be passed over it. The portion that had been wetted with water did not take the ink from the roller, and so when a piece of paper was laid over the stone and the whole passed through a press, only the areas drawn with the grease pencil were transferred to the paper. This process was easy, speedy and more delicate gradations of tone could be achieved. Zinc was later brought into use instead of the stone, as were treated chalk, ink and, later, colours.

Hooker produced *A Century of Orchidaceous Plants* (1867), written by James Bateman, and Robert Warner's *Select Orchidaceous Plants* (1862–91) was in preparation. Orchidomania had come to England, and Frederick Sander was known as the 'Orchid King' with his huge heated glasshouses and importation of huge numbers of these truly tropical exotics. During all this frenzy of illustration, Fitch was also producing all the drawings for the *British Flora* which came out in 1865. It is difficult to understand how one man could achieve so much at this time; but Fitch was phenomenal and his work was invaluable.

The Botanical Magazine (now *Curtis's Botanical Magazine*) had become almost a part of Kew, with precise and scholarly descriptions and dissections making it a totally scientific work. The editorship changed with the years; Joseph Hooker resigned in 1904 and was succeeded

23. *The 'Wardian case' had been invented by then and Hooker used them, in varying sizes, to transport living material from tree-size to minute alpine plants. He returned from this trip with, literally, tons of specimens, seeds, bulbs, live plants and ethnic oddities.*

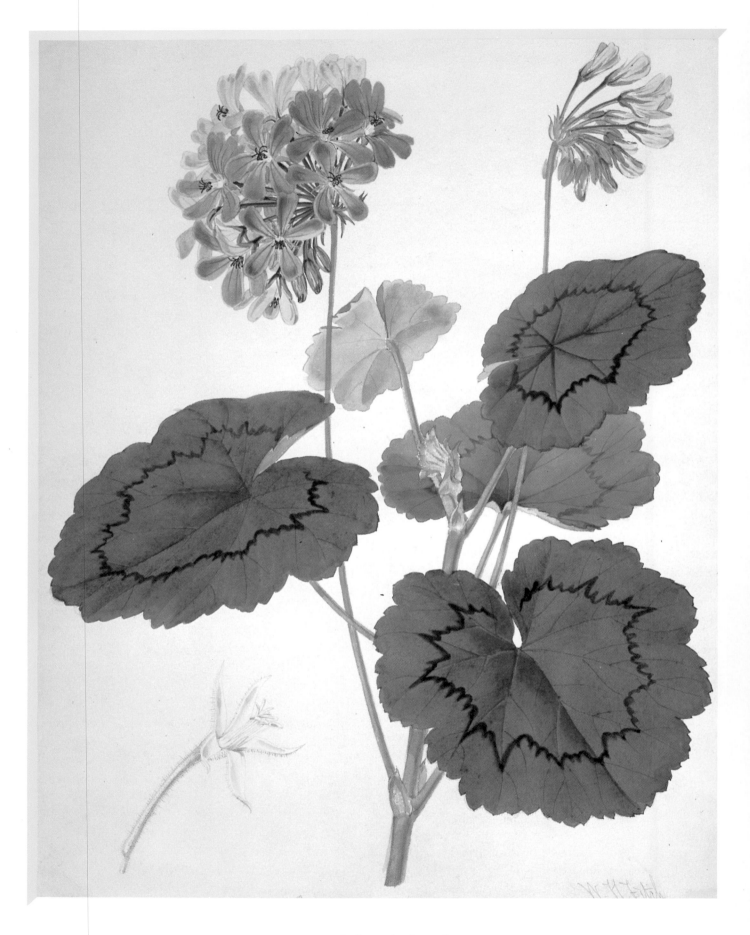

NEW P. (*pelargonium*) *zonale*
Walter Hood Fitch

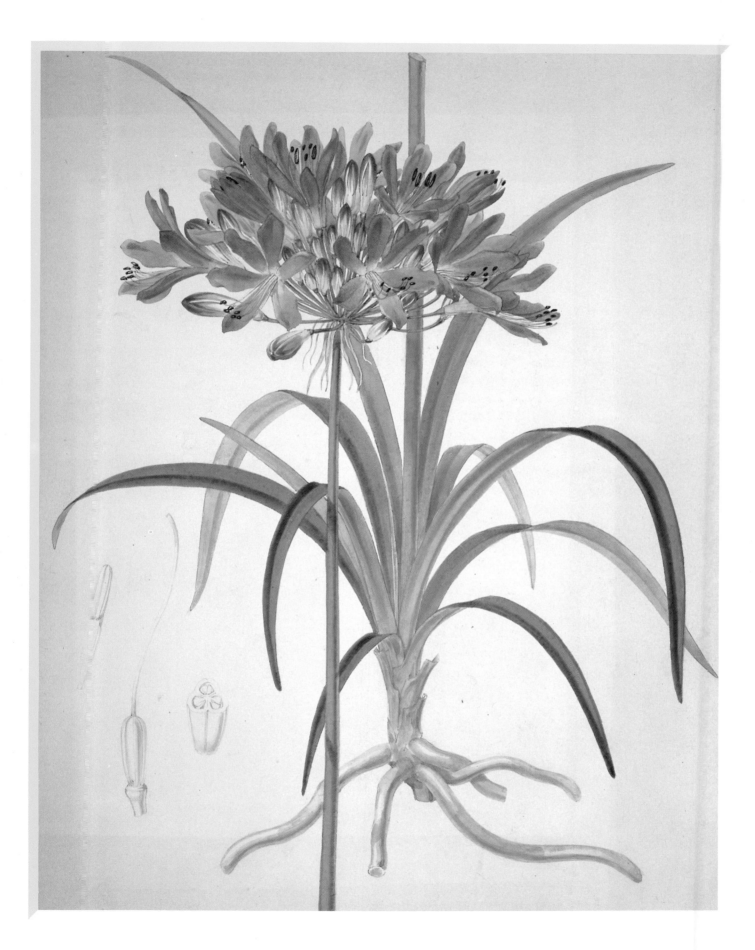

AGAPANTHUS
Walter Hood Fitch

RHODODENDRON – DALHOUSIE
(hand-coloured engraving)
The Rhododendrons of Sikkim-Himalaya
Walter Hood Fitch

Tab. I.

J.D.H. del. Fitch, lith.

Reeve, Benham & Reeve, imp.

FRONTISPIECE
(hand-coloured engraving)
The Rhododendrons of Sikkim-Himalaya
Walter Hood Fitch

by William Turner Thistleton-Dyer; two years later David Prain took office. The title was changed back to *The Botanical Magazine* and other writers began to take a share of the work, most of whom were based at Kew. From this time onwards, things went along fairly smoothly until after the First World War.

Sir William Hooker died in 1865, and his place at Kew was taken by his son, Joseph Dalton Hooker (1817–1911) though because of the Government's apparent lack of interest and financial backing, the future of Kew was at times precarious; however, during the lifetimes of the two Hookers, the scientific foundation of Kew was firmly laid despite the many difficulties, as had been foreseen by Joseph Banks. Fitch continued as the official artist well into old age; in 1879 Sir Joseph Hooker persuaded Disraeli, the prime minister, to consider a pension for Fitch which eventually was granted. After his death his place was taken by his nephew, John Nugent Fitch (1840–1927).

Occasionally, great folios were still being published though they were specific floras rather than florilegiums. Mrs Augusta Withers (1829–65) was such an illustrator who, with 'Miss Drake' produced the illustrations for one of the largest botanical books ever made – *Orchidaceae of Mexico and Guatemala* (1837–41) by James Bateman. The book was illustrated with 40 lithographic plates made by M. Gauci, a master of the new process. These plates were hand-coloured quite beautifully, and there is little difference between the printed pages and the original paintings, now at Kew. Mrs Withers was a teacher of botanical drawing but other than the fact that she drew and painted fruit for the *Pomological Magazine,* nothing much is known of her. She worked for Maund and J. C. Loudon praised her talent.

MARIANNE NORTH

Marianne North (1830–90). was an energetic and intrepid lady who typifies the idea of the prim Victorian spinster whose courage was as strong as the whalebone of her stays. She was born at Hastings and had an older brother, Charles, a younger sister, Catherine and a half-sister, Janet. Marianne was extremely close to her father, who was, intermittently, a Member of Parliament. During the periods when he was not, or during the recesses, the two went on extended tours of Europe, walking and contemplating the scenery. In 1850 Marianne had some watercolour lessons from a Miss van Fowinkel; in 1868 she had some lessons in oil-painting from an Australian artist and she took to this medium as a duckling does to water. She knew Sir William Hooker, and later his son Joseph; she walked in the gardens at Kew and often in the Royal Horticultural Society's gardens there at Chiswick. Her other interests lay in gardening and singing, she loved music and had a good voice, but, gradually, painting began to take pre-eminence. At some time she

must have learned more than the rudiments of botany, although there is no record of this; it is known, however, that she read much that was relevant about plants[24].

After the death of her mother in 1855 Marianne and her father spent many happy summers abroad in Europe and one summer in Egypt. In the summer of 1869 they went mountain climbing near Salzburg, where Marianne's father collapsed. She was able to get him back to England, but he died a few days later. These tours had left her with a strong desire to travel and see much more of the world. She missed the deep affection and close relationship that she shared with her father for so long (she was 40 at this time, and comfortably independent) and decided that she would dedicate her life to painting natural history subjects in an effort to fill the void left by her father's death.

Marianne's early life had been very social and she had made many useful friendships with notabilities of several countries. These, and their relatives, were often the starting point of her many expeditions. With letters of introduction she was passed on to yet more friends of theirs, usually in the same social station, who accepted this Victorian lady, travelling alone, more or less as a matter of course. They often accommodated her for long periods of time, or assisted with complex travel arrangements and provided her with yet more letters of introduction to Consuls, Governors, resident Ministers, judges, bankers, Maharajahs, Rajahs, native chiefs, Army officers, and a miscellany of other people, some of whom were also interested and knowledgeable about natural history.

Her first trip, in 1871, was to North America with a friend who lived in New York. After that she visited Jamaica and it is here that she really began her painting, renting a deserted house in the tropical luxuriance of the neglected botanic garden there. She learned to be very practical; in one place in Jamaica, the hotel was full so she stayed in a house nearby, where the rats came at night and ate holes in her boots. The stoic Miss North did not complain, she merely put the boots on top of her water jug, out of any rat's reach, each night that she remained on the island. Marianne returned to London, but must have been constantly thinking of her next trip, for within three months she was off to Brazil.

She admitted that she was a shy person, but her character must have been engaging to all who knew her. An example of this is when she met a Mr Gordon and his daughter while sightseeing in Brazil. These total strangers took to her and asked her to stay with them at Minas Geraes, the St Joao del Rey Mining company, for three weeks; accepting, she visited two other places nearby

24. *An account of Marianne North's life and work can be read in* A Vision of Eden – the life and work of Marianne North, *published in collaboration with the Royal Botanic Gardens, Kew, by Webb and Bower.*

Datura
Augusta Innes Withers

first and then went to the Morro Velho area where the Gordons lived and where she stayed for eight months painting and sightseeing. Marianne North had iron nerves, or probably none at all, for while staying in a deserted house one night, on a trip to visit a small mine, the company played cards to amuse themselves in the empty wainscotted hall which had large hooks in the ceiling that had once taken the weight of chandeliers. She casually remarked that a former mine superintendent had hung himself from one of these hooks. In this period, travellers in Brazil were at risk from runaway slaves, but nothing seemed to frighten this dauntless lady.

On all these trips she painted at every opportunity either out in the open, or if it rained, which it frequently does in the tropics, she would arrange her plants as foreground subjects or quite often as flower-pieces, which might have been due to the influence of her early teacher Miss van Fowinkel. Marianne North returned to England in September, 1873, but as the winter of 1874 was unusually cold her thoughts turned once more to the warmth of the tropics. She could bear any amount of humidity but cold weather affected her so badly that she could not work, nor even walk, as she suffered severely from rheumatism. So, on New Year's day in 1875 she left the freezing shores of England yet again for a short trip to Madeira. Her observations on the scenery, customs, animals and people are always quite fascinating, and it feels as though she spent her days with a paint-brush in one hand and a pen in the other. Of course, painting, like fishing, is a fairly solitary occupation and any disturbed wildlife will often come back when the intruder has settled to his or her chosen activity.

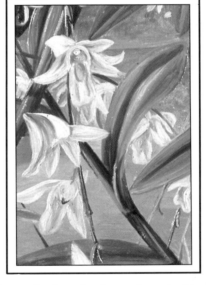

Her next trip was to Japan in August 1875, accompanied by some friends. They went by ship to Canada and by train and stage-coach to San Francisco. She did paintings of several subjects in the area, including part of a giant redwood, which she travelled specially to see. From San Francisco she went by the steamer *Oceanic*, crossing the date line, to Yokohama. Japan was still closed to most Europeans, but Marianne North stayed at the British Legation at Kobé under the aegis of Sir Henry and Lady Parkes, who seemed mostly to be away attending official functions. The Mikado gave Marianne a special pass, permitting her to stay for three months, providing she did not scribble on the public monuments, or attempt to convert the Japanese people to Christianity. Of course, parts of Japan are very cold and Marianne suffered greatly, but only mentions this in a line or two, afterwards going on to describe scenic beauty or strange new birds and beasts. This time, however, while in Kyoto, she was truly

ill, and had to go back to Yokohama where rheumatic fever was diagnosed. When she had more or less recovered, she boarded a ship bound for Singapore, where it was warm. Here, of course, she painted very happily, admitting to hanging one of her subjects upside down.

From Singapore she went to Sarawak to stay with the Rajah and Ranee in their Palace. She was given a beautiful room which had a stairway to the even more beautiful garden. There she was most utterly content, observing the monkeys, birds and, from a safe distance, water-snakes swimming in the river. A naval vessel was about to call with a new Consul, so, as space in the Palace was not unlimited, Marianne suggested – her word is 'persuaded' – the Rajah to 'pack her off out of the way' to a mountain farm. This he did, with a canoe, a cook, a soldier, a boy, a coopful of live chickens and 'a lot of bread'. There she stayed until all the chickens had been consumed, and then came back, the 'soldier using his fine long sword to decapitate the leeches which had stuck to me.[25]'

After that she went up-river in a small steam-launch to Tegoro, where she rhapsodized about the spectacular sunsets and moonlit views. They all had early-morning tea at 6.30 am on the verandah there, with a Fortnum and Mason's plum-pudding for the Rajah's Devonshire-born treasurer who was one of the party. It must have been an impossible place to try to leave, so full of wonderful sights, beautiful flowers and majestic trees. It was there that Marianne was brought some long trails of a very large pitcher-plant. This she painted, and when Veitch (of the famous firm of nurserymen) saw it, he sent a plant-hunter out to collect seed, and it was later named *Nepenthes northiana* by Sir Joseph Hooker.[26] She left this particular Eden, one of many, and took a berth aboard a steamer for Java. Marianne liked Java (except for Batavia) because in addition to its abundance of natural beauties it had a good road system, with excellent rest-houses and safety everywhere, thanks to the firm rule of the Dutch. She

25. *From* A Vision of Eden – the Life and Work of Marianne North.

26. *Marianne North did not actually collect plants herself, she merely painted what was beautiful or interesting in the area. But many other people collected flowers and plants of all kinds for her to paint, indeed, far more than she had time for. In this way and, also accidentally, she was responsible for the discovery of several new species and one genus which were named after her. They are the lupin tree Northea seychellana, Kniphofia northiae, Areca northiana and Crinum northianum. This is another reason for not denigrating her work, which, while not true 'botanical art' was, nevertheless, of immense value in some cases in showing typical subject locations.*

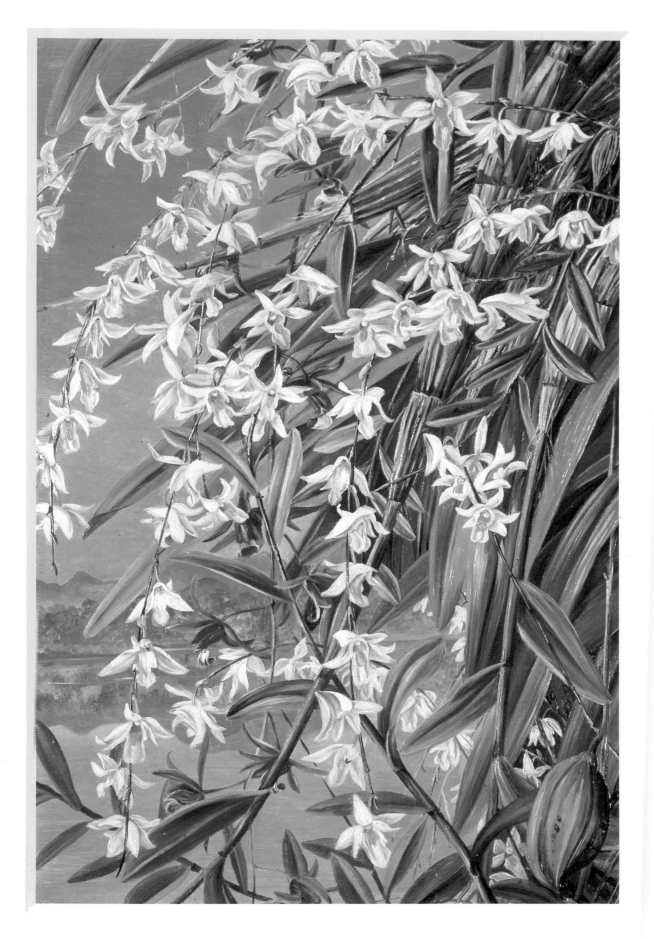

THE TURON OR PIGEON ORCHID IN BORNEO,
AND A PURPLE-BROWN *Cymbidium*
(*Dendrobium crumenatum* Lindl , and
Cymbidium finlaysonianum Lindl.)
Marianne North

preferred Java, it seems, to Brazil, Jamaica and even Borneo. Java had an excellent Botanic Garden, but her painting time was limited to the morning because of the regular tropical rainstorms during the afternoons.

She was introduced to all kinds of people, from town-clerks to tribal chiefs, Princes, Sultans and residents and many others described only by their initials. Those of quality lent her their carriages, and extra men to push or pull them out of deep river gullies. Some of these equip-ages went so fast that she would hardly have been able to see the scenery. Her traveller's tales make compulsive reading, particularly as she wrote very little about the details of her painting. She left Java saying that she was 'rather limp' and took ship for Singapore and Ceylon. At Colombo she met the Governor who showed her a mon-goose which ate buttered toast and snake. In Kandy she stayed with a judge who shortly after her arrival departed for India leaving her to mind his house. Here she was very busy with her work in his flourishing garden, painting as many of his flowers as she could, as well as those in the Botanic garden in the town.

After more expeditions, more paintings and a narrow escape from a small but deadly green snake, she came back to England in February 1877. The Kensington Museum – now the Natural History (British Museum) asked if they might stage an exhibition of her work, and since she had over 500 canvases, she was very pleased to allow them to arrange this and left England for India in the autumn of 1877. She wrote that starvation, fever and floods were all about her but she continued to paint with undiminished energy; and took time to go sightseeing as she went. Her views and landscape paintings really captured India as it was in the time of the Raj. One mosque at Lahore was covered with flowered tiles, whose designs showed all the well-known plants of the country in addition to the iris: these tiles clothed the walls as far up as the minarets. She stayed at a viceregal camp and was told not to be alarmed at any noises in the night, as these were only leopards and bears, not robbers. Mari-anne North says that 'they did not think her worth eating and all was peace'. She did not like the 'croqueting-badminton young ladies' when she had the misfortune to run into them, considering them to be frivolous and shallow. She had recently been carried up to the mountain tops for the spectacular views, and observed, 'Kinchin-junga did not keep fashionable hours'.

One of Marianne North's projects was to find and paint all the sacred plants of India. This she did and they are displayed separately at Kew. In February 1879 she returned to England, and became so wearied by the streams of interested callers that she took a room in Conduit Street in which to exhibit her work. Here it was seen by the Pall Mall Gazette which wrote up the exhibi-tion and suggested that the paintings should go to Kew. Marianne North had not, until then, given much thought

as to what to do with them all, and she took some time to consider the idea. But in due course she wrote to Sir Joseph Hooker and suggested that they be given to the nation, and that she would pay for a building to house them. Initially, she also offered to combine the picture gallery with a refreshment room, but when Sir Joseph replied, promptly accepting the gift of the pictures and the building, he said that it would not be possible to supply refreshments to all the Kew visitors, who were then numbering a possible 77,000 on a Bank holiday. He also remarked on the 'difficulty of keeping the British Public in order'. Marianne North lost no time in commis-sioning a Mr James Ferguson, author of *The History of Architecture,* to produce a design and oversee the work. This he did, and the building was begun.

Marianne met Charles Darwin, and his enthusiasm for the flora of Australia was such that she decided to leave for the sub-continent without delay. In April 1880 she left England once more. She stayed a short time in Sara-wak, re-visiting friends made on her previous trip and painting more flower-studies. Arriving at Brisbane, she found it very cold and dusty and not attractive. As usual, she started off on her travels and was passed from friend to friends of friends, painting and sightseeing. She stayed at the house of the prime minister, and even at a police station. Wherever she went kindness attended her and she continued to produce her paintings. She crossed to Tasmania in January 1881, and from there she went on to New Zealand, which she found to be very cold. She had heard that the building of her gallery at Kew was going well, and wanted to be back in England to see it, without the trouble and effort of the travelling. This is one of the few times when she was clearly depressed with her state of health. Her rheumatism had become much worse because of the climate. She left the antipodes and arrived in San Francisco in April 1881, where she made arrange-ments to see the redwood forests again. After this she visited Yosemite in California. On the journey home she was very near the border of New Mexico, and always regretted not having the strength to visit the country, but she was not sorry to reach New York in June and Liverpool nine days later. Her first call on her arrival in London was to Kew to see how her gallery was progress-ing. She was very pleased, particularly with the lighting, and spent a pleasant year planning the arrangement of the pictures, framing them and painting the doorways. The gallery was opened to the public on 7 June 1882.

She went to visit Darwin and took with her the Aust-ralian paintings which he was very pleased to see. He knew more about the plants than she did, though he had never been to Australia; but he was, as always, so gentle, tactful and charming that it was a pleasure, as well as a privilege to listen to his discourse. But now Marianne North realized that the continent of Africa was not rep-resented in her gallery. So in August of 1882 she left

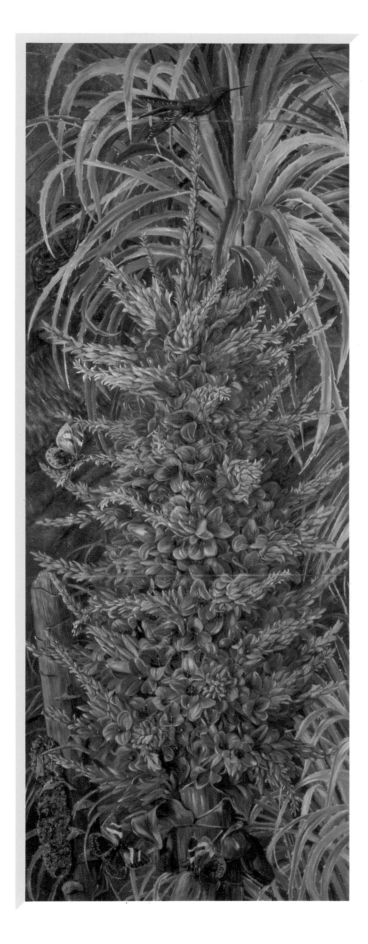

INFLORESCENCE OF THE BLUE PUYA, AND
MOTHS, CHILE – *Puya whytei* 'Hook'.
Marianne North

England again to land at the Cape. She had heard that Africa was littered with missionaries and found this to be true. In Stellenbosch, Calvinism was the strongest influence in the settlement, as in many like it: she said that the flowers were brighter and more plentiful as she got further away from the psalm singing. At Port Elizabeth she found warmth and a botanic garden and very many indigenous flowers, far more than she could paint, as always. She visited Durban, but by that time she was quite ill and wanted to be at home, so she left Africa in June 1883. The gallery at Kew was being extended to accommodate the new paintings, and though she does not say anything about it, there must have been some spare space, so in September 1883 she left England yet again for the islands of the Seychelles. By this time her knowledge of botany was extensive and she comments that she saw but two flowers, orchids, that were truly native to the Seychelles, everything else being from Madagascar, or the East or West Indies. In January 1884 smallpox was rife in the islands and she offered to go into voluntary quarantine on Long Island before sailing for home; for the first time she confesses to fear, and attempted to barricade herself in her room on the island, fearing that she would be robbed or even murdered. Although nothing happened to her, the experience left her ill and nervous.

It was 1884 and she had one last journey to make, though her health was not good. In November of that year she left for Chile, though now she begins to mention trouble with her 'nerves'. A more 'nerveless' narrative I have never read, so this ailment must have been something far more serious. One of the plants she particularly wanted was the 'great blue puya' and one of her new friends bribed a man to climb a mountain for it. When it was brought to her she was delighted, though the flower-scape was not in good condition. She also wished to paint the 'Puzzle-monkey' (Monkey-puzzle) *(Araucaria araucana)* in its native habitat. She made several more paintings and then left for Panama, hoping to go to Mexico; but she was too ill. She reached England early in 1885, and spent much time rearranging and finishing the gallery at Kew. This took about a year and then she found a comfortable house with a pleasant but very neglected garden in Gloucestershire, where she settled to enjoy her last years. Kew gave her plants, as did many famous gardeners such as Gertrude Jekyll and Canon Ellacombe; boxes and bundles of them were constantly arriving. These special plants she set in the ground herself, not trusting her gardeners. Friends from all over the world came to stay, and their visits were very much enjoyed. But her sufferings were now acute. Though she was deaf she continuously heard taunting 'voices' which she sensibly knew to be delusions. Then she had a liver-complaint, engendered, no doubt by her heroic overcoming of difficulties, though never-mentioned, during

her travels. The liver-complaint became rapidly worse and she nearly died at Chrismas 1887. Though she recovered from this she was never strong again and she died in August 1890. The gallery at Kew gave her great pleasure and she liked to see it when it was full of people. It and its contents represent over 14 years of work, often produced under the most difficult and sometimes dangerous conditions, at a period in world history when such journeys could only be undertaken by the determined.

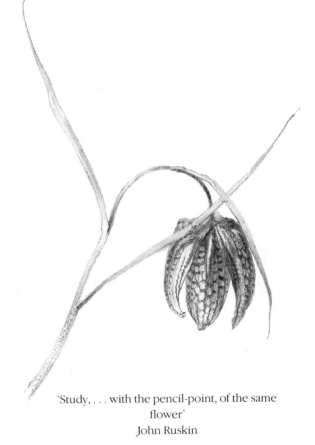

'Study, . . . with the pencil-point, of the same flower'
John Ruskin

THE TURN OF THE CENTURY

Kew was experiencing difficulties. Economy had always been necessary, but now it was mandatory under Ayrton, First Commissioner of Works under Gladstone. Ayrton made life as difficult as he could for Sir Joseph Hooker in an attempt to force his resignation. Fortunately for Hooker and for Kew, Ayrton's sphere of duties changed, Kew was reprieved and Hooker was able to return to his excellent administration. In 1875 William Thistleton-Dyer became his assistant, and about two years later he married Sir Joseph's daughter. Thistleton-Dyer was very interested in all aspects of economic botany, particularly in specimens from countries that were part of the British Empire. Kew became an exchange, a metaphorical seed-bed, if you like, for botanical information relating to the countries of the Empire and gradually of the whole world. Sir Joseph Hooker retired in 1885 and Thistleton-Dyer took his place, making such changes at Kew as were necessary to reflect changing trends of interest. Kew was gradually emerging as an international scientific instit-

FIELD LILY OF OXFORD – *Drosida Ælfred,*
Alfred's dew-flower
John Ruskin

ution and storehouse of plant material and research: it was also the world's most interesting and beautiful public park, as it still is today.

John Ruskin (1819–1900) rounds off the 19th century's emergence into the definable reality of botanical illustration; though the examples chosen of his work are the charming flower portraits that came so easily to him. He is, of course, better known as a critic and art theorist. There is no space here to explain his own divergent theories on botany but his eloquent style of writing was often as richly beautiful as a poem. In 1870 he was appointed Slade Profesor at Oxford where he founded the drawing school. He was as diverse in his interests and occupations as it is possible to be, being very interested in social reform and concerned with many economic and political questions. He produced a monthly magazine *Fors Clavigera* and many books, one, his illustrated *Proserpina* (1874–6) being particularly characteristic of his views. It was described as 'a series of drawing lessons in flowers'.

Modern Botanical Painting
— *1900 until the present day* —

THE PAST HAS ESTABLISHED a pattern of excellence, a goal for all aspiring botanical artists of today. Plants were, and still are, being discovered and introduced to the scientific and horticultural world, particularly up to the time of the 1914–18 war. New discoveries continue to be faithfully recorded at Kew by resident and freelance artists.

Having read about and examined the work of the artists portrayed in this book, it may be a little easier to define the difference between a competent and accurate flower-painter and a true botanical artist. The flower-painter paints exquisite flowers beautifully (as did Redouté) and for pleasure, sometimes for no financial return; the botanical artist has had the benefit of scientific training and draws or paints to an exact requirement usually for subsequent reference purposes. These drawings are no less beautiful for having such a precise pedigree and the best botanical artists of today have quite mastered the difficult balancing act of total accuracy allied to delicacy, textural representation, line, rhythm, colour-matching and, lastly, beauty. Some artists have the added capability of a natural capacity for *mise-en-scene*,[27] or placement on the page, which makes these representational drawings even more pleasing to look at.

Charles Edward Faxon (1846–1918) was a teacher of botany at the Bussey Institute, Harvard College, in America. He made nearly 2,000 drawings, mostly of trees, to illustrate the following books: C. S. Sargent's *Silva of North America* (1891–1902), *Trees and Shrubs* (1902–13), *Manual of Trees of North America* (1905) and illustrations to the journal *Garden and Forest* (1888–98), he also did some plates in C. D. Eaton's *The Ferns of North America* (1879–80). His composition of the illustrations was good, as was his technique, and he was able to work, as Sargent said, 'with great rapidity'.

Though Alfred Parsons (R.A.) (1847–1920) cannot truly be defined as a botanical artist, he was a most excellent flower-painter. He is best-known now for his most beautiful and accurate paintings of roses which breathe vitality. The story of the gestation of *The Genus*

Rosa is an unhappy one, but at least the paintings are safe in the Lindley Library today and their magic is distilled afresh at the opening of a page. Alfred's father, Dr Joshua Parsons, practised in Beckington, Somerset. The doctor liked gardening and was something of an expert on rock plants and perennials. In his spare time he painted some of his flowers and this interest he communicated to his son Alfred. Dr Parsons was a friend of William Robinson who founded *The Garden* magazine; consequently, Alfred always counted Robinson among his friends.

The Parsons family was a large one and impecunious, so Alfred had to find work at an early age. After a dreary four years spent in a Post Office Savings Bank, he managed to escape from this routine employment and take up painting. It took about 20 years before he had become established as an illustrator for *Harper's* Magazine; in addition he became something of a landscape gardener. He remained a bachelor all his life, sharing his home with the painter Millet and his family. Parsons did well and his house was one of the centres of the Broadway Group, among whose members were such notable names as Henry James, Lawrence Alma-Tadema and John Singer Sargent.

THE GENUS ROSA

Parsons must have met the wealthy gardener Ellen Willmott sometime in the latter part of the 19th century by which time he was President of the Society of Painters in Watercolour. Miss Willmott had conceived the idea of producing a comprehensive work on the genus *Rosa*, and this had found favour with the publishers John Murray. Ellen Willmott had been a Fellow of the Royal Horticultural Society for some time, as she was something of a hybridist. Her very considerable wealth enabled her to plan and plant the huge garden at Warley Place (about 60 acres) and keep it well maintained with the assistance of 104 gardeners. She, like Napoleon's Joséphine, fell in love with roses. They exerted so much charm over her that she resolved to immortalize them by means of a great work. For this she needed an artist, and she commissioned Alfred Parsons (by now a member of the Royal Academy) to do the whole of the publication. The book was to be called *The Genus Rosa* and was to contain

27. The phrase mise-en-page *is often used and has roughly the same meaning.*

Rosa chinensis Pseudo-indica
Fortune's double yellow or Beauty of
Glazenwood
Alfred Parsons
The Genus Rosa by Ellen Willmott

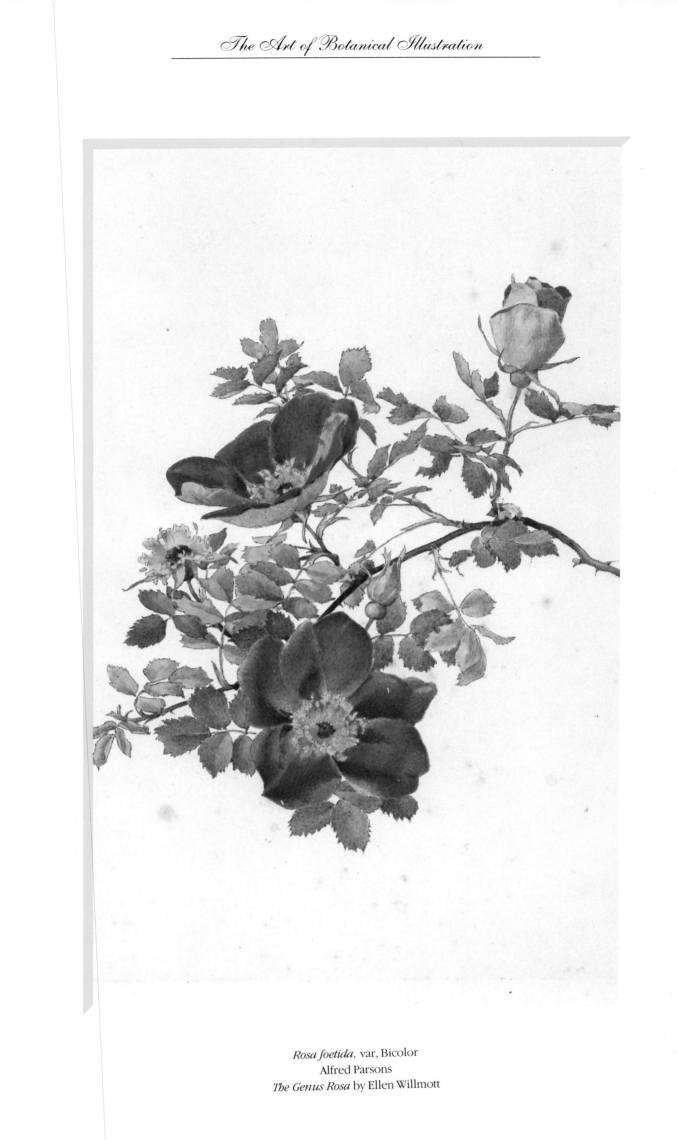

Rosa foetida, var, Bicolor
Alfred Parsons
The Genus Rosa by Ellen Willmott

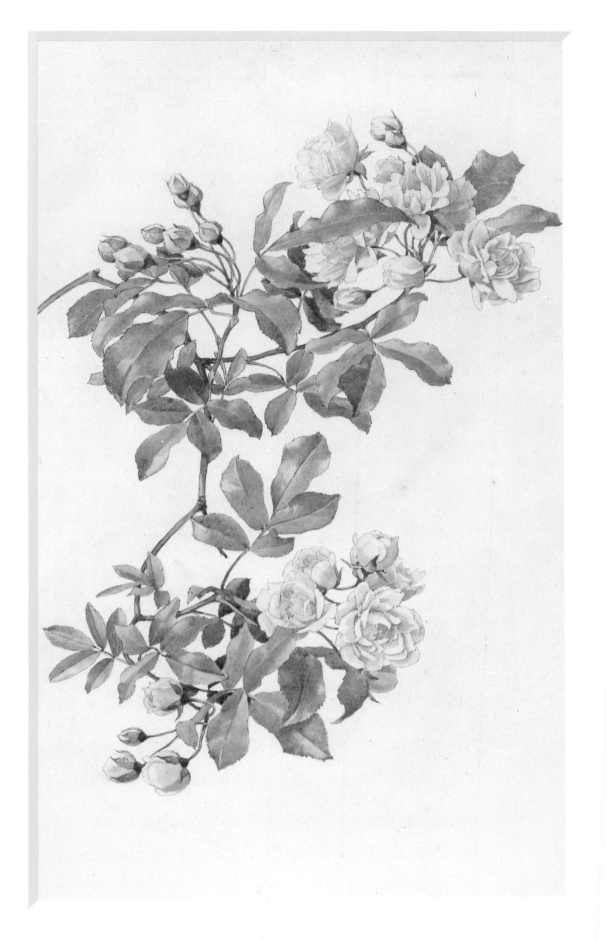

Rosa Banksiae – THE BANKSIAN ROSE
Alfred Parsons
The Genus Rosa by Ellen Willmott

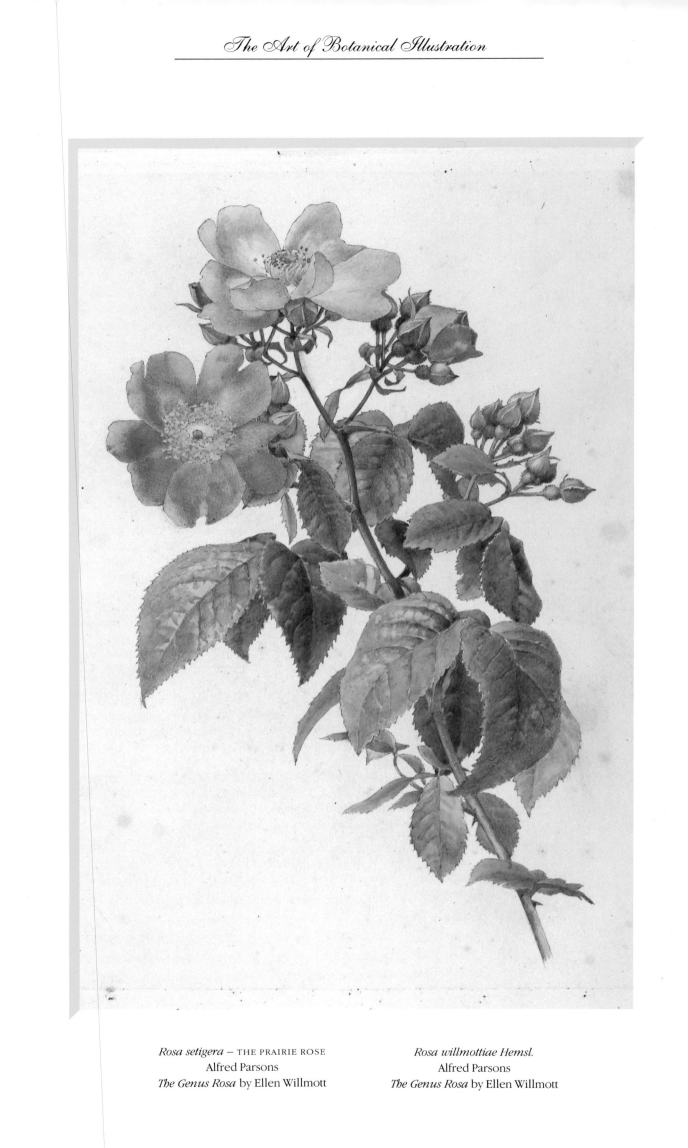

Rosa setigera – THE PRAIRIE ROSE
Alfred Parsons
The Genus Rosa by Ellen Willmott

Rosa willmottiae Hemsl.
Alfred Parsons
The Genus Rosa by Ellen Willmott

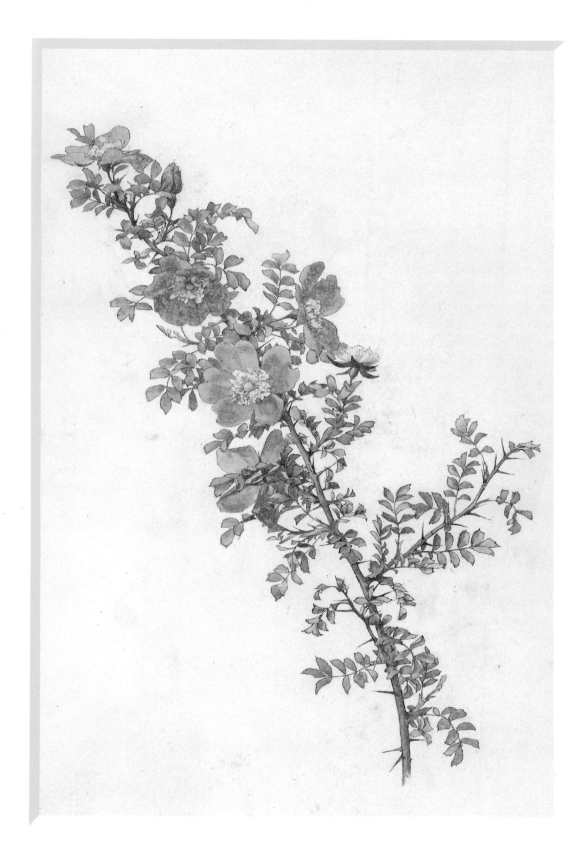

portraits of species roses only, no hybrids or varieties were to be included. It is, therefore, a very valuable reference work botanically. The text was written by Miss Willmott herself with assistance from J. G. Baker of Kew.

Miss Willmott had inherited a vast fortune at the age of 30, which enabled her to live in considerable style. In addition to the maintenance of Warley Place and its famous garden, she owned a house and garden at Menton and another at Ventimiglia. But *The Genus Rosa* was to prove the biggest problem or series of problems that she

had ever had to face, and it brought her nothing but unhappiness at a time when her financial affairs were sliding into a state of unmanaged chaos. The work also affected the fortunes of John Murray to an infuriating degree, and seemed to have a strange and unpleasant character-changing effect on Alfred Parsons also, who previously had been noted for his charm, kindness, unselfishness and general pleasant manner.

By 1901 Parsons had painted 40 of the plates. These are among the most beautiful of all rose-paintings. Being of species only, they do not have the voluptuousness of

Redouté's blooms, which had been chosen solely for their charm. What they do have is reality. Gazing at the original paintings one sees that the foliage is excellent, with its proper tones of green, blue-green, grey-green, light green or crimson, and has a sense of perfect tonal perspective in its presentation. These leaves are as those of a branch of *real* roses. They are presented sideways-on, upside down, advancing or retreating, often almost moving in the wind, exactly as they would be on the bush, with all the different colours that one would expect to find. In addition, since nothing is perfect, in nature and these paintings above all were *natural,* if a passing pest had taken a nibble this was also shown. There was no contrived artificiality whereby the pest itself was included to distract the eye. The flowers are, without doubt, exquisite. They show the habit of each bloom, the way it should and did grow. Consequently, the spray or branch is as life-like as if it had just been laid down on a page, with as many asymmetric blooms as in real life; some may have lost one or more, or even all, of their petals; many stages of buds are shown, too.

Ellen Willmott paid for the whole of the cost of this great work, expecting to get her return on the sales, with but 5 per cent of these being taken by John Murray. Soon after its inception, the project ran head-on into problems. Parsons wanted one printer, Murray a different one. Parsons had to abide by Murray's choice as Murray had, in the first place, been commissioned by Miss Willmott. Parsons had a financial interest in the printing firm of his choice, and began to create real trouble. He averred that Murray's printer was not using good paper, and had it analyzed as proof of this statement. Afterwards he would not allow the results of the analysis to be seen by the parties concerned and continued to vilify Murray's printer, Grigg. Parsons then went to America for a time, thus delaying the delivery of his paintings. Eventually he returned (after apologizing in writing to Murray) and continued with the work, finally finishing his part of it by about 1905.

Ellen Willmott was not an easy person to work with, being accustomed to getting her own way in all things, and was often abroad at one of her other residences when decisions had to be made. Having conceived the idea, she was dilatory in supplying the manuscript; John Murray was experiencing the obvious difficulties of escalating costs. The book *could* have been brought out by about 1906 but in the event it was published in 1914 – a calamitous time for anything as utterly luxurious as this publication. Miss Willmott was by then in serious financial difficulties, and was even reduced to borrowing from Murray. Though the first part of the work was actually ready by 1910, she made even more delays regarding the publication date and the reviewers. Her comment by then was, I think, patronizingly unforgivable: 'it will be given to someone who knows nothing of the subject (hardly anyone does know Roses) and the review will

simply be for Parsons' drawing and other minor features of the book which will be a great pity'. Without Parsons' beautifully exact drawings *The Genus Rosa* would have been a rambling, unmemorable dissertation. Here is an extract from the original text, relating to *Rosa cinnamomea*:

VOLUME TWO
ROSA CINNAMOMEA – THE CINNAMON ROSE

Although the cinnamon-scented rose is mentioned by Dodoens in his *HISTORIA* 1583 (p 187)

> *Clusius (RARIORUM ALIQUOT STIRPIUM*
> *PER PANNONIAM. OBSERVATORUM*
> *HISTORIA pp 109, 110, 112 (1583)*
> *Lobel KRUYDTBOECK pt 2, p 241 (1581)*
> *C.BAUHIN in PINAX p 483 (1623)*
> *J. BAUHIN, HISTORIA, Vol II p 39 (1651)*

None of the references can be intended for the plant now known as *Rosa Cinnamomea.*

'As Haller did not mention the Rose, it is probably that the single form had not in his time been introduced into cultivation. The double variety was common enough in the sixteenth and seventeenth centuries, and, varying somewhat seems to have been grown in most of the old gardens'.

ROSA CINNAMOMEA p142

'The double form figured is an old Rose formerly to be found in many continental gardens, known as the *Rose de Mai, Rose de Paques,* or *Rose du Saint-Sacrement,* and figured by Redouté under the name of *Rosa majalis*... The rose from which the drawing was made grew up in the old Carrevon garden at Yverdun, Canton de Vaud, Switzerland'.

Miss Willmott's remark illustrates how wide and deep the rift was between herself and Parsons. By the time of publication Miss Willmott had ordered 1,000 sets of the book (which was in 25 parts). By 1910 the cost was approximately £5,275. Of this Miss Willmott had paid £1,500, the remainder being defrayed by Murray. Only 260 sets were ultimately sold. During the war, Murray attempted to find American publishers who would buy the work, which had been one of Miss Willmott's ambitions in the first place. But even though the prices offered still gave her a small profit, and the publicity would have excited something of a market for this work, Miss Willmott turned the offers down, and in 1920 there still existed 740 unsold sets. Murray managed to find yet another American publisher who offered to buy the sets, still at a slight profit to Miss Willmott though none for Murray. Again, she delayed taking any positive action and this last chance was withdrawn.

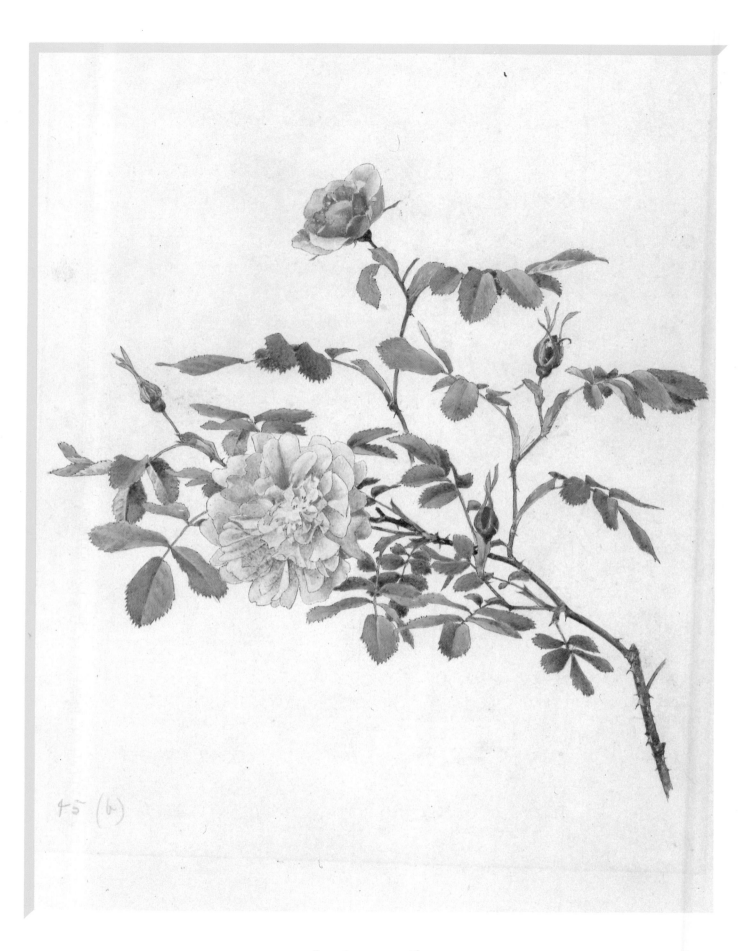

Modern Botanical Painting

Rosa cinnamomea plena –
THE DOUBLE CINNAMON ROSE
Alfred Parsons
The Genus Rosa by Ellen Willmott

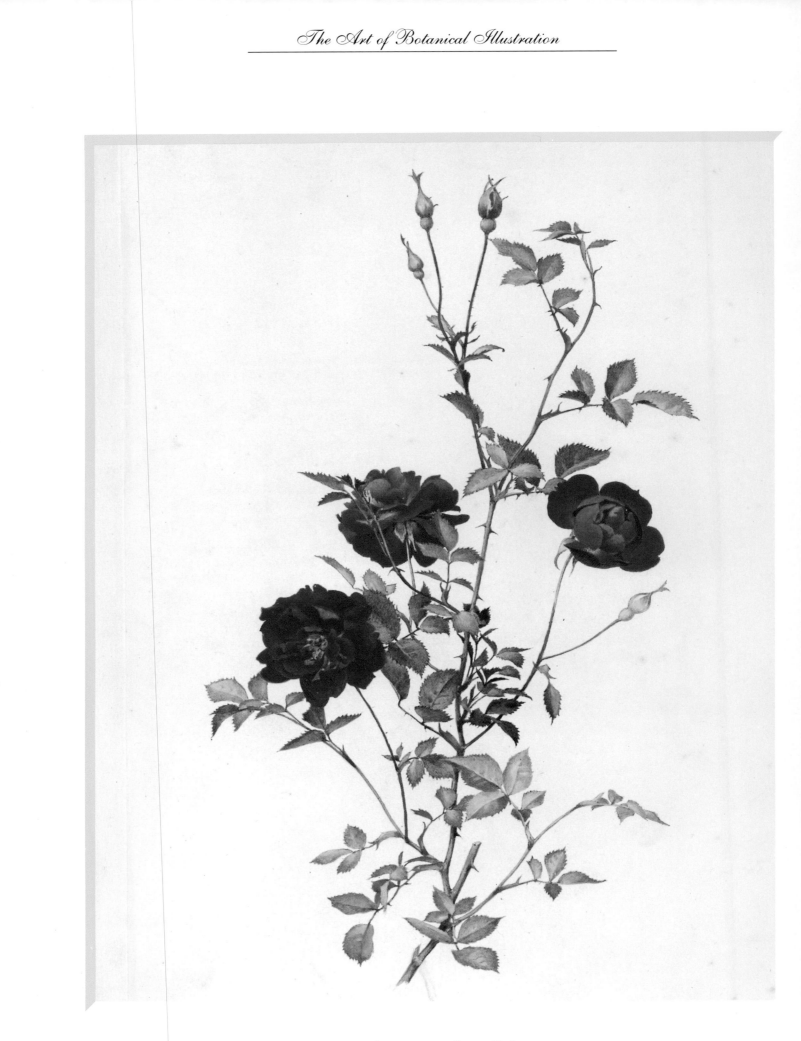

Rosa chinensis semperflorens: Koehne
Alfred Parsons
The Genus Rosa by Ellen Willmott

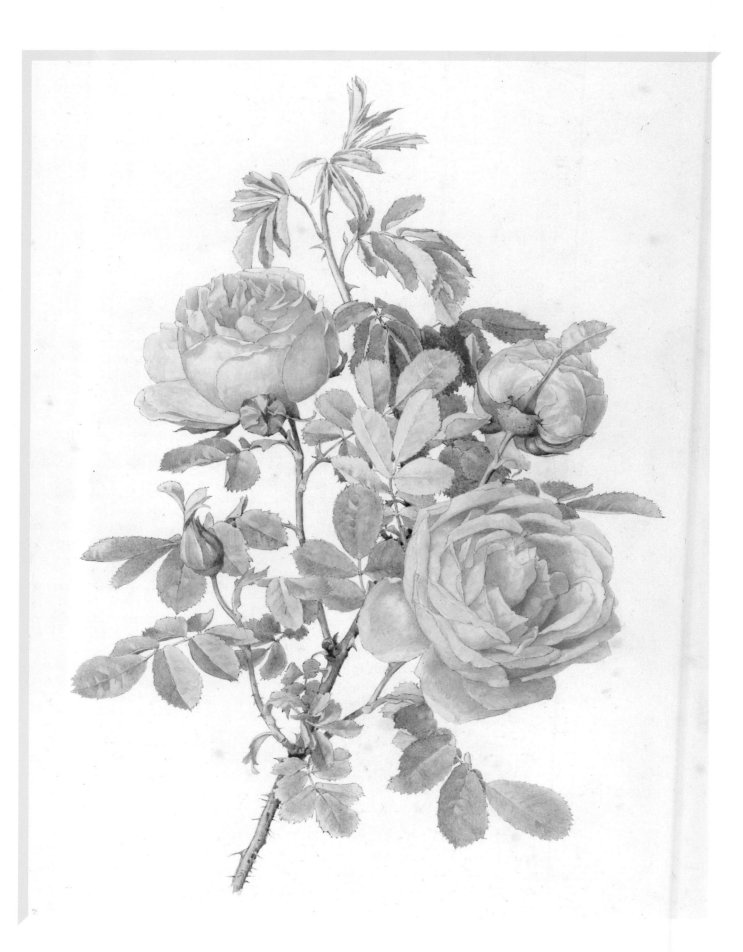

Rosa hemisphaerica, Herm – THE SULPHUR ROSE
Alfred Parsons
The Genus Rosa by Ellen Willmott

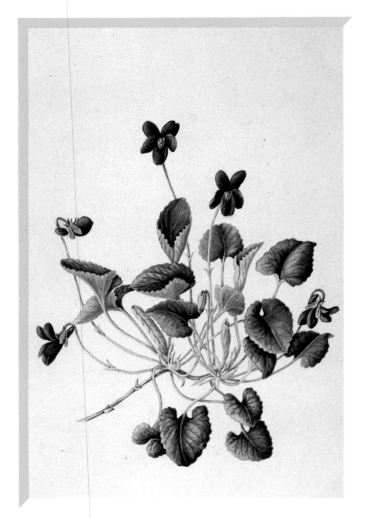

Viola odorata – SWEET VIOLET
Major J.R.G. Gwatkin

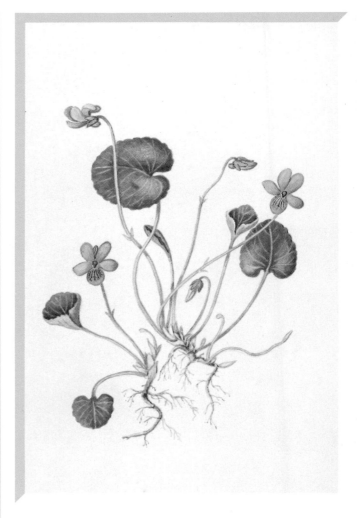

Viola palustris – MARSH VIOLET
Major J.R.G. Gwatkin

THE BOTANICAL MAGAZINE

Perhaps now might be a good place to catch up with the history of the *Botanical Magazine*. It was an expensive magazine to produce, and by the very nature of its scientific orientation it did not have the appeal to the general public whose support would have kept it going. Since 1845 it had been published by Messrs. Lovell Reeve, sometimes at a break-even situation but more often at a loss. By 1920 the publishers had decided that enough was enough and stopped production of the magazine, the last issue being volume 146 of the Fourth Series published in December 1920.

But this magazine had been a part of the horticultural world for so long that its absence was deeply felt; at a Chelsea flower show dinner in May 1921, Henry Elwes (naturalist, botanist, horticulturalist, traveller and producer of *The Genus Lilium)* discussed the possibility of the magazine's salvation. The guests had been carefully selected and a collection of £250 was made immediately to buy the copyright. The Royal Horticultural Society from then on were the owners. Publication was resumed in October 1922 with volume 148, missing out the 1921 volume 147. This was later paid for by that horticultural

philanthropist Reginald Cory, and the 'missing' issue was eventually produced in 1938 making the set complete. Many writers have contributed to the text and there have been several editors since that time: the present holder of the office is Christopher Grey-Wilson. The early plates in the 'new' magazine were, unbelievably, still coloured by hand as they had been since 1787; however, in 1948 it was decided to use a new four-colour printing process which with slight variations has been in use ever since.

MODERN BOTANICAL ARTISTS

The Reverend Keble Martin (1877–1969) became a legend in his own lifetime, and hopefully something of a lesson to us all as will be seen. Keble Martin went to school at Marlborough and became very interested in butterflies and botany, taking botany as his degree subject at Oxford. As a youth he lived at Dartington in Devon which, even now, is still a good area for the study of butterflies, birds, insects, mosses and flowers, but in those days, *c*1895, it must have been wonderful. After being ordained, the Reverend Martin became a curate and subsequently a vicar in successive parishes in the north of

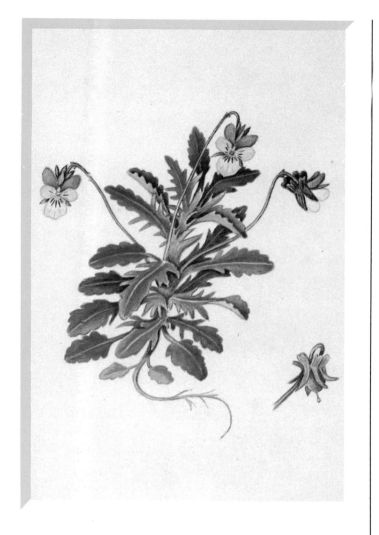

Viola contempta
Major J.R.G. Gwatkin

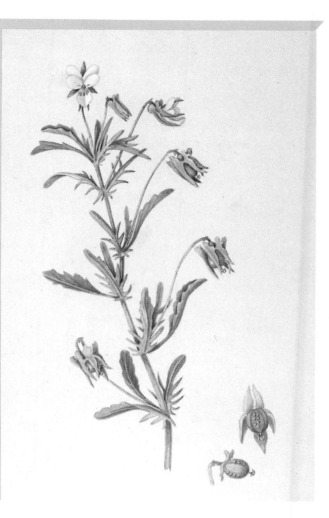

Viola tricolor – HEARTSEASE
Major J.R.G. Gwatkin

England, and in 1918 he was in France serving as an army Chaplain.

After the 1914–18 war was over he went to Devon again, where this time he began to study the flora of the surrounding countryside. As he was also interested in lepidoptera, his first studies and drawings were concerned with the food-plants of the various species; but soon the idea of collecting and painting all, or almost all, the flora of the British Isles became a possibility. The work took him 60 years to finish (he was still re-drawing some of the plates at the age of 72) because his parish duties had always to take precedence. Sometimes his livings were in busy industrial areas, leaving him little or no time for study and drawing; in other years he completed a few drawings except during his annual holiday. He travelled about wherever he lived, collecting the minimum number of specimens necessary for the work. Sometimes, as in the case of very rare plants, he would only take two florets from a good flower spike and an upper and a lower leaf. If he actually did dig up a plant in order to draw it at home, he would take it back again and re-plant it when he had done the work. Gradually, the pages of plates became complete, though sometimes it took many

years to fill in all the gaps. Sometimes he would take a train to Scotland and spend a few precious days searching for specific plants, even finishing off the drawings on his return train journey.

Martin belonged to two Botanical Exchange clubs and he was able to have some specimens sent to him, though if he was too occupied with his parish duties the specimens sometimes died before he could draw them and he had to wait for another year. In 1949 he retired, at the age of 72, though he still assisted with church duties when parishes became unexpectedly vacant. The book was almost finished, and at the age of 88 he married for the second time, in 1965, the same year that his book *Flora of the British Isles* was published. It became a best-seller. What a happy year that must have been. But there was even more to come. In 1966 he received an honorary degree of Doctor of Science at Exeter University, and in the following year he was asked to design four stamps for the Post Office, which were issued in 1967. Then he wrote his autobiography *Over the Hills* which was published in 1968; in 1969, after a long life of service and dedication, this gentle old cleric died.

Frank Harold Round (1878–1958) was Assistant Draw-

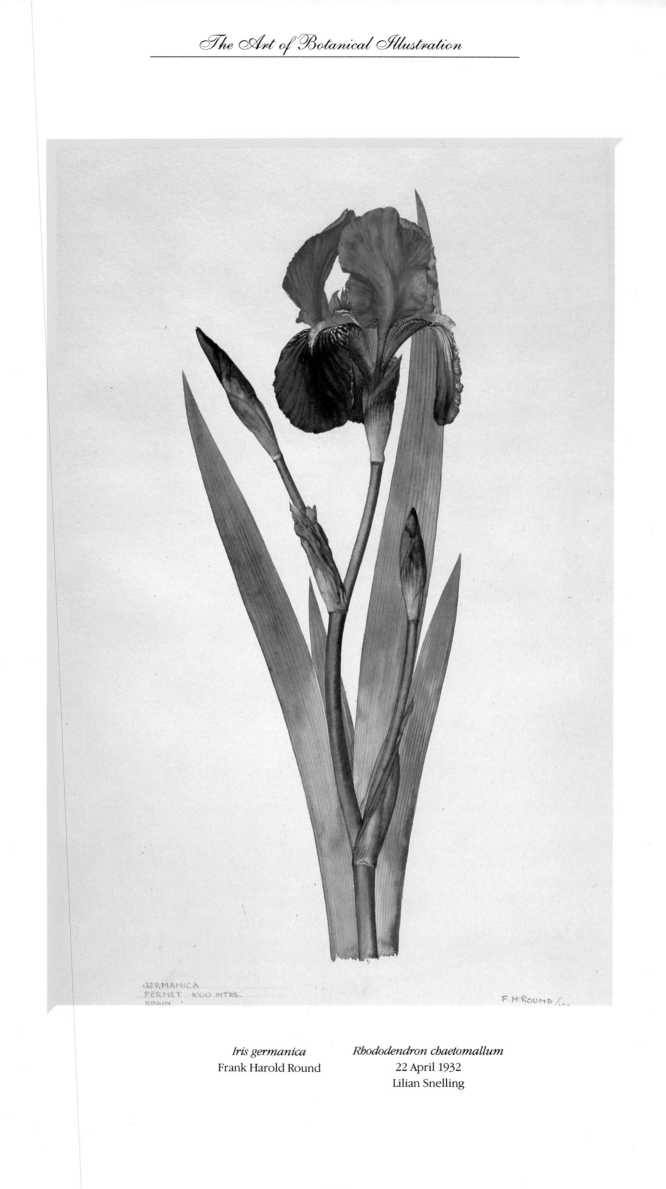

Iris germanica
Frank Harold Round

Rhododendron chaetomallum
22 April 1932
Lilian Snelling

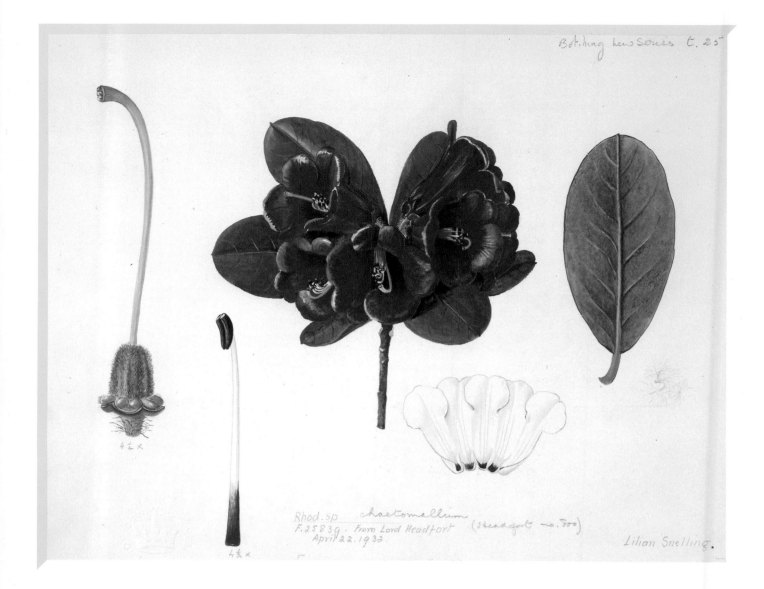

Rhod.sp chaetomallum (Headfort no. 500)
F.25839. From Lord Headfort
April 22.1932.

Lilian Snelling.

ing Master at Charterhouse School. Mr W. R. Dykes, a near neighbour and also a colleague was preparing his work on *The Genus Iris* (1913). He would often appear in his dressing-gown on Mr Round's doorstep at 5 am with a rare specimen that had to be drawn almost before breakfast. Mr Round was commissioned to do a collection of iris paintings for N. C. Rothschild, but these came by post, more than one at a time, and were difficult to cope with, especially as some iris-flowers are very short-lived, fading and curling unrecognizably.

Lilian Snelling (1879–1972) was the principal artist of the *Botanical Magazine* for 30 years from 1922–52. She began painting wildflowers when she was a young girl. These paintings came to the notice of the botanist H. J. Elwes of Colesborne who was preparing his supplement to the *Monograph of the Genus Lilium*. He needed a botanical artist and commissioned Miss Snelling to do 28 of the splendid plates for this work, which was published in parts from 1933–40. In addition, she produced the equally beautiful paintings of peonies for F. C. Stern's *Study of the Genus Paeonia* (1946) and F. Stoker's *Book of Lilies* (1943). She made many other studies of Elwes's plants, and worked at the Royal Botanical Gardens, Edinburgh, where she produced plant-portraits for Sir Isaac

Bailey-Balfour, Keeper of the Botanic Garden and Professor of Botany at Edinburgh University.

Miss Snelling mastered the art of lithography at an early age, studying under Morley Fletcher, and therefore at a later date she was able to produce both her own plates for the *Botanical Magazine* as well as the work of other artists, including Stella Ross-Craig. These lithographed plates were hand-coloured. Miss Snelling's work is accurate, but in addition it has delicacy and grace where this is appropriate; her colours are both brilliantly clear and true to life. Volume no. 169 of the *Botanical Magazine* was dedicated to her, and in it she was described as 'artist, lithographer and botanical illustrator who with remarkable delicacy of accurate outlines, brilliancy of colour and intricate gradations of tone has faithfully portrayed most of the plants figured in this magazine from 1922 to 1952.' Three years later the Royal Horticultural Society conferred on her its supreme honour, the VMH (Victoria Medal of Honour). She was a charming and gentle person, shy with strangers; her many friends found her kindly with a dry wit which was never malicious. She lived for 93 years and it is to be hoped that her work gave her as much pleasure as it gives those who have the opportunity to study it today.

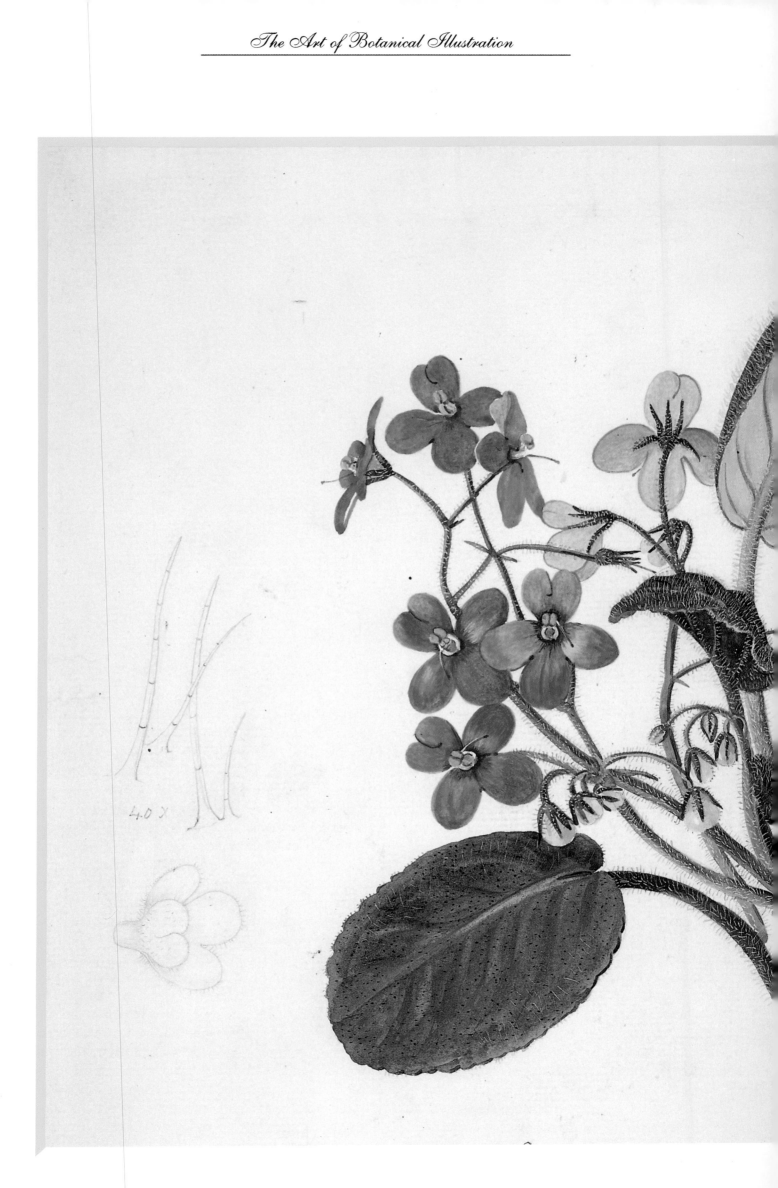

Saintpaulia tongwensis
Lilian Snelling
(*previous page*)

Sempervivum tectorum – HOUSE-LEEK
Major J.R.G. Gwatkin
No. 363, vol. 7

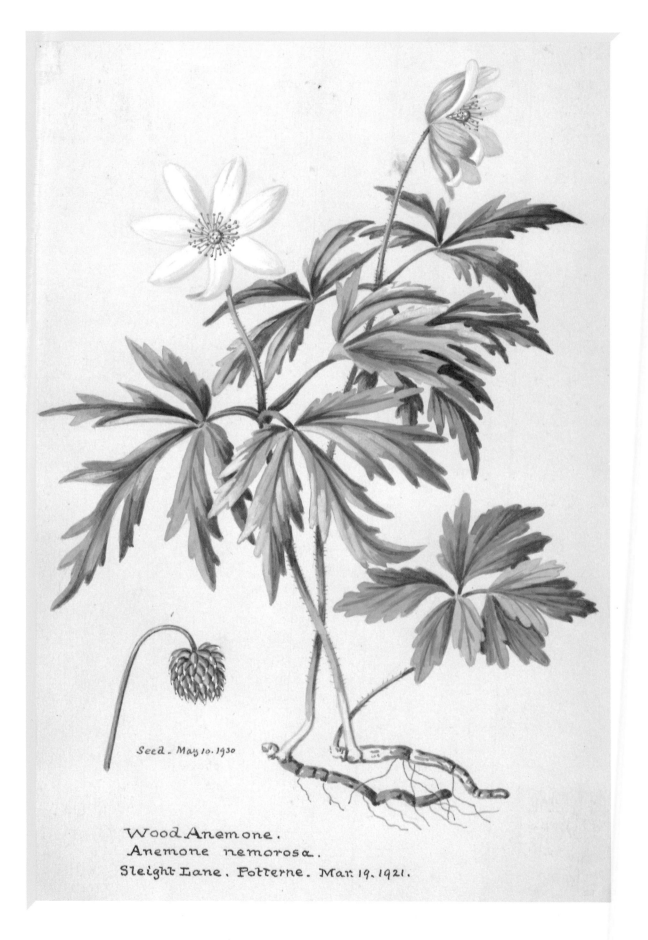

Anemone nemorosa – WOOD ANEMONE
Major J.R.G. Gwatkin
No. 6, vol. 1

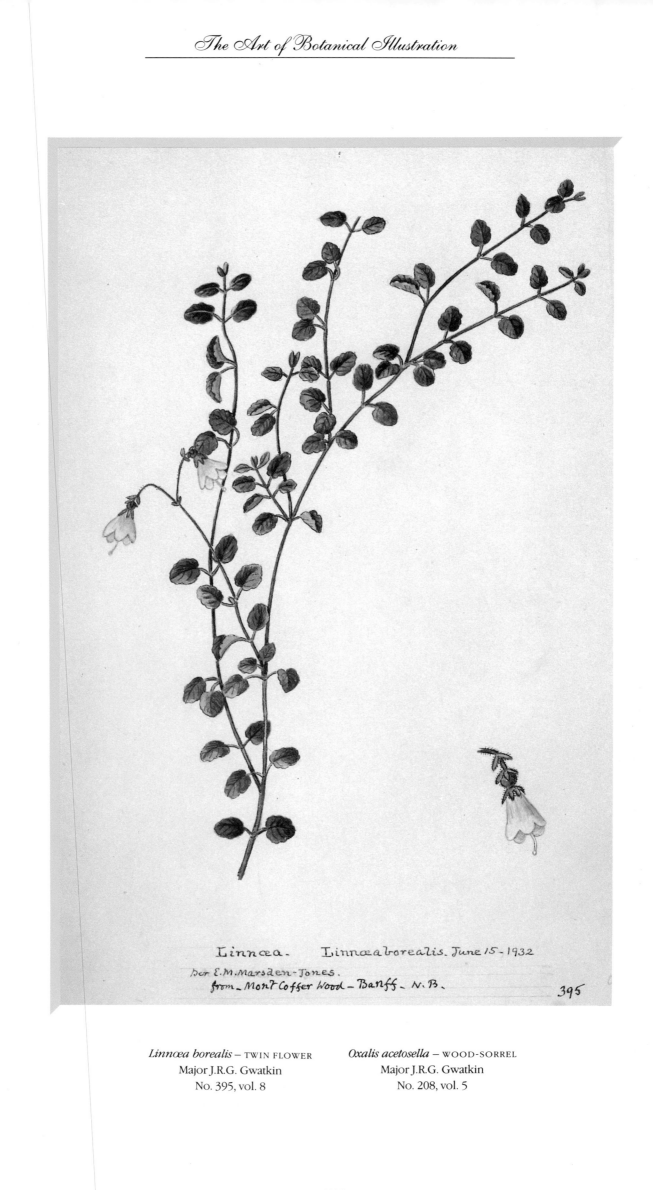

Linnœa. Linnœa borealis. June 15 - 1932
per E. M. Marsden-Jones.
from - Mont Coffer Wood - Banff - N. B.

395

Linnœa borealis – TWIN FLOWER *Oxalis acetosella* – WOOD-SORREL
Major J.R.G. Gwatkin Major J.R.G. Gwatkin
No. 395, vol. 8 No. 208, vol. 5

Joshua Reynolds Gascoigne Gwatkin, M.A., J.P., (1855–1939) of Potterne, near Devizes in Wiltshire was a collateral descendent of Sir Joshua Reynolds, P.R.A. Nothing very much is known of Major Gwatkin other than that he took his Master's degree at Cambridge, following which he entered the Army, becoming a Captain in the Royal Wilts Yeomanry and later a Major. He was fond of hunting and shooting, became a member of the British Ornithological Union, and was sufficiently skilled in taxidermy to set up his own specimens against natural-looking backgrounds. Late in life, at the age of about 60, he began a series of watercolour drawings which eventually numbered more than 1,000. These are catalogued as *Paintings of Flowering plants, mainly British'*. His drawings show a happy combination of botanical knowledge and artistic skill; most of the drawings have habit, location or other notes.

John Nash (RA) (1893–1977) was without formal art training. His early work was for the Imperial War Museum and later in landscape painting. His illustratve work showed great technical versatility; and his flower drawings were noted for their meticulous detail; Miss Mary Grierson, who was the resident artist at Kew from 1960–1972, was trained by him.

Stella Ross-Craig (Mrs J. Robert Sealy) (1906–) was born in Aldershot, Hampshire. Showing early interest and promise, she went on to the Thanet Art School and the Chelsea Polytechnic School of University London for botany training. Afterwards she became artist to the Royal Horticultural Society, and joined the staff of the Royal Botanic Gardens, Kew. She is particularly famous for her valuable work *Drawings of British Plants* in eight volumes (1948–68) but her other works are numerous. In 1937 she did the illustrations for *The Stapaelieae* (3 vols.); White, Dyer and Sloane's *The Succulent Euphorbieae (2 vols. 1941)*; G. H. Johnstone's *Asiatic Magnolias in Cultivation* (1955); *A Study of the Genus Paeonia* (1946); supplement to Elwes's *Monograph of Lilium*, Parts VI–VII (1958); Hooker's *Icones Plantarum* and the journals of the Royal Horticultural Society, Linnean Society and others; and, of course, the *Botanical Magazine*. In addition, she paints portraits, still-lifes, and landscapes, and works with equal freedom in watercolour, line, pencil or pastels. But it will be for her most excellent black and white drawings of British wild flowers that she will be best remembered. This set of reference books is the most accessible to botanists, fell-walkers and all lovers of the countryside. Her drawings of that most difficult and variable group of plants, the Hawkweeds *(Hieracium spp.)* are more helpful than any yet produced. The jackets on the eight books show, appropriately, the stylized draw-

ing of *Linnaea borealis,* which symbolizes the simple preference of that great naturalist.

Margaret Mee (born Margaret Ursula Brown) was one of the bravest and most remarkable botanical artists of our time, rivalling, if not exceeding the courage of earlier artists who endured privation, discomfort and danger in order to paint plants. Of the excellence of her artistry, there can be no doubt. All artists have differing styles but accuracy in plant portraiture is first in the list of essentials, allied to true colour rendition and that most elusive of requirements, an innate ability to give life and vitality to the image on the page. The final requirements of *mise-en-scene* is not essential, but its presence or absence is immediately apparent. Margaret Mee had all four of these gifts, allied to a fierce determination to fulfil her self-imposed task of collecting and painting both the known and the unknown plant species of her adopted country, Brazil.

Margaret Mee was born in Chelsea, Buckinghamshire, and seemed to be something of a late developer. She was always interested in art and painting but it was not until 1947, at the age of 38, that she went first to St Margaret's School of Art and then to Camberwell School of Art, where her studies were guided by Victor Pasmore. At Camberwell, Margaret met her husband, Greville Mee. Together they left London for Brazil in 1952. Greville Mee was a commercial artist and this compatibility must have been a great source of comfort, understanding and strength to Margaret.

Margaret Mee began teaching in Sao Paulo, where they had established a home and studio for Greville. Both were interested in natural history, and Margaret began her exploratory travels to seek out the indigenous flora to paint. She had no formal scientific training, but her consuming interest in Brazilian plants led to her home becoming a meeting place for botanists, other artists, conservationists, visitors and travellers in Brazil, most of whom were well aware of the escalating denudation of the forested areas. At first Margaret concentrated her efforts on the flora of the Atlantic coast rainforest, and it was as well that she did so, because much of this area has now disappeared, owing to the progress of so-called development. Later, she began visiting remote areas of Amazonia, often alone. This last, vast corner of our planet, largely unexplored, is full of danger in the form of beasts, reptiles, fish and insects, and even plants. Jaguars and anacondas do not recognize the difference between a single, harmless, ecologically-minded, botanical artist and an individual from a path-breaking party of destructive developers. Illness, accident and the possibility of native hostility never seemed to be a serious

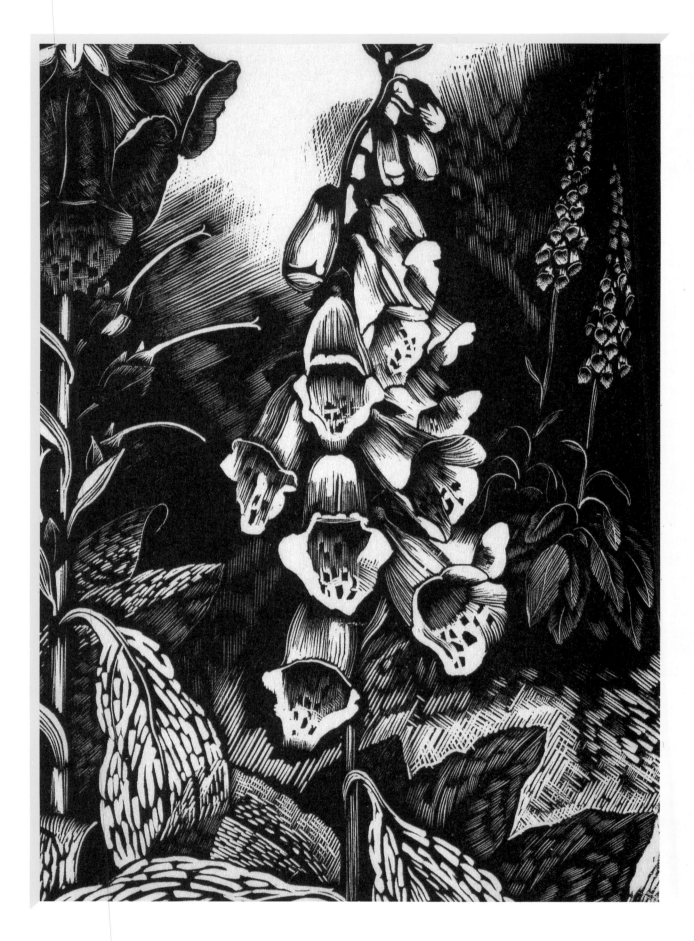

FOXGLOVE
Illustration from *Poisonous Herbs* (1927)
(wood engraving)
John Nash R.A.

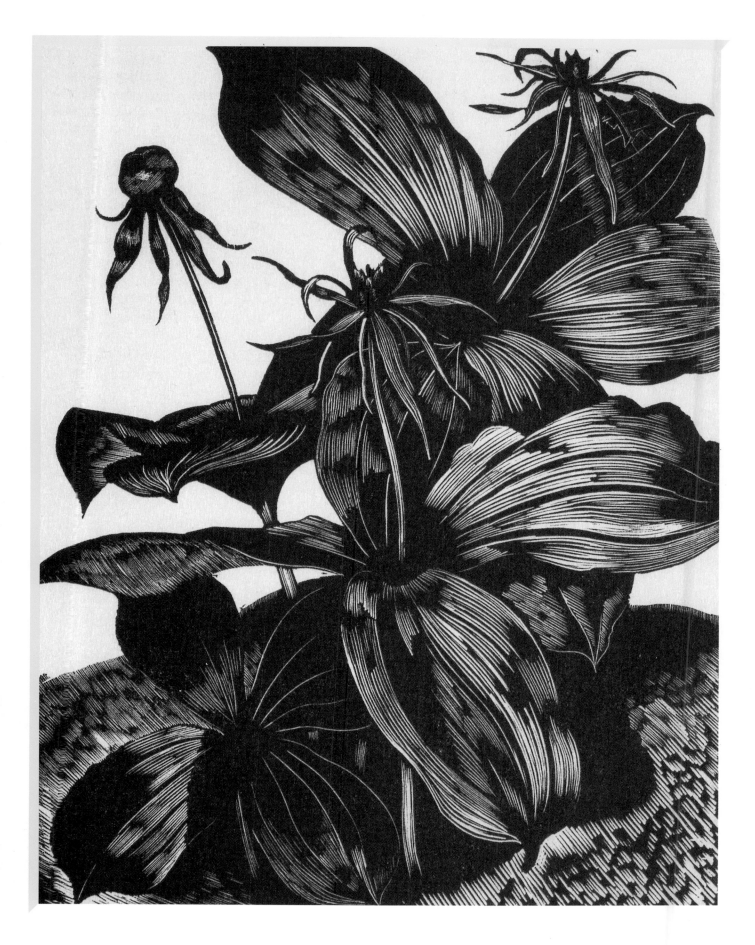

HERB PARIS
Illustrations from *Poisonous Herbs*
(wood engraving)
John Nash R.A.

problem to her. She had a well-developed sense of humour which must sometimes have helped in moments of pure terror.

In her searches, she discovered several completely new species, which have been named after her; some examples are the *bromeliads, Aechmea polyantha, Aechmea meeana,* and *Neoregilia margaritae* which is known only from her drawing, not having been re-collected as yet. Several of her paintings show species not hitherto known, and there is one mystery plant which cannot be assigned a genus until it can be rediscovered in flower. The epiphytic orchid, *Sobralia margaritae* is another of her discoveries. Her work has become invaluable to science, firstly, because there is no other collection as comprehensive and, secondly, because the plants were often painted in their natural habitat which in many cases has since been destroyed. In some cases, even her plants no longer exist, a truly sad reminder of the ecological destruction of this last great unknown area of our world.

Margaret Mee painted in gouache on paper. Her method involved producing detailed sketches of a plant specimen in its native forest, with appropriate colour notes and other records. Then she would collect the living plants and take them back, or have them sent back to her studio in Rio de Janeiro. Here she would paint the finished composition. Early on she made the decision never to sell any of her first paintings, because she could see how the forest areas were being pushed back all too quickly by the greed of the developers. Sadly, she recognized that some of her work would be historically valuable and possibly irreplaceable.

Her paintings are, first and foremost, beautiful. They have been given to Kew to be preserved for the nation, so that future generations can be inspired by her artistry, her courage, her dedication, and her exceptional capabilities during a continuing period of ecological attrition. Fortunately, plans to form the Margaret Mee Amazon Trust[28] were well in hand, and were incorporated ten days before her untimely death in a car crash in Leicester on 30 November 1988. The books – *Margaret Mee in Search of Flowers of the Amazon Forest* (edited by Tony Morrison), *Flowers of the Brazilian Forests* (1968) and *Flores do Amazonas* (Flowers of the Amazon, 1980) – form a lasting and accessible record of her beautiful work; the exhibition of her paintings, mounted by Kew immediately after her death, ended in March 1989.

Mary Anderson Grierson (1912–) was born at Bangor in North Wales and trained as an aerial photographic interpreter in the Second World War and later as a cartographical draughtswoman. She always had a deep love for plants and became a freelance botanical illustrator,

28. *The trust is dedicated to the preservation and wider dissemination of Margaret Mee's work and to the fostering of Amazonian plant study.*

afterwards studying under John Nash. In 1960 she was appointed the official botanical artist at Kew. Her subsequent work earned her four of the Royal Horticultural Society's gold medals and she produced many plates for the *Botanical Magazine,* drawings for the *Kew Bulletin* and Hooker's *Icones Plantarum.* The Post Office accepted designs featuring British flora and produced a set of stamps in 1967, and she had many very successful exhibitions.

In 1972 (just before she retired) I had the privilege of meeting her at Kew when I went to find out whether my new-found talent was of any significance. The meeting and the surroundings made a deep impression on me, as did her kind evaluation of my early work. She suggested that I should exhibit my drawings at the Royal Horticultural Society's Hall at Vincent Square – 'You may even get a medal!' she said. I admired the work that she was doing, which was a tonal study of a South American plant, brought by a native carrier to a collecting point where it had been packed and flown to England. It was decidedly the worse for wear. I marvelled at her ability to create life from the battered, browning leaves and crushed flowers of this rare jungle plant. She was used to it, she said. As we parted she uttered words that I have remembered ever since, 'I think we'll be hearing of you'. She taught classes of budding botanical artists at Flatford Mill Field Centre, where we met again. This was a delightful place, and half the class were superb artists, having no real need of lessons, they just went along for a busman's holiday and to talk shop. The other half were earnest triers who must have derived tremendous benefit from the range of talent around them. The floor squeaked and shook at any footfall, the lighting was not good, the mosquitoes were the most vicious and prolific I'd ever experienced and the quacking of the myriad ducks was a constant cacophany. It was all quite wonderful and knowledge was just soaked up through the pores.

Mary Grierson produced the handsome plates for *Orchidaceae* (1974) by P. F. Hunt and has turned to commercial design of high quality. She does exquisite embroidery. One of her designs is derived from Marianne North's inspirational doorframes, which Miss Grierson has turned into her own very individual and exact design.

Margaret E. Stones (1921–) was born at Colac, Victoria, Australia. She studied at Swinburne and National Gallery Art Schools, Melbourne, and then took up nursing during the Second World War. While nursing she developed tuberculosis, which meant that she was hospitalized for a year. During this enforced period of rest and quiet she made up her mind to take up botanical art as a career. Fortunately the disease was completely cured and she began to study botany, going out on field trips in the Australian mountains.

In 1951 she took a chance and came to England with no resources other than her talent. There were no letters of introduction for the young Margaret Stones. Naturally,

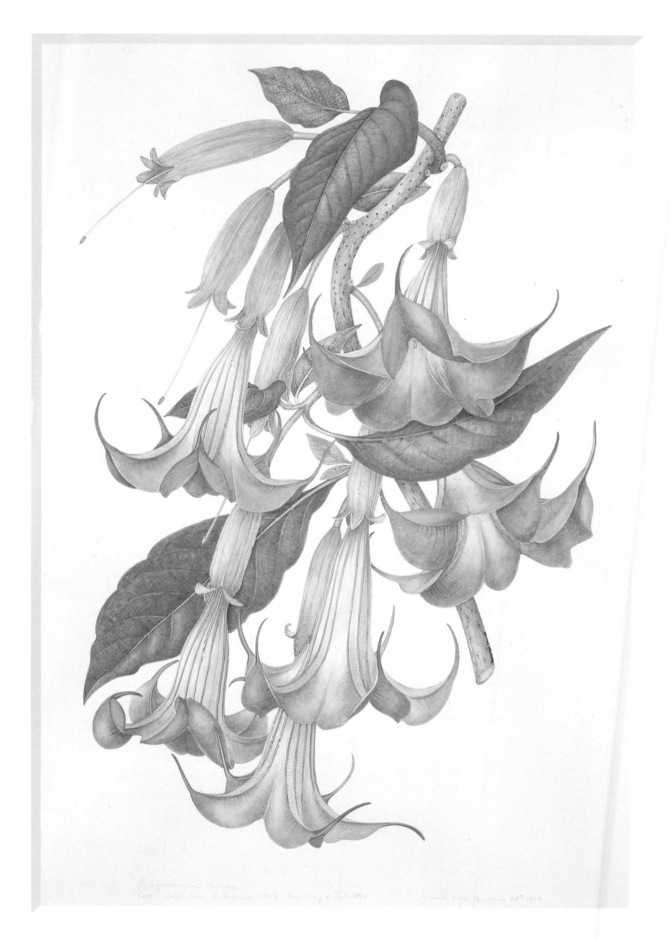

Brugmansia aurea
(watercolour over pencil lightened with white;
signed, inscribed and dated)
Margaret Stones

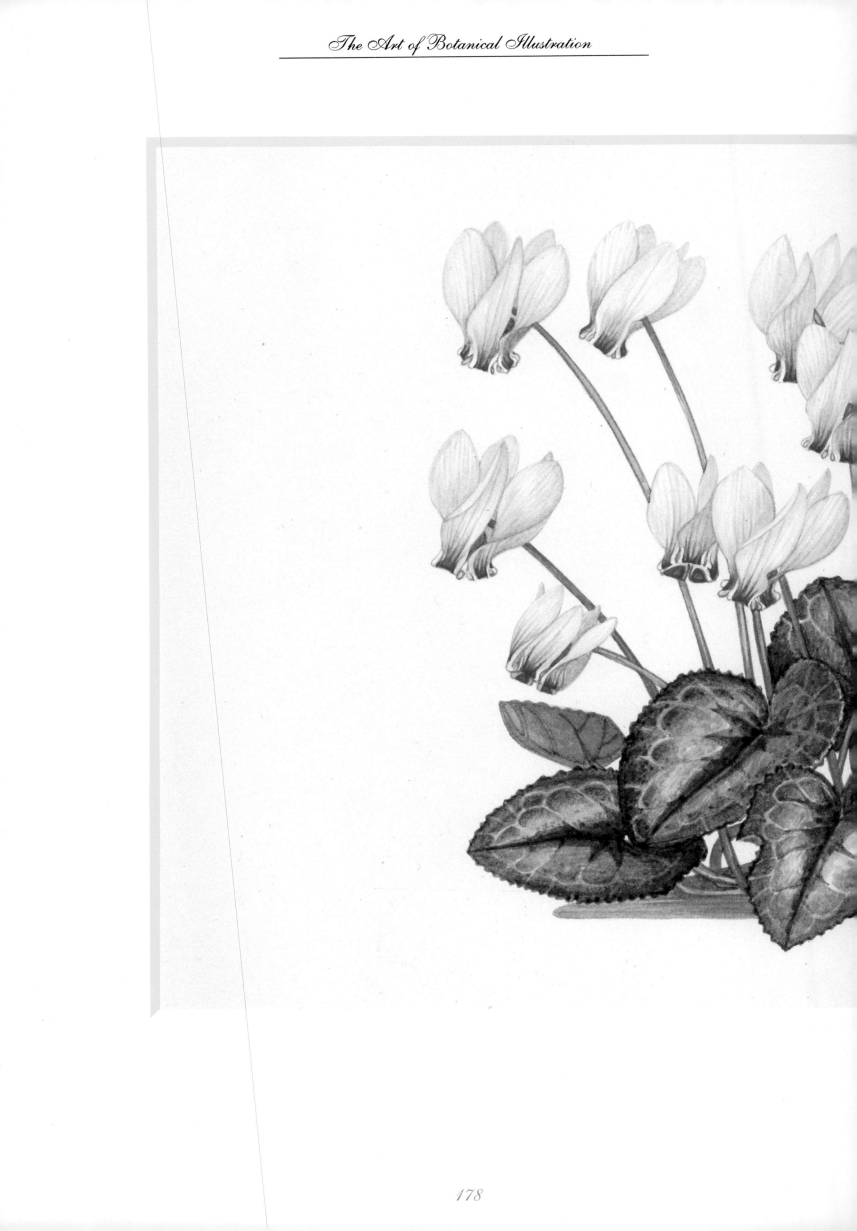

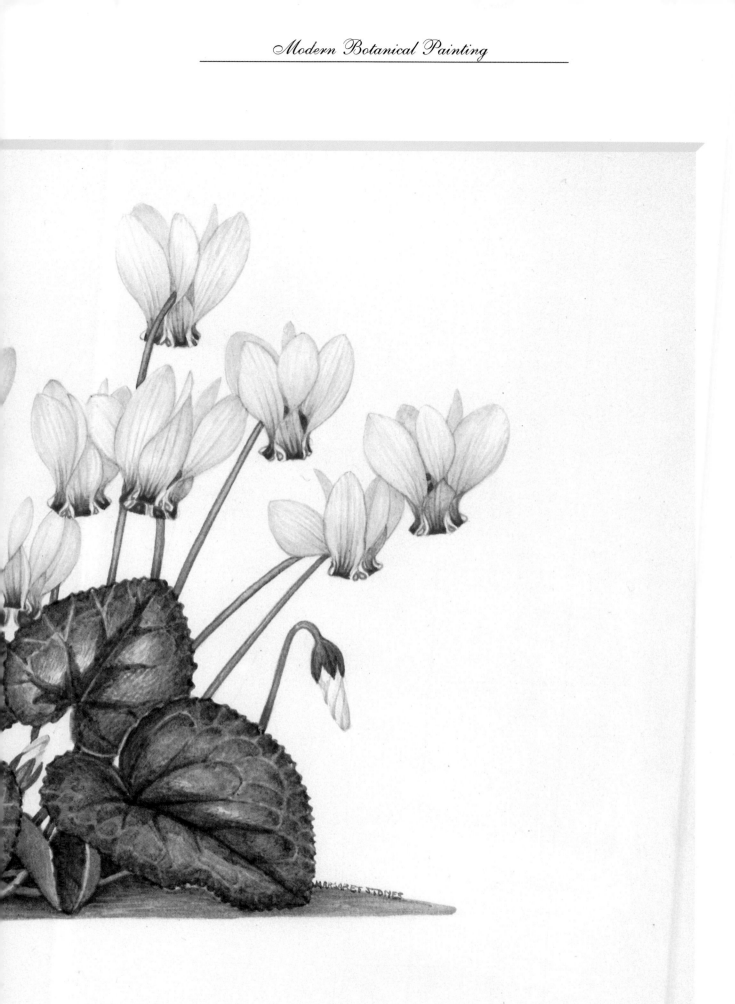

CYCLAMEN
Margaret Stones

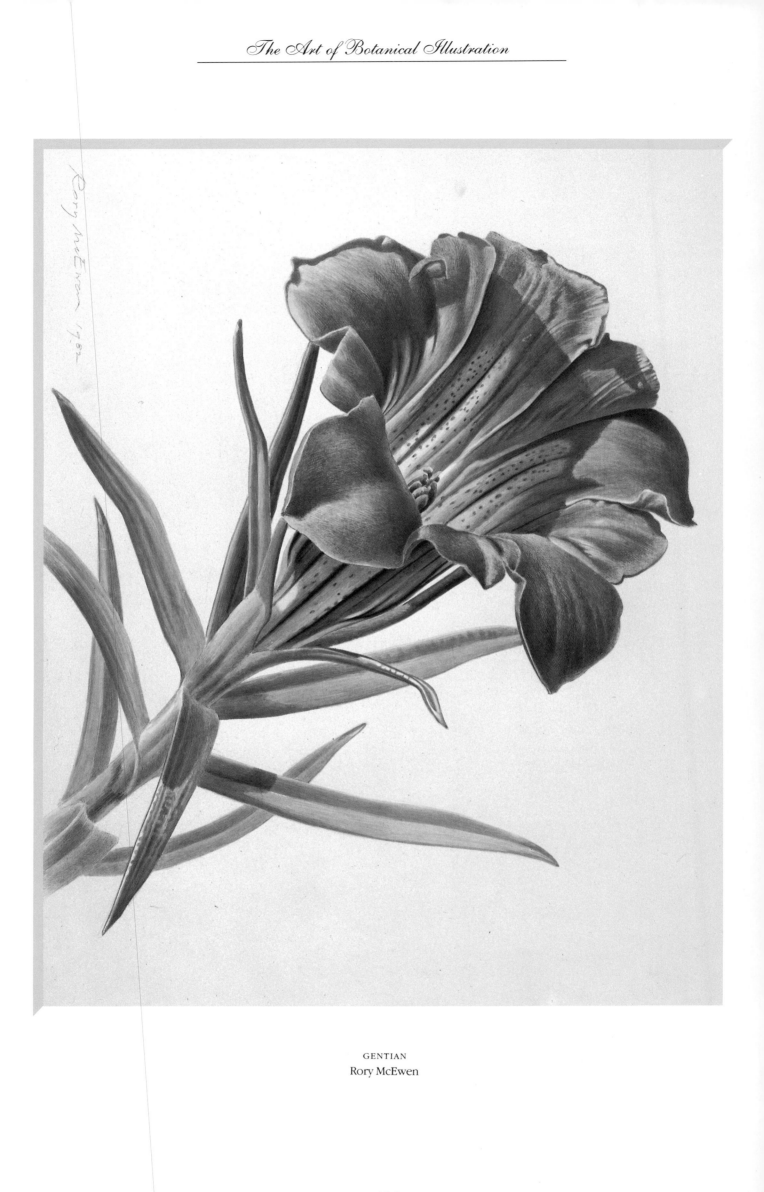

GENTIAN
Rory McEwen

she gravitated to Kew, and began work there independently, she also worked for the Natural History (British Museum). She lived in a flat in a house very near Kew, and in time she was able to buy the house itself. This is where she still lives. She was kept fairly busy by her work for the *Botanical Magazine, The Royal Horticultural Society* and other botanically-orientated institutions and by some private commissions, but it is a hard and worrying life when one is totally dependent on such an irregular income. Fortunately, her work is exceptionally good, and this was the reason that Lord Talbot of Malahide, an Irish baron and an English diplomat, chose her to do the illustration for his proposed book on the Tasmanian flora.

Lord Talbot inherited an Irish castle and the family estates in Tasmania. 'Commuting' between the two hemispheres, he realized that the Tasmanian plants might do very well at Malahide Castle, near Dublin, in Ireland. The plants thrived, and just as in times gone by, Lord Talbot commissioned some paintings of them; from these beginnings sprang the idea of producing a full-scale Tasmanian Flora. Sadly, Lord Talbot died in 1973, but his sister, Rose, continued the project so well begun. The book, *The Endemic Flora of Tasmania* came out in six parts between 1967 and 1978, with Margaret Stones producing all the plates. Though she visited Tasmania once, in 1962, for a few weeks, all the work has been done comfortably at home, where the plants were either flown to her direct from Tasmania or grown and flowered at Malahide Castle or Kew. The original paintings for this flora, which features 254 species on 155 plates are now kept at Launceston, Tasmania. Since that time, Margaret Stones has been asked by the Louisiana State University to make drawings of the flora of that state – some 200 drawings in all. Margaret Stones has said that it is better to be a botanical artist in Britain than anywhere else in the world because the pool of reference material in this country, most particularly at Kew, is second to none.

Her illustrations have appeared in F. C. Stern's *Snowdrops and Snowflakes* (1956), E. H. M. and P. A. Cox's *Modern Rhododendron* (1956), *Modern Shrubs* (1958), *A Supplement* (to) Elwes' *Monograph on the Genus Lilium, Modern Trees* (1961) and E. Mannering's *Flower Portraits*. She exhibits internationally and her work is in private collections all over the world.

Rory McEwen (1932–82) painted flowers from the age of eight. Born into a comfortable and privileged style of living, he was educated at Eton, where his art master was Wilfred Blunt. Mr Blunt describes Rory McEwen as, 'Perhaps the most gifted pupil to pass through my hands; at one moment he was painting on vellum a single flower or a dead leaf with a finesse that Redouté might have envied; at another he was producing abstract three-dimensional work that meant nothing to me'. Rory McEwen soaked up all that was good in the works of Robert, Aubriet, Ehret, the Bauer brothers and Redouté. Then he went into the army, serving for two years as an officer in the Queen's Own Cameron Highlanders. Sometimes, if an artist does not paint for a while, his hand and eye forget their relationship, and this can be a source of worry. But Rory McEwen's hand, as he says 'had unknowingly educated itself'. He painted a rose on the day that he left the Army and painting, from that time onwards, was to be almost all of his life.

Rory McEwen went to Cambridge where he met and became friendly with Sacheverell Sitwell, whose love of and for flowers was as a woven pattern throughout his life. Rory McEwen loved jazz music and abstract design in painting and glass; he studied and lived with the traditions of India and Pakistan and, during his last years, the cultures of Bhutan and Afghanistan drew him irresistibly. Though apparently alien to the Western heart, these Eastern philosophies made his being more endurable. He did not regard himself as a botanical illustrator but as he said, 'I paint flowers as a way of getting as close as possible to what I perceive as the truth, my truth of the time in which I live. This mostly means looking, looking and thinking; then painting, and then thinking how much better the painting could be'.[29]

Rory McEwen painted vegetables as well as flowers; the vegetables have a solid sculptural quality which must have been pleasing to produce. He was even more accomplished at painting skeletal leaves either in what was left of their entirety or, with a sense of spatial mastery in their sectional positioning on the page. The question of how he learned to paint flowers with such absolute exactitude has been a question to many but need never be answered. In some centuries are giants born and Rory McEwen's nascent talent was such – he had not to learn as do lesser mortals. He exhibited all over the world, from 1962 onwards; in 1982 he was seriously ill and died later that year. Pre-planned exhibitions continued until 1984 with the most recent at the Serpentine Gallery in London in the winter of 1988/1989.

Pandora Sellars (born Pandora Brace, 1936) came from Herefordshire in England, where as a child she wandered safely in the woods and fields of that verdant county. She went to a small private school and then to the College of Art at Hereford where she trained as a textile designer, afterwards becoming an art teacher herself. It was not long, however, before she turned to the economic perils of freelance illustrating. After her marriage in 1958 to James Sellars (a teacher of fine art printmaking) she became fascinated by the exotic appearance of the aroids and the orchids that they grew in their heated greenhouse. These are the plants that have become her speciality and almost her trademark.

29. *Extract from* An Autobiographical Fragment *by Rory McEwen.*

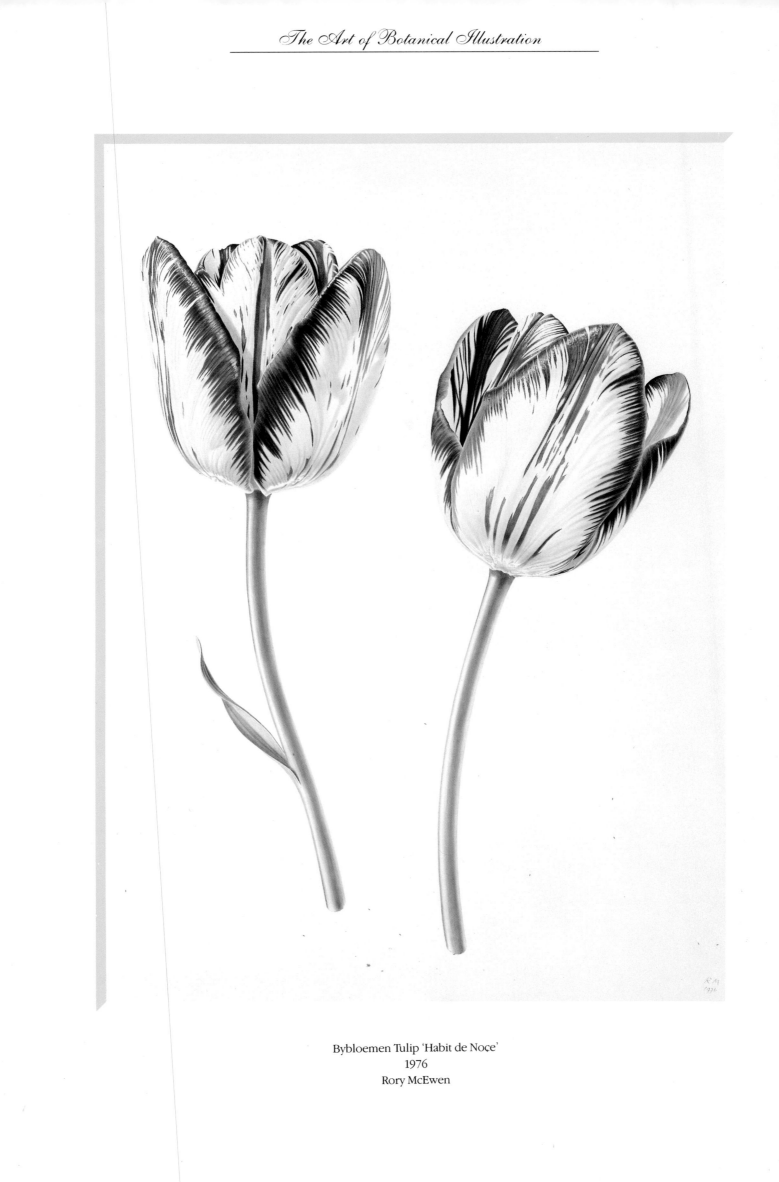

Bybloemen Tulip 'Habit de Noce'
1976
Rory McEwen

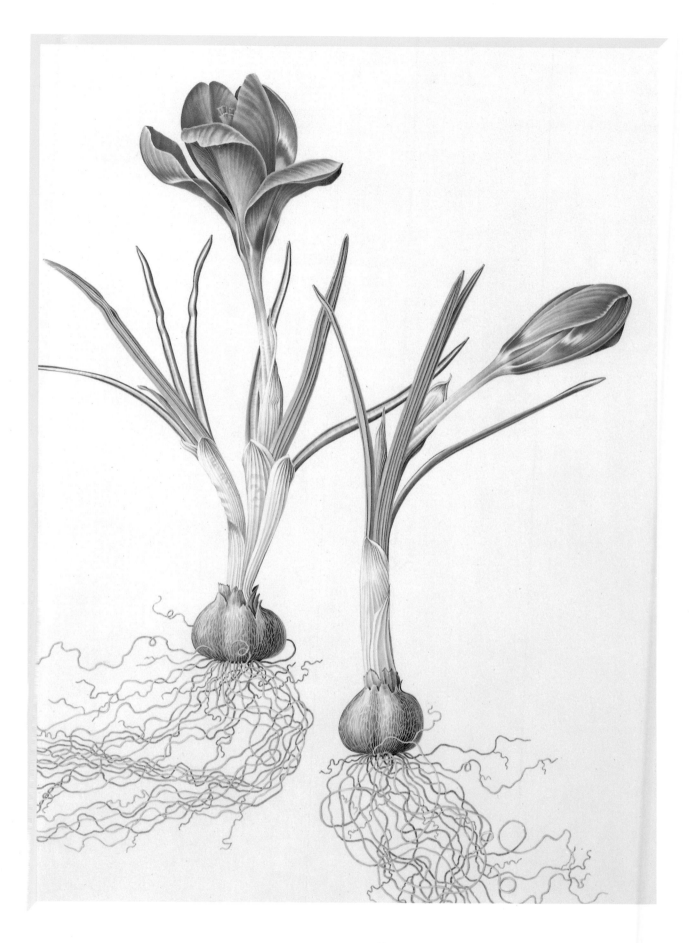

CROCUSES 1964
Rory McEwen

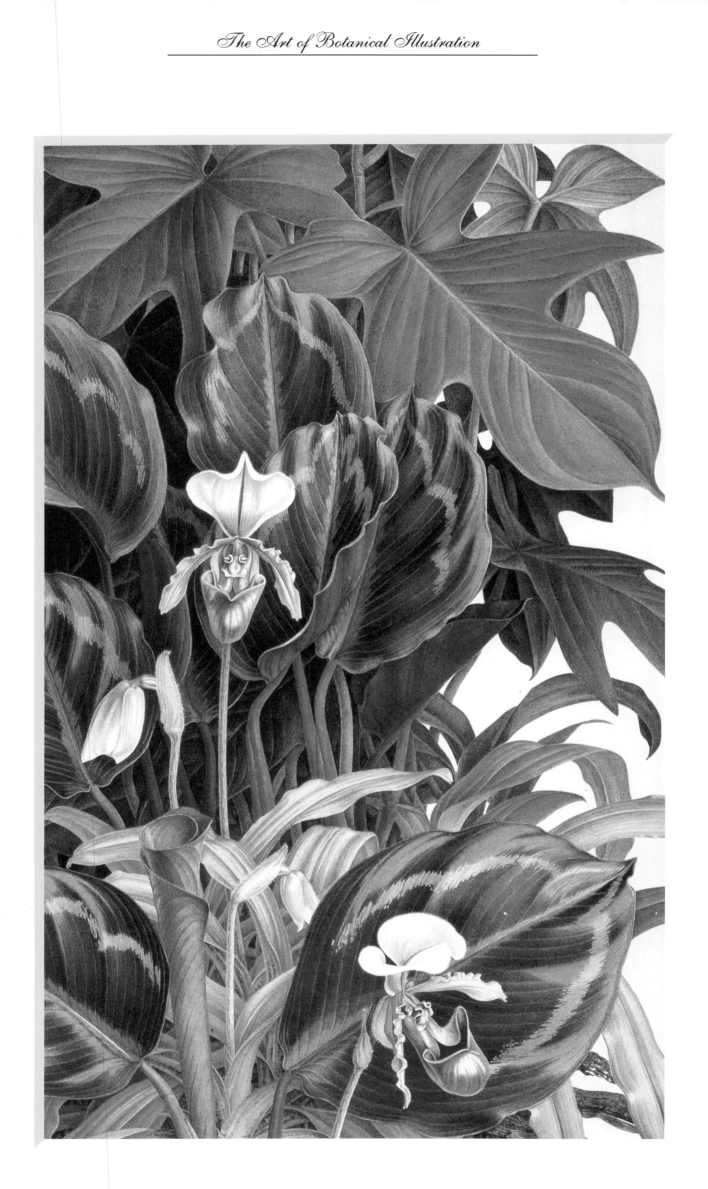

She met Margaret Stones at one of the Royal Horticultural Society's exhibitions and through her the then editor of the *Botanical Magazine*[30] for which she now produces illustrations Margaret Stones has continued to be a great source of help and inspiration during Pandora Sellar's career. Pandora Sellars has illustrated *The Flora of Jersey* (1984); *The Genus Paphiopedilum* by P. Cribb (1987); some plates in *A Celebration of Flowers*, Ray Desmond (1986); *Flower Painting*, by Claire Sydney (1986) and other works. She has been awarded the Royal Horticultural Society's Gold Medal for her work, and has done prestigious porcelain design to celebrate the new Princess of Wales glasshouse at Kew; she also designed two sets of stamps for the Jersey Post Office.

Pandora Sellars's aroids and orchids have a glistening lushness which is unique. Her excellent work needs no signature as it is so instantly recognizable. Though she can and does paint other flowers, it is these tropical plants that she loves best to portray. One of her dearest ambitions is to visit the equatorial parts of the world to see and paint these favourite plants in their natural habitats.

Christabel King (1930–) knew from an early age what she wanted to do in life and so she studied scientific illustration from 1972–4 at Middlesex Polytechnic. She then became part-time assistant (from 1975–84) to the editor of Curtis's *Botanical Magazine,* producing line and watercolour drawings. From 1985 she began teaching botanical drawing at Capel Manor College of Horticulture at Enfield. This is a subject that is not often taught anywhere because there are so few competent artists who have sufficient time to spare.

Christabel King's work has been published in Curtis's *Botanical Magazine,* now *Kew Magazine* in 1975, *Flowering Plants of the World,* edited by V. H. Heywood, (Elsevier International, Oxford University Press 1978), *Orchideenatlas* by Bechtel, Cribb and Launert (Eugen Ulmer 1979), *All Good Things Around Us* by Pamela Michael (Ernest Benn 1980), *World Book Encyclopaedia* (Childcraft International, Chicago), *The Genus Echinocereus,* Kew Magazine Monograph (Collingridge 1985), *The Plantsman* Vol. 10, Pt. 2 (1988). She is a member of the new Society of Botanical Artists.

In 1987 she took part in a fascinating expedition to the Rwenzori Mountains of Uganda, led and funded by the author Guy Yeoman who is most concerned about the conservation of the unique flora of that area. This book *Africa's Mountains of the Moon* is to be published in 1989. Her journey and work in the equatorial conditions of the area are in the best traditions of the botanical artists of old.

It will have been noticed that no mention of photography has been made in this book. It might be thought that the multifarious permutations of today's camera lenses and attachments coupled with their exactly measurable enlargement facilities would have superceded the painstakingly slow work of the botanical artist. But this is not so. The camera is exceedingly useful as a back-up tool and that is all. It is excellent for taking 'habit' and habitat photographs, because a known object can be introduced for scale. Sometimes it is good for 'colour notes', but blues seldom or never come true. When speed is of the essence and several specimens need to be represented or figured almost simultaneously, then several different all-round views can be taken of the same plant and the drawing can be done later from the dried specimen and with the aid of the photographs.

But the main reason for the camera not being used is that the human eye is a better instrument for the purpose than any camera. The eye adjusts to varying depths of field at a blink and remains in focus all the time. The eye sees what it needs and can concentrate the brain and hand on this essential part of the plant. The eye can see that a leaf, a stem, a petal, a bract is not characteristic; and brain and hand can correct the drawn image. The eye, with some help for magnification, is better when it comes to the scientific dissections; the camera sees all and all is too much, and may in any case be visually indistinct; in contrast, the eye, so to speak, knows what it is looking for and disregards all else. In addition, the finished drawing must be characteristic of the species and not of an individual specimen. The camera is obedient to the hand and pictures what it sees. The eye is obedient to the brain, sometimes of two brains, as the botanist may be standing right behind the artist, and the resulting drawing will be the reference for the future. So there is no substitute for the skill, the knowledge and the God-given talent of the botanical artist.

*Paphiopedilum spicenarum, Calathea rosea-
picta, Philodendron panduraforme*
1985
Pandora Sellars

30. The Botanical Magazine *is also called* The Kew Magazine *though its official title is still* Curtis's Botanical Magazine.

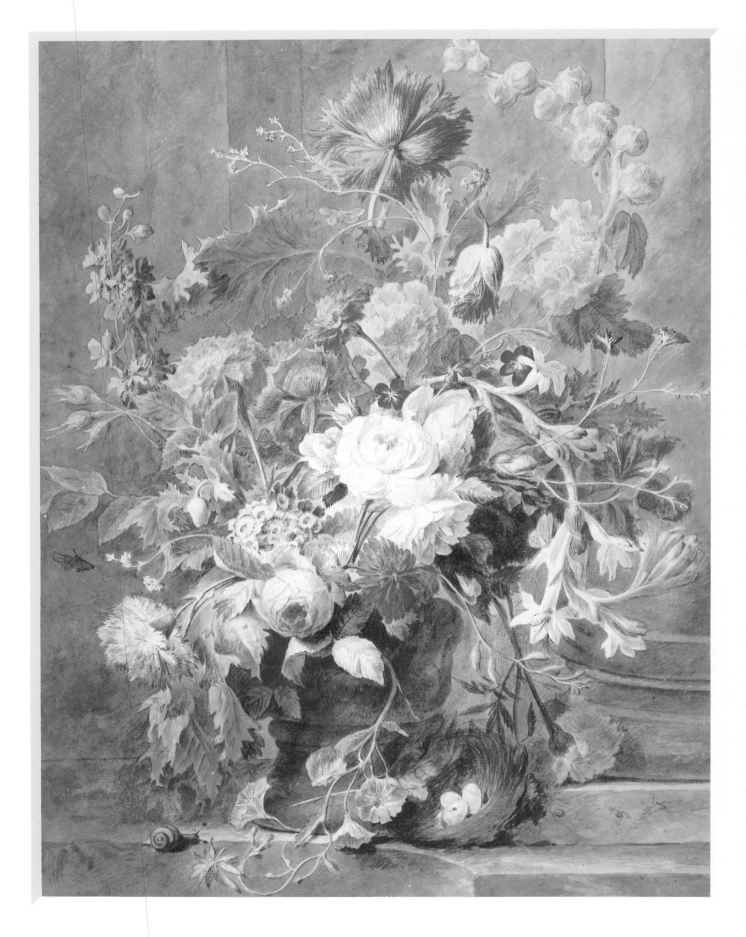

A VASE OF FLOWERS
Wybrand Hendriks

Bibliography

Barraclough, Geoffrey (ed.) *The Times Atlas of World History*, Times Books, 1979

Bean, W. J. *Trees and Shrubs Hardy in the British Isles* (8th Edition). John Murray (Publishers), 1970

Bingham, Madeleine *The Making of Kew*. Michael Joseph/Folio Press, 1975

Blunt, Wilfred *The Art of Botanical Illustration*, with the assistance of William T. Stearn. Collins, 1971

Blunt, Wilfred and Raphael, Sandra *The Illustrated Herbal*. Francis Lincoln/Weidenfeld & Nicholson, 1979

Blunt, Wilfred *Tulipomania*. Penguin Books, 1950

Calmann, Gerta *Ehret – Painter Extraordinary*. Phaidon, 1977

Clapham, A. R., Tutin, T. G. Warburg, E. F. *Flora of the British Isles* (2nd Edition). Cambridge University Press, 1962

Coats, Alice M. *The Quest for Plants (A History of Horticultural Explorers)*. Studio Vista London, 1969

— *The Treasury of Flowers*. Phaidon/Royal Horticultural Society, 1975

Coker, Peter *Etching Techniques*. B. T. Batsford, 1976

Cuthbert, Caroline *Rory McEwen (The Botanical Paintings)*. The Royal Botanic Garden Edinburgh, 1988

Dunthorne, Gordon, M.A. (Oxon) *Flower and Fruit Prints of the 18th and early 19th Centuries*. Published by the author, Washington D.C., 1938

Fisher, John *Mr. Marshal's Flower Album*. Gollancz, 1985

Grey-Wilson, Christopher, Ph.D. (ed.) *Curtis's Botanical Magazine*. The Bentham-Moxon Trust/Curwen Books, 1982

Keble Martin, W. *The Concise British Flora* (in colour). Michael Joseph, 1972

Mayo, Simon *Margaret Mee's Amazon*. Royal Botanic Gardens, Kew

North, Marianne *A Vision of Eden – The Life and Work of Marianne North*. Webb & Bower/The Royal Botanic Gardens, Kew, 1980

Osborne, Harold *The Oxford Companion to Art*. Oxford University Press, 1979

Rix, Martyn and Stearn, William T. *Redouté's Fairest Flowers*. The Herbert Press/The British Museum (Natural History), 1987

Rix, Martyn *The Art of the Botanist*. Lutterworth Press, 1981

Ross-Craig, Stella, F.L.S. *Drawings of British Plants*. Unwin Hyman, 1979

Rousseau, Jean-Jacques *Botany – A Study of Pure Curiosity*. Illustrated by P.J. Redouté. Michael Joseph, 1979

Scrase, David *Flowers of Three Centuries (One Hundred Drawings & Watercolours from the Broughton Collection)*. The International Exhibitions Foundation, U.S.A., 1983

Sitwell, Sacheverell *Old Fashioned Flowers*. Country Life Books, 1948

Synge, Patrick M., M.A. (Cantab), F.L.S. *Dictionary of Gardening* (2nd Edition). Oxford University Press, 1956

Thomas, Graham Stuart *A Garden of Roses*. Watercolours by Alfred Parsons, R.A. Pavilion Books, 1987

Trevelyan, G.M., O.M. *History of England*. Longman, 1981

Wilson, E.J. *West London Nursery Gardens*. 1982

Woodward, Marcus *Gerard's Herball*. From the Edition of T.H. John Johnson 1636 – Gerard Howe, Publisher, 1927

Index

Page numbers in italics indicate illustrations. 'n' after page number indicates footnote.

Dutch and German names beginning with Van or Von are found under these prepositions in the index.

ACKNOWLEDGMENTS

My sincerest thanks are due to the following people, some of whom gave me help and encouragement and from some of whom I learnt much along the way: Mrs Hilary Bampton; Miss Bridget Buckley; Miss Diana Cresswell; Miss Gina Douglas, Librarian, The Linnean Society of London; Miss Christine Elwood, Acting Botany Librarian and the staff at the British Museum, Natural History; Miss Sheila Edwards, Librarian, The Royal Society; Dr. Brent Elliott, Librarian, The Lindley Library, The Royal Horticultural Society; Miss Sylvia Fitzgerald and the staff of the Herbarium Library, the Royal Botanic Gardens, Kew; Miss Pat Halliday; Mrs Bella Holliday; Tim and Barbara Hooker; Mr Desmond Meikle; Dr. Nicholas Penney and Dr Catherine Whistler of the Print Room, the Ashmolean Museum; Ms Helen Pye-Smith, the National Art Library, Victoria and Albert Museum; the Hon. Mrs Jane Roberts, Curator of the Print Room, the Royal Library, Windsor Castle; Dr David Scrase, Keeper of Paintings, Drawings and Prints and the staff at the Fitzwilliam Museum; Dr. Richard and Dr Helen Skaer; Mrs Susan Sweatland; Miss Moira Thunder, Curator of the Print Room, Victoria and Albert Museum.

Lys de Bray.

Quarto would like to thank the following for providing photographs, and for permission to reproduce copyright material. While every effort has been made to trace and acknowledge all copyright holders, we would like to apologize should there have been any omissions.

page 2 Lys de Bray; p6 Fitzwilliam Museum, Cambridge; p8 The Linnean Society Library, London/Biblioteca Nazionale, Naples, MS Gr. 1 f58r; p10 The Linnean Society Library, London/Österreichische National Bibliotheck, Vienna, Med. Gr. 1; p11 Bodleian Library, Oxford, MS Bodley 130; p12 The British Library, London, MS Egerton 2020; p13 The British Library, London, MS Cotton Vitellius C. III; p14 The Linnean Society Library, London; p15 The Linnean Society Library, London, Ref. 129; p16 Bodleian Library, Oxford, MS Ashmole 1462; p17 Bodleian Library, Oxford, MS Ashmole 1431; p18 The Linnean Society Library, London/Herbarium Vivae Eiscones (1530) p217; p19 The Linnean Society Library, London/de Historia Stirpium (1542) p84; p20 The Linnean Society Library, London, Ref. 104; p21 The Linnean Society Library, London/de Historia Stirpium (1542) p87; p22 The Linnean Society Library, London/de Historia Stirpium (1542) p235; p23 The Linnean Society Library, London; p24 The Linnean Society Library, London/Commentarii in sex Libros Pedacii Dioscorides (1544) p688; p25 The Linnean Society Library, London/Uffizi Gallery, Florence; p26 The Linnean Society Library, London/Van der Borcht Collection; p27 The Linnean Society Library, London; p28 The Linnean Society Library, London; p29 The Linnean Society Library, London; p30 The Linnean Society Library, London/Rariorum Plantarum Historia (1601) p116; p31 The Linnean Society Library, London/Rariorum Plantarum Historia (1601) p115; p32 The Linnean Society Library, London/Herball p600; p34 The Linnean Society Library, London/Rariorum Plantarum Historia (1601) pp 1xx & 1xxj; p37 Windsor Castle, Royal Library ©Her Majesty the Queen, Inventory no. 24281; p38 Windsor Castle, Royal Library ©Her Majesty the Queen, Inventory no.24405; p41 Ashmolean Museum, Oxford/Daisy Linda Ward Collection, W17; p42 Ashmolean Museum, Oxford/Daisy Linda Ward Collection, W7; p44 Ashmolean Museum, Oxford/Daisy Linda Ward Collection, W63; p45 Ashmolean Museum, Oxford/Daisy Linda Ward Collection, W3; p46 Ashmolean Museum, Oxford/Daisy Linda Ward Collection, W6; p47 The Linnean Society Library, London; p49 Fitzwilliam Museum, Cambridge, PD 645 1973; p50 Fitzwilliam Museum, Cambridge, PD 420 1963; p51 Fitzwilliam Museum, Cambridge, PD 79 1973; p52 Ashmolean Museum, Oxford/Maden bequest; p53 Fitzwilliam Museum, Cambridge, 13; p54 Fitzwilliam Museum, Cambridge, PD 358 1973; p55 The Fitzwilliam Museum, Cambridge, PD 915 1973; p57 British Museum, Natural History; p58 British Museum, Natural History; p59 Fitzwilliam Museum, Cambridge, PD 729 1973; p60 Fitzwilliam Museum, Cambridge, PD 60 1975 91; p63 The Linnean Society Library, London/Catalogus Plantarum (1730) p18; p64 The Linnean Society Library, London/Catalogus Plantarum (1730) p7; p65 The Linnean Society Library, London/Catalogus Plantarum (1730) p12; p67 British Museum, Natural History; p68 British Museum, Natural History; p69 British Museum, Natural History; p70 The Linnean Society Library, London; p72 The Linnean Society Library, London; p74 British Museum, Natural History/Florilegium 686; p75 British Museum, Natural History/Florilegium 355; p76 Fitzwilliam Museum, Cambridge, PD 821 1973; p77 The Linnean Society Library, London; p78 The Linnean Society Library, London; p79 The Linnean Society Library, London; p80 The Linnean Society Library, London; p81 The Linnean Society Library, London; p82 The Linnean Society Library, London; p83 The Linnean Society Library, London; p84 The Linnean Society Library, London; p85 The Linnean Society Library, London; p86 Windsor Castle, Royal Library ©Her Majesty the Queen; p87 The Linnean Society Library, London/Albertina Collection, Vienna; p88-9 Windsor Castle, Royal Library ©Her Majesty the Queen; p90 Fitzwilliam Museum, Cambridge, PD 109 1973 f14; p91 (left) The Linnean Society Library, London/Kunsthalle, Bremen, (right) Fitzwilliam Museum, Cambridge, PD 109 1973 f8; p92 British Museum, Natural History; p93 Fitzwilliam Museum, Cambridge, PD 166 1973; p94-5 Fitzwilliam Museum, Cambridge, 17-6-34; p97 By courtesy of the Board of Trustees of the Victoria & Albert Museum/Collection Précieuse et Enliminée des fleurs les plus belles et les plus curieuses, qui se cultivent tant dans les jardins de la Chine, que dans ceux de l'Europe, vol 2 (48.c.30) pl XLV; p98 British Museum, Natural History 5; p99 British Museum, Natural History; p100 By courtesy of the Board of Trustees of the Victoria & Albert Museum/Collection Précieuse et Enliminée des fleurs les plus belles et les plus curieuses qui se culti-vent tant dans les jardins de la Chine, que dans ceux de l'Europe, (2pts 200 plates) Fol. Paris 1775-79; p103 British Museum, Natural History, 79/p162; p104 Fitzwilliam Museum, Cambridge, PD 96 1973 f14; p106 Fitzwilliam Museum, Cambridge, PD135 1973 J14; p109 By courtesy of the Board of Trustees of the Victoria & Albert Museum (Print Room) 608 - 1886 DP-3; p110 By courtesy of the Board of Trustees of the Victoria & Albert Museum (Print Room) D562 - 1886 DP-IC; p112 By courtesy of the Board of Trustees of the Victoria & Albert Museum (Print Room) 604 - 1886 DP-3; p113 By courtesy of the Board of Trustees of the Victoria & Albert Museum (Print Room) D577 - 1886 DP-2A; p115 British Museum, Natural History; p116 By courtesy of the Board of Trustees of the Victoria & Albert Museum (Print Room) D583 - 1886 DP-2A; p119 By courtesy of the Board of Trustees of the Victoria & Albert Museum (Print Room) D568 - 1886 DP-2; p121 British Museum, Natural History; p122 British Museum, Natural History; p125 British Museum, Natural History; p126 British Museum, Natural History; p129 British Museum, Natural History 4; p130-1 British Museum, Natural History; p133 The Linnean Society Library, London; p134 The Linnean Society Library, London; p136 British Museum, Natural History/New Botanic Garden t-38; p137 British Museum, Natural History; p138 British Museum, Natural History/British Flower Garden, 2nd series Vol III 1835 pl, 205; p139 British Museum, Natural History/New Botanic Garden t-17; p140 British Museum, Natural History 3; p142 British Museum, Natural History 16; p143 British Museum, Natural History 7; p144 The Linnean Society Library, London; p145 The Linnean Society Library, London; p147 Fitzwilliam Museum, Cambridge, PD 993 1973; p149 Royal Botanic Gardens ©Kew; p151 Royal Botanic Gardens ©Kew; p152 Ashmolean Museum, Oxford 14; p153 Ashmolean Museum, Oxford 13; p155 The Lindley Library/The Genus Rosa in 4 vols p84, Vol I; p156 The Lindley Library/The Genus Rosa p266, Vol III; p157 The Lindley Library/The Genus Rosa p102, Vol I; p158 The Lindley Library/The Genus Rosa p70; p159 The Lindley Library/The Genus Rosa p194; p161 The Lindley Library/The Genus Rosa p142; p162 The Lindley Library/The Genus Rosa p88, Vol I; p163 The Lindley Library/The Genus Rosa p272; p164 The Linnean Society Library, London (left) no 121, Vol 2 (right) no 120, Vol 2; p165 The Linnean Society Library, London (left) no 127, Vol 2 (right) no 126, Vol 2; p166 British Museum, Natural History; p167 Royal Botanic Gardens ©Kew; p168-9 Royal Botanic Gardens ©Kew; p170 The Linnean Soceity Library, London; p171 The Linnean Society Library, London; p172 The Linnean Society Library, London; p173 The Linnean Society Library, London; p174 Ashmolean Museum, Oxford; p175 Ashmolean Museum, Oxford; p177 ©M. Stones; p178-9 Ashmolean Museum, Oxford/©M. Stones; p180 Rory McEwen ©Romana McEwan; p182 Rory McEwan ©Romana McEwan; p183 Rory McEwan ©Romana McEwan; p184 British Museum, Natural History; p186 Fitzwilliam Museum, Cambridge, PD 642 1973.